Whistler's Mother

Whistler's Mother

PORTRAIT OF AN EXTRAORDINARY LIFE

Daniel E. Sutherland

and Georgia Toutziari

YALE UNIVERSITY PRESS
NEW HAVEN AND LONDON

To the Sistahs: Annie, Judi, and Barb
Daniel

To Jonathan and Sophia
Georgia

Contents

Preface

Her name was Anna Matilda Whistler, but the world knows her simply as Whistler's Mother. Not even her son, James Abbott McNeill Whistler, thought anyone need know more. In speaking of his most famous painting, he declared, "To me it is interesting as a picture of my mother, but what can or ought the public to care about the identity of the portrait?" But we do care, just as we care about the identity of the *Mona Lisa, The Girl with the Pearl Earring*, or any number of similarly famous yet enigmatic portraits. More than their identities, we want to know about their lives. Who were these people? How did they come to be immortalized? Are the images we see the *real* person? More to the point, do the images we *think* we see, the people we image or assume the subject to have been, accurately reflect their character and personality?

The answer in the case of Anna is yes and no, for she was as complex and nearly as paradoxical as her artist son. Anna never wrote a book, painted a picture, led a crusade, or did any of the other things that most often won renown for nineteenth-century women. She was neither a musician nor a poet. She invented nothing. Superficially, she does not seem to warrant her status as one of the most recognizable women in the western world and an indelible symbol of Motherhood. Certainly, she was very much shaped, affected, and, in some ways, limited by the values and perspectives of her world. Yet, she was also a surprisingly "modern" woman. The nineteenth century was a time of transition for many women, as the lines between private and public lives, domestic and public spheres, became blurred. Some women, operating openly in the new environment, became public figures. Others, like Anna, exploited the same opportunities but were content to work behind the scenes.

Poised and pious, with no higher ambition early in life than to marry the man she adored and maintain a well-ordered, economical, Christian household, Anna proved to be no ordinary woman, and she led nothing like an ordinary life. She became a quiet force in the destinies of everyone around her. Considering her children alone, she reared a great artist, an acclaimed physician, a successful

engineer, and a daughter who became a notable pianist and member of the British peerage. As son James made his name in the European art world, she became his unofficial "agent," promoted his work, sought commissions, managed his finances, and advised him on his best opportunities for success. That he, in turn, should immortalize her as a global celebrity and international icon was only appropriate.

Social class also defined Anna's life. Born in 1804 into what may conveniently be called the upper-middle class, she grew to adulthood at a time when American notions of class were in flux. People were aware of their place in society, of where they stood in the pecking order, but they also understood that the fluid nature of American society made it possible to rise and fall frequently in the course of a lifetime. There were no fixed boundaries. Anna's financial fortunes shifted several times during her seventy-six years, yet her relationships with others and her own sense of identity were consistently reaffirmed by the social position to which she had been born, a position dependent not on money alone, but also on education, religion, friendships, accomplishments, and race.

Above all, she was as independent, resilient, and unconventional as the heartiest pioneer woman. Indeed, she was a pioneer in some very real ways. Her semi-nomadic existence made it difficult to establish the permanence she so very much wanted, but the trials and setbacks she endured forged an unexpectedly resolute character. Rarely content to sit passively at home, Anna was constantly on the go, her bustling life brimming with excitement, crowded with important personalities, and filled with both triumphs and tragedies. She was a shrewd observer of the world around her and had decided opinions about important social, cultural, artistic, and political issues of the day. She knew and interacted with an astonishing array of people, from Russian peasants and American farmers to Robert E. Lee and Giuseppe Mazzini, and including diplomats, businessmen, manufacturers, religious leaders, politicians, journalists, soldiers, and, of course, artists.

If not a pioneer in the sense of joining the westward movement that swept across the American continent, she did endure a life-altering journey eastward, across the Atlantic Ocean and European continent to Russia. In fact, she made the Atlantic trek eleven times during her life. On the occasion of her voyage to Russia, she lost a child en route, as did many pioneer women in traversing the American West. She lost her husband, a world-renowned engineer, nearly six years later while in Russia, and so lived her remaining thirty-two years as a widow. She also outlived all but three of her eight children and stepchildren.

The American Civil War became the second most challenging time in Anna's life. The division of the nation posed a nearly impossible dilemma for her. On

the one hand, she was a Southern woman from a slaveholding family. She had relatives in the rebellious states, including a brother with a mixed-race family and a son serving as a surgeon in the Confederate army. That said, Anna had lived in the North for many years and been married to a Northern-born West Point graduate and army officer devoted to his country. Her solution, midway through the war, was to flee the United States for England.

Had she not fled, that famous portrait may never have been painted. In purely artistic terms, it was a revelation from the start, with the pose and setting soon copied by other artists. Though not immediately garnering universal praise, by the time of James Whistler's death in 1903, most people regarded it as one of his finest paintings. It would be many more years before the portrait achieved its status as an icon, but how and why that happened, the "biography" of the painting, is also an essential part of Anna's story.

Other people have told that story. The first full biography was Elizabeth Mumford's *Whistler's Mother: The Life of Anna McNeill Whistler*, published in 1939. Writing for a general audience, Mumford (a pseudonym for two people, Bessie Judith Jones and Elizabeth Herzog) offered a rather pedestrian account of Anna's life, with no attempt to place her in the context of her times. Although the book was based, the author said, on Anna's correspondence and diaries, Mumford provided no documentation.

Some of Mumford's information came from a distant cousin of Anna, Kate R. McDiarmid, who spent many years during the 1920s and 1930s gathering material for her own biography. That book, *Whistler's Mother: Her Life, Letters and Journal*, was not published until 1981, after her death, but as the title suggests, it was essentially a compilation of excerpts from Anna's known writings. McDiarmid did collect some rare and interesting information from other family members about Anna's life, but not all of it can be substantiated.

Crucially, by the 1980s, a few art historians had also begun to pay attention to Anna, and with more gratifying results. The most knowledgeable Whistler scholar, Margaret F. MacDonald, published several articles about Anna's portrait and a delightful little book entitled *Whistler's Mother's Cook Book*, based on Anna's own recipes. More notably, in 2003 she edited a book of essays, written by several Whistler scholars, about Anna and her portrait. A co-author of this biography, Georgia Toutziari, was one of those contributors. As a doctoral student of MacDonald at the University of Glasgow, Georgia became an authority on Anna. Her dissertation provides both an exhaustively annotated edition of Anna's correspondence (now part of the on-line edition of *The Correspondence of James McNeill Whistler*) and a series of perceptive biographical essays.

Most recently, in 2008, Sarah Walden published *Whistler and His Mother: An Unexpected Relationship*. Walden offers a brief account of Anna's life, particularly as it intersected with that of her artist son; but as Walden restored Anna's portrait for the Louvre in the mid 1980s, the most valuable part of her book deals with that restoration.

The latest biography of James Whistler, written by Daniel E. Sutherland, the other co-author of this volume, and published in 2014, also says much about Anna, but it should be seen as a complement, rather than a competitor, to a biography of his mother. The most fully developed character in any biography is its subject. So while Anna, as mentioned, was a crucial player in the lives of all her children, and while her children must necessarily play prominent roles in her biography, the complete story of her life has never been adequately told.

A 2009 cartoon by John Crowther depicts Anna as she sits for her portrait. She does not seem pleased. With a hawkish expression of disbelief, she fairly barks at her son, "That's what you're calling it, James? 'Whistler's Mother?' Like I don't have a name?" By rights, we, as her biographers, should have heeded that cartoon and called this book *Anna M. Whistler*. Doubting, though, that the name would resonate with very many people, we fell back on the one known to all. That said, we hope the following pages will compensate for our timidity and correct a glaring oversight of history.

Acknowledgments

With a story as rich and deep as this one, the people who have helped us come to know and understand Anna are many, and our debts of gratitude reach back many years. Daniel E. Sutherland first encountered Anna when he began research on his biography of James Whistler. That was in 2000. Georgia Toutziari began her pursuit of Anna in 1999 as a doctoral student at the University of Glasgow. The aid and encouragement of archivists and librarians who contributed to those earlier projects are now appreciated twofold.

More recently, in gathering material and forming our ideas for this book, we were well served by the librarians, archivists, and staff at nearly two dozen institutions. In the United States, these include the New York Public Library (especially Tad Nadam); New York Public Library for the Performing Arts, Billy Rose Division; New York Historical Society (especially Tammy Kiter); Southern Historical Collection, University of North Carolina, Chapel Hill; North Carolina Department of Archives and History; Connecticut Historical Society (especially Jennifer Busa); University of Massachusetts Lowell Center for Lowell History (especially Janine Whitcomb); Lowell Historical Society; Lowell National Historical Park; Scarsdale Public Library; Massachusetts Historical Society (especially Daniel Hinchen); Howard Gotlieb Archival Research Center, Boston University (especially Ryan Hendrickson and Laura Russo); Library and Archives of the Lyman and Merrie Wood Museum of Springfield (Massachusetts) History (especially Cliff McCarthy); Historical Society of Pennsylvania (especially David Haugaard); University of Pennsylvania Archives and Record Center (especially Timothy H. Horning); Maryland Historical Society; Archives of American Art; Taft Museum of Art (especially Tamera Lenz Muente); and Yale University Library (especially Diane Ducharme).

In Great Britain, we are grateful for the help we received at the British Library; the National Art Library, Victoria and Albert Museum; the Bodleian Library, University of Oxford; the Brotherton Library, University of Leeds (especially Richard Davies); University of Glasgow Library (especially Sarah

Hepworth); Hastings Reference Library; Rye Library; Southampton City Archives; Southampton Central Library (especially Penny Rudkin); and the Harris Library, Preston, Lancashire (especially Susan Gleave). Thanks also to Denise Faïfe at the Musée d'Orsay.

Individuals who provided valuable information, insights, or advice include the late Robert and Dorothy Kemper, Richard Marion, Simon Wartnaby, Ralfe Whistler, Grischka Petri, Catherine C. Goebel, Angie Mew, Marilyn Scott, Euan Desborough, Bryony Young, Kim S. Theriault, Frank Towers, and, at the Norton Simon Museum, Pasedena, Carol Togneri and Christine Goo. Daniel's research assistants at the University of Arkansas, Laura Smith, Eric P. Totten, and Mackenzie Taylor, also proved invaluable. Special thanks go to Martha Tedeschi and Ashley Whitehead Luskey for reading important portions of the manuscript and to Margaret F. MacDonald for critiquing the entire work. Additional encouragement came from Nigel Thorp, Linda Merrill, Patricia De Montfort, Lee Glazer, Julieta A. Ogaz, and Sara M. Bogosian and her staff at the Whistler House Museum of Art, Lowell. We are also grateful for the many insights provided by our colleagues at the Lunder Consortium Symposium held at the University of Glasgow in 2015. And we would be ungrateful, indeed, if we failed to acknowledge the steadfast and constant support of our fellow members of the Whistler Society, especially the late David Le Lay, John Thacker, Simon Wartnaby, Sandra Higgins, Eunan King, and Martin Riley.

Some of the many generous people who helped us to acquire copies and rights to the book's many fine and often rare images include Niki Russell at the University of Glasgow Library, Steve Ashcroft at the Longridge History Society, Marlana Cook at the West Point Museum, Daniel Glauber at the Scarsdale Public Library, Margaret Humberston at the Wood Museum of Springfield History, Jennifer McCormick at the Charleston Museum, Sandra and Walter Manco from their collection at the Sharon Springs Historical Society, Jeremy Munro at the Crystal Bridges Museum of American Art, Emily Olson at the Amon Carter Museum of American Art, Stacey Stachow at the Wadsworth Atheneum Museum of Art, and Winnie Tyrrell of the Glasgow Museums.

We very much appreciate the financial support made possible by Kathryn A. Sloan and Calvin White, former and current chairs, respectively, of the Department of History, University of Arkansas; Todd Shields, dean of Fulbright College, University of Arkansas; and Cynthia L. Sagers, associate vice provost for Research and Development, University of Arkansas. A sabbatical leave given to Daniel at a crucial stage of the project was also very helpful.

Finally, we are indebted to everyone at Yale University Press, London. Besides

her flawless handling of Daniel's biography of James Whistler, Gillian Malpass, former director of art and architecture in Bedford Square, initiated and promoted this biography of Anna. Thanks as well to Emily Lees, Daniel's former editor, for her ongoing support. Gillian and Emily's work has been carried on in admirable fashion by Mark Eastment and his staff, most notably managing editor Anjali Bulley, head of production, design, and editorial Clare Davis, project manager and copy-editor Caroline Brooke Johnson, and picture researcher Elizabeth O'Rafferty.

1
A Child of Two Worlds
1804–31

IF SHE STOOD ON TIPTOE, little Anna Matilda McNeill could see the masts of dozens of ships from the second-story porch of her home in Wilmington, North Carolina. The Cape Fear River flowed less than a quarter mile away, at the bottom of a steep hill. Anna need only skip down the hill to be engulfed by the swirl of energy and cacophony of sound that made Wilmington one of the new American nation's busiest seaports. Though two dozen miles from the Atlantic Ocean, she knew the rhythm of its tides, and could feel the freshness of breezes wafting upriver. What she could not see from the red-brick house on the corner of Fourth and Orange Streets was the extraordinary life that awaited her once she had sailed outward bound on that same river to oceans and continents beyond.

The forces propelling that life were fortuitous. Anna's mother, Martha Kingsley, was a beautiful, cultured woman from a somewhat scandalous family (fig. 1). Martha's father, Zephaniah Kingsley, had been born in England but emigrated with his Scottish wife (a Johnston by birth) and three children to the American colony of South Carolina in 1770. Based in Charles Town, Kingsley prospered as a merchant, plantation owner, and slave trader until the American Revolution. As "Tory" Loyalists, the Kingsleys then suffered the hostility of neighbors, with Zephaniah being imprisoned at least three times for refusing to join the local militia. For safety's sake, he had already sent his wife, pregnant with the last of their six children, to New Jersey, where Anna's mother was born in August 1775.[1]

After the American Revolution, when Zephaniah still refused to swear loyalty to the new nation, the state of South Carolina confiscated his property.

The family fled to Nova Scotia in 1785, and though returning to the United States six years later, they settled not in their old home but in Wilmington. It was there that Martha met Dr. Daniel McNeill, a widower five years her senior with two daughters. They married around 1800, although marriage did not mean instant motherhood for Martha. McNeill's daughters, twelve-year-old Eliza and fourteen-year-old Alicia, had been sent to live in Scotland, which adds another layer of complexity to Anna's lineage.[2]

Wilmington had been founded by English colonists in the 1720s, but by the 1740s, hundreds of Scots, including Daniel McNeill's family, had joined them. Daniel, descended from the Taynish McNeills, of Gigha, was born in 1756. Reliable information about his life is sketchy, but McNeill, like the Kingsleys, sided with the British during the American Revolution. When the British army invaded North Carolina, he enlisted as a supernumerary surgeon's mate. Young, passionate, and unable to reconcile himself to defeat at war's end, McNeill fled to Edinburgh, where he may have acquired formal medical training. It is certainly where he met Alicia Clunie, of Whitekirk, East Lothian, and married her in 1784. McNeill returned with his bride to Wilmington, but old neighbors were unforgiving. They created such a popular clamor that in late 1785 the county court banished him. Friends protested that McNeill had broken no law, but his sentence was upheld by the state legislature. So, shortly after the birth of the couple's first child, Alicia Margaret Caroline, in 1786, the McNeills moved to the Bahamas, where a second daughter, Eliza Isabella, was born two years later.[3]

By then, the exile was all but over. McNeill had returned to Wilmington by the autumn of 1788, though quite possibly without his family. His wife died either in the West Indies or very shortly after the return to North Carolina. McNeill then sent the motherless Eliza and Alicia to live with their Scottish grandparents. Whether he intended eventually to rejoin his daughters or bring them to America is unknown, but once having met the charming Miss Kingsley, the doctor's life took a new direction.[4]

Daniel and Martha had three children of their own (two daughters and a son) before Anna arrived on September 27, 1804. She entered a world already marked by the boisterous ambition and self-confidence that would define her native land. In February of 1804, Lt. Stephen Decatur's retaliatory naval raid against Tripolitan pirates in the Mediterranean made him a national hero. In May, Meriwether Lewis and William Clark departed St. Louis, the nation's westernmost outpost, to explore the recently acquired Louisiana Territory and the lands beyond. In July, Aaron Burr, vice president of the United States, shot and killed his political nemesis Alexander Hamilton in a duel. In December, Thomas

Jefferson, who in purchasing Louisiana and dispatching Lewis and Clark, envisioned a nation that would thrive on expansion, was re-elected president of the United States. Born that same year were future "mountain man" Jim Bridger, writer Nathaniel Hawthorne, and inventor and manufacturer John Deere.

By any measure, Anna enjoyed a happy childhood. Certainly, she was financially secure. Besides his medical practice, her father realized a profit of $1,200 in 1805 by selling a plantation, Oak Forest, located some forty miles northwest of Wilmington, to his brother. Even then, Anna and her siblings – the number increased to five by the time she was aged seven – continued to enjoy summers at Oak Forest, where the higher elevation offered moderate temperatures, and woods and fields provided adventures unknown to the streets of Wilmington.[5]

The children apparently had tutors for some part of their education, with the elder boy, William Gibbs, perhaps attending a private school. However, Anna's schooling would have been more restricted than her brother's "classical" education, which was based on Greek and Latin and fortified by history, geography, arithmetic, chemistry, philosophy, grammar, and oratory. Much of that curriculum, particularly ancient languages, the sciences, philosophy, and oratory, was still widely regarded as an "idle waste of time" for young ladies.[6]

Similarly, moral values had to be instilled, character molded, genteel behavior cultivated, habits of thrift and hard work propagated, but here again, there were differences between boys and girls. While boys were groomed to participate in the affairs of the wider world, girls of Anna's class and generation were reared to be ladies and agreeable companions for future husbands. Lessons in dancing, singing, and music were as important to them as literature and geography. They should know something of cooking, too, although that did not mean scouring pots and cleaning grates. Menial chores would be left to servants, which required, in turn, that young women learn how to manage and train domestics. Later generations would refer to these multiple talents collectively as the "cult of true womanhood."[7]

And there was something else. Because women were assumed to be more emotional and spiritual than men, religious training played a crucial part in their preparation for life. As wives and mothers, they would be responsible for the moral foundation of American homes. Men could not help but be sullied by their prescribed roles. Commerce, politics, even the professions often required moral and ethical compromises that might corrupt the most virtuous of them. Consequently, their homes and goodly wives provided a safe haven, a source of moral rejuvenation, a refuge from the outer world. Equally important, women were responsible for raising their children in a virtuous, devout, and patriotic

environment. Ideally, American women wedded "true" womanhood to "republican" and "evangelical" womanhood.[8]

Anna's spirituality grew from a mixed religious heritage. Her maternal grandmother, having grown up in the Church of England, converted to Zephaniah Kingsley's Quaker faith after marriage. Daniel McNeill was likely a good Scots Presbyterian, and North Carolina, with its ethnically diverse population, leaned heavily toward Protestantism during his youth. Despite all that, Anna was reared as a "Low Church," evangelical Episcopalian, and it is impossible to understand her devout nature without taking this into account.[9]

The Episcopal Church in North Carolina thrived after American independence, in part because the higher social status it conferred attracted a growing number of businessmen and ambitious professionals, but also because of the strong evangelical strain embraced by its so-called Low Church brethren. Compared to the more boisterous Baptists and Methodists, this branch of the Church remained emotionally restrained. It avoided, for instance, such excesses as camp meetings. Yet, evangelical Episcopalians insisted on playing a visible role in the world. Bible classes, Sunday schools, tract societies, temperance organizations, and, most especially, missionary ventures were their favored means of spreading God's word. Nor did they hesitate to work across denominational lines, all steps too far for the High Church.[10]

Religious training also impressed upon Anna the missionary role of women in society, even as her social status allowed for a privileged life. She learned that certain people did the world's hard, manual labor, while others, like her family and friends, enjoyed an abundance of leisure. Yet, to her parents' credit, she also learned to treat the laboring classes, white and black, free and slave, benevolently. They, too, were God's creatures, with souls to be saved and a need for food, raiment, and shelter. Her social class, especially its women, bore some responsibility, working through their churches or other charitably inspired organizations, to provide those necessities and lead the way to salvation.

That said, as a child of the antebellum South, Anna also belonged to a privileged race, another part of her inheritance that she accepted without question. The South's racial hierarchy, so often justified through Holy Scripture as a natural condition of mankind, could only survive scrutiny if the entire social order adhered to its rules. Among the most visible public reminders of that hierarchy were the slave auctions held in front of Wilmington's county court house. The scene shocked people not accustomed to it. "One cannot without pity and sympathy see these poor creatures exposed on a raised platform, to be carefully examined and felt by buyers," a German visitor to Wilmington commented not

long before Anna's birth. "Sorrow and despair are discovered in their look, and they must anxiously expect whether they are to fall to a hard-hearted barbarian or a philanthropist. If negresses are put up, scandalous and indecent questions and jests are permitted."[11]

Given her parents' benevolent view of the working classes, it is likely that Anna was shielded from such sights, yet the McNeills were slaveholders. It is difficult to judge the number they kept. Anna's father owned just two slaves in 1790, and while he inherited an additional but unknown number from his brother in 1811, he may have rented them out, his own need for house servants being limited. Anna's younger sister, Catherine Jane (called Kate by the family), recalled "a great many slaves," but those could well have belonged to her uncle, used to operate Oak Forest. Kate's more vivid memory was of "faithful house darkies," as opposed to field hands.[12]

The lessons were abiding. Anna grew to believe that life was a constant effort to please God, who demanded unquestioned obedience to His laws. Humility, reverence, repentance, salvation, human frailty, patience, obedience, quietude: Anna heard those words over and over again. She read them in tracts, prayer books, hymnals, and the right sort of novels. Published cookbooks and household manuals might even include passages from Scripture, such as Proverbs 31:27: "She looketh well to the ways of her household, and eateth not the bread of idleness." How well Anna understood this catechism as a young child is problematic, but the words, if not their deeper meaning and consequences, took deep roots. They became part of her fabric, as natural a part of her life as breathing.[13]

Two very practical benefits grew from these secular and religious educations: ingrained habits of reading and writing. From the time we know anything definite about Anna, she was an avid reader, not only of the religious tracts thrust upon her, but also of popular novels (the "improving" kind), newspapers, and history. As the New England novelist and social reformer Catherine Maria Sedgwick, who was very near Anna's age and had much the same education, insisted, "Reading has been to me 'education.'" Good penmanship was another highly prized ornament of female education, but only in so far as it instilled the *habit* of writing, which, as it happened, most religious denominations encouraged as an aid to self-reflection and confession. All her adult life, Anna would write long, reflective letters to family and friends, and for some six years, when in her early forties, she kept revealing diaries.[14]

In time, Anna also learned that letter writing was the surest way for women to preserve complex webs of family connections and friendships, even across continents. Lacking the "public sphere" of men to create social and political networks,

women achieved the same ends through a "private sphere" of friendships and alliances. A "community" of women, not limited by geography, legitimized and reinforced shared religious, educational, domestic, and social values. Although she could not foresee these consequences as she strove daily to transform her girl-ish scrawl into a genteel, ladylike script, those friendships and associations would shape and guide important moments in her life.[15]

Yet, this carefully choreographed education, at least the distinctly "Southern" part of it, would be modified by the time Anna was ten years old. That was when Dr. McNeill moved his family to Brooklyn, New York. It was not as odd a move as it might seem. Given their own unsettled childhoods, neither Daniel nor Martha had a very strong sense of place or permanence. They changed residences as easily as they replaced summer garments with winter ones. Daniel kept a residence in New York City, located on Greenwich Street, as early as 1807, although that was still not the family's principal home. A friend reported the McNeills *returning* to Wilmington that same year, and Dr. McNeill was practicing medicine in North Carolina as late as the summer of 1813, when a young woman battling yellow fever gave thanks for his "unremitting" and "*fatherly* attention." Anna's earliest definite memory of life in the North was a fireworks display over New York in early 1815 to celebrate U.S. victory in the Anglo-American War of 1812.[16]

Still, except for the often bitterly cold winters, Anna would not have found either Brooklyn or New York City totally alien. Both places, like Wilmington, were commercial hubs and seaports with a similar pulse. And while the population of New York vastly exceeded that of Wilmington (about 2,000 by 1815), Brooklyn (3,805) was much closer in size to the Southern town. One even found the remnants of slavery in Brooklyn, despite a state law that had enacted gradual emancipation in 1799. The village's nearly three hundred slaves could not compare to the black population of Wilmington, which slightly outnumbered whites, but it would be many more years before the institution was eradicated. The McNeills may even have taken their household servants with them. A good friend of McNeill, Col. Joseph G. Swift, did so when, having been assigned as chief engineer of the military defenses of New York Harbor, he moved from Wilmington to Brooklyn around this same time.[17]

A niece of Anna believed that Dr. McNeill moved north because he "hated" slavery, and "would never allow a family to be *separated*" through sale. That well may be true, but whatever his predilections, McNeill weaned himself from the institution gradually. He still owned the slaves inherited from his brother when the family went north, and surviving records, though admittedly incomplete,

show the sale of only three slaves. In 1812, he sold George for $520, and in 1817, well after the family moved to Brooklyn, Henry and Kitty brought him $285 and $300, respectively. The relatively low prices in 1817 suggest that Henry and Kitty were either very young or past middle age. What happened to the others is unknown.[18]

It is also true that Wilmington had not fared well financially during the War of 1812. The Wilmington of Anna's youth was known for its vibrancy, its many fine shops, elegant homes, balls, tea parties, and tradition of amateur theatricals; but the war, at least temporarily, made it "an abominable place for business." A visitor in late 1814 conceded that its citizens were "a jovial, sociable set of people fond of Company." He was especially taken by "some of the many Ladies," who were "not without their attractions." However, he also believed the town had been lately ruined by an "immense number of Privateers," a "most extravagant set of fellows" that had created an atmosphere of suffocating "corruption & dissipation" (fig. 2).[19]

And though not a reason to move north, the McNeills doubtless chose their destination because Martha's mother and sister Isabella already lived there. Martha's brother-in-law, George Gibbs, who was also a friend of Joseph Swift, had formed a partnership with her Florida-based brother, Zephaniah Jr., and opened a commission office in New York City to facilitate Zephaniah's widespread mercantile ventures, mostly in the slave trade. By the time the McNeills left North Carolina, the Gibbs family was moving from New York to Brooklyn, although, sadly, Grandmother Kingsley died in December 1814, shortly after Anna's arrival.[20]

The Brooklyn of Anna's youth experienced remarkable growth. When she first arrived, it was a mere village, barely a mile square. Its economic life flowed through the docks and ferry landing on the East River, with New York City standing opposite, only a mile away. A U.S. Navy shipyard, opened in 1806, sat about a half mile to the north, along the curving shore of the river. Beyond it lay the extensive farms of families whose ancestry could be traced to the earliest Dutch settlers. Much of the village was unprepossessing, especially along the river, which was a jumble of houses, taverns, stables, and shanties. A modern touch was added in 1814 when one of Robert Fulton's new steamboats replaced a fleet of rowboats that had previously ferried people back and forth to New York. Capable of carrying carriages and wagons as well as people, the ferry could make forty crossings per day (fig. 3).[21]

The expansion represented economic prosperity. A growing number of greengrocers, butchers, fishmongers, saddlers, carpenters, coach makers, coopers, and

cobblers crowded in, either buying old establishments or building new ones, and, as befitted a working-class port, there was a distillery. Gentlemen in the village raised a subscription to lure a New York barber to Brooklyn, his services being deemed "essential to the comfort and self-respect of a properly organized community." An iron foundry, banks, and insurance companies soon followed. By 1824, when a "commodious" new market and municipal court were established, Brooklyn had begun to assume "a more elegant and creditable appearance." That summer, scores of merchant ships, brigs, schooners, and sloops jammed its docks and wharves.[22]

Physical improvements deemed essential to a respectable town kept pace. Between 1818 and 1828, street signs were erected at each corner; more streets were paved and sidewalks laid. A library was built in 1825 and a second Episcopal church (St. John's) erected the following year. A board of health was created, and ordinances passed for the cleaning of the busiest streets every Tuesday and Friday morning. Garbage was collected on Wednesday and Saturday mornings. The village board of trustees passed a series of ordinances to improve the quality of life, including bans on firing guns in the village, obstructing streets with heavy merchandise, building fires or cutting sod in the streets, selling liquor or keeping a tavern without a license. Hogs found running at large were confiscated for reasons of both health and safety. Numerous, large, and "voracious," the hogs of New York and Brooklyn were known "to tug at small children sitting on the sidewalks of the more remote streets."[23]

The most desirable residences, including several mansions with extensive gardens, fields, and orchards, overlooked the river from Brooklyn Heights. In August 1776, British soldiers had defeated George Washington's rag-tag army on the upper reaches of the Heights. Forty years later, local promoters were touting the lower Heights as the perfect place for "families who may desire to associate in forming *a select neighborhood and circle of society.*" They emphasized the convenience of the region for "gentlemen whose business or profession requires daily attendance into the city," meaning New York. The McNeills resided on the northern slope, at 22 Hicks Street, very near the Gibbses, who lived a block west of them on the corner of Willow and Cranberry. Hicks descended so sharply toward Old Ferry Street (later, Fulton) that heavily loaded wagons passed up and down with "considerable difficulty." Of the sixteen homes on Hicks in 1814 (a number that would double by 1821), most were owned by prosperous artisans and tradesmen, some of whose shops were also located on the street. The McNeills probably lived in one of the larger, four-story, wood-frame homes, its main entrance standing well above the street, so that one entered on the second floor from a high front porch.

Willow trees lined the street, but the entire Heights were well shaded by a

combination of elm, mulberry, locust, cedar, poplar, cypress, and catalpa. A Swedish visitor was taken by the variety of flowers, noting "the numerous jasmine, caprifole, lilac, and wild rose hedges which surround[ed] the small farmhouses nearest the heights." George Gibbs left his own horticultural mark by introducing a new variety of grape to the area, transplanted from a cutting brought from North Carolina. He named it the "Isabella," after his wife.[24]

The Gibbses returned south to Florida in 1819 (selling their old house to Joseph Swift), but they and the McNeills remained close, with Anna's family visiting them at least once when she was in her mid teens. Years later, she could still recall "an old Spanish fort," likely the Castillo de San Marcos in St. Augustine, where she and her cousin Sophia enjoyed "echoes of song & laughter, as orange groves & unclouded skies, guitars & Spanish dances & graceful girls awakened romantic views" of a bygone time. The girls, who became as close as sisters, called each other Hope and Faith, Anna being Faith.[25]

Anna also visited her South Carolina cousins as a girl. The Porchers, Petigrus, and Draytons ranked among the elite cotton and rice planters of the state, their wealth and influence strengthened through intermarriage. Anna, who would ever recall them as being "conspicuous for talent & position," was both proud and fond of these relations. Her favorite was the charming Rose Drayton, two years her junior but envied by Anna for being so "unconsciously graceful, a belle but not a rattle!"[26]

Back home, on the Heights, the McNeills were not nearly so socially prominent. Anna's mother may well have been involved with the local temperance society, the Brooklyn Female Religious Tract Society, a movement to establish "Sunday" or "Sabbath" schools, a Humane Society to feed the poor, or any of several benevolent institutions and causes in the town. However, Martha does not appear to have been a member of the Brooklyn Woman's Club, nor was Anna's father a member of the gentlemen's Social Club, organized by Joseph Swift, who was himself visibly active in the cultural and philanthropic growth of Brooklyn. Dr. McNeill had never been much of one for society. He had not participated in one of Wilmington's most prominent male social bastions, the Nine-Penny Whist Club, either. Nonetheless, outbreaks of yellow fever and smallpox in the winter of 1815–16 and summer of 1823 established him as an invaluable addition to Brooklyn, his experience in treating yellow fever on the low, swampy coast of North Carolina having proved especially beneficial.[27]

The McNeills did attend St. Ann's, Brooklyn's first Episcopal church, with the Swifts and Gibbses. Anna's older sisters were married there in a double ceremony two years after the family settled in Brooklyn. Isabella married George William

Fairfax, from a prominent Virginia family; Mary wed Lt. Joseph Easterbrook, a British naval officer. Everyone assumed that Anna would do equally well. That said, the McNeills appear to have had mixed feelings about St. Ann's, which formed part of the "most High Church diocese" of the early nineteenth century. The evangelical McNeills were "removed" from the list of St. Ann communicants in 1822, which suggests that they had grown dissatisfied with its theological direction. Interestingly, five years later, by which time the McNeills had left Brooklyn, the church's membership expressed a similar disposition by calling a prominent evangelical pastor, Charles McIlvaine, to lead them.[28]

With her older sisters gone, Anna, twelve years old in 1816, would have assumed more responsibility for raising her younger siblings, five-year-old Charles Johnson and four-year-old Kate. Despite the difference in age, Anna and Kate might have been twins, so similar were their interests and opinions as they grew older. Ever the big sister to Charlie, Anna led him protectively by the hand through busy city streets and nursed him through a severe attack of typhus fever. Perhaps she took both siblings in 1820 to see the carcass of a seventy-foot long whale that some enterprising person had hauled ashore and exhibited at twenty-five cents a head. Crowds gathered from Brooklyn and New York to gawk at the dead monster, although it was not long before the stench of the rotting carcass became so potent that visitors "could be detected by the odor which had impregnated their garments."[29]

No record remains of Anna's northern education, although Kate remembered attending a school of some sort, and most girls with their advantages continued formal lessons at least into their mid teens. They may also have been exposed to a "more advanced" education in the North, which differentiated less between boys and girls by 1814. Although the trend would become more marked after 1820, some female academies and seminaries were already adding mathematics, moral philosophy, the sciences, and Latin to their curricula. There were at least three private schools in Brooklyn, but the cornerstone for the first exclusively girls' academy was not laid until 1829.[30]

Joseph Swift helped to decide the educational fate of Anna's elder brother, thirteen-year-old William (fig. 4). The boy was prepared to begin theological studies at a seminary on Long Island when Swift, who was by then an army general, invited him to visit his own alma mater, the U.S. Military Academy, at West Point. Described as "dignified and courteous" by virtually everyone, Swift liked to "promote the interests" of the academy, as he put it, "by selecting the intellectual sons of . . . respectable acquaintances and inviting them to apply." He also served at this time as the ranking officer of the academy (fig. 5). William

was immediately taken with the idea of becoming a soldier, and Swift assured the McNeills that their son gave "evidence of being suited to the place." William was duly enrolled at West Point in July 1814, with consequences that no one could have foreseen.[31]

Smart and spirited Anna enjoyed a wide circle of friends. Even when her Gibbs cousins left for Florida, she still had the Swift children, and brother William introduced her to a number of fellow cadets from West Point. Anna visited the academy more than once, perhaps as early as 1814, and William may have taken friends to see Brooklyn. Anna's favorite was George Washington Whistler. The son and grandson of soldiers, Whistler had been born on the frontier, at Fort Wayne, Indiana Territory, in 1800. His Irish-born father had fought in the British army during the American Revolution but subsequently returned to America and enlisted in the new U.S. army. Consequently, George grew up on a series of military posts, including Fort Dearborn (modern Chicago) and Fort Detroit. There seemed little question that he would follow the family trade, and so, in 1814, he was enrolled along with William McNeill as a cadet (fig. 6).[32]

McNeill, Whistler, and William H. Swift, a younger brother of the general who had entered the academy a year earlier, became fast friends. Though the youngest, McNeill was the most serious and precocious of the three teenagers. Having given up theology, he devoted himself to mathematics and engineering, the core of the West Point curriculum. Under normal circumstances, he would have spent five years at the academy, but when a new superintendent took charge in 1817, he deemed McNeill and several other cadets sufficiently prepared for graduation. Within days, he was commissioned a third lieutenant in the artillery.[33]

Whistler and Swift were not as fortunate, nor as mature. Those high-spirited lads were better known for pranks and mischief than devotion to studies. Whistler, especially, perhaps having been spoiled as the pet on every army post where his father had served, spent an uncommon amount of time in the guardhouse. He was also a gifted flute player, which earned him the nickname "Pipes" and made Whistler the center of many a jolly gathering in barracks and parlor. Still, he graduated in the upper half of his class and demonstrated marked skill in drawing and the closely related subject of descriptive geometry. Two years after graduation, in 1821, he would be recalled to the academy to serve as a drawing instructor.[34]

Anna gradually became infatuated with the strikingly handsome Whistler, with his dark, curly hair and exuberant yet shy nature. Unfortunately, he had become smitten with Mary Roberdeau Swift, William's younger sister. More

daring and vivacious than Anna, Mary had reportedly stolen the heart of every cadet at the academy, but she settled on Pipes. They married in early 1821, or rather, they eloped. Mary's father was none too pleased. Whistler was only twenty-one, his bride just seventeen, and it was not possible that an army lieutenant could provide the comfort and security to which she was accustomed (fig. 7).

Luckily, Joseph Swift and his mother had "a favorable estimate" of Whistler's "worth and ability," and they persuaded Dr. Swift to overlook the young man's rashness. "Father has considered the late affair in its best light," William informed Joseph, "and kindly consented to receive Mary and Whistler under his roof in forgiveness." William then offered a shrewd assessment of his new brother-in-law: "It cannot be denied that Whistler acted very imprudently [but] . . . he is a young man of no ordinary talents. His mind is well disposed and his habits are correct. He has sufficient pride to hold dependence in abhorrence, at least I think so. Time, perseverance, and economy will I hope enable him to secure a decent livelihood."[35]

Anna, herself just sixteen, was reportedly crushed by news of the wedding and vowed in her grief never to marry. How gladly *she* would have run off with Pipes in such an impossibly romantic way! Yet, as time would tell, Anna was never down for long. The excitement of her brother William's marriage to Maria M. Cammann, of New York City, a few months later was distraction enough, and William's marriage also brought with it a wider family circle and some new, ultimately important, friends.[36]

Most important was Margaret G. Hill, known to all as Meg. With the Cammanns and Hills, both families of prosperous merchants, being close friends, the girls likely met during William's courtship of Maria. Meg's father, William Hill, was Irish by birth but had lived in New York City since the age of ten. He suffered significant financial losses in the 1820s through some unfortunate investments, but the marriage of one of Meg's four older sisters to William S. Popham, a coal merchant, kept him afloat. This financially successful family alliance would leave Meg, who never married, an independent woman by 1828, when her father died. That such a woman, two years Anna's senior, should become a life-long friend and one of her closest confidants – so close that they called each other "spouse" in those early years – was not insignificant.[37]

Anna and Meg felt particularly close in 1828, for in the same year that Meg lost her father, Dr. McNeill also died, aged seventy-two. The family had moved recently to Georgetown, in the District of Columbia. In fact, they lived in the same house General Swift had occupied during one of his army postings. Why they left Brooklyn is unknown, although Martha McNeill apparently

believed the town had grown too large. "Upon the whole," she decided in the summer of 1827, "the society [there] is to me so changed that it is not as desirable as formerly." Martha enjoyed her Georgetown neighbors but found that village wanting, too. For one thing, a lack of "regular" Episcopal services had compelled the family more than once to attend divine worship at one of Georgetown's two Catholic churches. Nor could Martha find a suitable school for Charles, who, while "very studious," had been forced to do "his best at home."[38]

When the doctor died, she may have considered a return to North Carolina. She had visited Wilmington a year earlier and reported to Louisa Swift, wife of the general, that the town was "vastly improved." She had, as well, been gratified by the "heart felt . . . reception" given her by old friends. Or perhaps Philadelphia would be a good place to settle, she ruminated to Louisa; not the city itself, she emphasized, but the surrounding countryside. "[That] will be by far more desirable [than Georgetown]," she told her, "as this is certainly out of the way, and at this season a very dull place."[39]

Instead, the family moved to Baltimore to live with William McNeill. By then a captain in the topographical engineers, Anna's brother had led an adventurous eleven years since leaving West Point. He had been assigned initially to survey sites for fortifications on the Atlantic and Gulf coasts, but with a war against the Seminole Indians raging in Florida, he immediately volunteered for action. After serving on the staffs of both Gen. Andrew Jackson and Gen. Edmund P. Gaines, he returned to topographical duty, mostly in Virginia and Maryland, until 1827. That is when he became one of seven army engineers released from their normal military duties to help build the Baltimore and Ohio Railroad.[40]

The army regularly assisted private companies in this way. The U.S. Military Academy had been created in 1802 as much to produce engineers as to provide military officers for a young country. Indeed, as the nation continued to expand geographically and prosper economically, graduates of West Point, educated at public expense, were expected to assist in building its roads, bridges, canals, and harbor facilities. Beginning in 1825, they were even seconded, and for additional pay, to private companies engaged in construction works that benefitted the common weal. The B&O, which was to be the nation's first major railroad, secured McNeill's services for $1,500.[41]

Baltimore was not much of an improvement over Georgetown, save for its Episcopal church. Even five years later, in 1833, the English actress Fanny Kemble described the place as "a large, rambling, red-brick village." Its "untidy, unfinished, straggling appearance" reminded her of an English manufacturing town. But William needed his mother's help. His wife and three children had

been quite ill, and with duties on the railroad keeping him away from home for weeks at a time, it would comfort him to have Martha near at hand. The arrangement also benefitted Anna, who had just recovered from an apparently serious, though unspecified, illness. A move to Baltimore, rather than Philadelphia or Wilmington, was far easier on her physically (fig. 8).[42]

Living with William helped Anna emotionally, too, for, as things turned out, the recently widowed George Whistler was a frequent guest at her brother's home, one of a block of handsome brick townhouses known as Pascault Row (fig. 9). Whistler's wife Mary had died of typhoid nearly a year before Anna's own father. Still an army lieutenant, Whistler's career, if not as exciting as McNeill's, had been noteworthy. Following his stint as a drawing instructor at West Point, he served mostly with the topographical engineers, assigned to projects in Massachusetts, Kentucky, Missouri, and on the Canadian border. Eventually, he joined McNeill's team on the B&O.

Anna was doubtless shy and hesitant in his presence after so many years. She could, though, provide a warm and sympathetic smile when the men returned from their long and exhausting inspections of the railroad, all done on horseback. Whistler, in turn, relished the opportunity to join the McNeill family circle, especially since the work required that he leave his three young children, five-year-old George, three-year-old Joseph, and two-year-old Deborah, with Joseph Swift's family in Geneva, New York.[43]

In November 1828, a year into Anna's fortuitous reunion with Whistler, both he and McNeill were dispatched to England on behalf of the B&O. They were to consult with British engineers and inspect the fledgling English railroad system. England had launched this new revolution in transportation, powered by steam locomotives, less than two decades earlier. Used at first to haul coal and other heavy freight, by the 1820s, both the English and Americans recognized the possibilities for passenger travel. England's twenty-five-mile-long Stockton and Darlington Railway had been the first to try the experiment, in 1825. By 1829, the Liverpool and Manchester Railway was also in operation, and Americans were primed to follow the English example.[44]

After arriving in Liverpool, Whistler and McNeill were joined by Ross Winans, a thirty-three-year-old "plain country farmer" from New Jersey who happened to be a mechanical genius. Having invented a revolutionary "friction wheel" for the railroad cars of the B&O, his assignment in England was to study the locomotives and rolling stock of that country. McNeill was the acknowledged leader of the group, as well as being the most experienced engineer. Whistler admired him, although on this trip, he proved himself to be equally

shrewd and insightful, as well as a man of decided opinions. Such was his patriotic belief in American exceptionalism that little of what Whistler saw impressed him. That included British engineers, several of whose qualifications and abilities he found "vastly inferior" to his expectations.[45]

When Anna welcomed him home six months later, in May 1829, she was thrilled to discover that Whistler's favorite parts of the trip were closest to her own heart. He had fallen in love with Scotland and was "*astonished*" by the natural beauty of Edinburgh, the "City of Palaces." "Nature and art have combined to make it all that could be said [of] it," he reported. The greatest artist could not produce a more perfect landscape. Passing through Preston, England, he and William also visited the McNeills' half-sisters at their home, Alston Lodge. Eliza and her second husband, John Winstanley, a solicitor, owned the lodge, but the unmarried Alicia had lived with them for several years. Whistler thought Eliza bore a "striking" resemblance to Anna's brother, whom the sisters fairly worshipped.[46]

The depth of feeling between Whistler and Anna grew. She called him "brother," even as she hoped for a less platonic relationship. Family tradition has it that Mary Whistler told him on her deathbed, "If ever you should marry again, it must be to Miss McNeill." Whether or not true, and whether or not Anna knew of the remark at the time, she steadily endeared herself to Whistler. While not the beauty that Mary had been, she was attractive enough, petite in stature with warm brown hair, blue-grey eyes, small feet, and "shapely and carefully kept" hands. Still, it was too soon for the young widower to consider remarrying. He remained "much depressed" by the loss of Mary, and the feelings of his children, with whom Anna enjoyed little contact, had to be considered. It was simply too soon.[47]

The time did seem right, though, for Anna to go abroad, or so thought her mother, who convinced Anna to visit the half-sisters in England. She departed in October on what was to be the first of eleven transatlantic voyages during her lifetime, more than any other family member or friend. She sailed unescorted, too, as an independent woman, although Anna found several gentleman on board eager to attend her. The captain of the vessel, whom she described as "kind as a parent," provided Anna with an excellent servant who helped to dress her and attend her on those days when the rolling sea made Anna feel puny. Two male passengers, one of them a cousin of William's wife, enquired after her each day, but Anna spent much of the fourteen-day voyage dreaming of home, sewing, reading, and walking the deck. "A ship is the school to teach patience," she wrote to sister Kate in her earliest surviving letter, "and tho we may often fancy we are

enjoying ourselves in it, we find upon looking into our hearts they feel no pleasure but that it is all forced."[48]

That comment to Kate reveals much about Anna McNeill. Though sprightly and good-humored, her light-heartedness, even aged twenty-five, was always restrained. She also knew her own mind and never feared to speak it. William's wife, Maria, once said of her, "Anna is so *unshakable* that sometimes – I could shake her. And the way she will stand out even against people whose opinion means the most to her. One can't help admiring it but it seems so – well, so old!" Anna's mother was much the same, and certainly the daughter of a physician would be acutely aware of the perilous balance between life and death. Her deep religious convictions only reinforced that awareness.

At the same time, the way in which Whistler had suddenly reentered her life made this voyage a test (as she saw it) of their feelings for each other, a romantic notion worthy of the female novelists she liked to read. She felt the pangs of separation most keenly one evening when several musical "gents" began playing Scottish airs on their flutes. "Oh how my heart [ached] the first time I listened to *Kinlock*," she confided to Kate, "but when the Yellow haired laddie followed, I covered my hands over my eyes & wished to fancy I was again at home." Having heard Pipes Whistler perform those same tunes, she may well have returned to her cabin that night to play the music box "Brother George" had given her in saying *bon voyage*. She listened to it often on the trip.[49]

A family friend, Betsey Sandland, welcomed Anna in Liverpool and sent word to the Winstanleys of her safe arrival. Over the next several days, a whirl of visiting left the new arrival feeling as though she had met every friend and relation within a dozen miles of either Liverpool or Preston, nearly fifty miles to the north. Alicia, eighteen years her senior, greeted Anna at Alston Lodge as her "*own child*." Eliza, sixteen years older than Anna but born on the same date of September 27, became her "twin sister." Anna marveled at how much Eliza, whom Whistler had thought resembled William, looked like their father, and would have liked to think that she, too, resembled her twin. As other family members would say, "Aunt Eliza was a very beautiful woman. Aunt Alicia quite the reverse." John Winstanley, whom Anna soon called Brother Winny, teased her relentlessly but affectionately, as though she were *his* younger sister.[50]

Next came a shopping spree, which began with a pair of "stout Boots" for Anna. Seeking to justify the extravagance, she assured her "spouse," Meg Hill, that the purchase was essential. "I thought the mud would cost my life either from a fall or the damp penetrating my thin slippers," she declared. Never one to put on airs, Anna then made an even harder admission: "From the shoe shop

Sister took me to ... the most fashionable hair dresser's." She sounded almost embarrassed by the excursion, although Anna knew that her sister-in-law Maria would be pleased by the new pile of "curls, puffs, &c." Eliza thought her the personification of Julia D'Clifford, the orphaned heroine of Catherine Cuthbertson's wildly popular novel, *Santo Sebastiano: or, the Young Protector*, who turned out to be an heiress. Anna felt more like the "egotistic" heroine of Fanny Burney's *Evelina*. She begged Meg not to tell Kate about her indulgences. "I know my own inferiority too well!" she insisted.[51]

Anna believed, as well, that every obstacle, misfortune, or misstep in life presented an opportunity for self-improvement. When John Winstanley poked fun at her "*Yankee* accent," Anna declared to Meg, "I am not in the least offended & perhaps gain by good nature what my deficiencies in other respects might make me lose." She believed that God clearly intended that such challenges should strengthen one's patience and resolve. Learning that Eliza was pregnant, and that she had been "quite ill" during a previous confinement, Anna refused to worry. "[F]or God will bless her," she decided confidently, "whose whole reliance is on His Mercy."[52]

Anna's letters from England also showed her to be keenly aware of the world around her and well informed about public affairs. Besides commenting on the differences in "dialect" between the English and Americans, she sensed that American visitors to Great Britain were closely observed by the locals, like some familiar yet exotic plant. When a friend of the Winstanleys spotted a lengthy address by President Andrew Jackson to the U.S. Congress reprinted in an English newspaper, Anna took time to read it. More importantly, she became "vexed," as she put it, by some "dreadful disturbance" in the construction of the B&O that might affect the fortunes of William and Whistler.

The railroad aside, Whistler was much in Anna's thoughts. She always asked about him when writing to family and friends, and rejoiced to learn that he had found time to visit "little Deborah" at her grandfather's home in New London, Connecticut. Besides listening to Brother George's music box, she also read a volume of sermons by the eighteenth-century American Anglican Devereux Jarratt that he had given her. And while she understood that the railroad kept him terribly busy, she wanted Whistler to know that she felt "impatient" with him for not writing. Showing, though, that their relationship could tolerate gentle sarcasm, she instructed Meg, "You may even ... give my regards to Mr. Whistler. Thank him for his letter & then if he has not really written it his conscience will spur him on to making the exertion."

Even so, Anna found it hard to return home. She missed her friends and

family, but everyone in England was so "extremely kind" to her that she lingered. Several bouts of illness, which she attributed to the damp climate, also delayed her. The most serious incident, which she described cryptically as one of her "old attacks," complete with swollen feet, caused Brother Winny to place her under the care of his sister and brother-in-law, a physician, in Manchester. Despite the "smoke & gas" of that industrial city, which made it "dreadful to breathe," she soon returned to the "pure air of the country" at Alston Lodge. Then came a "bright Summer" in Scotland, her "Fatherland," including stays with friends near Edinburgh and in Stirling and a visit to Dunfermline. She enjoyed herself so much, and the Winstanleys implored her so incessantly to stay on, that instead of leaving in September 1830, as intended, she remained until April 1831.[53]

Brother William met her when Anna landed in New York, where he then lived. His move from Baltimore was a result of the "dreadful disturbance" of the previous year, which Anna now learned had been caused by the politics of the railroad business. It started with tension between stockholders and the B&O's board of directors over costs and the pace of construction, all of which filtered down to the engineers. Then, and not unrelated to the first problem, divisions grew between army and civilian engineers. The latter, who represented the "craft" tradition in engineering, relied on intuition and experience to do their job. They expressed little sympathy for frugal investors who wanted the work done as cheaply and quickly as possible. Army engineers, such as McNeill and Whistler, were far more grounded in the science and mathematics of their profession. They worked deliberately, their methods requiring closer management and organization, and so were more conscious of costs.[54]

Worse, though, was the corruption, and this was the disturbance that would most affect Anna. McNeill and Whistler had discovered that the supervisor of construction, a civilian with no formal training as an engineer, had deliberately underestimated the cost of building a particular section of the B&O in order to gain approval by the board. When reforms McNeill insisted on were ignored, Anna's strong-willed and "impetuous" brother quit the B&O to work for a rival line. Whistler joined him in June 1830, and within a few weeks, both men spoke of resigning from the army to form their own engineering company. "The plan," William Swift informed the general, "is to form an association of 5 or 6 individuals for the purposes as Whistler writes 'of pursuing Engineering as a profession, to make it an object of ambition, and tho' last, not least, profit.'"[55]

Nothing came of the "association," but Whistler, as usual, lost himself in his new job, at least one reason his letters to Anna had been so infrequent. By the summer of 1831, he was physically and emotionally drained. "For the last three

or four months," he confessed to General Swift in July, "I've scarcely had time
to [engage in] the necessary eating and sleeping. I do not think I've averaged five
hours sleep in the twenty-four." Besides the work, Whistler also worried about his
children, from whom he remained separated. They had flourished under the care
of their grandparents, for which Whistler was grateful, but the education of his
sons, now nine and seven years old, had become a concern. There being a "great
deficiency" of good schools near New London, it was not a place he wished his
children "to *grow up* in." Besides that, the old doctor, their grandfather, spoke of
retiring to a farm, which did not at all please Whistler.[56]

He decided it was time to remarry, and no woman better suited him than
Anna McNeill. She was attractive, clever, well educated, intuitive, a good conver-
sationalist, gentle, and pious. Her "beautiful expression" and "charming manner"
concealed a sharp sense of humor and an appreciation for the ridiculous. Her
brother was his best friend, and her family had known the Swifts for years. And
so, on November 3, 1831, George and Anna were wed. The ceremony took place
in the Bond Street home of William and Maria, conducted by the same minister
who had blessed their marriage.[57]

2

Wife and Mother
1832–43

MARRIAGE BROUGHT ANNA ANOTHER NEW home in another new place. Having lived in Wilmington, Brooklyn, Georgetown, Baltimore, and New York, she now found herself in the mill town of Paterson, New Jersey, where her husband's work for yet another railroad, the Paterson and Hudson, had landed them. Taking an "unpretentious cottage" on the northern bank of the Passaic River, opposite the center of town, Whistler, now an army captain, finally had his children with him. Anna was not so fortunate. She had to travel to New York to see her mother and sister or brother William's family, a long enough trip to make visits worthy of comment. Her most distant relative was nineteen-year-old brother Charles, who had been sent to live with his great-uncle Zephaniah Kingsley Jr. in Florida, seemingly for his health.[1]

Yet, Anna was sublimely happy in New Jersey, even if she had not entered the storybook setting dreamed of by most brides. Aged twenty-seven, she was not, strictly speaking, the "young wife" addressed by marriage and advice manuals of the day. While as sexually innocent, we may assume, as Mary Swift had been at seventeen, she had no illusions about her husband's experience in such matters. What was more, while the couple doubtless spoke of having children, Anna's marriage vows had already made her a mother, as her own mother's marriage had done in less immediate fashion. Responsibility for raising Whistler's three children, at ages six through nine, required that she be, from the start, something more than "a help-meet" to her husband.

Luckily, she and Whistler were perfectly matched. They both enjoyed music, took an interest in public affairs, shared numerous friends, and were devout

Christians. Whistler was not as insistent as Anna on the rituals of religion, but he believed in the power of prayer and understood that life was a struggle of good versus evil. Though forced to travel by horseback thirty to forty miles nearly every day to inspect work on the railroad, he rarely missed eating dinner at home or the opportunity to kiss his children good-night. Whistler also shared Anna's suspicions of fashionable society. He especially "lamented that frivolity in manner, indelicacy or extravagance of dress" that undermined a woman's dignity.[2]

In raising their children and maintaining their household, the Whistlers had what would have been regarded as a "modern" American marriage in the 1830s. The notion of separate spheres, with women responsible for the home and children while men operated in the wider world, remained the norm in both the North and the South. In this context, Anna appreciated her husband's respect for the "calling of the *mother*" and the "sacred responsibility of women" to "extend happiness thru out all classes of society." Yet, husbands in educated, middle-class families had become less domineering, less lord and master over either their wives or children, than they would have been a generation earlier. Certainly, the Whistlers believed that husbands and wives should be companionable and treat their children as reasonable people, if not miniature adults. Above all, they agreed never to "practice any injustice upon a helpless little one."[3]

Anna also exhibited an innate sensitivity concerning her husband's previous marriage. She kept, like many housekeepers of the day, a recipe book, which she maintained for the rest of her life. However, the most interesting thing about Anna's book is that she had inherited it from her husband's first wife and her friend, Mary. That Anna kept alive the memory of her predecessor in this way is striking. It reveals not only a generous spirit, but also a desire to disrupt the lives of Whistler and his children as little as possible. She would feed them the same dishes, prepared in the same way, as Mary had done.[4]

But the Whistlers were not long in New Jersey before Anna's restless husband grew dissatisfied (fig. 10). He was only an *associate* engineer for the Paterson and Hudson, still working under William McNeill. Not that Whistler resented their relationship. By now the chief engineer for four different railroads, all of them designed to link budding northeastern manufacturing centers more closely to Boston and New York, McNeill was one of the most highly sought after railroad men in the country. Yet, McNeill's principal responsibilities were to manage construction costs, compile reports, and submit drawings, whereas Whistler bore the burden of daily operations. Never lacking in ambition, he wanted a more senior – and better-paid – position. He considered quitting the railroad business

entirely to engage in manufacturing, but when McNeill asked him in 1833 to take an only slightly better job with another of his railroads, the Providence and Stonington, Whistler consented.[5]

Two other events in 1833 changed the Whistlers' lives. First, a new army regulation forced Whistler to resign his commission, effective from the end of 1833. In the name of discipline and efficiency, the army had drastically reduced the number of officers, particularly topographical engineers, allowed to supervise public works. McNeill was spared the decree because of his seniority, but Whistler had either to resume his military duties or resign. He did not want to leave the army; it was the only life he had ever known. He requested a furlough, something he had never done in fifteen years of service, in order to appeal his case. However, the commanding general of the army, Alexander Macomb, refused it with the curt and totally unjustified remark that Whistler had essentially been "on furlough" the whole time he had been working for the railroads. His service to the nation, insisted Macomb, had been "merely nominal." Whistler was "mortified."[6]

However, humiliation turned quickly to triumph, for no sooner had Whistler resigned than he was recruited to be chief engineer for a railroad at Lowell, Massachusetts, another mill town, but one of the nation's newest ones. It would be a new challenge, too, for Whistler's principal job would be to design and construct locomotives. As always when wrestling with a major professional decision, he asked General Swift for advice. Whistler disliked the idea of abandoning McNeill, who very much depended on him. Indeed, he hated generally "to break up old associations and old associates" and to leave a place where he felt like "somebody." He also dreaded possible failure. He never doubted his ability as an engineer, but as *chief* engineer, he, like McNeill, would also be *"Chief Politician"* of the company, forced to be as mindful of profits and investors as of the quality of the work.

Swift told him to take the job, as it would allow Whistler to expand his knowledge of the railroad business and hone his skills as an engineer. He would make less money at Lowell, only $3,000 per annum, compared to $4,000 with the Paterson and Hudson or Providence and Stonington, but he would also be provided with a fine house for what would soon be a larger family, for Anna was pregnant. Equally, the job would require less travel, his new house being only a short stroll from the machine shops where he would spend most of his time (fig. 11).[7]

Lowell was different from the relatively more pastoral world Anna had known on the "beautiful banks of the Passaic." In some ways, with its bustle, noise, and

growing population, Lowell felt more like the Brooklyn of her youth, but whereas ships and commerce had been at the heart of Brooklyn's prosperity, cotton looms, industrial canals, and the railroad defined life and labor at Lowell. It was a "modern" town, in that respect, a product of America's industrial revolution, a town built expressly as a manufacturing center. The first cotton cloth had been produced there twenty years earlier, and almost from the start, the mostly female work force operated under the "Lowell system." It was an enlightened approach to factory labor, in which the women lived in company-owned boarding houses, ate well, and received fair wages. The town prospered. More factories were built, more streets laid, more homes constructed. The town's first bank opened in 1828, a hotel in 1832. By 1834, the population had reached 12,000.[8]

Nonetheless, and almost inevitably, growth brought tension and disenchantment. In February 1834, only weeks before the Whistlers arrived, eight hundred "factory girls" went on strike to protest a reduction in wages. They signed "spirited resolutions" and marched noisily through the heart of town, with one of their leaders halting mid route to deliver a powerful speech about "the rights of women and the iniquities of the 'monied aristocracy.'" Not that they achieved anything. The protestors, who represented just one-sixth of all female operatives, had only disrupted production, not shut it down. In less than a week, the malcontents had either quit or returned to work.[9]

Whistler was not involved directly with the mills, but his railroad would deliver their products more swiftly and cheaply to Boston. That was enough for the family to earn a place among the town's leading citizens. One of their closest friends was Kirk Boott, an English-born entrepreneur who, more than any other single person, had created the Lowell of the 1830s. Besides operating two of its most important companies, including the one that hired Whistler, Boott had designed and supervised construction of several mills and boarding houses, a brewery, and St. Ann's Episcopal Church. He was not universally popular, especially not among the mill workers, who thought him autocratic. Whistler, though, considered Boott a "very *clever gentleman*."[10]

Socially, the Whistlers were even closer to the family of John Prince, who lived next door. Boott had hired Prince, a fellow Englishman, to oversee production of calico prints in the mills. Besides their proximity, the Whistlers and Princes were drawn together by a shared passion for music. Members of the Prince family constituted a "string band" good enough to play at community charitable events. With Pipes Whistler joining them on flute and Deborah showing promise as a pianist, the two families spent frequent evenings playing everything from Hayden and Mozart to sentimental ballads and country ditties. Anna was not

herself musical, but she and Mrs. Prince beamed their appreciation while sewing and serving tea to the performers.[11]

They also had children of approximately the same age. One of the Prince boys, Frederick, found George and Joseph "very pleasant companions." He also had a juvenile crush on Deborah, or Debo, whom everyone adored. The pair of them learned to play a piano duet, and the way Frederick expressed his disappointment on an evening when a sick Debo could not join him suggests that he missed her company as much as the music. An older Prince girl thought all the Whistlers were "a great acquisition" for the community. "Mr. W is very musical which brings us much together," she declared to another sister attending school in England. "Mrs. W is a charming lady-like woman, and the children, especially the little girl, about Eliza Boott's age, very love-able."[12]

Besides their neighbors, the Whistlers welcomed a constant flow of friends and relatives from outside Lowell. Anna's mother and sister came regularly, and Alicia McNeill visited from England in 1836. Members of the Swift family, including Sarah, the general's teenage daughter and a favorite of Anna, stopped on occasion. William McNeill continued to consult with Whistler and, being now active as engineer for half a dozen railroads in the region, had ample opportunity to pass through Lowell.[13]

There was plenty of room for everyone in the Whistlers' spacious, three-story, fourteen-room house, still standing on Worthen Street (fig. 12). They needed the space, too, for Anna's family was expanding. First came James Abbott Whistler on July 11, 1834. Anna's mother and sister arrived from New York to help during her confinement, and Whistler, who had been traveling on business, returned home in time for the great event. "We are all as joyous and happy as you can imagine," a proud papa informed General Swift; "none however seems to give such a decided demonstration of delight on the occasion as our little Deborah dear child – she is so delighted with the prospect of something to play with she seems to think her fortunes made." She gained a second plaything almost exactly two years later with the birth on July 22, 1836, of William McNeill Whistler, named after Anna's brother.[14]

Given her large house, many guests, social position, and growing family, Anna probably employed several live-in servants. She appears to have had at least some household help in Paterson, where, at the very least, she would have required a laundress once weekly to wash and iron clothes for five people. At Lowell, she would also require a cook and chambermaid. The cook allowed her to escape the drudgery of preparing daily meals. The chambermaid was responsible for dusting, cleaning, and keeping the fireplaces glowing in winter. Once her sons

were born, a full-time laundress could have helped to dress, bathe, and look after them, if, indeed, Anna did not by then employ a nursemaid. Besides monthly wages, which ranged from ten dollars for a good cook to one or two dollars for a laundress, the women would have received room and board, their sleeping quarters being on the third floor. Except for the cook, they could have earned more in the mills, where, depending on the job and level of experience, the average monthly wage for women was about nine dollars after room and board; but most servants – again, excepting the cook – were considered to be unskilled workers. They would have been white, too, either native-born Americans or immigrants, most likely Irish. The family apparently hired a gardener seasonally, as Anna enjoyed growing flowers and vegetables.

This is not to say that Anna escaped all household labor. Rather, the definition of *labor* had changed for someone in her situation. The era's "cult of domesticity" (an outgrowth of true womanhood) made directing servants, arranging meals, entertaining, shopping, and governing children all-important tasks that consumed most of her days. She still liked to putter around the kitchen, too, especially to bake and make puddings. Like many young housekeepers, she considered "good baking" an artistic form of cookery, a means of expression, and a source of personal satisfaction. As an occasional activity, it also allowed ample time for other household responsibilities and social obligations, which was the whole point of having servants. Not surprisingly, then, recipes for baked goods and puddings eventually filled the bulk of Anna's recipe book.[15]

Whatever the situation, the Whistlers believed that servants, like children, should be treated with "forbearance, kindness and watchful care," and that employers must show "an interest in their conduct and concerns." Whistler took a similarly enlightened attitude toward the men working under his charge. He had a reputation for caring deeply about their health and safety. At home, both he and Anna prized a cheerful, loving household, free of discord, where, as Anna phrased it, "the law of kindness held its gentle sway." In other words, a Christian household, in which no lines were drawn between religious responsibilities and daily tasks.[16]

But life is not always that easy. As committed as Anna may have been to the physical and spiritual well-being of her servants, she expected reliable and efficient service in return, and freeborn Americans were notoriously independent. If consenting to do household work, they wanted to be called "help," rather than servants, and they were ever alert to personal slights. This was especially true in Lowell, where ambitious young women could earn more money, enjoy more freedom, feel less isolated, and receive more respect by working in the mills.

Consequently, many housekeepers relied on immigrants, who were generally more pliable and willing to work for lower wages than the native born. Anna, even having been around servants all her life, and with a mother who was considered a font of wisdom on the subject, would always find managing servants the trickiest part of the cult of domesticity.[17]

She likely sympathized, then, with Lowell's mill owners when they faced their next labor dispute in October 1836. This time, twice as many women, over a quarter of the female work force, walked out to protest reduced wages. They showed more resolve, too, with many of them staying out for several months, rather than a few days. Responses to the stoppage varied among the several companies, but all of them made concessions. It would have been hard for Anna to approve of workers, especially female workers, who so openly challenged authority. Reared in a culture that justified black slavery as a benevolent institution, yet living in a region where a nascent abolitionist movement was becoming quite vocal, she may have winced when hearing parading strikers sing:

Oh! I cannot be a slave,
I will not be a slave,
For I'm so fond of liberty,
That I cannot be a slave.[18]

Around the time of the strike, her husband's restless spirit reemerged. Throwing himself, as usual, into work, he had achieved his first success in only a year at Lowell. On May 26, 1835, a locomotive of his design steamed out of the machine shops and along the tracks of what, until then, had been a horse-drawn railroad. A month later, one of his trains completed the entire run to Boston in seventy minutes. Passengers paid one dollar for the trip, the same price charged for riding the Lowell to Boston Mail Stage. One witness recalled "the great excitement" generated by the occasion. "People were gathered along the street near the 'deepot,' discussing the great wonder," he explained years later; "and we children stayed at home from school, or ran barefooted from our play, at the first 'toot' of the whistle." The whistle was Whistler's idea. Reportedly, the first one used on an American locomotive, it was intended to warn people and animals of the approaching monster, although that did not prevent the line's first fatality when a man stepped too near the tracks to see the inaugural celebration.[19]

By early 1837, Whistler believed that he had learned all he could do about the operation of a machine shop, and Boott, while very pleased with him, was pressing for an expansion of Whistler's work that would have taken several more years

to complete. Always loath to disappoint people who had been good to him and his family, Whistler asked Gen. Swift, McNeill, and William Swift, who now, as an army captain, was the superintending engineer for the Massachusetts Western Railroad, for advice. They agreed that the longer he stayed at Lowell, the harder it would be to leave.[20]

Accordingly, Whistler accepted two new offers from McNeill. His brother-in-law, now an army major and chief engineer for the state of Georgia, wanted Whistler to rejoin the Providence and Stonington Railroad, in which McNeill retained an interest, but also to assist William Swift on the Western, where McNeill had been the chief engineer. He would again be traveling quite often, this time between Providence, Rhode Island; Stonington, Connecticut; Springfield, Massachusetts; and New York City, but by moving to the lovely village of Stonington, Anna and the children would be very near the Swifts, in New London, and a bit closer to the McNeills, in New York. "I hope he will be contented," sighed William Swift when informed of Whistler's complex assignment, "but his disposition is peculiar, and not readily left contented."[21]

Anna raised no objections. She knew when she married a soldier that frequent moves were part of the bargain, and the life of an itinerant engineer was no different. Whistler loved her for it. He knew the constant relocation put a strain on her and the children, especially considering the dismal economic condition of the nation. With the United States mired in its first serious financial depression in 1837, relinquishing the economic security of Lowell was a risky business. Still, the Whistlers had not exactly grown rich at Lowell, having only the household furniture to call their own. "It was for that reason I left," Whistler confessed to General Swift. "I thought it proper to leave, and with even prospects of doing better."[22]

The family spent three happy years in Stonington. The brightest moment came when Anna gave birth to her third child in five years. He was named Kirk Boott, after the Lowell autocrat who had given Whistler's post-army career such an auspicious beginning. And the family had fun there. They took long carriage rides through the countryside and day trips to the seashore. The children lacked for nothing. James, whom the family called Jemie or Jamie, and William, dubbed Willie, had toys galore, and Anna bought their clothes in New York City, which she sometimes visited with one or more of the children when Whistler conducted railroad business there. The family continued to entertain at home, with musical evenings still the favored pastime. Now, though, instead of playing duets with other children, Deborah was accomplished enough on the piano to accompany her father's flute playing.[23]

The oldest children were often away from home. Deborah and Joseph spent at least part of each year at school, although where they attended is unknown. During school holidays, Deborah was much in demand at the Swifts' home in New London. A year after their arrival at Stonington, Whistler found a place for sixteen-year-old George in the Springfield offices of the Western Railroad, where his Uncle William Swift could tutor him in the business. This was done after Whistler had failed to obtain a warrant for George as a navy midshipman, something his eldest son had very much desired, and which Whistler had hoped "would strengthen his constitution."[24]

The years at Stonington proved eventful for Anna's sister Catherine, too. While on a visit to the Whistlers from New York, she met her future husband, Dr. George E. Palmer, who happened to be the Whistlers' family physician. He and Kate were wed in March 1840 at St. Ann's Church, New York City, and lived in what the family would always call the Old Corner House, still standing at Main and Wall Streets in Stonington (fig. 14). Coincidentally, Kate, like Anna, married a widower with three children.

The only annoying part of life in Stonington for Anna was the absence of a local Episcopal church. Her mother, faced with a similar problem in Baltimore, had resorted to attending a Catholic church. Luckily for Anna, another town on her husband's railroad, Westerly, Rhode Island, just five miles to the east, had an Episcopal congregation. To please his wife, Whistler arranged for the family to travel the distance on Sunday mornings aboard a horse-drawn rail car that he used during the week to inspect the line.[25]

The saddest moment came on New Year's morning of 1840, when the "highly gifted" fifteen-year-old Joseph Swift Whistler died of typhus fever. Everyone thanked God that the "gentle, so affectionate" boy had at least died surrounded by loved ones. They laid him "among the winter frost and deep snows" of what is now Evergreen Cemetery. It is a quiet spot, well away from the bustle of the town, and though none could have guessed it at the time, Joseph would be only the first of five Whistlers, three of them younger even than he, to be buried there over the next decade. It became the only fixed point for a family in perpetual motion.[26]

The family's distress was deepened by their impending departure from Stonington. Unhappy with the political demands of his job, the "constant negotiation and bargaining" required to pacify stockholders, Whistler jumped at the chance to replace William Swift, who had returned to military duties, as consulting engineer on the Western Railroad, in Springfield. He had tried unsuccessfully to convince McNeill, who had recently left the army, to return north

and join him. Indeed, Whistler had been seeking places for as many members of the Swift–McNeill–Whistler clan as possible on northeastern railroads. Building railroads had become a family business, and a very successful one. "I think there is a good field for the young Engineer of our country," he told the general, "if they enter it with the resolution to do something for the profession and not depend upon the profession doing every thing for them." McNeill finally did leave the South but chose to work on projects outside New England.[27]

Anna left Stonington more reluctantly than she had done Lowell, and only partly because she would be leaving sister Kate. A neighbor who would remember the Whistlers "vividly" recalled, "The family were much beloved here, and were very much regretted when they left." But Anna and the children soon adapted to Springfield. They again rented a large house, this one with twenty rooms and a broad, pillared veranda on Chestnut Street (fig. 13). They needed more space, too, when another son, Charles Donald, was born in August 1841. If Anna had not previously employed a nursemaid, she needed one now. Mary Brennan, a fifteen-year-old Irish immigrant, may already have been with the family at Stonington, but she was definitely present in Springfield, where she had relatives. Mary would serve Anna devotedly as both nursemaid and housekeeper for many years. Nor did the family have to travel five miles to worship. Christ Church, located just a few blocks away on Chestnut, had been dedicated in April 1840.[28]

The house and neighborhood befitted George Whistler's status as one of the nation's leading engineers. Described at this time as "well proportioned" and of medium height, Whistler was "fastidious in matters of dress, neatness and appropriateness." He was visible and active enough politically in the Whig party to be invited to a ball at the town hall in March 1841 to celebrate the inauguration of William Henry Harrison as president of the United States. The following year, he had his portrait painted, further evidence of his stature.[29]

But Whistler's growing fame also meant the Springfield residence would be short-lived. In April 1842, he received an invitation from the Russian government to build a railroad from St. Petersburg to Moscow. It was an astonishing offer, based in no small measure on his success in pushing the Western Railroad through the beautiful but formidable Berkshire Mountains, thus completing the line from Boston to Albany, New York. Anticipating an even tougher assignment in Russia, Whistler consulted General Swift, who also accompanied him to Washington, D.C., for discussions with the Russian envoy to the United States, Alexander de Bodisco, and Ivan Bouttatz, a Russian army officer. Whistler would receive $12,000 per year for his services, which would include manufacturing the railroad's locomotives and rolling stock. He insisted on going to St. Petersburg

and meeting with officials there before accepting the offer, but as he told Swift, "I have not felt so happy . . . for a long time." He set sail for Liverpool from Boston, accompanied by Bouttatz, in mid June.[30]

Anna, always supportive, was a bit unnerved. Hopscotching across New England was one thing, to move half way around the world to an alien land quite another. She and the children would not join Whistler unless he was satisfied with the situation and had made satisfactory living arrangements for them. Even so, the thought of rearing her young boys and a teenage daughter abroad weighed heavily on her. Whistler, too, had second thoughts by the time he reached England, though he concealed them from his wife. He was eager to see St. Petersburg, but, as he confessed to Anna's brother, it required all his "strength to struggle with a dreadful feeling of regret at the step taken."[31]

Had Whistler known of events at home, he would have returned immediately. While he was still at sea, his second youngest son, Kirk Boott, died of scarlet fever. Hopes for the child's recovery had risen and fallen for over a week. Finally, the day before brother Jemie's eighth birthday, the little fellow breathed his last. He was buried in the cemetery at Stonington beside his brother.[32]

At the same time, seventeen-year-old Deborah had begun to chafe under Anna's supervision. The circumstances were difficult for both of them. Debo was only six when Anna married Whistler, still young enough to be educated and reared as Anna thought proper. Yet, Debo continued to see much of the Swift family, and as the only daughter of Mary Swift, they thought the child could do no wrong. It is easy to imagine quick little Debo, though sweet-natured and affectionate, understanding early on how to play off her grandparents and uncles against her stepmother. Then, too, once Anna bore her own children, all of them boys, with the eldest nine years younger than Deborah, it became difficult for her to rear them all according to the same standards.

William Swift, of all the family, resented Anna for her perceived treatment of Debo. "I am sorry that I do not like her," he confided to the general, "but I cannot. I believe her to be both artful and selfish." Swift claimed to see "a difference, and [a] great difference, in the treatment of Debo when W is at home and when he is absent." His appraisal was overly harsh, and displayed little understanding of the deep responsibility Anna felt for all her children. If anything, she was overly protective of both their persons and their souls. Anna sometimes erred in *how* she loved, but her actions were never tainted by malice, envy, or conceit.[33]

Whistler certainly would have rejected his brother-in-law's opinion, but by autumn, when the lease on their Springfield home expired, he was still not ready to summon his family to Russia. Accordingly, Anna, after selling their furniture,

returned with the children to Stonington and the comfort of her sister's home. Jemie and Willie had a fine time sledding that winter, and Willie learned to whistle. However, that did not mean the boys could neglect their studies. Whistler, writing from St. Petersburg, urged Jemie to master French. "Many little boys here not older than you speak two or three languages," he assured him, and without French, he would "not be able to understand any body" in St. Petersburg.

By spring 1843, with Whistler still hesitating to expose them to the rigors of such an arduous trip, an impatient Anna considered moving as far as England. She would still be among friends and family, and her boys would be assured of a proper education, both secular and religious. Then, however, she considered the expense of living in England with Whistler still in Russia. Next, Jemie suffered an attack of rheumatic fever, the first of three serious bouts with that illness over the next few years. He nearly died. Any move, for the moment, seemed impossible.[34]

Not until August 17 did Anna, the children, and Mary Brennan leave Boston for St. Petersburg by way of England. Young George Whistler accompanied them as escort. Their ship was the steam-powered, side-wheeler *Acadia*, one of three ships launched by Canadian Samuel Cunard to take advantage of the new transatlantic packet service that provided regular mail delivery between North America and England (fig. 15). It was a revolutionary mode of travel, certainly a leap forward from Anna's first two Atlantic crossings by sailing ship, and every bit as innovative as Whistler's railroads. The first steam voyage had occurred only fifteen years earlier, in 1819, and even in 1843, ocean travel by steam was a source of wonder and cause for excitement. While steamboats had been plying American lakes and rivers since the 1820s, the first ocean crossings between New York and Liverpool did not come until 1838.[35]

The packets did have faults. Their engines used so much coal to create so little power, and their paddles were so unreliable in high seas, that much of a journey was still completed under sail. A steamer might well "go wheezing and puffing alongside of the proudest ship in the British or American navy," observed a New Yorker, but what might happen when "the waves run high as the topmast ... with the weight of machinery, with a burning volcano in her bowels?" Still, accommodations easily exceeded in comfort the old sailing vessels. It was the dawn of a new era in a "'go-ahead' age" of mechanical inventions and innovations, and Anna, as she so often would do, not only observed but also embraced the revolution as enthusiastically as any of America's "novelty-looking population."

Like her two sister ships, the *Acadia* was 207 feet long, had a top speed of nine knots, and carried 115 passengers, all cabins being on the main deck. The dining

room was a long gallery with two rows of tables and bench seats divided by a center aisle. Charles Dickens, who had sailed to America a year earlier on one of those sister ships, the *Britannia*, had little good to say about the voyage, from the cramped quarters to the "extraordinary compound of strange smells, which is to be found nowhere but on board ship."[36]

The Whistlers voiced no such concerns. For them, and especially the boys, the voyage was an adventure. Stopping first in Halifax, Nova Scotia, before commencing its twelve-day voyage to Liverpool, the *Acadia* had no sooner broken into open water than it rammed a barque. The collision "terrified" Jemie and Willie, but once the crew had been rescued and brought safely aboard, the incident acquired a sheen of romance. As they talked with the survivors, the boys felt like regular salts and knew they could later boast of their friendship with veteran seamen. Thereafter, the passage was filled with "novelties and delights," including the celebration of Charlie's second birthday, on August 27.[37]

The family was welcomed in Liverpool, as Anna had been fourteen years earlier, by Betsey Sandland before moving on to the Winstanleys' "hospitable mansion" near Preston. They enjoyed a fortnight of visiting and resting, but Anna was anxious to reach London, where her little band was to board a steamer for Hamburg. Uncle Winny was so saddened by their departure that he took an early train for work in Liverpool to avoid tearful good-byes. Alicia insisted on escorting them to the Great Metropolis, where they found "commodious lodgings" in Norfolk Street. Courtesy dictated that they spend another week visiting friends, including a family they had met on the *Acadia* and the mother of Kirk Boott, their old benefactor in Lowell. Mrs. Boott insisted on showing them the city, and they borrowed her carriage one day so that the boys might see the newly opened Zoological Gardens in Regent's Park. They were fascinated by the giraffes. Anna was most impressed, on the morning of their departure, by the eerie beauty of the "Thames by lamp light & star light," as a boatman rowed them to their waiting ship.

Even more enchanting was the journey from Hamburg by coach across Germany to Lübeck, en route to the Baltic port of Travemünde. They traveled by night, with George, Debo, and Mary Brennan in one coach and Anna and the boys in a second one. Willie soon fell asleep, but Anna stayed awake with Jemie and Charlie, who were too excited to close their eyes. "Never in my life have I enjoyed a ride as much as ours that night," Anna recalled, with her boys around her, in good health, and only one week of travel remaining. "The road was fine, the stars shone brightly," and "James and little Charlie were as bright as the stars, and had so much to point out to Mother!" They stopped often to feed the horses and pay tolls. At midnight, they paused at an inn to enjoy coffee and cakes.

By dawn, they had reached Lübeck, where, after having their passports inspected and eating breakfast at a local hotel, they set out for Travemünde. They arrived later that day, September 22, to begin the final leg of their journey. Their departure aboard yet another steamer, the *Alexandria*, began with tears, as it was here that George bid adieu and returned to America. Willie was almost heart-broken, and Anna had to walk the deck with Debo for an hour to cheer her. Anna then gave up a comfortable private stateroom at the bow of the ship for fear of storms. The family settled, instead, in a communal "Ladies Cabin," even though some occupants initially opposed having the boys present.[38]

However, real tragedy came when Charlie fell ill. Returning from dinner the first night out, Anna learned from Mary that her son had refused his meal. Everyone thought it was a case of seasickness, but after a restless night in his mother's arms, Charlie showed no improvement. Anna administered "powders" that had relieved him of illness in the past, but the lively two-year old who had amused everyone throughout the journey remained weak. When, on the second day, he asked if he might say his evening prayer lying in bed, rather than kneeling beside Anna, she became alarmed. Holding him close for a second night, she paced the cabin before immersing him in a warm bath drawn by a concerned stewardess. It did no good. The boy died before dawn, the diagnosis being inflammation of the bowels.

Charlie's death affected Anna profoundly. Thereafter, she dwelled more often on death and saw life more often as a vale of tears. She had grieved the passing of Joseph and Kirkie, but in years to come, it was Charlie's death that triggered spasms of grief. It was one loss too many. Charlie's birth had allowed her to survive Kirkie's death, and now he, too, was gone. She would come to feel a special bond with other mothers who had lost young children or infants. "There is a chord in a mothers heart of such exquisite tenderness," she would say, "which as it vibrates to memory, awakening is so of mingled pleasure & pain, of fondness & sorrow that none but a mother who has outlived a darling child can understand it."[39]

The dreaded task of breaking the news to her husband, who had now lost two sons since leaving America, drained much of the joy from the family's reunion in St. Petersburg on September 28, 1843. Compounding the agony were the bureaucratic procedures they encountered. First, and most dispiriting, health laws forbade Charlie's body from being taken into the city. The family received this shocking news in Kronstadt, a fortified city that guarded the entrance to the River Neva from the Baltic and Gulf of Finland – the "coldest looking town I have ever seen!" remarked another newly arrived American. After a small army of soldiers had clambered aboard the *Alexandria* to inspect passports and ask

passengers their purpose in coming to Russia, the Whistlers and their luggage were transferred to shallow-draft steamers for final passage up the Neva. Charlie's body remained in Kronstadt, to be returned to Stonington on the first available vessel and laid beside his brothers.

As they drew closer to St. Petersburg, the city's beauty and grandeur excited Jemie, as it did most people upon glimpsing the "resplendent spires, the shining cupolas, and the tapering columns" of its magnificent palaces, regal churches, grand edifices, and towering monuments. Anna strained to catch a glimpse of Whistler on the quay, but it was he who first spotted them, shouting out Jemie's name to catch their attention as he rushed to stand beside their vessel. Even then, a final delay, approaching humiliation, awaited the arrivals. Their dozen or so trunks of clothing, china, silver, and books had to be inspected for contraband, which could include anything from banned literature to jewelry for the black market. Not even Whistler's prominence could spare them this "truly harassing procedure," as Anna described it.[40]

Exactly how she broke the news about Charlie is unknown, but a distraught Whistler blamed himself for the boy's death. Mercifully, the family was spared further delay in an ordeal that had already lasted several hours when John S. Maxwell, secretary to the American diplomatic legation in St. Petersburg, convinced Whistler to conduct the exhausted travelers to their new home while he remained at the customs house with Mary Brennan and the luggage.

Anna required more than a week to recover from the strain and fatigue of the journey, the sadness of Charlie's death, and the shocking realization that she had reached her destination. John Maxwell felt sorry for her. Having taken up his diplomatic post only a few months after Whistler arrived in Russia, the twenty-six-year-old secretary had become an ardent admirer of the major, as he was now known. He felt as though he knew the entire family through Whistler's incessant speaking of them, and he had been touched to see "the tears jump from his eyes when speaking of his lady." As for Anna, "I really do pity any well educated American lady who has to make a residence here," Maxwell told his mother.[41]

The weather certainly did nothing to buoy Anna's spirits. October was considered the "most disagreeable month" of the year in St. Petersburg, "very damp and chilly and constant rain." In fact, winter was fast approaching, and it would last until May. The entire family, as with virtually all newcomers to St. Petersburg, soon fell ill from the effects of drinking the water, drawn from the Neva. Whistler had "suffered considerably" from diarrhea upon his arrival. Yet, as Anna recovered her strength and took stock of the situation, she gained hope that her worst fears of living in an alien land might not be realized.[42]

3
Russia
1843–44

ANNA'S NEW HOME WAS ON Galernaya Street, only one block removed from the quay. It derived its name from the galleys and boats that had for centuries been drawn up to the riverbank. Debo declared the house "very comfortable," though far larger than the family required. They assumed the $18,000 lease from Col. Charles Stewart Todd, the fifty-two-year-old Kentuckian who served as U.S. minister to Russia. So great was his desire to please Whistler that he voluntarily moved to an English-run boarding house, even though that meant losing "caste" in diplomatic circles. Todd also bequeathed a retinue of ten servants to the family, which Whistler promptly set to work cleaning the house before Anna arrived. Among the ten was an efficient and "uncommonly good natured" cook who spoke some English and presided over a kitchen that included "every convenience," all of which made the prospect of housekeeping less daunting than Anna had feared.[1]

She was even more relieved to discover a large contingent of British citizens and a scattering of Americans living in St. Petersburg. The most influential of them were merchants, some of whose firms had been operating in the city for well over a century. It was a city built on commerce, with iron, hemp, flax, and sailcloth flowing abroad in return for sugar, silk, wool, and, by the 1840s, machinery. And that was not to mention the many items of "convenience, comfort, or luxury" imported from England, including books, furniture, clothing, carriages, and medicine. The very place where the Whistlers had landed was known as the English Quay or English Embankment. A broad granite-paved road made it fashionable for the Russian upper classes to

promenade along that part of the river, and the tsar himself often rumbled by in his carriage (fig. 16).

Which is not to say the neighborhood was entirely English speaking. By the 1840s, some of the most striking buildings along the quay, all of them uniformly grand, had either been reclaimed by Russians or put to some commercial use by other Europeans. Residences often sat above ground-floor offices and shops, and there was a variety of government buildings, hotels, and boarding houses. The foreign population of St. Petersburg was itself relatively small, only about 14,000 of 475,000 in 1843, but foreigners filled a disproportionate number of important positions and controlled much of the city's private wealth. Germans were the most numerous, followed by the French, British, and Austrians. French being the language of the court, it was the "most *fashionable*" tongue to be heard, but one could detect three or four different ethnicities at any boarding house or hotel.[2]

Yet, it all *felt* British, and most shopkeepers, hotel operators, and tavern keepers, who often catered to English-speaking sailors and travelers, knew some English. The British were also the only foreigners, as noted by one observer, to "cohere as a distinct, privileged community, and form a state within a state, or at least continually strive to do so." The business community, which numbered only about eight hundred people, was "extremely wealthy, and equal perhaps in consequence, power and opulence." Most importantly to Anna, there was a well-established "English Church" on the quay, which many residents considered the heart of their community.[3]

By the 1840s, as exemplified by Whistler, English-speaking manufacturers and industrialists were joining the merchants and bankers. Skilled artisans and mechanics, mostly from Scotland and the English Midlands, arrived to work either in the British establishments or, having been recruited to train native operatives, in Russian foundries and textile mills. Compared to the resources previously devoted to Russia's steam-powered industry and manufacturing, the 1840s brought an absolute revolution, with textiles, metalworking, tobacco and food products leading the way. Anna's husband and his railroad were the heart of the revolution, not only stimulating such industries as iron production and metal-working, but also creating a transportation and distribution network that would connect the capital city to Moscow.[4]

Whistler took charge of the largest foundry, covering some 160 acres, in Alexandroffsky, near the city gates. By the time his family arrived, Whistler had contracted with his old friend Ross Winans and the Philadelphia firm of Eastwick and Harrison to build the railroad's locomotives and rolling stock.

The latter company had also worked with the B&O, though after Whistler's time. Winans, too old for the rigors of Russia, remained in Baltimore, but he formed an alliance with Eastwick and Harrison by sending his two sons, Thomas and William, to help oversee operations in St. Petersburg. The combined firms received a five-year contract worth seven million dollars. The majority of their workers was necessarily Russian, with three hundred men already being employed at the foundry, but between fifteen and twenty English and American mechanics soon arrived to supervise production. Likewise, American machinery was imported to replace aging and broken Russian equivalents.[5]

The Whistler, Winans, Eastwick, and Harrison families became enduring friends, and they soon fell in with several American and British families already in St. Petersburg. First came William and Ellen Harriet Ropes, who had three daughters, the youngest one born less than two months before Anna's arrival. William H. Ropes, a third-generation Boston merchant, directed the foremost American mercantile firm in the city, established by his father in 1833. The Ropeses, in turn, introduced the Whistlers to their British and American friends, including the Gellibrand, Prince, and Mirrielees families, all of whom had some connection to Ropes & Company. English-born William C. Gellibrand, a widower, had made the much younger Mary Tyler Ropes, the eldest daughter, his second wife. He was now fifty-two, she was thirty. George Henry Prince, of Salem, Massachusetts, was a Ropes nephew. Archibald Mirrielees was a self-educated Scot who had been in St. Petersburg since 1822. In 1843, he founded his own import business.[6]

It was not a large circle, all things considered, but probably as much as Anna could expect. John Maxwell observed that each of St. Petersburg's ethnic conclaves was "cut up into little knots or coteries whose sole amusement ... [was] to slander and abuse each other." That was especially so among some of the English, given how swiftly Whistler had gained the favor of the tsar. "[The] John Bulls who have grown fat and saucy upon the idea ... that nobody but themselves could do any thing for Russia" were annoyed by the major's popularity, Maxwell boasted, and "growl[ed] most prodigiously about the Yankee genius."[7]

More than sharing the same language and customs with these particular families, Anna found them to be devout Christians. Indeed, American merchants throughout Russia, many of them from New England, thought it their duty to import not only sugar, cotton, and iron, but also republican institutions and humanitarian ideals. The Ropeses, for instance, belonged to the Tract Society, held prayer meetings in their home, and invited like-minded families to tea. Overlooking the fact that the Gellibrands were Congregationalists, Anna rejoiced

in the Christian fellowship she enjoyed with Mary and the entire family's habit of visiting the poor.

The British were equally devoted to philanthropic causes. They raised funds to aid the victims of floods and outbreaks of cholera, disasters that occurred with alarming frequency in the city. There was a "Poor Fund" to assist British and European mechanics and artisans who had fallen on hard times. Anna found solace, too, in the fact that several women in these families had recently lost loved ones, especially children. The "truly pious" Elizabeth Maingay, wife of merchant William Maingay, whom the Whistlers would meet early the next year, was one such person. "We talked of our departed little ones! Of our churches & pastors in England and America," Anna remarked.[8]

Almost from the start, then, Anna enjoyed as cozy and intimate a social circle as she had known in Lowell or Stonington. That also meant a revival of musical evenings. Whistler was overjoyed to have Debo once again as accompanist, and Colonel Todd, learning of her talent, procured a piano for the family. Debo had also brought her harp from America. Before long, Ellen Ropes, William's wife and a "superior musician," joined Debo in piano duets. The jolly and socially inclined chaplain of the English Church, a Reverend Law, and his daughter also participated, with Debo and Miss Law learning songs in Russian.[9]

John Maxwell also became part of the family. As Colonel Todd's secretary, he had shared apartments on the ground floor of the house with Whistler upon arriving in St. Petersburg, and the Whistlers now insisted that he stay on. A handsome, Princeton-educated fellow, nearly six-feet tall with blue eyes and light brown hair, Maxwell appears to have left America under a cloud. His appointment as secretary probably came through the influence of his father, Hugh Maxwell, a New York attorney and prominent Whig in that state's politics. After savoring the nightlife of St. Petersburg during his first months in the city, Maxwell tired of the "dissipation and pleasure." Whistler became his hero. "[H]e has seen much of life on the good side and the bad," Maxwell informed his mother, "without being spoiled by either. . . . He is the most admirable gentleman I ever knew." Anna, touched by his devotion, invited Maxwell to spend evenings above stairs. "Mrs. Whistler is too good to me," Maxwell assured his mother, "and possesses what I shall henceforth esteem and admire above all in women, a fervent and unaffected piety."[10]

Anna also inherited a genuine charity case from her husband's early months in Russia. First spotting three-year-old Andrei in the street with his "degraded looking mother," the major had been struck by the boy's resemblance to Kirkie. When he paused to give the woman a few kopeks, she showed her gratitude,

as was the custom among Russian peasants, by touching her forehead to the pavement and kissing his feet. A horrified Whistler motioned her to rise and arranged to have the boy cleaned and sent to visit him for the sake of company. Anna continued to provide the mother with money, besides giving Andrea a plaid coat that Willie had outgrown. Whenever meeting Anna, the little chap marched right up to her and shook hands. "He is a noble looking child," Anna observed, "& oh that a way may be opened for us to serve him more effectively than by temporary relief."[11]

Despite this relatively rapid, if artificial, integration into Russian life, Anna was reluctant to leave her Galernaya home, save to attend church, during her first few weeks in St. Petersburg. Finally, though, with Colonel Todd securing permission for the family to visit the tsar's Winter Palace, Whistler and Debo insisted that she venture out. The palace, which sat about a mile north of their home, served as the tsar's principal residence and formed part of a complex of majestic buildings along the Neva, including the Admiralty, the largest of them all. Anna had been determined to resist the reported decadence and temptations of St. Petersburg, but she was "astonished by the magnificence" of the palace and its incomparable collection of art.

Thereafter, she saw more of St. Petersburg and found it the most architecturally impressive city she had ever known, not accepting London. Besides the imposing edifices and graceful buildings, most of them Neo-Classical, she admired the large public squares and broad avenues. Most imposing of all was the three-mile long Nevsky Prospect, lined with government offices, shops, and churches representing at least five religious denominations, though none of them Anglican. Yet, strictly speaking, the Prospect was designed for neither business nor worship, but as a place where fashionable people could be seen and the poor could be entertained. With its "fairground atmosphere," it had long been a rich subject for Russian poets and novelists. As Nikolai Gogol had declared, "It epitomizes the whole town!" (fig. 17).[12]

The contrasts on Nevsky Prospect were only a sample of what Anna found through the whole of St. Petersburg. The city was no different, in that respect, than New York, Baltimore, or London, except for its scale and the degree of contradictions. Alongside the broad avenues and fragrant open spaces, warrens of foul-smelling lanes and streets bisected the city. A French visitor described them as "a horrible mixture of stalls and workshops, confused piles of nondescript buildings." The gracious facades of many residences, even on fashionable streets, were belied by the narrow alleyways in their rear, often lined with shabby flats for the working classes. And it was the working poor, rather than the smartly

dressed soldiers and bureaucrats that one saw most often in the streets. Peasants, wearing their traditional sheepskin coats and knee-high boots, were the single largest part of the population, but thousands of dock workers, servants, and factory operatives offered additional testimony to the gulf between rich and poor (fig. 18).[13]

More disturbing were the contrasts Anna detected in the oppressive, if sometimes contradictory, Russian State. It all stemmed from the man who had hired her husband, Nicholas I. He was just twenty-nine years old upon succeeding his brother as tsar, in 1825, and the timing of his accession proved unfortunate for Russia. He was immediately confronted by the Decembrist revolt, an uprising led by liberal army officers who demanded democratic political reforms. Nicholas quashed the ill-coordinated movement, executed or banished its principal leaders, and remained leery of liberal ideology and excessive freedom. He secured his reign by blanketing the country with spies and informers, imposing a severe censorship, restricting access to education, and demanding absolute loyalty, if not outright homage, to himself. Nicholas became the State.[14]

If not constitutionally the head of the Church, Nicholas did claim to rule through divine will, and he insisted that the Church bound together all Russians, regardless of class, in a uniquely Russian, or Slavic, culture and society. The Church made them peculiarly Russian, and for that reason, if no other, it was to be revered. By extension, Nicholas ruled as a Christian autocrat, though in the guise of a shepherd to his people. He reasoned that society would sink into chaos without the guidance of his stern yet sympathetic hand. The result, as a critic of the regime, Vissarion Belinsky, insisted, was that "the Church became a hierarchy and a champion of inequality, a flatterer of authority and an enemy and persecutor of brotherhood among men."[15]

Anna was immediately struck by what another Russian critic, Alexander Herzen, later known as the father of Russian socialism, called the "official class," a sycophantic army of clerks and bureaucrats. "It is a kind of civilian priesthood," Herzen said scornfully, "celebrating divine service in the law-courts and the police forces and sucking the blood of the people." Underscoring this subservient regimentation, everyone in government employ wore a uniform of some kind. Surrounding himself with military aides, Nicholas always dressed as a soldier, and even Anna, the wife, sister, and descendant of soldiers, would have understood what Herzen meant when, in the Russian context, he concluded, "Uniforms and uniformity are passionately loved by despotism."[16]

Yet, in all this, Nicholas was not blind to needed reforms and the advantages of westernization. Thus the contradictions in his regime. If an absolute monarch,

Nicholas thought of himself as an enlightened one. By the time the Whistlers arrived in St. Petersburg, the forty-seven-year-old tsar impressed most people with his charm and charisma. Queen Victoria described him as "a *very striking* man," "handsome," with "manners most dignified and graceful." Despite the intellectual revolt against the "Nicholas System," the decades of his reign produced such luminous literary figures as Nikolai Gogol, Alexander Pushkin, and Ivan Turgenev, harbingers of a golden age in Russian literature. Trained as a soldier and engineer, Nicholas encouraged, if reluctantly, the industrialization process that made Whistler's appointment feasible. The only existing Russian railroad, opened in 1838, was a sixteen-mile line between St. Petersburg and Tsarskoye Selo, a village south of the city the Whistlers would come to know well. Consequently, Whistler's railroad was a bold, even revolutionary, venture.[17]

While all these dynamics of Russian life would only gradually be revealed to Anna, she determined in short order to keep her household as American as possible. In this, as in so much else, she and Whistler were of one mind. Upon accepting the tsar's offer of employment, Whistler had declined a commission in the Russian army, even though that would have supposedly given him more leverage at court. As it turned out, he believed his independence proved a blessing. "I rank nobody and nobody ranks me," he informed General Swift. "I am free to act, talk and think as an equal with every body – and that is more than any other person here can say."[18]

Nothing better represented Anna's own ambitions than the family's first Christmas in Russia. She began by celebrating it on the proper day, December 25 of the Gregorian calendar, not the Russian observance, which during the nineteenth century came twelve days later. Her sons, awaking first, roused the family in order to empty their stockings of the sweets Santa Claus had left them. After breakfast, everyone invaded the "chancery," as Whistler's office was known, to open the presents Anna had concealed there. They included a brooch containing a lock of Charlie's hair for Mary Brennan, specially ordered by Anna from a German jeweler in the city. Anna's gift from Whistler and the children was a rosewood escritoire and several gold pens.

Three other American families plus John Maxwell joined the Whistlers for a Christmas dinner of roast turkey and pumpkin pie. Maxwell was gratified to find that, even with a cook, Anna made her own pies. Only a prior commitment kept Colonel Todd away, although he had stopped at the house earlier that day in hopes of taking Debo for a ride in his sled, ample snow having accumulated by that time for gliding along city streets. Debo, who thought the flirtatious diplomat a "great goose," considered herself lucky to have been at the Ropes house at

the time. After dinner, the families likely sang Christmas carols or asked Debo to play sacred music on the piano.[19]

However, all joy was dashed the following morning when the family discovered that thieves had made off in the night with Anna's new writing desk and Whistler's flute. Anna mourned her own loss less than the disappearance of the flute, which had "many tender associations" for them all. It was not the first time Whistler had been robbed in Russia. Just weeks before Anna joined him, someone had stolen the equivalent of $600 in rubles and two gold U.S. coins from a desk in his apartments. On that occasion, the police told him that the thief was likely someone who lived "on the premises" and knew where he kept his money.

That meant the servants, and, in fact, the Whistlers had already experienced problems with their household staff. Anna released some of the people inherited from Todd within a few weeks, though apparently for inefficiency, not dishonesty. It had even been hard to find a reliable *dvornik*, or yard man. Everyone liked the second fellow they tried, "a bear" of a man named Fritz, but Anna despaired at his muddy boots and habit of smoking up the house when lighting the heating stoves, or *pechi*. Debo complained of his foul-smelling sheepskin coat. Whistler was about to sack him when their cook revealed that the poor fellow was trying to support a wife and child in the country. Whistler gave him a second chance, and Fritz became a model of efficiency, smoke-filled rooms a thing of the past. When Whistler then found a proper coat for him, neither he nor Anna had the heart to dismiss the man. "I hope he may prove a rough diamond," a relieved Anna declared, "for he is very industrious & good natured, ... & as he wears his new coat now & has learned the way to the bath looks always tidy himself."[20]

Unfortunately, suspicion in the Christmas heist fell most heavily on Fritz and another servant. Taken in for questioning, both men professed innocence, but when the police recommended that they be dismissed, Whistler reluctantly let them go. John Maxwell pitied the family. "They have been unaccustomed to lock up from their servants," he said of the Whistlers, "but to treat them kindly and with confidence. Those they have they pay better and treat better than they could expect, and to be plundered in this impudent way is outrageous." Luckily, they were able to replace Fritz with "a much more civilized looking creature," the brother of a man who had served the Ropeses for years.[21]

The Whistlers were less fortunate in recovering their property, despite offering "a tempting award & *no questions*." That did not surprise Maxwell. The Russian police were notorious, he observed, for locating but not returning stolen goods. Composed of men of "desperate character, who wield[ed] an almost irresistible and irresponsible power," they were, Maxwell declared, "an instrument of evil

rather than of good." Until that Christmas day, Anna had known the Russian police only as the efficient, if sometimes overbearing, officials who held each household responsible for daily clearing the snow from their sidewalks into the street. The results were clean, safe sidewalks and ample snow for sledges and sleighs. Now, though, she saw another side of Russian law enforcement.[22]

Nonetheless, by the start of 1844, all the Whistlers had settled into their new life. The notoriously brutal Russian winter, with temperatures dropping to 20 or 30 degrees below zero, did not prove as daunting as Anna had feared. Their house was positively cozy. With the windows double-glazed and *pechi* in nearly every room, one could sleep comfortably at night with but a single blanket. The wood-burning *pechi* were very tall, made of glazed earthenware painted white, and as smooth as porcelain. Though slow to warm a room, if a fire was set in early morning, the heat radiated through the night. It helped, too, that the solid brick walls of the house were two to three feet thick. If venturing outside, Anna wrapped herself in a fox-skin *shube*, or floor-length coat, which kept her all "in a glow."[23]

Anna rose early, generally by 6 a.m., and awakened Jemie and Willie soon after for morning prayers before breakfast. She then consulted with her cook about daily menus, leaving Mary Brennan to supervise the other servants. She next directed the boys in their studies, with Debo also lending a hand. An occasional tutor would also be employed as Jemie and Willie grew older. Ever mindful of her own deficiencies, Anna set an example for her sons by trying to acquire a speaking knowledge of French and Russian. She claimed to *understand* French, only to lack confidence in speaking the language, but Russian bewildered her. She generally relied on Willie, who picked up the language fairly quickly, to translate for her when shopping.

The grocers and shops on Galernaya were convenient and reliable for most daily needs, but Anna visited the busier Nevsky Prospect for gifts and more important purchases, such as the boys' clothes. She frequently went with friends, especially Ellen Ropes and Mary Gellibrand, who advised her on the most reliable shops. All seemed to prefer a large emporium known as the English Magazine. When on her own, Anna was always wary of Russian shopkeepers, even the ones who spoke some English. "I shall never be sharp enough for the rogues I have to deal with," she despaired, "so rare is honesty among the lower classes of this country that even Russians of the respectable sort acknowledge this as a nation of thieves." The Christmas heist had a lingering effect.[24]

Most days ended in the parlor, where the entire family read and Anna could sew. They generally read silently, each with a book, newspaper, or tract of their choosing, although if anyone found a particularly interesting or humorous item,

it might be read aloud for the benefit of all. One evening, for instance, Anna very much enjoyed listening to her husband read an essay by John J. Blunt, an Anglican theologian, on the life of St. Paul. On Sundays, sacred music, with Debo at the keyboard, might be allowed, but whatever the pursuit, Anna would ever believe that the "family circle" should be used for "improving each other."[25]

Whether in early morning, the fading light of day, or late at night, Anna also made time to write long letters to family and friends in America and Britain. These became her lifelines to the people and world she had left behind. She later described letters from her children as the "choicest luxuries," but she treasured all her correspondence, and worked hard all her life to maintain those ethereal links to loved ones.

She kept a diary, too. It was intended, she said, for Jemie and Willie, that they might remember the great adventure, but she sent each completed volume to her mother, that Martha might know something of their lives. As it happens, her letters and diaries for the Russian years provide our earliest detailed knowledge of Anna's thoughts and feelings. In them, she recorded the family's fortunes and misfortunes, made observations on the world around her, reaffirmed her religious convictions, and confessed her failings. The diaries had occasional gaps, sometimes of several months, while elsewhere she provided meticulous, day-by-day accounts of events. Other entries severely compressed time, being summaries of weeks or months. Most interruptions were caused by family or household duties, but Anna's failing eyesight could also be blamed. Already, aged thirty-nine, the strain on her eyes had begun to show, as had the "many silvery" strands in her hair. She claimed not to need glasses when Colonel Todd offered his pair to her, but he had offered them for a reason.[26]

Yet, writing was an indulgence compared to the time and energy invested in her family. Debo, especially, continued to concern both her and Whistler. "The truth is we feel very careful of our only daughter," Anna confessed. Debo, or Dasha, as her Russian friends called her, was intelligent, poised, musically gifted, amiable, sensitive, and ever cheerful, but she was also eighteen, loved the glitz and glamour of society, and was beginning to form definite likes and dislikes. She made friends easily, enjoyed shopping, spent days at a time with female friends, and attracted male admirers with little effort. She was not beautiful in the conventional sense but possessed, in the eyes of John Maxwell, "the severe and classic beauty seen in the Grecian models." He was smitten with her, although, recognizing the difference in their ages – nearly a decade – and believing her destined for "a man of fortune," he said nothing. Besides, Maxwell told his mother, "If her Pa knew it he might shoot me."[27]

Anna worried that Debo neglected her domestic education for the sake of society. Whistler's position at court and their friendship with Todd and Colonel Bouttatz gave the family unlimited access to royal functions and excellent seats at the opera, theatre, and concerts. The girl found this hard to resist, and would have gone out every evening if allowed. "Debo does not think with me on this subject," Anna sighed. She feared her impressionable daughter might become another Madame de Bodisco.[28]

The vivacious Harriet de Bodisco, American wife of the Russian minister to the United States, represented for Anna all the potentially corrupting influences and temptations that could befall a young woman in the imperial court. When she married Bodisco in Washington three years earlier, tongues wagged, primarily because the "enamored bridegroom" was old enough to be the lady's grandfather. He shrugged off the disparity in age by saying, "No matter, we shall have a few years of enjoyment, and then I shall die and leave her a rich widow and she can get a young husband." Anna judged Madame Bodisco fully capable of doing just that, for while she was pleased to see the couple raising their own child in a Christian home, and appreciated the kindness they showed Jemie and Willie, she thought the mother a shallow creature. Having observed her at a party, dressed in velvet and bedecked with pearls and diamonds, Anna confessed, "I am not fond of seeing young persons who need no borrowed ornaments, so lavish of them." Though "perfectly amiable," Anna continued, the lady preferred Russian to American society, and seemed to spend every evening at a ball or the theater.[29]

It was a stern judgment, but it was how Anna had been reared. Her religious convictions, as much as her ideas about domesticity, made Anna suspicious of the "gay metropolis" and "dissipated court." "I do not condemn those who act differently from my views," she insisted more or less honestly, "& have no merit in declining amusements which I could not enjoy. But Oh I tremble for my children 'the snares of the world' are so enticing until proved by Christian experience that they are destructive to our love of Christ, and the young are slow to turn from the 'voice of the charmer.'"[30]

John Maxwell believed that Anna had no need of society because she was "perfectly happy in the affection of her husband and children," and in that, Anna and Whistler again thought alike. Having allowed Debo to attend a royal wedding in company with Emma Maingay, Whistler was nonetheless "rather ashamed that his Yankee girl should condescend to mingle even in a fashionable crowd ... [where] she could not be received." Both parents were pleased a few days later when, given the choice of attending an opera (*The Barber of Seville*) or a court ball, Debo chose the less objectionable opera. Anna showed her gratitude

by rushing out with Ellen Ropes in minus-twelve-degrees weather to purchase a gold chain for Debo's opera glasses. As instances of Debo's willingness to respect "her fathers views of what is right" continued, Anna rejoiced, "How much I admire her amiability she does not know! & surely she will retain the good opinion of those who revel longer, for moderation wins respect."[31]

Her boys caused less trouble, even if Jemie showed signs of being a handful. The brothers had a wonderful time that first winter in Russia. With more snow than they had ever known in New England, they could sled by simply stepping into the street, and an ice pond in their backyard offered convenient skating, a skill that Willie was only just acquiring. Both boys were lighthearted. They delighted in telling riddles, and when they had stumped their sister or John Maxwell, who was a favorite with them, their "laughter was infectious." They could be mischievous, regular little partners in crime, but they had good hearts.[32]

Willie, without doubt, was the more compliant. "What should I do without this darling child," Anna mused after a shopping trip in the Nevsky Prospect. "He is rather less excitable than Jemmie & therefore more tractable. They each can make their wants comprehended in Russian but I prefer the gentlest of my dear boys to go with me." At seven years, Willie was still small enough to stand between the seated Anna and Debo when they rode in a *droshky*, one of the small, two-person open cabs that crowded St. Petersburg streets. Willie depended on his more aggressive brother for protection when play with other boys turned rough, yet he was the healthiest member of the family, falling ill to the effects of the climate and drinking water far less often than anyone else. With Charlie gone, Mary Brennan doted on Willie, taking him out regularly for walks. And he, more than Debo or Jemie, shared his parents' religious convictions. "Don't you think Mother," he would say, "it is delightful to see a church quite full? I think it is a splendid sight."[33]

Anna's biggest concern with the more rambunctious Jemie was his health. She was relieved to see, after his near-death experience the previous summer, that he had grown stronger in Russia, but it was always touch and go. He felt "quite poorly" in February 1844. In March, he became so ill with "croup" after skating on the Neva that he missed both a church bazaar and a birthday party for one of the Ropes girls. Late April found him confined to bed with a mustard plaster on his throat. In every instance, Anna was a constant presence at his bedside. "When I gaze upon his pale face sleeping, contrasted with Willie's round rosy cheeks, my heart is full," she breathed.[34]

Anna became nearly as protective of John Maxwell. As suggested, the boys were enormously fond of him. They often walked the streets with Maxwell and

visited his rooms, where, given a choice, they would have resided. When he became desperately ill in mid February, sinking at times into delirium, the whole family grew anxious. A doctor was summoned, and Anna visited his rooms as often as delicacy allowed. Whistler took turns at his young countryman's bedside whenever he could escape his duties with the railroad. The boys "walked on tip toe lest they might disturb one whom they loved so fondly." Debo neither went out nor expressed any joy until Maxwell was out of danger. As he recovered, Anna encouraged him to escape the loneliness of his own parlor by rejoining them in the evenings or to take tea and dine. "She is one of the sweetest women I ever saw," the grateful invalid assured his mother.[35]

Anna found another charity case in a Miss Hirst, a middle-aged Englishwoman who had lived in St. Petersburg for many years. Discovering Hirst to be not only devout but also an invalid, the result of a crippling fall on winter ice, Anna paid regular visits to read aloud from the Bible and religious tracts. Hirst was especially fond of the fourth and fifth chapters of 2nd Corinthians, which describe the ministry of St. Paul. Appropriately, then, the two women lamented how often the "poor deluded souls" that constituted the bulk of Russia's citizens broke the Sabbath. Hirst, like Anna, would have given anything but her own salvation "to convert them to Christ." Willie sometimes accompanied his mother on the two-mile walk to Hirst's home, and always received from the invalid some "good book" for his and Jemie's improvement.[36]

The pace of life quickened, though, with the elaborate, nearly two-month long, celebration of Easter. This grandest event on the Russian calendar began the week before Lent with *Maslianitza*, or Butter Week, the oldest Russian holiday. The faithful ate no meat, and it was the last time they tasted butter before a week in which both eggs and butter were banished from their diet. The poor existed only on fish, bread, vegetables, and a thin pancake or crepe called *bliny*, while the upper classes also enjoyed oysters and fruit.

Despite this dietary regimen, the weeks before Easter became a national carnival, during which, reported John Maxwell, the "utmost extravagance and licentiousness prevail[ed]." A German observer called it a time of "drinking and carousing." While St. Petersburg's grand theaters closed, a sprawling outdoor drama opened in Admiralty Square. Every social class flocked to enjoy the entertainment afforded by scores of temporary stalls, theaters, carousels, giant swings, and man-made "ice hills" – large wooden ramps coated with ice for sledding. Vendors of every sort manned their booths, while jugglers, tumblers, and a variety of circus animals animated the scene. For refreshment, people consumed large quantities of tea, nuts, sweetmeats, and honey cakes.

During Easter week, two new items appeared in the stalls: oranges and eggs, although not all the eggs came from hens, and nor were they necessarily to be eaten. One found every variety of bird's egg, from nightingales to ostriches, but eggs might also be manufactured from metal, wax, glass, wood, or confectionary sugar. It was the custom to present friends and acquaintances with eggs when meeting them on Easter day.[37]

Anna was both taken aback and amused by this "tawdry" combination of self-denial and self-indulgence. Allowing herself and the boys to be escorted by Colonel Bouttatz in his carriage, she marveled at the rows of vendors and was amused to watch Willie bargain with one of them for a harmonica and a banner bearing a Russian eagle. Both boys were excited by the "novelty of the scene," but Whistler and Anna had no intention of turning them lose in what even the boys recognized as "a *rowdy* crowd." Mary Brennan was allowed to take them to see a puppet show. Otherwise, their biggest pleasure, as the season progressed, was to climb the wooden steps of the ice hills, some forty feet high, and slide down the steep ramps.[38]

The Whistlers did not observe the Russian diet during these weeks, but Anna did reluctantly accept the custom of exchanging gifts on Easter Sunday. Sitting down to breakfast that morning, the family found an "ornamental loaf" of bread, "stuck full of flowers," prepared by their excellent cook and a small plate of colored eggs from the other servants. In return, the Whistlers gave each servant a few rubles to mark the day, but Anna silently vowed to preserve the sanctity of her home in future by postponing the exchange of gifts until Easter Monday, as did the Ropes family.[39]

In most years, Easter also ushered in a change of seasons, and so it was that the Neva had already begun to thaw. That brought, in turn, a revival of the bustle and noise along the quay. With shipping and river transport resumed by early May, Anna, Willie, and Debo celebrated by crossing to see the Maingays, who lived on Vasilyevksky Island, the most exclusive of the river's several residential islands, and situated opposite the Winter Palace. As they were ferried across on one of the Neva's gaily painted gondolas, the water was "smooth as a lake," the weather "bright and summer like." The days were growing longer, too, until by June, the Whistlers enjoyed the magic of St. Petersburg's famous "summer nights." Visiting the city a few years later, Alexandre Dumas, the French novelist, marveled at the spectacle: "Imagine the sky and the air around you are pearly grey, shot with opal, quite unlike dawn or dusk; a light that is pale, yet not wan, encircles every object but casts no shadow."[40]

More importantly, summer signaled an escape from the city. Because Peter the

Great had built his imperial capital on a sandy marsh, honeycombed with canals, warm weather brought suffocating humidity and a plague of flies and mosquitoes, all of which increased the risk of sickness. Families who could afford it rented a suburban dacha. The most popular spot to reside was along the Peterhof Road, which ran west of St. Petersburg. Besides the airy, open plans of the homes, most of them with piazzas, many offered elaborate gardens, and were, in any case, generally bound by extensive woods and fields. Whistler and Anna had inspected several potential retreats as early as March. They selected one on a large estate less than four miles from St. Petersburg, and a bargain at only $225 for the entire "season" of four months. Besides a flower garden, it had a large pond, which the boys especially liked, and ducks, chickens, and turkeys ranged freely over the grounds.[41]

Anna could not have asked for more. Being relatively close to the city, she could still attend church and visit friends, such as Miss Hirst, who remained behind. Likewise, many of those friends could visit the family, although they also knew that Anna preferred they not come on Sundays. At the same time, she could lose herself in the countryside, walking the fields in search of wildflowers with Willie, watching the setting sun with Whistler, or sitting quietly with her husband in their garden. Her landlord sent dozens of flowers from his own garden, mostly roses and hydrangeas, to suffuse the house.

Nor did she lack for daily society. The Ropes and Gellibrand families had rented dachas nearby, and a family on a neighboring estate, the Andersons, whose daughter had a lovely singing voice, joined them for a continuation of their musical evenings. The Whistlers made sure to bring their piano and Debo's harp, and the major had received a new flute from London. They also brought their servants, Anna having finally gathered together a retinue on which she could depend. Best of all, sister Alicia (who may have delivered Whistler's flute) arrived to spend the summer. She looked quite matronly by this time. Plump, round-faced, and wearing spectacles, she did not resemble in the least her slender, more elegant sister Eliza, but Jemie and Willie adored her.[42]

Not that country life was a continuous holiday. Unwilling to succumb entirely to earthly pleasures, Anna maintained the same daily routine as in town. Morning and evening prayers knew no season, and Anna was never shy about asking visitors to join the family when it knelt to pray. Once, Colonel Bouttatz, having spent the night, found himself, at Anna's suggestion, in the parlor for devotionals. Whistler had been reluctant to impose their "form of prayer" on him, but Anna saw no reason for embarrassment. "Our kind friend knelt with us," she reported pleasantly, "& I have no doubt at breakfast he listened to my boys verses of scripture with approbation."[43]

The boys' school lessons also continued through the summer, although they did enjoy a reprieve from studies on their birthdays, both of which came in July. Always willing to set a good example, Anna continued her own study of French and Russian, though try as she might, any expression in Russian remained a challenge. For both amusement and enlightenment, she had Debo read aloud in the afternoons from Walter Prescott's *The History of the Conquest of Mexico*, published the previous year. They finished the first of its three volumes, which Anna thought read like a "romance," in three days.[44]

Not so romantic were the unexpected perils in their idyllic retreat. The threat of thieves persisted to such an extent that windows had to be boarded each evening, even with watchmen patrolling the neighborhood. In daylight, Anna watched anxiously whenever peddlers approached the front gate, even though Jemie and Willie conversed freely with them and sometimes negotiated "bargains." For Anna, the situation was simply further "shameful evidence of the defect of the religious system" among the Russians. Nor could the family totally escape the summer invasion of flies and mosquitoes. The "tormenting flies," impossible to brush away, crawled into the corners of Anna's eyes. Debo awoke one morning to find that mosquitoes had "feasted" on her face. Anna treated her puffy forehead and swollen eyelids with ice water and vinegar. Another reason to shutter the windows at night, despite the warm evenings.[45]

Anna held Sunday school in her parlor for Jemie, Willie, and any neighborhood children who wished to attend. Each child read aloud from the Scriptures after Anna had delivered her own "sermon for children." Each also recited a Bible lesson memorized during the week. As a reward for their attendance and diligence, Anna ended the sessions with bowls of cherries that had been kept in the icehouse until almost frozen.[46]

She was equally keen to spread God's word among the Russian peasantry. As in America, her attitude toward the lower classes was complex. The genuine thieves and roughs apart, she was appalled by the sordidness and indifference toward religion shown by many common folk. Riding home from church one Sunday, she could not help but be distressed by "the crowds of idle Russian peasants herded together" along the road, "some sleeping, some drunken, some playing their native game with bones." On a similar occasion, she sadly observed "crowds of idlers . . . , not a few so intoxicated that their boon companions were carrying them, or they were like swine wallowing along the road side."[47]

Supplied with religious literature in the Russian language by the Tract Society, and encouraged in her efforts by local landlords, Anna had Jemie and Willie distribute the pamphlets to "idle young men" in the neighborhood. She

and the Gellibrands both handed them to the long columns of soldiers that passed regularly along the Peterhof Road. She was gratified by how the peasants bowed and thanked her for the pamphlets, "as if from their hearts," but was astonished by the enthusiasm of the soldiers, who "broke their ranks and shoved each other in the ditch in their haste to receive the tracts." She was perhaps told later that this apparent thirst for God's word was actually a craving for paper, a precious commodity used by the men to make cigarettes. When returned to town, she adopted the habit of keeping several tracts in the vestibule of her home, to be pressed upon couriers and messengers sent to her husband.[48]

Anna recruited fellow Americans to join her crusade. On a visit to the machine shops in Alexandroffsky, she urged the Winanses and Harrisons to have their American and British workers attend church. "It certainly is the duty of each one of us from the home of the Pilgrims," she told them, "to let our light shine." She later reflected in her diary that, after all, it was the duty of all God's creatures, whatever their earthly calling, to win "souls to Christ."[49]

As for Anna's personal charity cases, poor Miss Hirst died that summer. She then learned of a woman who had recently lost a child, always a circumstance that affected her deeply. The woman's "style of . . . living," which included Sunday dinner parties, troubled her, but she had apparently been a good mother, and so Anna paid visits of consolation. She found it easier to sympathize with the widowed wife of a Scottish sea captain who had died while in port. Only recently married, the woman had been living with him aboard ship, and now faced the long voyage home. Anna invited her to stay in the country for at least a few days, but the woman was anxious to leave Russia at once.[50]

However, Anna's gravest concern that summer was the way her husband pushed himself to finish the railroad. They both felt the unrelenting professional pressure on Whistler. The work in Alexandroffsky aside – although Whistler remained responsible for that, too – his reputation rested on its timely completion. Were that not enough to worry him, Whistler had received reports of William McNeill's erratic behavior in America, apparently brought on by drink. His brother-in-law had also been requesting large cash loans that Whistler could not possibly afford. He kept this dark news to himself, but the major had many sleepless nights, and Anna saw frequent "traces of emotion" in him.[51]

And now that the extremely short "working season" for constructing the road – roughly June to December – had begun, the pressure intensified. Besides consulting with Winans nearly every evening, frequent journeys of a fortnight to and from Moscow were essential. Anna fretted until he returned from each trip, although her husband, when once more at home, felt a different kind of agony.

"Whistler says he must not indulge himself by staying so much at home again, as he suffers from home sickness dreadfully," Anna revealed, "but I should think the remedy painful as the effect." As for her own feelings, a gratified wife could only admit, "I wish we may never be reconciled to a separation from each other in this world!"[52]

Work prevented Whistler from joining his family in a final summer outing when the ever-attentive Colonel Todd invited them to dinner at Tsarskoye Selo. Anna and the children had already visited the "Village of the Tsar" that summer, when they toured its centerpiece, the Catherine Palace, built by Catherine the Great as a summer residence. Besides the "neatness and freshness" of the palace, the richness of its furnishings, art work, and lovely decor had impressed Anna. Here was the sort of imperial grandeur, as with the Winter Palace, she could appreciate. However, on this second trip, as her coach passed through some of the "neatest" villages she had seen in Russia, Anna was most gratified to spot several "gorgeous Greek churches at suitable points of access" for the peasantry.[53]

Once arrived, the dinner proved more elaborate than Anna would have wished. Among the guests was a dashing captain of the Chevalier Guards whom Todd seated next to Debo. Anna was a bit flummoxed when Todd proposed a champagne toast to the tsar, but not wishing, for her husband's sake, to seem disrespectful, she "went thro the motions" by raising a glass to her own lips. Jemie and Willie, astonished to see their teetotaling mother act so out of character, gleefully asked that their glasses also be filled. Everyone laughed when Willie shouted "Sante à la Emperor!" The captain "clapped his hands with delight & . . . called the boys 'bon subjects.'"

Not surprisingly, all were saddened by the inevitable return to St. Petersburg. The family's landlord sent baskets of string beans, grapes, and dahlias as a parting gift, but with Whistler preparing to embark on another trip to Moscow, it was Anna who bore responsibility for transporting their "goods & chattels" back to town. Having given up their original residence on Galernaya, the family watched as six carts creaked toward a new home, the seventh Anna would know in nearly twelve years of married life.[54]

The new place, a third floor flat of ten rooms, sat directly on the English Quay. The Ropes family would occupy apartments directly across the broad hallway, and they, like the Whistlers, had moved there as much for the "healthy situation" as for the fashionable location and sweeping views of the Neva. The building, like all houses on the quay, was made of brick with substantial two-to-three-foot-thick walls. Even the floors were made of brick, overlaid with boards and covered by carpets. The Whistlers' quarters were less spacious than the house

on Galernaya yet required no fewer servants. A back parlor became the principal family room, furnished, too, with a pair of adjacent writing desks so that Anna and Whistler could work side by side. Guests were entertained in a front parlor and formal dining room. The boys had a schoolroom for their lessons, separate from the nursery where they slept.

At $900 per month, the new quarters, though half the cost of the Galernaya house, did not come cheap, and repairs and repainting were required to make it entirely suitable. Alicia helped supervise the work, and both she and Anna prayed it would be finished quickly, as much to rid the house of the grubby laborers as for the sake of the repairs. "They are so filthy in their persons!" Anna exclaimed, "their long matted hair & beards, never disturbed by water or comb except in their monthly baths." The odor was frightful, and Alicia dusted for fleas at the end of each day. Even so, Anna confessed, "I shudder as their long dirty robes sweep past me & fly from their sheep skins as from contagion."[55]

4
Impatient Reformer
1845–49

NOT EVEN ANNA COULD HAVE predicted how fond she would become of their new home on the quay. By now resigned to life in a foreign land, she had learned to adapt, even to accept and enjoy, some aspects of Russian life. While she never conquered the language, several Russian words and phrases crept into her vocabulary. She learned to measure distances in *versts* (0.6629 of a mile), sometimes used both the Gregorian and Julian calendars to date letters and diary entries, and celebrated both the Russian and western Christmas. Yet, to adapt is not to conquer, nor to anticipate unforeseen detours and pitfalls (fig. 19).

Beyond her husband, Anna's children remained her greatest joy and chief focus of her life, with a fifth child, John Bouttatz, named in tribute to their Russian friend, added in August 1845. By then, both of her older boys had blossomed into proper little gentlemen. They said "No, sir," and "Yes, mam," without prompting and doffed their caps to ladies when introduced. Anna was quietly proud of their behavior, especially at formal social gatherings. Willie, with his "model politeness," remained the more docile and sensitive of the brothers, while Jemie, with his "eagerness to attain all his desires for information & his fearlessness," too often gave offense.[1]

Yet, neither Anna nor her husband was a stern disciplinarian. They tended to overlook, or at least excuse, the antics of their "madcap" boys. Perhaps both parents were simply wise enough to understand that children of their age had an excess of energy and were far more likely to learn life's most important lessons if allowed occasionally to cut loose. Consequently, Anna never failed to send them outside to exercise before morning school lessons. This generally meant a

walk along the quay with either Mary Brennan or Debo. Teatime came in mid afternoon, after which the boys could again romp and play before dinner. Only on Sundays did Anna prohibit vigorous activities.[2]

Jemie was granted a special treat upon their return to St. Petersburg: drawing lessons at the Imperial Academy of Fine Arts. He had always shown a talent, not to say a passion, for drawing. He had received private lessons soon after arriving in Russia from an acquaintance of his father, Alexander Koritsky, who was himself a student of and later assistant to Russia's best-known artist, Karl Bryullov. Both men became frequent visitors in the Whistler home. There had also been an interesting encounter that summer when a famous Scottish painter, Sir William Allen, having received a commission from the tsar, was introduced to the Whistlers. After inspecting some of Jemie's work, he had declared to Anna, "Your little boy has uncommon genius, but do not urge him beyond his inclination."[3]

A smiling Anna had assured Allen that Jemie's drawing was encouraged only "as an amusement," intended to promote "improvement in his leisure hours." Yet, there was no denying that, in this gift, he was his father's son, and both parents appreciated good art. The promise of seeing the masterpieces at the Winter Palace had first drawn Anna from their home in Galernaya. Similarly, she had relished the art and decor of the Catherine Palace. Beginning that spring, she and Whistler, with the boys in tow, attended the impressive annual art exhibition at the Imperial Academy, and they encouraged the boys to revisit the display as often as they pleased. Anna knew art, and she knew her artists.

As she settled more comfortably into the flow of Russian life, Anna also found more time to follow public events in Europe and America. Colonel Todd was a reliable source of news about American politics, as was Ralph I. Ingersoll when he replaced Todd as minister in 1847. Whistler, with his keen interest in the fortunes of the Whig party, greedily devoured the latest American and British newspapers, even if it meant going to the embassy to read them. Anna was more concerned about the fate of Queen Pōmare, of Tahiti, whom she believed had been "deserted" by Queen Victoria in a confrontation with France. When war between England and the United States over control of the Oregon Territory seemed likely in 1845, the entire family paid attention. Jemie engaged in a "good natured argument" with an English sea captain who visited the Whistlers, and while, in the end, they laughingly agreed that the territory should best be left to the Indians, Anna knew that English merchants in St. Petersburg did not take the issue lightly.[4]

Not surprisingly, the family was absorbed by the U.S. war with Mexico, which Whistler had predicted would come many months before the fighting

started. Family letters brought the welcome news of Gen. Zachary Taylor's early battlefield victories but also the sad tidings that one of Whistler's West Point classmates had been killed in battle at Monterey. Anna pitied the man's wife, who now suffered the ultimate trial faced by every soldier's family, a fate that she had blessedly escaped. Yet, as always, Anna could not help but see God's hand in these earthly afflictions. "This is an era in the world's history when wars & rumours of wars verify our Saviours testimony that these must be the latter days," she contemplated, "for our journals are filled with news of distress of nations from famine, pestilence & storms."[5]

So even here, as in her private life, Anna's perspective on world events was influenced by Christian faith. She did not shun secular literature. If no longer drawn to the romantic novels of her youth, she had enjoyed Prescott's *Conquest of Mexico* that summer. She had also reread Elizabeth Rigby's *Letters from the Shores of the Baltic*. Having already read it before leaving America, she found the book "much more forcible" after living in Russia for a year. Still, there was scarcely a Christian theologian she had not studied, including Thomas Arnold, Charles Wesley, Augustus Toplady, and John Newton. She found spiritual strength in published sermons, with those of the evangelical English cleric Henry Blunt, who had died shortly before she came to Russia, among her favorites. She and friends shared issues of the *Christian Watchman* and *Christian Spectator*. She was fascinated by life in India, Syria, and Egypt, but mainly because of the work of Christian missions in those distant lands. She devoured a new book about the Hold Land by George William, whom Anna had met during his year as a chaplain in St. Petersburg.

She also enjoyed the memoirs, novels, and poems of such spiritually inclined writers as Robert Murray M'Cheyne, Elizabeth M. Sewell, Edward Munro, and Julia Carney. Toward the end of her time in Russia, she read a biography of the Quaker social and prison reformer Elizabeth Fry, who had died a few years earlier. "I feel with her," Anna reflected, "that expansion of heart which embraces all Christians of every sect, & that by loving one another in Him we prove that we are His true witnesses."[6]

All of which helped her, as Anna saw it, to foster ever-greater self-reflection and awareness. She knew her weaknesses and shortcomings, and she had decided that her "besetting sin" was impatience. More than that, she feared that Jemie had inherited her failing, perhaps one reason she was slow to punish him for his animated displays. "If Jemie & I could take time to think before we act or speak," she confessed to her husband, "how much mortification we should save both you and ourselves."[7]

Her own impatience was born of death. Experience had taught Anna that our earthly lives can be snuffed out at any moment, that the purpose of this life is to prepare us for the next world, and that one can never conform to God's will at too early an age. If a somewhat fated conviction, it had been impressed upon her by the loss of two of her own small children and those of many friends and relations. Whether from sickness or accident, the tragic reports came with frightening regularity. Forced to confront and make sense of the irrational, Anna acquired a toughness that bordered on the morbid. She came to believe that a little one's death could be a blessing. Better that an incurably sick child be relieved of suffering, its untainted soul redeemed and made safe in Heaven. It was comforting, even cheering, she said, to believe that, on "our pilgrimage thro this vale of tears," these innocents had "gone before us to an unseen world [and] . . . entered upon unending happiness." Her unwavering faith made a deep impression on John Maxwell. "So amiable, so benevolent and so truly pious, and who amidst all her calamities is so resigned to the will of God," he marveled. When she spoke to him of her dead children, it was with "the perfect hope of rejoining them again forever."[8]

This helps to explain Anna's ceaseless efforts to ease the suffering of all around her. Her tracts, Sunday school, ministrations to Miss Hirst, let alone the care given to her own family and friends, defined Anna. Of course, her social position and relative affluence gave her the leisure for such pursuits, but Anna had also been taught, as the daughter of a physician and morally conscious mother, that her position and affluence required that she do good in the world. This is why she disapproved of Harriet de Bodisco and members of the Russian court. It was the lesson she tried to impress upon her own children. Among her new charity cases was an old German pauper dying of consumption and living in a "miserable shed." Not much could be done for him, but she sent Jemie and Willie to give him a few rubles for food, "wishing them," she explained, "to take a lesson in contentment by comparing their lot with his." He died less than a week later.[9]

She pursued further charitable work through the English Church in St. Petersburg and the chapel in Alexandroffsky, although, given her self-confessed impatience, these efforts sometimes frustrated her. An attempt by her pastor's wife, Mrs. Law, to establish a hospital and school for the poor had been opposed by some merchants in the English Church as too costly. In response to an appeal to aid the starving poor of Ireland and Scotland – it being the time of the Great Famine – the same congregation responded with 1,800 rubles (about $1350, or £270), but given the size and affluence of its members, this seemed a "paltry" sum to Anna. She noted with pride that the much smaller, "not rich," but more

American chapel in Alexandroffsky had responded to a similar appeal with 600 rubles.[10]

Her frustration came to a head when she accepted a position on a "ladies committee" organized by the British legation to create a school for the children of English mechanics and weavers in St. Petersburg. Anna would have preferred to serve as a Sunday school teacher at her church, but Reverend Law assured her that "religious instruction" would form an important part of the new school's curriculum. Still, despite "extraordinary efforts," the school folded after a few months. Several mill owners and merchants, including William Gellibrand, spared "no expense" in constructing the school, but its two teachers, a married couple from England, proved inept. Anna "timidly" suggested that a school be sponsored, instead, by the English Church, which she had long lamented had "neither Sunday school, bible class, or missionary society." "We have no religious instruction but from our pulpit," she argued, "& I fear youth is not so impressed by it as when it is personal, in a class." Her plea brought a negligible response.[11]

Anna had become equally impatient with what she regarded as the failure of the imperial government and the Russian Church to create a more equitable society. She most blamed the Church, whose priests, she believed, could have done far more to guide their flocks. Of course, her verdict may have been distorted by her evangelical impulses and devotion to the "beautiful forms of the Episcopal" Church, but she considered herself an objective observer. "I cannot be so bigoted as to think the service of other sincere Christians less acceptable to the Saviour, merely because their order is not that I have been educated to like best," she insisted. Yet, while judging the chanting "delightful" during vespers at a Russian monastery she visited, she also noticed "the high priest while his back was turned to the people take out a pocket comb & smooth his long beard!" In addition, the black raiment of the priests looked "like Nuns robes," and their long black hair, parted in the middle, "gave them quite a feminine appearance."[12]

The result, she maintained, was that an illiterate people crowded into their churches to learn a catechism they could not understand. They responded by rote only, and, as in the Catholic Church, crossed themselves in the name of saints as often as in the name of Christ. Even Russia's upper classes, Anna believed, worshiped without conviction. She judged their religious holidays ill conceived, too. The Easter fast, for example, with its "unwholesome diet," had made some of her servants quite ill. All the more reason, she was convinced, that the English-speaking community should exhibit more interest in the "poor, good natured peasantry," rather than exploit them as cheap labor.[13]

The government, for its part, was simply indifferent to the people's welfare. If Anna had not realized this initially, she came to understand it through her own and Whistler's experiences with the oppressive Russian State. The absolutism was most glaring in St. Petersburg, with its highly visible military garrison and policemen lurking everywhere. At large public gatherings, such as carnival, police mounted on "huge black horses" surrounded Admiralty Square to remind people, as Anna interpreted their presence, to "keep their mirth within bounds." A new American friend of the Whistlers, Edward Maynard, an inventor who arrived at St. Petersburg in September 1845 to sell his priming mechanism for muskets to the Russian army, observed that, in addition to the uniformed police, one had to beware of the "Secret Police" and government spies, so numerous that strangers were "cautioned against conversing upon [or] even mentioning many topics."[14]

The strict censorship and import laws, first encountered by Anna in the rigorous customs procedures, continued to affect the family. When George Prince, the Ropeses' nephew, returned from a visit to America, it took several days for some books he had brought the Whistlers to pass the censors. Heavy duties were levied on newspapers and journals sent through the mail, and at least one paper, the London *Times*, was forbidden altogether in Russia. Whistler, rather than trying to maintain personal subscriptions, preferred to read newspapers received by the U.S. consulate, which Russian censors were less likely to mutilate with ink or a pumice stone as a means of erasing "objectionable material."[15]

Anna was most annoyed by import regulations designed to control the black market. Not even shipments to the embassy went unscathed in most instances. On one occasion, barely half of a shipment of "*Yankee notions*" sent by son George via that route survived the Customs House. Most of the candy had been "*tasted* away," Anna complained, and even though some cases of hermetically sealed oysters survived having a knife jabbed into them, only one of two kegs of biscuits reached the family.[16]

Correspondence in and out of the country was equally scrutinized, even for someone as highly placed as Whistler. General Swift reminded him of the danger. "I wrote ... a caution," the general noted in his diary, "not to write me too plainly of the misdoings of Klein Michel [Count Kleinmichel, minister of public works, and a favored advisor of the tsar], lest his letters should be overhauled and he sent to Siberia." For her part, Anna hoped to receive precious letters from home "without the Censors clipping out all the highest seasoned bits of news."[17]

For all these reasons, and despite the grand balls, stunning military reviews, opulent palaces, and extravagant public celebrations, Anna perceived a dark

shadow hovering over the Russian populace. Sometimes it was overt, as with the police presence; at other times, it was subtler. Having agreed to attend the annual military review on the Champs de Mars with Whistler and the boys, Anna admired the spectacle of 80,000 splendidly uniformed men, "with the field pieces, banners &c glittering in the sun shine." Yet, as she surveyed the panoramic backdrop of the Winter Palace and Summer Garden from her own privileged perspective at the window of a neighboring palace, Anna instinctively compared the cost of such pageantry to "the sheep skins of the ignorant & dirty peasantry." She knew, too, "how many hearts were wrung to afford the army numbers for its ranks," composed mostly of conscripts and "supported at an expense which would have made the poor comfortable." And to what end? she asked. Merely to demonstrate the power of "one man & to make his subjects tremble to obey his slightest wish."[18]

And so Anna remained torn. She went occasionally into society for Whistler's sake or if she believed that an event was staged for charitable reasons, but she preferred to live and entertain quietly and privately. "Music at home with a few dear friends to enjoy it with us is a source of unfailing delight," she insisted, and it was "a happiness," she emphasized stubbornly, "to have ones mind made up as to what constitutes *enjoyment*." Even then, if called upon to have formal entertainments, she confessed, "It is always a weight off my mind when a dinner party is over. . . . I prefer unceremonious hospitality."[19]

To her credit, Anna never conveyed her strongest opinions in a doctrinaire or mean-spirited way. Yes, she maintained a strictly Christian household, but so, too, did most of her friends, and her husband most certainly approved. Yet, she never, for example, allowed her sons to think of the laboring classes as a dissolute or drunken rabble. Those opinions she reserved for her diary, which continued to serve as her confessional. She encouraged her sons to play with Russian boys, to respect the household servants, to sympathize with the peasants and soldiers who received her tracts. They conversed and interacted with all sorts of people in Russia, a fact in which Anna took satisfaction. One of Jemie's sketchbooks from those years is filled with drawings of Russians from many walks of life.[20]

With Debo, whose natural enthusiasm for society still worried Anna, she dealt gently. "I often err no doubt," Anna conceded, "thro my wish to gratify my dear daughter for my judgement & experience both condemn the false system of *enjoyment* the world offers, but I so yearn for sympathy from Debo that I am willing when there is no glaring folly to meet her more than half way." Anna was more concerned when Debo's late hours inconvenienced or saddened Whistler,

who also expected consideration and respect for his idea of propriety. "I trust I do not deceive myself in *sincerely* desiring only spiritual gifts for my dear children," Anna told herself, and she believed that both they and her husband understood her views to be "simply those of the bible."[21]

While never one to wear expensive gowns or flashy jewelry, Anna was not unfashionable, and she took joy in shopping. This was often done for the sake of others, as when looking for gifts or necessities for the boys and Whistler, or simply to be sociable, as when accompanying Debo or Ellen Ropes. When shopping for herself, Anna had a good eye for bargains, and her frugality prevented overspending. While in search of a riding habit for her daughter, Anna resisted the temptation to buy two new dresses for her own "spring outfit," even though she had only one suitable ensemble at the time.[22]

Anna very much enjoyed a bit of fun, and snatches of her free-spiritedness surfaced at the most unexpected moments. After celebrating the "American" Christmas in a pious manner in 1845, the family agreed to exchange presents on the later Russian holiday. All pretended to have forgotten the plan during the intervening days, hiding their gifts for others and remaining outwardly nonchalant. Jemie nearly exploded from the effort before being allowed, on the magical day, to present his father with a beautifully decorated Russian-made tobacco box. Whistler, feigning astonishment, swore that he thought only the servants were to receive presents. He then produced, after savoring the boys' expression of disbelief, a gold watch for Jemie and an "instructive" game called the *Gallery of Versailles* for Willie. Not to be outdone, Anna took her turn as prankster. Excusing herself from the merriment on the pretext of household business, she returned silently a few moments later, slipped up behind her husband, and opened a new umbrella over his head. The shouts and dancing of her sons in appreciation of her stealth were Anna's best present of the day.[23]

Ever solicitous of her husband, Anna never forgot their reason for being in Russia: to build a railroad, and that the sooner it was finished, the sooner they could return home. By the summer of 1846, Whistler did not believe the road could be completed before 1849, a year later than his original projection, but he and his associates had made visible progress. The locomotive works, which Anna and the boys visited regularly, throbbed with activity. Over 1,600 workers from thirteen different countries, including some 400 Russian serfs to do the hardest manual labor, made it the largest operation of its kind in the world. However, Whistler and Anna both cringed at the treatment of the serfs, especially those assigned to lay track. They labored in all weather, short of the deadly winter months, while fed a diet of black bread and salt and whipped for their errors.

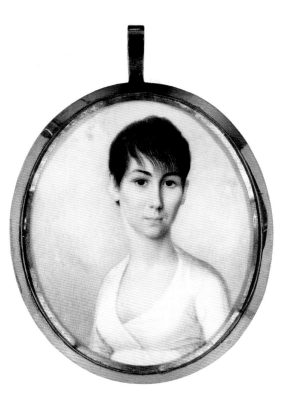

1
Martha Kingsley McNeill,
Anna's mother c. 1800.

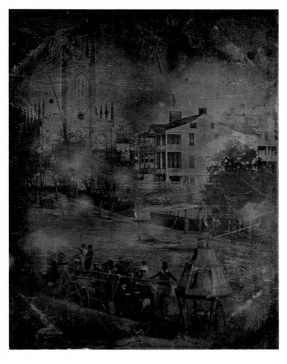

2
Wilmington, North Carolina,
c. 1847, looking east on Market
Street toward St. James Church,
constructed in 1839.

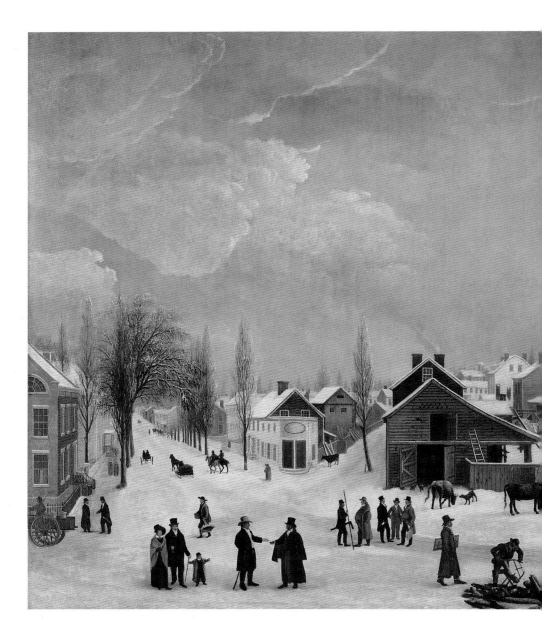

3
Winter Scene in Brooklyn, 1820, by Francis Guy,
shows the intersection of Front Street, James
Street, and Old Ferry Road (now Fulton Street).
Brooklyn Heights rose to the right, above Old
Ferry Road.

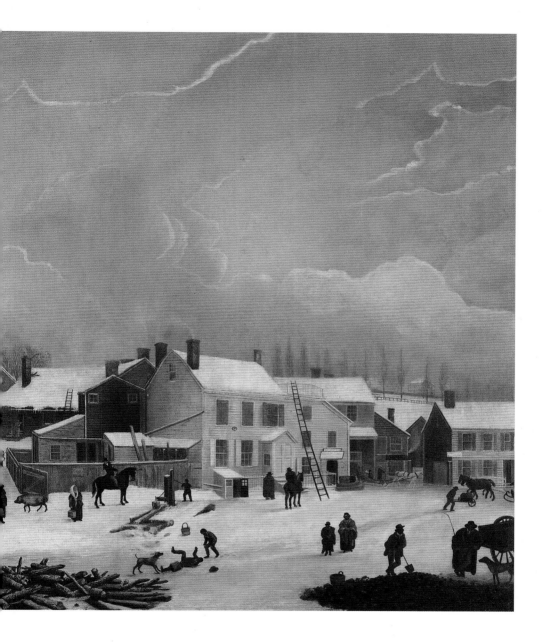

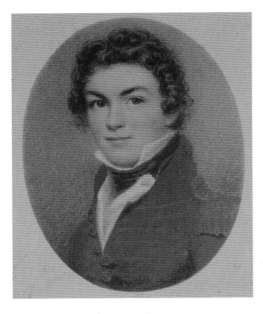

4
William Gibbs McNeill,
Anna's elder brother, 1820s.

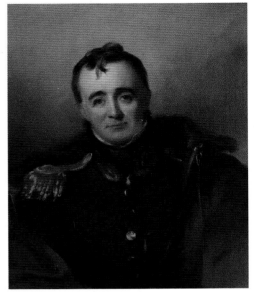

5
Gen. Joseph Gardner Swift, c. 1815, advisor
and confidant of the McNeills and Whistlers.

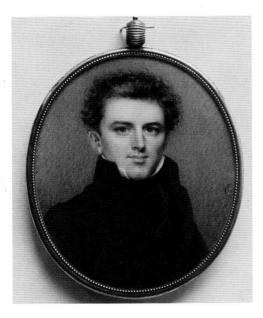

6
George Washington Whistler, 1820s.

7
Mary Roberdeau Swift Whistler, c. 1820.

8
View of Baltimore Harbor, c. 1845–50.

9
A typical house in Pascault Row, Baltimore, where Anna and George Whistler were reunited in the late 1820s at the home of William Gibbs McNeill. The "row" has been restored on West Lexington Street.

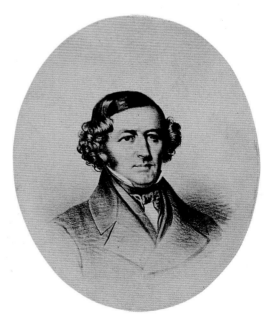

10
George Washington Whistler, 1840s.

11

"John Bull" locomotive. This English locomotive
of 1831 served as a model for such American
engineers as Whistler.

12

The Whistler house in Lowell, currently
243 Worthen Street, photographed in 1941.

13
The Whistler house in Springfield,
Massachusetts, date unknown.
The house was demolished in 1939.

14
The Palmer house in Stonington, Connecticut,
the Old Corner House, at Main and Wall
Streets, date unknown.

THE "ACADIA," NORTH AMERICAN MAIL STEAMER.

15
The *Acadia,* which carried Anna and
her family to England in 1843.

16
English Embankment in St. Petersburg, 1835,
watercolour by Eduard Gärtner.

17
Nevsky Prospeckt by Anichkov Bridge, 1847, watercolour by Ludwig Bohnstedt.

18
These coachmen in a St. Petersburg teahouse were typical of the working-class Russians encountered by Anna.

19
Anna McNeill Whistler at the time of her Russian residence, watercolour by Thomas Wright, 1845.

20
William McNeill and James Abbott Whistler (standing on the right), pastel, 1845.

21

Alston Lodge, the Winstanley home
near Preston, England.

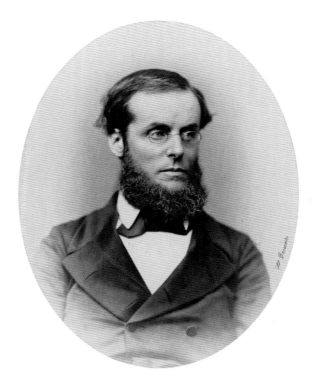

22

George William Whistler,
Anna's eldest surviving stepson
and a reliable advisor, 1860.

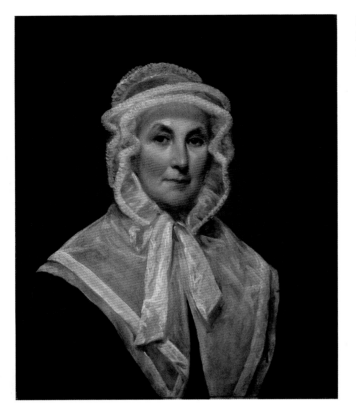

23
Martha Kingsley McNeill, 1834.

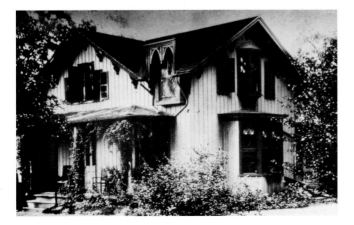

24
Anna's cottage in Scarsdale, New York, where she lived on and off between 1852 and 1858. The photograph shows the cottage (which still stands) as Anna would have known it.

25
Thomas de Kay Winans, one of
Anna's most important benefactors
in the 1850s, date unknown.

26
Alexandroffsky, Thomas Winans's
splendid house in Baltimore,
constructed when he returned from
Russia in 1851, photographed
c. 1875.

27
Homeland, the country house of
David M. Perine near Baltimore,
built in the early 1840s,
photographed 1903.

28
Donald McNeill Fairfax, the nephew
whose house Anna shared in Baltimore,
1858.

29
Anna McNeill Whistler,
date unknown, probably 1860s.

30
Anna McNeill Whistler,
probably 1850s.

31
The bath houses at Sharon Springs, New York,
possibly 1850s.

32
Goslington, or Otranto, plantation house of the
Porcher family near Charleston, South Carolina,
photographed 1932.

Whistler tried to persuade the Russian authorities that the road could be built more quickly under a "more civilized system."

However, the tsar, who never tired of praising his American mercenaries, Whistler in particular, was so pleased that he expanded the contract for Winans, Eastwick, and Harrison to include passenger as well as freight cars. To commemorate the public opening of the first sixteen miles of track, Nicholas presented large diamond rings to the three manufacturers and made Whistler a member of the Order of St. Anne. Anna was proud to see that her husband, with his strong "republican instincts," was embarrassed by the ceremony, which involved being kissed on each cheek by the tsar and having a large medallion, suspended on a scarlet ribbon, draped round his neck. She marveled all the more because she knew the frustration he felt when dealing with pettyfogging Russian army officers and government clerks.[24]

Anna helped him when possible, mainly by copying documents, mailing correspondence, and attending public functions where her presence was expected. Of course, her larger role was simply to keep him in good health and minimize the chaos at home, but she also made herself agreeable to people encountered outside their usual social circle. For instance, in befriending Edward Maynard, Whistler gave the thirty-two-year-old New Yorker, who had briefly attended West Point, a tour of Alexandroffsky, introduced him to important people, and advised him on everything from how to deal with the government to the best winter clothes. Having taken lodgings on the English Quay, Maynard occasionally visited the Whistler's new home, where Anna received him warmly. "I found Mrs. Whistler like most of our women," he informed his wife, still in America, "very sensible and well informed and very amiable." When compared to a musical evening spent with the Ropes family, which also welcomed fellow Americans, the contrast was stark. Ellen Ropes and her sister, Maynard declared, played and sang "delightfully," but he "never felt . . . so much at a loss what to say or do in order not to appear stupid." Whereas the Whistlers were conversant with a broad range of issues and interested in all topics, the Ropeses talked of people and things "known to themselves and of no earthly interest" to him.[25]

Maynard repaid his benefactors when they discovered that he was a skilled dentist as well as inventor. Reluctant to be put upon by the entire Anglo-American community, Maynard nonetheless obliged a few people, including the amiable Whistlers, who sought his help. Until then, the English-speaking community had relied on a British dentist who was, by all accounts, quite competent. He had filled two cavities for Jemie with good results. However, Maynard soon

gained a reputation as a "magician." Anna found that his "skill & gentleness" nearly eliminated her "dread of a dentists chair," even as he extracted three teeth. Whistler and Willie also paid visits.[26]

Anna's dental woes would continue for decades, but she was so grateful to Maynard, both for his professional services and his cordial embrace of Whistler, that she gave him several "peculiarly Russian" gifts when he returned to America. Maynard had failed to sell his invention to the government, but when the tsar's family also benefitted from his dental skills, Nicholas offered him the position of court dentist. Whistler urged him to accept the offer as a "compliment" to himself and "the Profession in America." Maynard ultimately declined the appointment, but one of his last acts before returning home was to "bid the Whistlers good bye."[27]

The one time Anna disagreed substantially with her husband involved the education of their sons. Whistler decided in the autumn of 1846 that tutoring and lessons at home had ill-prepared the boys for university. A bit more discipline, he said, would not be amiss either. Accordingly, he placed them in the semi-military boarding school of a Monsieur Jourdan, located on the Champ de Mars. Anna could not deny that the boys looked "almost handsome" in their uniforms of grey trousers, black jacket, velvet stock, and black cap, but their sudden absence from home was a wrenching experience for both her and the boys. Jemie, who thought it "first rate" to be among fifty other adventurous chaps, adapted more quickly than his younger brother. Willie, whom Anna thought a "more complete Whistler," grew desperately homesick, even though the boys spent most of Saturday and Sunday at home.

Anna, without the boys and with Whistler gone much of the time, was simply at sea, and could not resist the opportunity to catch a glimpse of her sons during their first week away. Going out for a drive, she asked the coachman, who, understanding Anna's anxiety, had purposefully passed in front of the school, to turn into the Summer Gardens, which sat opposite. "There I took a solitary promenade," she admitted in her diary, "wishing I might be met by the pupils," who generally took exercise in the garden. Unfortunately, they failed to appear on that day.[28]

Mother and sons made the most of their time together, and the boys spoke excitedly about their studies and classmates, but that did not make their Sunday evening departures any easier. "Tender hearted" Willie put on a brave face and assured Anna through his sobs, "It is *right* to go to school. Father wishes it & I will try all I can to study and please him." When she asked her "more manly" Jemie to support his brother, he, too, broke into tears and exclaimed, "Oh

Mother you think I don't miss being away from home!" Anna could only think as they drove off, "Dear boys! May they never miss me as I do them."[29]

The weekly anguish continued through the autumn, until overtaken by genuine tragedies. First, in mid October, Little Johnnie, barely a year old, died of dysentery. The physician told Anna that there had been an epidemic of the disease, with ten people a day succumbing in St. Petersburg. He tried to comfort her by calling Johnnie's passing "a visitation sent from God," but that did little to soften the crushing blow. Equally painful for her, Whistler was away from home, the third time that Anna had to endure the death of one of their children alone. He had gone to Hamburg two weeks earlier to escort Debo home, their daughter having left with Aunt Alicia the previous year to restore her health in Great Britain. Johnnie's little body was sent to New York, where it was received by John Maxwell. Todd's former secretary, like his boss, had left the diplomatic service and returned to America, but he remained in contact with the Whistlers. At their request, he escorted the body to Stonington, where a fourth young Whistler, this one in a coffin made by "sympathizing countrymen" in Alexandoffsky, was laid to rest.[30]

Jemie almost went next. Having received permission to spend the western as well Russian Christmas at home, the boys had relished the unbridled freedom to skate and slide down the ice hills constructed in Alexandrofffsky. On Christmas Eve, Anna welcomed the children of their friends to a "small party of young folks," the sort of entertainment that most pleased her. However, just as the boys were to return to school, Jemie fell ill from his old nemesis, rheumatic fever. Anna scarcely left his bedside for the next nine weeks, although Whistler and Debo proved equally stalwart in relieving her. She read to Jemie and sang his favorite hymns when he could not sleep. As he grew stronger, the boy played chess with his father, and Debo borrowed a large book of prints by William Hogarth for him to study, his compensation for having missed the annual spring exhibition at the Academy of Fine Arts.[31]

Jemie's illness also gave Anna and Debo, now allies, the argument they needed to withdraw the boys from Jourdan's school. Willie had been ill, too, and it seemed cruel to send him back alone. Whistler, who could not deny missing his sons when at home, conceded that the "experiment" had "disappointed expectations." A relieved Anna assured him that "any advantage in the way of study" that may have been gained had been "at too great a sacrifice, that of health most apparent." She also feared for their boys' moral progress. Better that they "remain at home under my care & their gentle Sisters tuition," Anna declared, "where their habits of virtue will be strengthened."[32]

These changes, though, were nothing compared to the next peril faced by the Whistlers and all St. Petersburg. A violent influenza epidemic swept through the city that spring of 1847. Their English doctor, who had practiced in St. Petersburg for many years, said he had never seen anything to equal its scope and virulence. The robust Whistler went down for several days; the boys had milder cases. Anna volunteered to nurse stricken friends. With summer approaching, which would further jeopardize health, the need to escape the city seemed imperative. The Whistlers had not rented a dacha the previous two years, preferring to keep their home on the quay and relying on invitations from friends to spend time in the country. In town, the boys had kept cool by rowing on the river and frequenting public "swimming baths." Anna took them for refreshing drives through the Summer Gardens and the parks in Tsarskoye Selo. However, none of that would suffice in 1847, especially not with Jemie still recovering from his rheumatic attack.[33]

The Whistlers decided that Debo would join British friends on an excursion to Switzerland while Anna took the boys and Mary Brennan to England. The Baltic crossing, begun in mid June aboard the steamer *Nicolai*, was rough, with all the party affected by seasickness. However, Jemie and Willie felt quite grown up when given their own stateroom. Willie impressed the ship's captain by conversing with him in German. Jemie, too, seemed to be maturing, more "readily heeding his mother's instructions and advice." Again passing through Lübeck, they remained long enough this time to tour the town, visit its Gothic church, and for Jemie to seek out a picture gallery known to his father.[34]

In England, they landed in Hull, rather than London, so that they might visit some of the Ropes family in Scarborough before pushing on to Preston. A Ropes employee met them at the docks to help Anna exchange Russian rubles for British sovereigns and put them on a train to Scarborough. Their journey, which included a stop in York, allowed Anna to inspect several churches and attend multiple divine services, including two at York Minster. She was equally enraptured by the green countryside, filled with blossoming hawthorn and the promise, local farmers told her, of fine crops that year, all so different from the brown and barren Russian landscape they had left behind.

Following a week in Scarborough, the refugees spent the next four months in and around Preston, where they were reunited with Alicia and the Winstanleys at Alston Lodge (fig. 21). Mary Brennan took the opportunity to visit her own family in Ireland. Anna and the boys rambled far and wide, with visits to nearby Walton, Kirkby Londsdale, Lancaster, Liverpool, and Blackpool, and she continued to use every opportunity, after "four years absence from a land of gospel

light," to inspect local churches. In July, they rented a cottage in South Shore to enjoy the salt air and sea bathing, which their doctor in St. Petersburg had prescribed for the full restoration of Jemie's health. Anna, who had felt weak ever since their arrival in Hull, was also revitalized. "How many solitary musings I had in my strolls along that long beach at low tide!" she reflected, "when the dear boys were amusing themselves with bows & arrows, or on donkeys or in throwing stones as far as they could send them into the surf."[35]

She took another cottage when Mary returned in August, this time in Egremont, on the Cheshire coast, where Alicia and Eliza Sandland, daughter of her old Liverpool friend, also joined them. Betsey Sandland and son John visited occasionally via the ferry from Liverpool, and Anna used that same ferry to shop in town, although the most agreeable part of those trips was simply cruising the river, with the ferry's band playing and river breezes tempering the summer heat. John Sandland, who had occupied the boys in Liverpool with excursions to the docks, the courts of assizes, and the countryside (where they could fly kites), led them in all variety of "juvenile sports" in Egremont. Debo swelled their ranks at the end of the month. Her Swiss holiday over, she had been staying near London with the Maingays, their old friends from St. Petersburg, who had returned home to Woolwich.[36]

However, Debo brought unsettling news. She had fallen in love in Switzerland with a handsome physician, son of a prominent London family, the Hadens. She and Francis Seymour Haden wanted to marry as soon as possible. Anna's natural reaction would have been to balk at such a sudden arrangement, but she happened to know of the Hadens, who were related to the Kirk Boott family of Lowell, and mutual friends, including the Maingays, assured Anna that it was a good match. Debo was now twenty-one, and as her Aunt Alicia pointed out, "We might as well chop her head off as propose her going back to Russia." Anna, an arch-romantic in her own way, sympathized with her daughter, whose daily letters to Haden were evidence enough of her devotion to him. The trick would be to convince Whistler to relinquish his precious Debo.[37]

Whistler was shaken by the news, broken to him in letters from both Anna and Debo, but he gamely pronounced his faith in Anna's judgment. "Be assured," he replied to her, "I can never disapprove of anything you think right." He wrote at once to Haden and made plans to join the family in Preston, where the wedding would take place. He wished that Debo, his "greatest treasure," might spend one more year in St. Petersburg, rather than abandoning them in "this hurried way," but he again trusted, "most willingly, most gratefully," that his Annie would do what was "proper."[38]

He arrived in England only a few days before the wedding, scheduled for October 16. That gave him sufficient time to meet privately with his prospective son-in-law and thrash out the "business" end of the marriage, but Anna regretted that Debo did not find more time to spend with her father, whose melancholy was evident to all. With so many female friends in Liverpool and Preston, she and Debo had plenty of help in organizing the celebration and preparing for the proposed wedding tour in Wales.

The wedding day was one of the brightest Anna had ever seen in England, with the sun shining in magical "rainbow hues" through the windows of the old parish church in Preston. Emma Maingay was Debo's maid of honour; Jemie served proudly as groomsman, dressed, as was Willie, in a spiffy polka jacket and white trousers. Debo, of course, looked radiant in her white satin gown. Everyone retired to the Winstanleys' home, Alston Lodge, for a champagne breakfast after the ceremony. Besides toasting the newlyweds, Whistler asked that the assembly raise their glasses to Debo's Uncle William McNeill, whose portrait still hung above the mantelpiece, and whom Whistler knew would have delighted in the occasion. Anna thought the only discordant note on the day was the "rudeness" of a crowd of local people that pressed around the couple outside the church in hopes of receiving a traditional sixpence. Uncle Winny, though himself deploring the English custom, had Jemie and Willie toss pockets full of silver coins to the crowd.[39]

John Maxwell was crushed when he learned of the marriage. He traveled widely for more than a year after leaving St. Petersburg, going as far, to Anna's gratification, as Egypt and the Holy Land. He visited the Winstanleys in Preston and became acquainted with the Palmers, George Whistler, William McNeill, and Anna's mother once he returned to America. He corresponded regularly with the Whistlers, and never quite lost hope of winning Debo. Learning at various times that she was either in London or Preston during the several months he spent in Great Britain, Maxwell tried to meet her, but they always seemed to be moving in different directions. In the end, he could do naught but send congratulations to the new couple through Debo's father, perhaps also recalling his own prediction that she was destined to marry "a man of fortune."[40]

By then, the Whistlers had returned to Russia. Jemie and Willie begged to remain in Preston, where they had already begun their studies at a fine school, but it would have been impossible for their parents to break from all their children at one time. The family stayed in London for a week while Whistler arranged passage. Their hotel, the Waterloo, overlooked the Thames, but they spent little time there. Anna and the boys were in perpetual motion, calling

on old friends and visiting such landmarks as Westminster Abbey, St. Paul's Cathedral, and the Coliseum. Naturally, they inspected Debo's impressive new home at 62 Sloane Street, in Chelsea. Anna was later struck by the contrast between this quiet, genteel part of the great metropolis and the "squalid wretchedness" of its eastern quarter, through which the family passed en route to the docks. "It did not do to think of the luxury of the favored few at the court end," she decided on the evening of their departure. "It seemed to us all we were driving thro a district of pollution and crime, and then the Thames boatmen! What a set, swearing at each other, seizing our luggage & hurrying us so savagely into the boats in the darkness of the evening I almost trembled."[41]

How comforting, then, to step aboard the *Victoria* for the three-day voyage to Hamburg, even if the ladies' cabin was "rather confined & very crowded." Anna found excellent shopping once landed in the German city. "Such an abundant supply of French goods especially," she remarked, and with "no duties . . . upon them." She bought several dresses, but resisted an elegant black gown, trimmed in dark blue, that Whistler and Jemie wished her to take. They reached St. Petersburg along the familiar route, through Germany and across the Baltic. When finally reaching Kronstadt, in early November, Anna found the customs officers "exceedingly polite" to the major, whose passport identified him as a courier for the U.S. embassy. They sped through the arrival process without having their luggage inspected.[42]

"I could not have imagined it would be so delightful to return to our St. Petersburg home," Anna confessed, "but no place had seemed so comfortable & none so commodious in all my travels." She returned with presents for the servants, who welcomed the family enthusiastically. Though resuming her household duties within the week, she gladly let friends assume the burden of entertaining at Thanksgiving and Christmas. Yet, Anna was mistaken if she thought life would settle into familiar patterns. Europe exploded the following spring, in 1848. The news, as usual, was late arriving in Russia, but the Whistlers soon learned that British troops had been sent to quell rebellion in Ireland, while in England, the relatively peaceful Chartist movement agitated for universal male suffrage and the secret ballot. More volatile were revolutions on the Continent, most especially France. In Russia, Nicholas published a series of manifestos to announce that no such nonsense would seize his country.

"May God so over rule in the councils of Europe that a better state of society be ordered," Anna considered. Her husband, with whom she discussed the gravity of the situation, and to whom she read the most recent news articles, did not think there would be a general war, but if the tsar massed troops on his frontiers

in defense of Russia, the maneuvers would seriously disrupt work on the railroad. As it was, Whistler now hoped to be finished in two more years, when, God willing, the family could return home. "I am very anxious," he told friends, "to get my boys back to America."[43]

In June, one of those boys, Jemie, again fell ill with rheumatic fever. With Debo gone and Whistler traveling more than ever to Moscow, Anna was left alone to quiet his fits of hysteria and sooth his physical pain. Then, as he gradually convalesced, another outbreak of cholera threatened the city. Many common Russians, including Anna's cook, blamed the epidemic on a plot by Poles, who, chaffing under Russian rule, had been infected by the rumblings of rebellion to the west. Polish revolutionaries had poisoned all the vegetable stalls and the river, the cook insisted. "She feared to buy rice or aught else from the green grocers," Anna marveled, "where we had dealt for five years." The woman voiced herself so adamantly that Willie became "terrified."[44]

This time, even their physician, his own health far from robust, fled to England, and he advised Anna to do the same. She, Mary Brennan, and the boys were among 100,000 people to leave Russia in July. Debo and Haden took them in, and Anna expressed both joy and relief to see the couple so well suited. "He & Debo truly see one," she reported, "their tastes the same, perfect harmony & cheerfulness reigns." Anna regretted that, while the couple attended church regularly, family worship was not one of their daily habits. She could only hope that in time, especially with the coming of children, they would have their own "family altar." For the moment, she wished only to leave London for the English coast. The sea voyage had aided Jemie's recovery, and she wanted to continue the treatment of fresh air.[45]

Accordingly, Anna rented a cottage on the Isle of Wight, at Shanklin, where the little band of refugees spent more than a month. She chose to stay at a cottage, rather than at one of Shanklin's two "commodious" hotels, because it placed them closer to the "bracing air" of the sea. Perched, as they were, atop one of the islands imposing chines, or cliffs, they also enjoyed the pleasure of the surrounding woodlands while remaining close to the village shops. A housekeeper tended the cottage and prepared their meals, and such a cook! She dressed crabs "most temptingly," and the local people kept her supplied with fresh eggs, chickens, vegetables, and milk at modest prices. Add to this a remarkably fine climate, "never chilly, yet never warm," and Anna wanted only for Whistler.[46]

She took advantage of this leisurely life to visit virtually every church in Shanklin and the other principal villages, Bonmarch and Brading. Shanklin had two churches. At one of them, a "small dissenting chapel," she donated a few

books to serve as the "foundation of a library" for its Sunday school. The church in Bonmarch she thought "finer" but finally decided that the new Gothic-style chapel in Brading was the "prettiest" church on the island. That said, Bonmarch had "much more stylish" shops than either Shanklin or Brading.[47]

The boys ended each day in near exhaustion, such were the attractions of climbing the chines, roaming the woods, combing the beach, riding donkeys (rented out to tourists), and swimming in the sea. During quieter moments, Jemie made good use of a paint box Haden had given him, and Willie made wax imitations of flowers Anna gathered on her daily walks with a kit given him by Debo. The daughter of a neighboring family, about Willie's age, joined them on picnic excursions, either on foot or with donkeys to carry their lounge chairs and hamper, and Debo and the Winstanleys visited at different times during the summer.[48]

Jemie had to pace himself at first, but his strength grew each day, a fact clearly demonstrated one day on a family carriage drive along the cliffs. The driver having stopped to rest the horses, Jemie leaped from the carriage and flew "like a sea fowl" down the side of a nearly perpendicular chine, sketchbook in hand, toward the beach below. None of the adults could possibly follow him. Anna, with Willie's assistance, descended near enough to summon him back, but she knew he would not respond until he had finished drawing a waterfall and cavern that had drawn his attention. When he eventually reappeared, none the worse for wear, Aunt Eliza, who had joined them on the ride, warned that "Jack last" had nearly been left behind, to which Jemie only laughed.[49]

But in fact, he would be left behind. When Anna learned in September that Whistler was suffering from the lingering effects of influenza and cholera, she decided the holiday must end. However, this time it was agreed that Jemie should remain in England for the sake of his health and education. He would attend Eldon Villa boarding school, in Portishead, near Bristol, while Anna and Willie returning to St. Petersburg. Mary Brennan also remained behind, in London, to serve as Debo's housekeeper and nurse for Anna's expected grandchild, due before the end of the year.

Anna and Willie departed from Hull aboard the steamer *City of Aberdeen*, which proceeded directly to the Baltic, bypassing Germany. They had used that route in June, on their way to England, although their new ship was twice the size of any other on which Anna had traveled. The Prince of Hesse, Friedrich Wilhelm Hessen-Kassel, twenty-eight-year-old heir to the Danish throne and a son-in-law of Tsar Nicholas, sailed with them. Sitting opposite him at the captain's table one evening, Anna was pleased that the prince "condescended"

to address her several times. She was also pleased that the captain assembled passengers and crew for prayers each morning and evening, an occasion Anna used to distribute childrens' religious tracts to the steerage passengers. A quarantine kept the ship in Copenhagen long enough to tour the city, a treat nearly equaled on the final leg of the journey to Russia when lobster – one of Anna's favorite dishes – was served each day for luncheon.[50]

However, upon reaching St. Petersburg, Anna was appalled by Whistler's "sadly changed" appearance. His lingering illness had been worsened by an uncompromising work schedule, his constitution weakened further by a diet of rice, dry toast, and tea, all his stomach could bear. He had given up predicting when the railroad might be finished. The Russian economy was stagnant, due largely to a disastrous harvest in 1848, a steep decline in foreign trade, and the continuing possibility of war. The government, always slow to respond to Whistler's suggestions and requests, seemed disinterested in both his railroad and the works in Alexandroffsky.[51]

What was more, Jemie became as much a concern in distant England as at home. Anna wrote no fewer than fifteen letters to her absent son from September through November to provide news of the family and reassure the sometimes lonely boy how much everyone missed him. She responded to his every need by sending books, clothes, even ice skates. Her associations with so many merchants and diplomats in St. Petersburg allowed her to dispatch the items with minimal interference by Russian customs officials, sometimes having packages delivered with dispatches to the U.S. embassy in London. Naturally, too, she sent advice. Do not be idle, she said. Exercise with moderation. Visit the dentist. Acquire orderly habits. Improve spelling and penmanship. Be obedient and respectful. Dress warmly. Avoid "temptation to wasting precious time." And ultimately, "Oh my own beloved Jemie, I beseech you to remember your accountability to an ever present Redeemer, strive to improve in every way." The Winstanleys, Haden, and Debo sent similar, if less frequent, cautions.[52]

In St. Petersburg, Anna's other son had entered a new English-language school, operated by James Baxter, a Scotsman who had been employed for many years in the Russian department of education. Anna and Whistler chose the school at least partly because all students, regardless of family connections, were treated equally. The uniforms were more modest than the ones at Jourdan's school, the purpose being to "*prevent* dandyism." Willie liked it at first. Being the only American enrolled, the other boys considered him "a natural curiosity." However, as the year progressed, some classmates began to "cuff and taunt" him as an "'American Monkey,' 'Milk Sop' &c." Willie cried that things would be

different if Jemie had been there to protect him. Anna advised him to "make his books his resources for lack of friends." His father thought otherwise. Willie should either disassociate himself from that crowd or "knock any down" who threatened him. Become "hardened to rough and tumble," Whistler said. Regardless, as Willie struggled with Latin and Russian history, his academic standing suffered.[53]

Meantime, Anna continued with her charitable work and worried about signs of societal decay. She marveled at all the fuss being made about the discovery of gold in California. "All sensible Americans hope it is romance," she decided. "It would ruin the country if the people left off cultivating the soil for digging gold." Speaking of which, the family had again been robbed, this time of several silver tablespoons. Anna suspected one of her husband's clerks, but, she complained mildly, "father would not accuse him or any man without proof, if all our silver disappeared!"[54]

She and other Americans in St. Petersburg were also embarrassed by the brusque manner of the new U.S. minister to Russia. Unlike Todd and Ingersoll, whom the Whistlers had enjoyed equally, Arthur P. Bagby, an Alabamian, appeared to dislike his fellow "Yankees abroad," and he positively despised the low moral, intellectual, and social condition of the Russian people, whose priests had caused them, in his opinion, to be steeped in "the deepest and grossest superstition." If that sounded a bit like Anna, she wanted no part of Bagby's graceless behavior, and was appalled to learn that, having heard so many good things about Anna, he wished to call on her. "Do you think I wish to receive such a man?" she asked in amazement. Bagby, she assured friends, would never enter her "sanctum."[55]

As Christmas approached, she enjoyed, as always, Russian winter nights, with the pure white snow enhancing the light of moon and stars. The holiday was further brightened by the birth of her first grandchild, Annie Harriet Haden, on December 13. Anna gushed over her namesake. Surely she was beautiful. All of her boys had been beautiful, "so what must one of the softer sex be?" she asked. Did she have dark curly hair or "golden ringlets?" *My* babies always have beautiful silken ringlets," Anna boasted, "& this is one of mine, only a step removed." She asked Jemie, who was spending the holidays at 62 Sloane Street, to send her a sketch of little Annie.

As for that unpredictable boy, Jemie had performed nearly as poorly at school academically as Willie (although Willie seemed to be slowly rebounding at Baxter's), and certainly below his capabilities. He had been allowed to travel to London for Christmas, but then Debo persuaded their parents to let him remain

with her, rather than return to Eldon Villa, for the sake of his health. Anna regretted the decision before the new year of 1849 had barely begun. First, the fourteen-year-old told his parents that he wished to be an artist, the implication being that formal schooling – all that Greek and Latin – would be of little use to him. Next came reports that he had been corrupted by a fast set of young "seekers of amusements" in the wicked city. "Jemie has got among the snobs!" his exasperated father snorted upon hearing the news. Anna fretted that her son had become "a butterfly sporting about from one temptation to another." More pointedly, she queried him, "Do you ask yourself 'would mother or father approve of my joining this or that pursuit?'" Did he no longer pray and read his Bible daily? "Oh," she implored, "come back to your Mothers embrace artless as when you left her side, at least preferring what is real to all false glitter."[56]

She began to fear that Whistler's health would worsen from his worrying about Jemie. Anna had built up her husband's strength by introducing chicken soup, beef, and more rice to his diet, but that seemed barely to compensate for the energy he expended on his work. What was more, the dreaded cholera still lurked in St. Petersburg, even as the effects of that disease continued to drain the formerly robust, seemingly indestructible, engineer. Anna spoke of taking him to the Continent or England for "a change of place & scene," but that scarcely seemed possible, given Whistler's determination to complete his railroad.

It was extraordinary, really, the way this spunky little woman pushed on, persevered, took charge, and managed her household, the fortunes of her children, and now, with a devotion that defied words, the care of her perilously ill husband. Their marriage could well have begun as a matter of convenience for Whistler, a widower desperate for a more settled life. Anna, one might imagine, had simply been in the right place, at the right time, under the right circumstances. Yet, for all that, Anna had made their marriage a success. Whatever the strength of Whistler's initial feelings, she had willed him to love her, the result being a tender, funny, caring, and wonderful union.

Then, suddenly, it was over. Whistler died on April 7, 1849, of heart failure. A desolate Anna, her belief in God's will tested as never before, broke the news to Jemie, her mother, and William McNeill. "Prayer strengthens me, & the word of God comforts me," she wrote to Jemie, "but this morning . . . I sink under the weight of my selfish sorrow."[57]

5
A Widowed Mother
1849–54

ANNA'S "CHEQUERED LIFE," AS SHE called it, had dealt her some hard blows but none more profound or enduring as the death of Whistler. She remained physically weak for weeks, and it would be months before she fully regained her footing. Memories of her husband's radiant "countenance in death," the "gentle patient accent" of his dying words would linger. He had not feared death. Christ had been his "rock," and he promised to meet his darling Annie in Heaven. When, toward the end, he began to fade, she urged him not to speak. There was no need, she said: "We have but one heart & mind."

Anna also knew that the best remedy for grief was action. She would rally her family, send Whistler's remains to New York, pack up her household, return to America, and raise her boys – their boys – to become men of whom Whistler could be proud. Some women would have wilted under the pressure, and even Anna, who often had been content to play a role of virtuous submission during her marriage, had to regain the self-confidence of earlier years. In that sense, Whistler's death transformed her life in more ways than one.

Friends pitched in to help with the "bustle of packing," but no one questioned who was in charge as Anna gently queried, instructed, and directed them. "I try to do promptly what must be done that I may have no self approaches when far away," she explained. Only William Ropes disappointed. When Anna asked the Boston-based merchant to ship the family piano given them by Colonel Todd to Debo, in London, he sent it by way of Hull, thus incurring greater expense and more risk of damage. It was not the first time Ropes had mismanaged a consignment for her, but a sympathetic Joseph Harrison, who had made the

Alexandroffsky foundry hum with efficiency, calmed Anna by reminding her that Ropes always acted with the best of intentions. He then recommended a different firm to handle the shipments to America and assumed the "expense & toil" of arranging them.[1]

The Mirrielees family insisted that she and Willie stay with them until their departure, but Anna waited impatiently for the spring thaw that would clear the Neva of ice and allow her to escape. Eerily, that day came on May 19, which would have been Whistler's forty-ninth birthday. To her surprise, she felt a pang of regret in leaving St. Petersburg, a place she had found so alien nearly six years earlier. "But, ah," she confessed to Sarah Harrison, Joseph's wife, and a person to whom she had been drawn at their very first meeting, "I did not know how sacred would become my association with it!" Despite occasional trials, even tragedies, her family had shared many sweet moments in Russia.[2]

Memories of Whistler, "the one on whom we all leaned," endured longest, and Anna would rely on those memories over the coming weeks to comfort, discipline, and guide their sons. "Oh my darling boy," she told Jemie when informing him of Whistler's death, "often ponder over his lessons that with your coming years good impressions may deepen, & thus your father from the grave will still speak to you. . . . When you are in doubt how to act, only stop to ask what would father have advised his boy Jemie to do?" Both boys heard the same message echoed on all sides. Debo, herself now a mother, simply understood the heavy responsibilities Anna bore. "Remember Jemmie dear, how much she has gone through," Debo intoned, "& how much sorrow there is still in store for her – & how she is in your power – either to add or to take from it."[3]

The healing process continued in London. Sheltered by Debo and Haden, mother and sons took long walks together and spoke of Whistler, in order that they might "weep together & . . . [be] more closely bound." Anna impressed upon them how different their lives must now be. Their "very small income," which she estimated to be $1,500 per year, would come solely from Whistler's investments and railroad stocks. She had received no assistance, financial or otherwise, from the tsar. He expressed his "high appreciation" for her loss through a courier and paid Whistler's salary to the day of his death but did nothing more. Nonetheless, Anna assured the boys that there was enough money, "with economy," to complete their educations. As for herself, she had never wished to be rich, and they would all be "better citizens for inheriting no fortune but an unsullied name."[4]

Finally, on July 28, following another round of mourning in Preston, they were ready to leave Liverpool. Anna had preferred passage on a sailing ship, it being cheaper than a steamer, besides affording more room for her rambunctious

boys and "less distraction from their books." She also had to pay the expenses of Mary Brennan, who wished to continue in her service. In the end, though, they all boarded a steamer, the aptly named *America*, on the advice of stepson George, with whom Anna had been corresponding. He thought the danger of sickness among steerage passengers on a sailing vessel justified the cost. Even so, £90 for four berths and steward's fees would have exhausted Anna's funds had not Joseph Harrison intervened with a loan of £150.[5]

Once at sea, the recently launched *America*, with its seventy cabin passengers, was a "floating castle" compared to the older, smaller, and slower *Acadia*, which had first taken them to England. Anna spent most of the trip in the ladies' cabin, where she, Willie, and Mary also took their meals. Jemie, now fifteen years old, was allowed to eat in the dining saloon with an English gentleman who had taken a "Fatherly interest" in him. The only cloud over Anna's journey was the obnoxious presence of Arthur Bagby. Having resigned his diplomatic post, he had sailed with the Whistlers from St. Petersburg and was now a fellow passenger on the *America*. She would have wished to avoid him in any event, but Anna had also heard that Bagby, by associating with "companions of the lowest stamp," had behaved as disgracefully in London as he had done in Russia. Perhaps this was another reason Anna confined herself to the ladies' cabin, although she did emerge to admire an iceberg, which rose above the ship one day "like a large snowy tent . . . with rainbow hues."[6]

To land, then, in New York on August 9, 1849, was a great blessing, not least because a recent cholera epidemic in the city had failed to return, as Anna feared it might do. She had enough worries without it. First, despite all the precautions and planning, shipping arrangements from Russia had been mishandled. Half her boxes had gone to New York, as desired, but the other dozen or so wound up in Boston. Even Whistler's remains had been shipped to Boston, although this happened, Joseph Harrison later explained, because the next available ship to America had been bound for that port. All was well in the end. Having George "on the spot" in New York was a great advantage, and John Maxwell's father, who had recently been appointed head of the New York customs house, promised to have Anna's boxes and the coffin waived speedily through both New York and Boston.[7]

With Whistler's body secured, Anna went directly to Stonington. His burial came first. Sadly, though, she never again saw his face. He had not been embalmed, and his leaden coffin, with an outer covering of stained pine, had been soldered shut. Most people assumed that Anna would then settle in Stonington, but she surprised everyone by renting part of a house on the outskirts

of Pomfret, Connecticut, forty miles to the north, for $100 per year. It seemed an odd choice for a woman who had spent most of her life in large towns and cities. With a population under 2,000, Pomfret was not half the size of Stonington. Although the village boasted both cotton and woolen mills, it was mainly a farming community. Anna settled there because it had an excellent Episcopal school, Christ Church Hall, operated by the church rector, Roswell Park. Nor would she be as isolated as it seemed. A railroad, originally surveyed by her brother and William Swift, ran from Pomfret to Norwich. From Norwich, a steamer could transport her down the Thames to New London, Long Island Sound, and so to Stonington.[8]

She would also have something approximating a family circle in Pomfret. Besides the boys and Mary, one of sister Kate's stepdaughters, Emma, would stay with them for a time. Being a year younger than Jemie and a year older than Willie, she attended school with the boys and helped with the housekeeping. More significantly, Anna insisted that her own mother, Martha, live with them. Anna was very much like her mother. They were both inveterate walkers and heedless of the most daunting challenges. Three years earlier, aged seventy-one, Martha had spoken of a possible visit to Russia as "an excursion of pleasure." Now, mother and daughter would be widows together, and Anna fully intended to abide by the biblical stricture in Paul's first letter to Timothy: "But if any widow have children or nephews, let them live first to shew piety at home, and to requite their parents: for that is good and acceptable before God." She had also resolved to learn by this directive from Paul: "Now she that is a widow indeed, and desolate, trusteth in God, ... But she that liveth in pleasure is dead while she liveth."[9]

Anna was just as determined to maintain familiar routines. She still rose daily before 6:30 a.m. to lead morning prayers and hear the boys' lessons before they went to school. She enjoyed long walks with them, although, as usual, Willie was her more willing partner. Martha filled the role of female companion Anna had known in Debo, Alicia, and her St. Petersburg friends. She kept busy with the work of Christ Church and local charities. She visited or nursed elderly or sick neighbors. And she wrote almost every day to family and friends, including the ones she had left behind in Russia and England. Indeed, failure either to write or receive correspondence was a rare enough occasion to be noted in a diary she kept during her first year in Pomfret.[10]

Yet, the differences in these routines and habits were just as evident. She no longer walked along the English Quay but down country lanes. The boys had no tutors to help them with French and German. There were no piano lessons or, for

Jemie, drawing lessons. Anna was relieved to be rid of opulent Russian palaces and pageants, but neither could she and the boys enjoy the Summer Garden, Catherine Palace, Nevsky Prospect, or exhibitions at the Academy of Fine Arts. Life with Whistler had been immensely comfortable; her dignified and astute husband had "every thing of the best," and she had wanted for nothing. While living in Pomfret, the family could still afford to visit New York and Brooklyn, thanks largely to the free railroad passes to which Whistler's stocks entitled them, but there would be no summer holidays, splendid dachas, or seaside cottages. And while her mother provided adult company and conversation, Anna would miss, after nearly twenty years of marriage, the intimacy of male companionship.

Anna also missed, as she had anticipated, Whistler's steadying influence on the boys. Willie, who turned fourteen in 1850, could be nearly as disobedient as the incorrigible Jemie. "Generally disturbed this afternoon by my boys indolence & resistance of my authority," Anna conceded on one occasion; or, regarding their preparation for school, "They have both been very indifferent in attention to me." A few days later, they were simply "selfish & unkind," and even when Jemie tried to make amends by volunteering to walk with her, Anna's "heart was too full of grief for their disobedience to enjoy it." The usually pliant Emma could also be "saucy."[11]

The fact that Jemie and Willie, as Emma observed, had been "brought up like little princes" did not help matters. They now had *chores* to do, including looking after pigs and chickens, although Willie took responsibility for most of the animals. A garden also had to be planted, a task made easier by the timely arrival of the Whistlers' former gardener Thomas, from Lowell and Stonington days. Working by then for the railroad in Springfield, he had heard of Anna's plight and deemed it a "privilege" to help her for several days. He even brought his young daughter Martha, who made delightful company for Anna.[12]

And Anna did her own share of household chores. She hired a laundress once weekly, and Mary Brennan did most of the cooking and heavy work, such as taking up the carpets for cleaning, but Anna still enjoyed baking and making jellies, and she was fully capable of preparing meals when necessary. She worked alongside Mary during canning season, when Grandmother McNeill also lent a hand by making "pigs head cheese." As for daily cleaning, Anna rolled up her sleeves every now and then to sweep the rooms or clean the kitchen. When Mary was away, she took pride in leaving "nothing undone that ought to be done," noting, as well, that she was never "in a bustle," unlike the inordinately energetic Mary. She kept her own flower garden, too, filled with violets, lilies, and a cactus she had first planted many years earlier in Springfield.[13]

Naturally, everyone offered encouragement, and they openly admired the grit and determination of this widow and single mother. In Pomfret, her landlady, fifty-eight-year-old Hannah Searls, introduced Anna to the community and provided all variety of help and advice. Dr. and Mrs. Park made a habit of joining her for tea, and a neighboring couple, Captain and Mrs. Bowers, became good friends, with the captain driving Anna and Martha to the railroad depot whenever they traveled. A local judge offered legal counsel and witnessed documents required to settle Whistler's estate. Old friends, too, found their way to Pomfret. Meg Hill paid the longest visits, but Eliza Boott and Kate Prince made day trips from Massachusetts to sew and gossip. Edward Eastwick relayed all the news from St. Petersburg in a surprise appearance. Also stepping out of her Russian past, two grown children of Ralph Ingersoll, the U.S. minister who had replaced Colonel Todd, paid their respects.[14]

George William Whistler visited frequently in his new role as Anna's chief "comforter and advisor," especially in financial matters (fig. 22). George's lack of initiative and resolve in earlier years had sometimes disappointed his father, but he had since become "very industrious & persevering." He lived in New York, employed as an engineer by the Erie Railroad, and had recently married Mary Ann Ducatel, a "charming girl" and daughter of family friends in New York and Brooklyn. Anna gave the couple much of her furniture from St. Petersburg. The ever-generous Joseph Harrison offered them a loan of $10,000, but Anna was relieved when George declined it. Insisting that Whistler had "always shrunk from debt," she did not want the new head of their clan to begin married life on a false note.[15]

As for her own finances, Anna knew how to manage a household budget, but the cost of supporting five people on her slender means sometimes caught her off guard. On one occasion, she allowed the grocer's bill to fall $69.49 in arrears. That was the same week the balance of the year's school fees, $68.85, for Jemie, Willie, and Emma was due. Add to these debts the cost of rent and clothing, and Anna confronted circumstances immune to hopes and prayers. George settled the grocer's bill by sending her $100, but he knew Anna required more. In winding up his father's estate, he petitioned Tsar Nicholas for $2,000 to cover her moving expenses from Russia, a sum that he and others thought due Anna according to Whistler's contract. "God be thanked!" Anna told Joseph Harrison, "that I have yet a George Whistler to aid me."[16]

Anna also found a surprisingly devoted financial advisor in William Swift, who now lived in Philadelphia. Having repented of his once unkind assessment of Anna's character, Swift handled the legal formalities of Whistler's life

insurance policy and agreed to manage the income from his stocks, which meant sending Anna both a regular allowance and funds to cover unexpected expenses. Anna apparently kept little money on hand, relying, instead, on credit with local shopkeepers. On one occasion, Swift had to send $20 as an advance on Mary Brennan's quarterly wages so that she, in turn, could send money to her brother in Ireland. As it happened, Mary had also asked Swift to invest what must have been her life's savings of $300.[17]

Joseph Harrison pitched in from far off St. Petersburg to assist George and Swift in pressing the family's claim against the tsar. Anna found such distant financial concerns "perplexing & mortifying." She wanted her friends "to do only as he [Whistler] would have done," and under no circumstances should her case "be indelicately urged." Knowing the tsar and his circle better than did George and Swift, Harrison was not hopeful of prying money out of the Russians, and so was satisfied when the government finally coughed up $1,000 in the summer of 1850. Meanwhile, he was still willing to advance money to Anna's family, this time to her younger brother, Charles, who gratefully accepted a loan of $1,000 in early 1850. When Charlie dutifully began repaying the loan nearly two years later, Harrison told Anna that her brother should "not put himself to any inconvenience," as he had "no special need" of the money.[18]

Charlie's story was part of a complex and, by 1850, prolonged drama within the Kingsley-McNeill clan. Since his late teens, Charlie and two of his Gibbs cousins, with whom he played as a boy in Brooklyn, had lived in Florida with their great-uncle, Zephaniah Kingsley, Jr. As suggested, Charlie may have been placed there for his health. He had been a sickly child, well under five feet tall and with a deformed spine that made him a partial cripple. The latter affliction, and very likely his small stature, have been attributed to his being dropped as a baby by a slave girl. In any event, he spent the rest of his life in Florida, a very different world from that of his brother and sisters. He stayed on Kingsley's plantation on Fort George Island, at the mouth of the St. Johns River, along with Kingsley's three black wives, all of them former slaves, and a passel of multiracial children. The wives lived in separate quarters on the one-thousand-acre estate, but Zephaniah's favorite was a woman named Anna, who managed the plantation house. A possible fourth wife lived on a neighboring plantation.[19]

When Kingsley died, shortly after Anna Whistler left America for Russia, he bequeathed the bulk of his fortune to his wives and children. Charlie, who by that time worked as an overseer on the plantation, received two tracts of land totaling 362 acres and two female slaves. Between them, the women, Betsy and Peggy, had five children, who also became Charlie's property. Learning that other

members of the McNeill family had inherited nothing, Martha McNeill went to Florida to contest her brother's will. Her principal legal challenge, to which she added as plaintiffs her other four children and two nieces, was that the will had been improperly witnessed. Her purpose was to have all "colored legatees" barred from inheriting any portion of the estate (fig. 23).[20]

The case was not settled until 1846, when, after winning a judgment in a federal circuit court, Martha's suit was denied in the higher district court. Kingsley's principal wife, and the main benefactor of the will, sought revenge for Martha's interference by asking the courts to remove Charlie as overseer. Her suit failed, but either she found another way to force him out or he resigned. In any case, by 1850, Charlie was farming the land inherited from Kingsley and had bought seven more of his uncle's former slaves at auction for $1,580. He lived with his own "free colored" wife, Elizabeth, sixteen years his junior, their three children, and his Georgia-born white father-in-law, a surveyor. His life, though, remained unsettled enough for a concerned Anna to confess in May 1850 that Charlie's affairs "greatly distress[ed]" her.[21]

Martha appears to have spent a considerable part of the litigious and stressful years between 1844 and 1847 in Florida, not only to pursue her court case, but also to comfort her younger son. While living with his family, she welcomed the opportunity to spread God's word to Charlie's slaves, much as Anna had done with peasants and soldiers in Russia. Martha's efforts and Anna's response to them make clear the source of the daughter's own devotion to charitable causes and the strong bond between mother and daughter. "The tears . . . streamed over my pale face from joy that the poor negroes were so anxious for the scriptures," Anna had written at the time, and to think her mother worked for "so blessed a purpose."[22]

Indeed, despite being slave owners and slave traders, a curious strain of benevolence ran through the Kingsley and McNeill families. Martha's father and brother had always insisted that slaves be treated humanely, a credo that extended to keeping families intact, rather than separating parents and children through sales. Her husband divested himself of his slaves as opportunities arose, and shortly before his death, her brother had told famed abolitionist Lydia Maria Child that he tried always to "balance evils judiciously." Charlie, after so many years in his great-uncle's household and employ, adopted the same credo. In purchasing former Kingsley slaves in 1847–48, he prevented two families from being separated by acquiring Peggy's husband, mother, and sister and a second entire family of husband, wife, and son. That likely explains why he needed $1,000 in 1850, and why his affairs so troubled Anna.[23]

But Anna's chief concern by 1851 was to find a career for Jemie. She and Whistler had thought, given their son's passion and talent for drawing, that he would make a fine architect, and that Yale or Harvard would be a fitting way to complete his education. Jemie had decided while living in England that *he* wished to be an artist, but neither art nor architecture seemed a realistic option any longer. Instead, it was decided, largely by the Swifts and Anna's brother William, that he should attend West Point. Jemie seemed indifferent to the idea until Joseph Swift took him, as he had done a young William McNeill, to see the alma mater of so many of their male relatives. The boy came away smitten with the academy and the "charming & kind old gentleman" who had escorted him. Aided by an impressive number of other influential people, including U.S. senators Henry Clay and Daniel Webster, Swift secured Jemie's appointment to the academy from President Millard Fillmore.[24]

Anna acquiesced, but no sooner had Jemie enrolled as a cadet than she received reports, both official and unofficial, of his lackadaisical attitude toward both military discipline and his studies. Swift, having staked his reputation on seeing a second generation of Whistler–McNeills succeed at West Point, was "mortified." Even worse, all of Pomfret learned of Anna's private embarrassment when another village boy at the academy gleefully – Anna thought maliciously – informed his parents of Jemie's failings. The neglect extended to his family. Weeks passed without a letter from their cadet, despite Anna's appeals as a "widowed mother" for some word. She even sent postage stamps in an attempt simultaneously to encourage and embarrass her first born.[25]

She also had the natural concerns of any mother. Did Jemie have enough socks and under drawers? Enough blankets? Enough clean linen? Was he taking care of his health? Beware of catching a chill when standing sentry duty, she warned. "*You know* my anxieties about you Jemie dear!" she reminded him. "Write me if you think of my comfort at all." And he must never forget his "dear departed father." "[R]ouse your energies young soldier, & prove the benefit of good discipline for the honor of your country & *your name*," she appealed. Jemie must have the "moral courage" to resist the influence of less studious and perhaps morally bankrupt classmates. "Read your Bible!" she exclaimed, "and forsake not the law of your father that 'Mother's wishes should be your rule of daily action.'"[26]

A visit to West Point in September 1851 reassured Anna for the moment. She planned the trip carefully, stopping first to see friends in Scarsdale before going on to make the rounds in New York and Brooklyn. At the academy, she stayed, as did most visitors, at Cozzens Hotel, although she requested, as

the widow of George Washington Whistler, whom Cozzens had known and admired, a "retired room," where she might also take her meals. She wanted to avoid the "public table," with its "crowd of fashionable[s] (my abhorrence)," Anna explained. Sister Kate went with her, partly to help carry the baskets full of new shirts, collars, hosiery, handkerchiefs, homemade cakes and fresh fruit for their cadet. Neither woman had ever seen Jemie looking "so well, so healthy, so happy!"

That evening, while other cadets marched to the mess hall, Anna and Kate, with permission from the academy's superintendent, took Jemie "triumphantly" to have supper with Professor William H. Bartlett and his wife Harriet. Bartlett, a professor of mathematics, was one of the several friends of Whistler who had taken an interest in the son. Showing, too, that she knew how these things worked, Anna urged Jemie thereafter to attend the Sunday afternoon teas given for cadets by the Bartletts, and always to convey her best wishes to the professor and his wife. Upon returning to Pomfret, Anna sent Harriet Bartlett a barrel of apples. Aunt Kate followed with "boxes of virgin honey."[27]

As for her younger son, Willie had a year of school remaining at Christ Church Hall, but plans were already being made for him to complete his education at Columbia College, in New York. Columbia was "not such an old affair or perhaps quite so well known" as some other colleges, Willie explained to Jemie. "Still," he reasoned, with a slight dig at his brother, "I suppose after all that it depends more upon the person than the place what progress one makes." Roswell Park had urged Anna to send him to a certain Episcopal college in Wisconsin, but that was too far from the rest of the family, clustered mostly in New York and Connecticut. No definite career had been decided on, but Anna hoped Willie would enter the ministry.

With both her sons soon to be in or near New York City, Anna contemplated a move that would keep her closer to them. Meg Hill and the Pophams proposed that she move to their "rather English" village of Scarsdale, with its "circle of very charming people." Positioned midway between New York and West Point, Scarsdale's convenient railroad connections would allow Willie to commute to Columbia, while Anna could easily visit the academy, Brooklyn, and family in Connecticut, most especially George and Mary, who now lived in New Haven with their first child, George Worthen Whistler.[28]

Anna also calculated that she could live more frugally in Scarsdale. Because of a drop in the value of Whistler's stocks, her anticipated annual income had shrunk by over a third, to $900. As she emphasized to Jemie, "*We must be very careful of health and expenditures.*" It was imperative that she pay to have four

more teeth removed in November, which also required that she receive ether for the first time; but Willie's approaching Christmas holiday with Kate Prince's family in Boston had to be delayed until spring.[29]

She consulted George, who had been urging Anna to move to New Haven. Despite his arduous new duties as superintendent of two new railroads, George went dutifully to Scarsdale to discuss with Mr. Popham the options for her accommodations. He left believing the time might be right for her to settle there. For one thing, Anna found herself staying less and less in Pomfret. She seemed to be always on the go. If not in Scarsdale, she was in Stonington. If not there, then in Brooklyn, New York, or New Haven, and friends in Baltimore were ever urging her to visit them. Pomfret was changing, too. Dr. Park had already announced his impending departure, and other families were leaving as their sons (Willie's friends) went off to college.[30]

She would most miss the proximity to Stonington. Jemie and Willie still thought of it as their American home, and she was immensely fond of Kate's family. One of the Palmer girls recalled Anna always dressing in black after Whistler's death, the somber attire brightened only by her white "widow's cap." Indoors, she wore black satin slippers, which allowed her to "noiseless[ly] approach" misbehaving children, "unmindful of her presence till apprehended." She confiscated any toys not in their proper place, the owner being obliged to pay a "fine" to reclaim them. She deposited the money in a "mission box," thereby teaching the children two lessons: tidiness and generosity. Still, they adored her.[31]

Anna had intended to move at once and board with the family of a local pastor. Instead, the Pophams persuaded her to wait a year, until they had built a gingerbread-style cottage, situated in one of their orchards. She would rent it for a nominal fee. The cottage was not so large that she would be embarrassed by her "dwindling stock of furniture," but its four upstairs bedrooms provided ample space for visitors, including Meg and her sister, who would keep her company in winter. Anna's favorite room became the library, which allowed breezes to come "creeping in" at all hours. The house was also within skipping distance of both the Popham house and the Church of St. James the Less. Anna knew Whistler would have approved. Only a private home, he believed, could provide the "*domestic* benefits" necessary for parents and children, and nothing was more important to Anna than to make her cottage a home for their boys. It would be a home for Mary Brennan, too, who had by then given Anna more than a decade of loyal service (fig. 24).[32]

Sadly, Martha McNeill would not accompany them. The grand dame of the McNeill clan passed away on April 7, 1852, the third anniversary of Major

Whistler's death. Born a year before the American Revolution, Martha, now aged seventy-seven, had only recently shown marked signs of physical decline. Anna had been ever solicitous of her health, never allowing Martha to rise in cold weather until the house was comfortably warm. "Every memory of her is full of love, peace & thankfulness," Anna told Meg Hill. Almost muting the pain came news, within weeks either side of her mother's passing, that both George's wife and sister-in-law had died. Mary Ann Whistler, aged twenty-six, never recovered fully from giving birth to baby George eight months earlier. So many tragedies in such a short time.[33]

Although largely a farming community, like Pomfret, Scarsdale was even smaller, with less than a quarter of the population. Completion of the New York and Harlem Railroad, connecting it to New York, in 1846, slowly boosted growth, but while the village had a post office, school, livery stable, and two churches, it had no shops. The size did not bother Willie, who already had friends among the Popham children as a result of his many visits there, and he soon made other acquaintances, including several young ladies. Living in Pomfret, he had been content to go "chestnutting" with other schoolboys. Now, at nearly sixteen, he and his male companions preferred "the sea beach &c for the mutual gratification of a band of nymphs, whose grace," Anna worried, was "unfettered by fashion."[34]

Jemie, meantime, had survived his first year at West Point, despite mediocre grades and a dangerous number of demerits. He certainly had not lacked for encouragement, not to say pressure, and not only from his mother. George visited him regularly to deliver whatever essentials his brother required and keep Anna advised of his progress. More distant people, from his sister and Dr. Park to the Gellibrands and Harrisons, either wrote to him or sent advice through Anna. Willie and Mary Brennan offered light-hearted words of cheer, with Willie being his usual cheeky self. Mary did not write but sent cakes she had baked and shirts she had mended while reminding "Master James" through Anna of how much she loved and missed him.[35]

Seemingly, Anna should have been content, but no sooner had a string of summer visitors come and gone from the Scarsdale cottage, including her motherless grandson Georgie, who spent an entire month, than she was away again. This time, it was a matter of health. She had experienced occasional pain in her side (possibly rheumatism) and general weakness. Friends, fearing her condition would worsen in winter, urged a change of scene in England. The idea appealed to Anna. Besides improving her physical condition, she could spend time with her English grandchildren, who now numbered three. The thought of leaving

Willie for several months distressed her, but she arranged to have him admitted to St. James College, near Hagerstown, Maryland, for a year of preparation before entering Columbia. She probably chose the school, and may even have succeeded in having Willie admitted, because of David M. Perine. As Baltimore's former registrar of wills, Perine was politically well connected. He had known Whistler in the 1830s because of his interest in the Baltimore and Ohio Railroad, and Whistler and Anna became the godparents of his two youngest children, born in 1829 and 1830. At least one of those boys, Thomas H. Perine, had attended St. James.[36]

Attempting to gather her boys together before departing in mid October 1852, Anna asked the new superintendent at West Point, Col. Robert E. Lee, if Jemie might be granted a week's furlough to stay with her and Willie in Scarsdale. Not many such requests would have been considered, but Lee, another admirer of Whistler, wished to spare "an invalid and widowed Mother," as Anna had described herself, the exertion of a trip up the Hudson River to bid her cadet adieu. She had also assured Lee that the memory of even a brief reunion, with part of it to include a Sabbath, would "comfort a lonely voyager." Lee gave Jemie a three-day weekend pass.[37]

Unfortunately, the reunion proved bittersweet. Exactly what happened is unclear, although Anna, who could recall the incident as much as six years later, admitted that she had perhaps reminded Jemie once too often to be wary of the "hollow friendship of the fops & idlers & triflers" who were leading him astray. In any event, he sulked, it being perhaps natural for a young man, just turned eighteen, to resent a mother's interference in such matters. Two days after his return to the academy, Anna wrote to him, "Your visit to the cottage exposed to me *folly* which is so *ungraceful* that I trust you will throw off the mask to virtue & let your own native sweetness shine when next you visit me." Seven days after that, and one day before Anna left for England, Jemie was admitted to the cadet hospital with gonorrhea.[38]

Willie, too, was suffering, if not as painfully as his brother. Besides leaving his new friends in Scarsdale, he needed three teeth extracted before going to Maryland. Once there, he felt like an exile. "Oh James," he confessed to his brother, "[I am] so very homesick!" His new school felt like a "Penitentiary," with nothing but work, work, work. And unlike Jemie, who had always been enraptured by their mother's stories of her Southern childhood, Willie had no such "nonsensical idea about Southern aristocracy." "We northerners are by far the best," he insisted. His big mistake, Willie decided, had been to pass the school's entrance examination, for now he was stuck at St. James for ten months. Please,

though, he begged Jemie, "When you write mother don't mention to her what I have said about our having so much to do; for maybe she will think that is first rate and not let me leave."[39]

Anna would have sympathized, for she felt equally homesick for much of her six months in England. Arriving, as usual in Liverpool, she spent several weeks in Preston before going to London. She stayed with Debo and the grandchildren but also saw much of her brother William, who had been in Britain for over a year trying to advance his financial prospects and repair his own health. Anna persuaded him, as one of West Point's most prominent graduates, to send some encouraging yet sober words to Jemie. Uncle William reminded his lackadaisical nephew of the importance of discipline in the army. If Jemie wished to graduate with distinction, and so join the topographical engineers, which would be the best field for him, he must learn "to *obey orders*."[40]

Still, while Anna's months in "the great Babylon" sometimes felt like years, she marveled at how the weeks "slipped away in reality." To begin with, she had arrived in time for a momentous occasion. The Duke of Wellington had died a month before Anna left America, but his opulent state funeral was not held until two months later. Haden's family connections allowed Debo to attend the memorial service at St. Paul's, where the duke was to be interred, but Anna, who could have accompanied her, preferred to watch the procession to the cathedral. That opportunity came through Samuel Colt. The thirty-eight-year-old American inventor, who had been trying to establish an arms manufactory in London against stiff opposition from British businessmen, was always pleased to see another American, and he was "highly gratified" that the widow of Major Whistler should join him and some friends to view the funeral march from the balcony of his house on Cockspur Street. Not only did he admire Whistler, but he had known William McNeill for over ten years. Colt had invited him, too, but Anna's brother was by then "tired of all England & ... its bustle." Anna might also have hesitated to join Colt had she known of a party he gave for about twenty "Yanks" earlier that week, and from which "all went home comfortably drunk." As it was, she despaired at the cost of the funeral, estimated to be £80,000, even though she was impressed, as "*a New Yorker*," by "the order of the crowd, & its quiet, by control of its admirable police."[41]

Similarly, she thought Debo had done a marvelous job rearing her "nicely trained happy & obedient children." It was the first time Anna had seen two-year-old Francis Seymour and infant Arthur Charles. She found Francis "surprisingly intelligent" for his age, with a remarkable memory for the rhymes and hymns that four-year-old Annie had taught him. He also showed a family

fondness for pictures, and knew his "colors so distinctly," boasted Anna. "Ganmama Wisseler," as he called her, taught him to play "pat a cake" and slowly persuaded both Francis and Annie to "substitute bible stories, pictures & hymns, for toys on the Lords day." She confessed to a pang when listening to Annie play the old "Russian piano" but concealed her emotions behind a "mask of . . . cheerfulness." Neither did she voice her disappointment that Arthur had not been christened George Washington Haden, which Debo had wished as well.[42]

Anna also became concerned about Debo. Despite being pleased by her daughter's accomplishments as housekeeper and mother, Anna worried that a continued fondness for society had injured her health. Seeking to lighten Debo's burdens, she encouraged her to take breakfast in bed while "ganmama" fed the children and led them in morning prayers. The two women then found time each day to read aloud to each other while sewing or crocheting, as in the old days. On Christmas Day, they took communion together at Holy Trinity, in Sloane Street. Anna called it her favorite church in all London, partly because one of her favorite theologians, Henry Blunt, had been its first vicar. She gave thanks that Debo had married such a loving man as Haden, whom Anna had always found to be a reliable advisor and generous host. She imagined that Whistler would have found Haden, with his "excellent virtues" and "refined tastes & talents," a kindred spirit.[43]

In fact, it was Haden who escorted Anna on several of her favorite outings in London. One week, they visited both an exhibition of drawings and the first photographic display ever staged in Great Britain. The first event made Anna think of Jemie's "favorite art," especially when Haden pointed out a watercolor sketch by J. M. W. Turner, whom Jemie admired. When Haden offered several amusing anecdotes about Turner's "peculiarities," Anna promised herself to recount them to her son. At the photographic show, she met the only Spanish photographer represented in the exhibition, Count de Montizón, Juan Carlos Maria Isidro de Borbón. Unfortunately, as an admitted novice in this art form, she could not fully appreciate his work, any more than she could have anticipated that the count would one day be a claimant to both the Spanish and French thrones.[44]

Naturally, she missed Jemie and Willie, and she felt their presence whenever entering Debo's dining room, thanks to a portrait of Jemie by the well-respected English artist William Boxall that hung there. Commissioned by Whistler and painted in early 1849, when Jemie was living with Debo, Anna saw "the mingled likeness" of both "dear boys" in the picture. She shared her adventures with them in letters home and sent copies of *The Times* and the *London Illustrated News* in hopes of eliciting letters from them. She was doubly rewarded when the usually

recalcitrant Jemie responded with several drawings. She suspected they were intended as an apology for his truculence in Scarsdale, especially when he admitted to having a fit of "the blues" after leaving the cottage. He did not, though, mention his embarrassing disease.[45]

Anna's health improved but slowly. She still had fits of coughing well into the new year of 1853, and her right hand remained weak, likely from arthritis. She missed hearing a performance of Handel's *Messiah* at Exeter Hall because she feared exposing herself to an outbreak of influenza in the city. That said, she visited several churches, including St. Paul's, and spent four hours touring the British Museum. She became good friends with Haden's thirty-one-year-old sister Rose, who often accompanied Anna to church and arranged other excursions for her. Samuel Colt sent her a box of hickory nuts for Christmas and supplied her with American newspapers and apples throughout her stay. She, in turn, befriended the colonel's sickly eighteen-year-old niece. Anna secured a governess to look after her and had Haden prescribe medicine for the young woman. "[S]he has a warm & grateful nature," Anna observed, "is touched by the suffering of the poor in this vast multitude & joins us in relieving families from her own purse."[46]

Debo persuaded Anna to linger in London through March, but no sooner had she agreed than word came of William McNeill's death in Brooklyn. He had returned to America just weeks earlier, and Anna had worried even then about his still sickly appearance. Her spirits, already dampened by the alternating rain and "sooted" snow of a London winter, so different from winter in America or Russia, would have sunk completely without her faith. She now treasured a long walk she had taken with William the day before Christmas. He had been lonely, missed his wife and children, fretted about his business affairs, and looked "bleached & attenuated." As he unburdened himself, Anna realized that they had not talked together in this way for ages and fancied that the tête-à-tête had reinforced William's "affection" for her. Yet, she had lost far more than a brother. William had also been her oldest remaining link to Whistler. As for her boys, they had "lost a second father." Even little Annie understood the severity of the loss. "[I]t seems to me dear Grandmama," she had consoled her, "almost all yours have gone to the heavenly home & you are left!" The emotional strain caused such pain in Anna's neck and right side – her old "disease," she called it – that she had difficulty sleeping.[47]

Resisting an impulse to return at once to America, Anna remained, as promised, with Debo, the pair of them glad for the mutual solace. When she finally did leave for Preston, Debo escorted her and persuaded Anna to pause along the

way to see still other relatives and visit such tourist attractions as Warwick Castle, Guy's Cliffe, and the ruins of Kenilworth. The warmth of her welcome in Preston melted Anna's remaining anxiety. She left Liverpool for Boston on May 7 aboard the paddle-steamer *Africa*, the same vessel that had carried her brother home. As usual, she traveled unescorted. "Many English ladies timid even in crossing a ferry, say to me they dare not venture out of sight of land," she told an old friend in an amused tone, "& they are amazed at my temerity." Anna's family, which would ever consider her a "very worldly woman," was not at all surprised.[48]

She arrived in time for a new crisis. Jemie had been felled by such a severe attack of rheumatic fever that he could not complete the year at West Point. Released to the care of Anna and Dr. George P. Cammann, William McNeill's brother-in-law, he was allowed to convalesce in Scarsdale through the summer, his final examinations postponed until fall. He could not have done better than Cammann, who specialized in heart and lung diseases, and had all but invented the binaural stethoscope. Willie, Anna's "young colt," joined his mother and brother a few weeks later, a family reunion made complete by the arrival of Mary Brennan, who had been longing to resume her place in the Scarsdale cottage.

Even so, with Jemie halfway through his four years at West Point, Anna suffered occasional remorse in knowing that his career as a soldier would mean constant separation. As friends and relatives came and went that autumn, many of them keen to attend the newly opened World's Fair in New York City, and as Anna resumed her charitable work in Scarsdale, the thought weighed on her. She regretted not having nudged him more aggressively toward architecture, especially when a friend remarked that Jemie's "originality & classic taste" would have earned him a lucrative position in New York.[49]

Instead, it was Anna who moved to the city. Willie's daily fifty-mile round trip to Columbia, where he began classes that autumn, soon wore on him physically and interfered with his studies. In December, as the approaching winter threatened to make travel even more arduous, she and Willie took rooms at 220 West 14th Street. The place suited her perfectly. Folding doors converted the bedroom, which she and Willie shared, into a parlor with large windows facing east. It had gas fixtures, "heated air," and warm and cold water. A bathroom and water closet were next door, and a separate room – most likely in the attic – was secured for Mary Brennan. The owners provided quite a nice dinner and tea, and fellow boarders included several "musical & lively" young ladies. Then, too, several friends, most notably the Cammanns, lived either on 14th Street or nearby, and George's office was on 9th Avenue. Columbia College, located at the time between Broadway and the Hudson River, was only a two-mile walk to the south.[50]

The situation seemed ideal, but over the next four months, Anna's world was again turned topsy-turvy. First, Willie decided to leave college and join his cousin Patrick "Jackson" McNeill, William's youngest son, as a mechanic in the Winans locomotive works. Anna worried that this sudden change came because Willie had grown bored with the "easy" courses at Columbia. However, the deciding factor was the advice of George Whistler. He had grown concerned about the direction in which the pair, just a year apart in age, were headed in life. "Jacks" had been working in Baltimore for several months, and appeared to like it. Willie, for his part, had been a mediocre student at St. James. It was time, George insisted, that both boys seriously consider their future professions.[51]

As it happened, George could personally guide and supervise the pair, as he, too, was moving to Baltimore, both to take a position in the Winans's business and to marry Ross Winans's daughter Julia. Then there was the matter of Willie's health. Both he and Anna had been vaccinated against smallpox upon moving to New York, but Willie had grown fearfully thin, and Dr. Cammann had diagnosed a "violent pain" in his side as rheumatic. "[T]he experiment," as Anna called it, was to last one year, with Willie moving to Baltimore in mid March. George was convinced the hard factory work would mature and strengthen him, but Anna could only marvel at how her family's life course was still being determined by railroads. As she told a friend, "[D]uty will call me oftener through Steam power than is suited to my love of repose."[52]

Anna did not follow Willie, even though many friends in Baltimore would have welcomed her warmly. But neither did she return to Scarsdale, at least not for the moment. Instead, she stored her furniture and went with Mary Brennan to Kate's home in Stonington. "My solace will be in lightening my sisters cares," she told a friend, "& especially in helping to train her children to adorn the doctrine of God our savior in all things." She would serve in the local church, too, as her own mother had done. Indeed, Anna was consciously assuming her mother's role in the family. She would stay in her mother's old room, "looking out upon the sea," at the Old Corner House. "I shall be recognized in my Mothers place," she rejoiced, "in the home & in the Church."[53]

But then came the most troubling development of the season: Jemie was dismissed from West Point. Not only had he failed his final examination in chemistry, but he had also nearly shattered all existing records for demerits. Appeals to Colonel Lee, family friends in both politics and the army, even the secretary of war, Jefferson Davis, were of no avail. Knowing himself to be disgraced, the ex-cadet joined his mother in Stonington to chart a course of rehabilitation.

Anna's instinct was to take him to Baltimore and reform the family circle, which seemed badly in need of repair if reports of Willie's behavior were true. Anna had hoped the "severe discipline" and "privations & hardships, in the den of iron" would make him eager to resume his studies for the ministry. Instead, her "home-boy" had adopted the rollicking ways of his shop companions, become "very rebellious," began smoking cigars, and claimed that he was "good for nothing without tobacco!" "[B]owed down by grief" over Willie's conduct, Anna took comfort in a pastel drawing of Jemie and Willie made in more innocent times, in St. Petersburg. Whistler had called it "his" portrait of their sons, which made it all the more precious to Anna (fig.20).[54]

So to Baltimore she went, the original plan being for Jemie to apply his training in draughtmanship from West Point to design locomotives and rolling stock for Ross Winans. Instead, he soon took a job making maps for the U.S. Coast and Geodetic Survey, in Washington, D.C. The opportunity had again come through the influence of his father's old army friends. If not the ideal solution, Anna and her boys had, at least for the moment, struck a sort of equilibrium.

Shortly before leaving Stonington, she tried to ensure that equilibrium by severing a final tie to Jemie's ill-stared past. She had inadvertently opened a letter from one of her son's female acquaintances at West Point. When shown the missive, Jemie dismissed it with a laugh and promised to discourage future advances by this particular "belle." However, when a second letter in the same dainty hand arrived, Anna answered it. She explained that whatever the relationship with her son, this "Fair Stranger" should understand that Jemie had a roving eye. He had spent considerable time that summer with a young lady in Stonington, and he would, in future, doubtless "find as much fascination in other bright eyes." Whether or not Anna told Jemie of her uninvited "interposition" is unknown, but she prayed that his admirer would understand the desire of an "anxious mother" to protect a young woman's "delicacy" and a son's "honor."[55]

6
Sojourner
1854–60

WHERE TO LIVE BECAME THE question in Baltimore. Thomas Winans, who had returned from Russia with his family nineteen months after Anna, would have welcomed her at either Alexandroffsky, his grand house in town, or The Crimea, his country house; but she thought both places, especially Alexandroffsky, ostentatious (figs. 25–26). George and Julia offered another option, but Anna refused to impose on the newlyweds. David Perine and his wife Mary had a comfortable country estate, Homeland, five miles north of Baltimore, and were a deeply religious family, but they had already been more than kind in trying to keep a watchful eye on Willie and Jackson McNeill (fig. 27). In the end, Anna shared a house with her thirty-three-year-old nephew Donald Fairfax, a U.S. naval officer, and his wife Virginia (fig. 28). Donald would pay the rent and buy fuel at 176 Preston Street, Bolton Terrace, if Anna shared other expenses. Naturally, Mary Brennan accompanied her.

Still, Anna remained anxious through the winter and into the spring of 1855 (figs. 29–30). She had hoped Jemie might be a steadying influence on Willie, but with the elder brother now in Washington, Willie became even more wayward, as though Jemie's failure had licensed his own "unsettled" state. In a way, the situation was humorous, for this most dutiful of Anna's children knew he was on the wrong track. "He tried dissipation," she mused, "& it aggravates his discontent." Nonetheless, Anna feared "a crisis . . . pending in the poor boys life."[1]

If the boys had not quite reversed roles, Jemie, at least, seemed to have been sobered by his dismissal from West Point, and Anna saw some hope of

encouraging that maturity. "If you are the sport of the winds yourself," she told him, "how can you offer advice to Willie? Oh think of what he was! & what he is! . . . & ask your conscience what is required of you to help your Willie." Yet, she knew her "butterfly," as she continued to think of Jemie, also required rehabilitation. "Pleasure certainly has crippled you!" she realized as winter approached, "& indolence has ensnared you."

She asked Donald, who traveled occasionally to Washington, to check on Jemie's progress and the state of his health, as George had done earlier on visits to West Point. She sent her son ginger snaps, mince pasties, new cuffs, collars, and candles, as she had done to West Point, and urged him to send in return his laundry and any shirts that required mending or buttons. Then there was the matter of Jemie's soul. Did he attend church and say his prayers? When would he and George, whose own lack of religious conviction also concerned her, be reaffirmed in the Episcopal faith?[2]

Other concerns clouded the future. Most essentially, money had become an even more serious problem. By the new year of 1855, the income from Whistler's stocks had declined to such a point that Anna asked the new U.S. minister to Russia, Thomas Henry Seymour, to revive her claim against the tsar. She knew she could always depend on Thomas Winans for loans or outright gifts, but she already felt heavily obligated to him. During the past two years, he had given her $500 to cover the costs of her residence in New York and Willie's admittance to Columbia, and the total of smaller sums to Jemie and Willie had reached $136.[3]

Then, complete upheaval, the result of both glad and troubled tidings. Willie accounted for much of the gladness. The "hardships" and "iron discipline" of the shop had caused him to lose all interest in machinery, engines, and railroads. He wished to return to school, this time at Trinity College, in Connecticut, a decision reached after spending a Sunday afternoon at the home of Reverdy Johnston, a prominent Baltimore attorney, friend of David Perine, and Whig politician whose own son was to attend the college. The resolution transformed Willie. Though still addicted, like Jemie, to tobacco, he became in other respects the buoyant, dutiful son of old. He again confided in Anna, sat and read with her, attended church and took communion with her. Anna's joy was further enhanced by word from England of a new grandson, Harry Lee Haden.[4]

The troubling news, not unpredictably, came from Jemie. Early in 1855, he left his government job. Whether he resigned or was discharged is unclear, but he was again rootless. What was more, the news came just as Anna was also required to find a new home. Donald, having been ordered to Washington in expectation of sea duty, was giving up the Baltimore house. Anna had considered moving

with him until Donald's wife Virginia let it be known that she disapproved. Perhaps she simply wanted more privacy in her own home, but it was also true that "Ginnie," as she was known, had never warmed to Anna. Donald softened the news by telling his aunt she would find Washington a "very uncomfortable" place to live. Willie, rather tactfully, advised against trying to live with Jemie, if that had been a consideration. His "late hours," Willie suggested, would be too much for her.[5]

George and Julia again opened their home to Anna, but Thomas Winans prevailed on her to stay with his family in order to help his wife Celeste recover from the birth of their fourth child. Jemie, too, was invited to stay, with Winans even offering to nurture his artistic talent by providing a studio and introducing him to potential clients. The arrangement suited Anna, as it allowed her to repay the family's generosity in other than hard cash. By now, she regarded her mounting debts and declining fortunes as nothing less than "bankruptcy." William Swift told her in mid March that she should expect no dividends from her railroad stocks until June, and even then, the sums would be small. The thought of unpaid bills and financial obligations tormented her, especially the money due Donald. George had to assure her, "Everybody is satisfied Mother you have done your duty here, as everywhere."

Yet, besides her own upkeep, she now had Willie's tuition, tailor bills for both Willie and Jemie, and a potential dentist bill for Jemie. Hopeful of saving a bit of money, Anna urged Jemie to see Dr. Maynard, their old friend from St. Petersburg, who had resumed his dental practice in Washington. "Say frankly to the kind doctor that you hope to earn enough this year to pay all you owe him," she instructed her son, "& ask him if he can trust you. *Do not delay this. Artificials* are not to be compared to teeth that are set by the creator." Thomas Winans again came to the rescue, this time with a loan of $500.[6]

By Jemie earning enough, Anna was suggesting – and hoping – that he would see the wisdom of fulfilling her long-held wish that he establish himself as an architect in New York. Jacks, who had left the machine shops and returned to school in New York, was also urging his cousin to move there. However, Jemie had other plans. He would turn twenty-one on July 11 and be able to draw on his own inheritance from his father's estate. With that money and a loan of $450 from Thomas Winans, Jemie announced that he was going to Paris to pursue his dream of being an artist.

Anna was dumbfounded, perplexed, grieved, fretful, but she soon came to terms with her son's decision. After all, as she had realized long ago, he had inherited her chief sin of impatience. She knew his restless disposition well enough to

see he would never be content until allowed to forge his own path. While she may have been "sobered by the Experience of this worlds discipline," she understood, even silently rejoiced, that Jemie, blessed with "the buoyancy of youth," still lived in expectation of achieving all he dreamed. At least he would have friends near at hand. One of Haden's sisters lived in Paris, and Debo and Haden would be just across the Channel.[7]

Jemie's decision also freed Anna. With Willie at school in Connecticut, she could return to Scarsdale, where Meg Hill and Meg's younger sister Sarah would share the old cottage with her. Anna had regarded the place as a sanctuary since first moving there. She may have been an itinerant tenant, but the cozy home had grown replete with memories. Among themselves, and with Mary Brennan's help, the women soon made the cottage, in Anna's words, "snug enough to read, write and quietly pursue my routine of duty." They lived frugally, in keeping with Anna's mantra of "moderation in all things," yet everything, too, "good in quality."[8]

Scarsdale would be Anna's home for the next three years, until the summer of 1858, although that is not to say she was confined there. As usual, it was impossible to restrict or limit Anna's movements in any way. She had always to be doing something, helping someone, making herself useful, as God had intended. As she was fond of saying, "It is better to *wear* out than to rust out." She did not stray often from Scarsdale, but she stayed away longer when she travelled. Though rootless for most of her life, she felt peculiarly adrift during these years. "I am but a sojourner," she told friends, and to Jemie she confessed, "I have no home on earth." Thankfully, she added, "many are open to welcome me on my pilgrimage."[9]

New York, Brooklyn, Stonington, and Springfield were her most frequent destinations, although her first extended visit that autumn was to Pomfret to see her dentist. Anna's teeth had deteriorated to such an extent while living there that she had been fitted with the "artificials," or dentures, she hoped Jemie could avoid. They were probably made of vulcanite, a hardened rubber compound, set with porcelain teeth, but the teeth had so loosened that they needed to be reset for the sake of both "health and respectability." Luckily, Anna could afford the "renovation" thanks to a timely gift of $130 from Brother Winny, in England, "just enough," Anna rejoiced, "to keep out of debt." She enjoyed visiting old neighbors in Pomfret, and the village itself had improved in appearance, but the journey home was a sad one. It came on November 3, what would have been her twenty-fourth wedding anniversary. The realization brought memories of "sweet & aching bygones."[10]

Besides her decaying teeth, Anna's general health had also grown precarious. She sometimes complained of "lurking disorders of the liver," but Anna's most consistent, if inexact, ailments were all associated with pain in her side, neck, and hands, which sounded very much like rheumatism or arthritis. She decided to seek relief from the pain by "taking the waters."[11]

The popularity of hydropathy, or the "water cure," became something of a craze in the United States during the 1840s and 1850s. Thousands of people visited natural springs and watering places (many of them magnificent hotels) to combat every conceivable ill, from cancer, measles, and venereal disease, to diarrhea, toothache, and gout. Popular magazines, newspapers, and water-cure journals extolled their healing powers. So did many religious publications, including the *Christian Examiner*, one of Anna's favorites. Even Lowell and Springfield had joined the rush for customers by 1850, although New York State led the way, with at least nine resorts by that date. Perhaps not coincidentally, *Harper's Monthly* published an effusive and wonderfully illustrated article about the wonders of New York's medicinal springs in June 1856, the month before Anna made her first visit.[12]

Anna chose Sharon Springs, famed not only for its waters, but also, as described in *Harper's*, for the "purity and salubrity of air, magnificent views, variety of natural scenery, and ever-changing pictures of rural life." She traveled by way of Brooklyn, where Isabella King, formerly one of the Gibbs cousins with whom Anna had played as a child in that city, had returned to live. Isabella would join her in the pursuit of health. Together, they traveled by ferry up the Hudson River to Albany, where they spent a day with yet another cousin before continuing by rail to the springs, nestled in a ravine nine hundred feet above the Mohawk Valley and some fifty miles west of Albany. From the depot, they had to journey another twelve miles by carriage to the village. William Swift and his wife Hannah, who had been going to Sharon Springs for years and probably recommended the place to Anna, met the ladies and escorted them to their hotel.

Still mindful of expenses, Anna had asked Swift to reserve rooms for them at the Eldredge House, which charged only ten dollars per week. That was five dollars less than the larger and more elegant Pavilion Hotel, preferred by the Swifts. Anna had scarcely unpacked before walking down to the bath houses (fig. 31). "I . . . drank a tumbler of the cold clear beverage, not heeding the smell," she reported to Jemie, "then a warm bath! I could scarcely bear to get out of it, so soothing to the hurts & weakness in the limbs." Fully invigorated, she and Isabella returned the next morning before breakfast for another treatment. "We

were in the sulphur baths at 6½," she revealed, "after our draught of magnesia & Sulphur." By 8 a.m., her appetite much sharpened, Anna was ready for a breakfast of coffee, cornbread, and broiled chicken. She apparently neglected during her two-week stay to visit a seasonal encampment of St. Francis Indians, perched in the hills above the springs. Recognizing the opportunity to profit from the summer influx of affluent whites, the Indians sold baskets, fans, and other native crafts to the tourists, besides giving them "pleasure . . . by their novelty and the picturesqueness of their little village."[13]

The following summer, Anna spent five weeks in Richfield Springs, twenty miles northwest of Sharon. Her companion on that trip was Ann Maxwell. Born in Scotland, Ann was a friend of Anna's sister Eliza and of a Scottish cousin related to Eliza and Alicia's mother. Ann and her three "accomplished and beautiful" daughters moved to New York upon the death of her husband, a physician. The three daughters married well, one of them to the wealthy merchant John Scott Aspinwall. Ann was twenty years older than Anna, but the two ladies had so much in common that they felt "as Mother & daughter, congenial in opinions & practice." In Richfield, they took rooms at a boarding house known for its "excellent table," laden with "the best of homemade bread, home churned butter & home laid eggs. . . . [and] Goblets of fresh milk at every meal."[14]

Ann Maxwell and cousin Isabella were among several friends and relatives that Anna either first met or saw more frequently in the mid 1850s. Isabella, a year younger than Anna, had married Ralph King, one of ten children born to Roswell and Catherine Barrington King. Roswell King had been born in Connecticut but, having moved to Georgia as a young man, made his fortune there as a cotton broker and manufacturer. Ralph, his fourth oldest boy, moved his family to Brooklyn about 1853, after completing a four-year appointment as consul to the U.S. legation in Bremen. His position in Brooklyn as a financier and broker provided a Northern presence for his family's Southern enterprises, including cotton, much as Isabella's father, George Gibbs, had done four decades earlier. In 1844, Isabella and Ralph were also among the family members who contested Zephaniah Kingsley's will.[15]

However, Ann Maxwell became the touchstone for several of Anna's newest, most interesting, and longest-lived friendships. Most immediately, there were Ann's daughter and son-in-law, James Stevenson, with whom she lived at their home on 88th Street. They also had a country house in Nyack, some twenty miles north of the city on the western bank of the Hudson River. Mother and daughter shared Anna's devotion to charitable causes and spreading the word of God. Indeed, Anna was deeply impressed, upon first meeting Ann, by her recent

visit to a local "Colored Home," where she read the Scriptures to aged and poor black women.[16]

Anna likely met another new friend, the notorious Harriet Douglas Cruger, through Ann. Born to immense wealth, Harriet Douglas was a spirited, independent, flirtatious, widely traveled woman who defied the laws of conventional society, especially those that applied to married women. She would allow no man to control her substantial fortune, the consequence being that she remained unmarried until the age of forty-three, a spinster, in the language of the day. In 1833, she finally accepted Henry N. Cruger. Having rejected the South Carolina-born New York lawyer twice before, Harriet married him only when he agreed that she would hold the purse strings. She had also demanded that he change his name to Douglas but relented when he consented to her being known as Mrs. Douglas Cruger.

The apparent spirit of compromise ended ten years later. Thinking better of his rash promise, Henry sued his wife in order to gain at least partial control of her income. He won the suit, but Harriet gained something of a victory on appeal. In return for a settlement of $20,000 and an allowance of $4,000 per year, she received a legal separation, although the couple had not then lived together for years. By the time Anna met her, Harriet was divorced, an occasion that legend says she celebrated by chopping her marital bed in half to make a pair of sofas. Like many of Anna's wealthy friends, Harriet had houses in both town and country. Her house at 128 West 14th Street became one of the early homes of the Metropolitan Museum of Art after her death, in 1874, but Anna appears to have visited Harriet almost exclusively at her country estate, Henderson House, near Richfield, which she had constructed to resemble a Scottish castle.[17]

One cannot imagine a less likely friend for Anna. Some people thought Harriet mad, and she does appear to have suffered from dementia toward the end of her life. Still, Anna would have been fascinated to hear her describe the years before her marriage. Harriet had known four U.S. presidents and, in pursuing her "literary enthusiasms" through Great Britain and Europe, became acquainted with Sir Walter Scott, William Wordsworth, Harriet Martineau, Fanny Kemble, and the widow of Robert Burns. And while Harriet's views on marriage would have seemed odd to Anna, she likely admired the older woman's spirit. They were also both widely traveled, and had visited many of the same places in Britain. It would have been only natural for them to compare experiences, and Harriet would have been intrigued by Anna's life in Russia. Most importantly, though, by the time Anna met her, Harriet was known for her "pious Presbyterian exaltations." She so feared the fate of her soul that she left the largest portion of her wealth to several religious and missionary institutions.[18]

Anna's most enduring friend from these years was James G. Gamble. They may have met through either Ann or Harriet, either in gatherings at Henderson House or on Staten Island, where Gamble lived and Harriet often visited a brother. In some ways, this friendship was just as unlikely as Anna's relationship with Harriet, even if it rested on much clearer ground. The Irish-born Gamble, who worked as a clerk for his brother-in-law merchant, Samuel Wann, also a native of Ireland, was sixteen years younger than Anna, but he shared her piety and sighed with Anna over "the degeneracy of the 19th century." He became one of her closest confidantes for over a quarter century. He visited her in Scarsdale, and she was always welcome at his home, which, during their early friendship, he shared with his mother and sister. By the autumn of 1853, Gamble had met and become very fond of Jemie, Willie, the Palmers, and all the Pophams and Hills of Scarsdale. As Anna somewhat awkwardly but unabashedly expressed it to him, "We all love your Mother's James as a brother!"[19]

Meantime, having benefitted "in health and spirits" from her treatment in Richfield, Anna returned home to face a series of new trials. First, she found Willie recovering from a severe attack of "erratic rheumatism," of which she had only been told shortly before leaving the springs. Thankfully, by the time Anna reached her son at the Cammanns' home in Brooklyn, he was in "excellent spirits." Not so Isabella King. She had been ill since before Anna left for Richfield Springs. A cousin had since arrived from Georgia to serve as nurse, but Anna continued to spend a part of each day with her. Sadder news came from England, where Eliza Winstanley had died. Victimized by a stroke some time earlier, she had been an invalid at the end, unable even to speak. Anna told herself that death had been a blessing.

Less painfully, if no less seriously, she learned that one of the railroads in which Whistler had invested was now bankrupt. Anna was not alone in her losses. Widespread and unreasonable speculation in railroad securities and real estate across the nation had caused what would become known as the Panic of 1857. Cammann & Company took action on her behalf to limit the damage, but it was yet another reminder for Anna of her always precarious financial condition.[20]

And her physical maladies were far from cured. By mid September, Anna was visiting both her dentist and physician in Pomfret. Her teeth had caused suffering ever since she left Richfield, and her right eye had recently become so inflamed that she had difficulty reading, writing, and sewing. Anna's physician reduced the irritation by applying a "small blister" to her temple, a treatment he advised her to continue.[21]

When the eye remained weak after several weeks, Anna decided to restore her health generally by spending the winter in the South. She had spoken of such a trip for the past two years, whenever winter's grip tightened on the Northeast. In the coldest weather, when the north wind blew with gale force and snowdrifts buried one or more sides of the Scarsdale cottage, she wore a "wadded sack" over her usual morning wrapper when indoors. If venturing out to church or on some necessary errand, she donned her Russian fox *shube* and a pair of buffalo-fur gaiters. A pair of carpet moccasins her mother had made into overshoes prevented her from slipping on ice.[22]

Anna went in easy stages. Leaving New York in late November 1857, she paused in Philadelphia, where she had been invited to stay with the Eastwicks. Her nephew Jackson McNeill, now employed as an accountant in New York, escorted her on the train. A week later, she headed for Baltimore. The Winans had asked her to spend time at Alexandroffsky, and while the mansion's "weight of luxury" still oppressed her, she did look forward to seeing her six-year-old grandson Georgie. She also modified her opinion of the Winans's lavish life when she arrived to find that Thomas's wife Celeste had established a soup house on the grounds in order to feed the city's poor three days each week through the winter. No small undertaking, the cost of food, wood, and labor one year reached nearly $27,000.[23]

Anna returned to Philadelphia for Christmas but in early 1858 resumed her trek southward. Again accompanied by Jacks, she travelled by steamer to Wilmington and from there, without her nephew, by railroad to Charleston, South Carolina. Having arrived in Wilmington after dark and leaving early the next morning, she missed seeing her hometown but felt compensated by the unexpected comfort of Southern railroads. "No tobacco spitters, no swearing & jostle," she reported to James Gamble. "The travelers select & polite." Anna spent the next four months recuperating in the warmth of the Southern sun, most of the time with family in Charleston, but also enjoying a month with her brother Charles in Florida.[24]

Of course, the restless Anna could not be content to bask in sunny, fragrant gardens without feeling as though she had earned it. Elderly cousins had to be nursed in Charleston, and in Florida, she had Charlie's entire family to attend. Her brother had prospered on the land inherited from Zephaniah Kingsley. He retained only 100 acres, thirty of them under cultivation, but the whole was worth $2,000, with his livestock valued at $500. The family's home, constructed of logs on a bluff overlooking the St. Johns River, was sparsely furnished but "neatly kept," the grounds brightened by cape jasmines and twenty-foot-high

oleanders. Charlie and his wife Elizabeth now had six children, ages one to fourteen. Anna grew quite fond of Elizabeth, if in a somewhat condescending way. The "poor girl" had grown up without a mother, and so it had been Martha McNeill, during her sojourn with the family ten years earlier, who had taught Elizabeth to be "a lady." More than that, she had trained Charlie's "promising sons … gently & firmly to do right." As for their father, he had grown into a "true hearted" man, popular among his neighbors and with a taste for literature. Equally, he took pride in being a farmer. He had "kept up with the times & their changes," Anna told Jemie: "agriculture is his pursuit and he informs himself of the improvements."[25]

Although Charlie at one time owned as many as sixteen slaves, he retained only a fifty-eight-year-old woman, very likely as cook, in 1858. It has been suggested that he sold the others purely for profit, but it is also true that Charlie had adopted Zephaniah's Kingsley's liberal views on emancipation, even allowing slaves to purchase their freedom. As an overseer, he had treated slaves, as Kingsley would have insisted, with "justice, prudence, & moderation." By 1858, he relied on hired slaves, and only at planting and harvest time, rather than undertaking the expense and responsibility of owning them. It being planting time during Anna's visit, she noted how he worked alongside his small band of field hands. She told Jemie that he would like his uncle, should they ever meet.[26]

Assuming the roles of "chaplain" and "teacher" on the banks of the St. Johns, Anna led devotionals every morning and read Bible stories to the children each Sunday, after which she offered a homily to Charlie's hired slaves, at their request. She enjoyed strolls with one or another of the boys, as she had done with Jemie and Willie at their age. Whenever they "surreptitiously cut-up" by poking each other and giggling during prayers, she never let the horseplay interrupt her, but would afterwards turn to their father and say, "Charles, are you bringing these boys up to be true Christians?" Charlie humored her – sometimes with a sly smile directed toward his sons – by replying, "Yes Anna, they will be good boys." Nonetheless, he appreciated his sister, and her visit reaffirmed their sibling bond, much as her trip to London had done five years earlier with William. Charlie begged her to return the following winter, and he and Elizabeth named their next child, born a year later, Anna.[27]

If the tawny color of her sister-in-law, nephews, and nieces unsettled Anna, she never mentioned it, which in itself is worthy of comment. Charlie's family was listed as neither black nor mulatto in the U.S. censuses of 1850 and 1860, and it was positively categorized as "white" in 1870. However, scholars attribute this misidentification to the vagaries of nineteenth-century census takers,

and describe Elizabeth unequivocally as a "free colored" person. In later years, when two of her sons visited Stonington, the family remembered them as "*large handsome boyes*" with "very *dark*" skin. "[T]here was something about it [their marriage] Mother never understood, being very young," related Kate Palmer's grandson, "but she suspected 'dark blood.'" Many of Elizabeth's descendants, who called her Nana, explained the dark skin by saying she came from "an old and aristocratic Florida-Spanish family."[28]

In fact, Anna's experience with slavery had been surprisingly slight for some-one born in the South. Once removed to Brooklyn, her only significant contact had been on brief childhood visits to Southern relatives and time spent in Baltimore. During the 1850s, the latter city had 25,000 free blacks but fewer than 2,500 slaves, so that while she had lived in a racially mixed society, whites had far outnumbered blacks. Among her Baltimore friends, only the Perines appear to have kept slaves, that family owning nine blacks by 1860, ages two to sixty. The Winanses used no slaves in their locomotive works, and while they quite likely had black domestic servants, those could have been free people. For his part, Thomas Winans once gave three dollars to a "Colored man to assist in purchasing the freedom of his wife," an unlikely gesture for a slaveholder.[29]

The largest number of slaves Anna ever encountered came on a visit to Goslington, also known by its original name of Otranto, the plantation of her Porcher relations (fig. 32). Slave labor was required there to cultivate vast acres of rice and cotton, but in Charleston, less than twenty miles to the south, she encountered only house servants, craftsmen, and urban laborers, and even they were less conspicuous than one might suppose. While slaves formed nearly 58 percent of South Carolina's population, that proportion was reversed in Charleston, the second largest city in the South after New Orleans. Moreover, a majority of the white population in this city of 40,500 people consisted of Irish and German immigrants, and over a third of the black population was free. With the slave community itself being so diffuse and such an integral part of the city's economic life, the harsher realities of slavery seemed less stark.[30]

And so, as with many antebellum Americans, Anna's racial views were com-plex, her assumption of black inferiority made slightly less objectionable by an instinct for benevolence. "The [slave] owners have the severest task & such a weight of responsibility in the care & training of such families!" Anna told James Gamble from South Carolina. And no part of their responsibility weighed more heavily on Southerners, she maintained, than bringing slaves to Christianity. Just as Anna believed that spiritually starved Russian serfs could be saved by hearing God's word, so, she insisted, could the souls of enslaved blacks. It was a common

justification for slavery, and not uniquely American, having been repeated throughout the British Empire for generations. Listening to a Charleston preacher who had worked as a missionary in Africa praise the beneficial effects of Christianity on that continent, Anna felt vindicated. "[I]t has long been my conviction," she explained to Gamble, with whom she sometimes debated the issue, "[through] the Providence of our Lord that heathen Africa may be enlightened by their people of our Southern States. The galleries of all the churches are free to them & very attentive hearers they appear."[31]

This attitude also sharpened Anna's perception of the growing national political divide over slavery, which she had first encountered during her 1853 visit to England. Harriet Beecher Stowe had published *Uncle Tom's Cabin* a year before, and the novel, written, in Stowe's words, "to illustrate the cruelties of slavery," had sold 300,000 copies in the United States by 1853, with separate editions being marketed in England, Scotland, France, and Germany. The book had inspired stage adaptations in America and England as well as a parade of derivative novels, songs, pamphlets, and poetry. "Never, since books were first printed," proclaimed an American magazine, "has the success of *Uncle Tom's Cabin* been equaled; the history of literature contains nothing parallel to it, or approaching it."[32]

Anna attributed the book's combination of "romance & poison" to Stowe's "abolishionist prejudices," and she was not the only American, North or South, who judged the antislavery movement a danger to the nation's political equilibrium. While there had been hints of trouble in the mid 1830s, when Anna lived in Lowell, public debate about slavery's future in the United States reached a point of crisis twenty years later, with the creation of a new political party, the Republicans, devoted to halting slavery's expansion. Defenders of the South's "peculiar institution," deeming it essential to the region's social stability and economic prosperity, feared the consequences if such a party ever gained power. Anna's own Connecticut-born brother-in-law, George Palmer, worried about the sectional divide. When Kate, seemingly unwittingly, brought home a copy of Stowe's book from a trip to New York, her husband threw it in the fire, "remarking that he did not wish his children to read 'any such libel on the south.'"[33]

The "popular mania" created in England by Stowe had caught Anna off guard, and she was perplexed when people asked her opinion of the book. "I am no advocate of slavery," she insisted defensively, "but can witness to the humanity of the owners of [the] Atlantic states & testify that such are benefactors to the race of Ham, believing as I have been led to from my mothers opinions, that the blacks in the south are cared for by Christian owners, being taught from

the gospel & all their religious indulgencies provided." Indeed, the presence of slavery in America, she continued, could be seen as part of a Divine plan. "I take the view," she explained, "that God has permitted the stigma to remain upon our country that missionaries might be prepared for Africa, thro the religious instruction provided by slave owners in our Atlantic States & that thro the Colonization Society it will be affected."[34]

Anna demonstrated her convictions soon after settling in Pomfret. Anna's mother, Martha, had returned from her sojourn in Florida with a free black servant named Eliza. Whether Eliza had ever been a slave is unknown, but Anna trained her to help Mary Brennan. Religious teachings, undoubtedly already begun by Martha, were part of the program, and Anna could not have been more pleased with the results. When first considering a winter hiatus in the South, in 1856, Anna mused, "Poor Elizas hope that I might visit Florida & be a missionary ... makes my desire great to be my brothers helper in the work of Christianizing his people."[35]

By the time she moved to Scarsdale, Anna had given Eliza the nickname Topsy, a character in *Uncle Tom's Cabin*. When first mentioned in the novel, Topsy was shrewd, cunning, and devious, but only as a result of being mistreated by a series of cruel owners. Coming under the protection of the saintly little Eva, she was transformed by kindness and the saving grace of Christ. Eliza appears to have been a mature woman, not a child, as was the Topsy of the novel, but a similar transition apparently took place in her behavior. In any case, after training Eliza for three years as a "maid of all work," Anna confidently sent her in the autumn of 1853 to work for the newlywed Kate Prince (now Livermore), daughter of her good friends from Lowell.[36]

Even then, Anna did not abandon Eliza. Three years later, in September 1856, shortly after returning from Sharon Springs, she went to see the by then dying servant. Eliza had been placed seven months earlier in a Stonington asylum, or poorhouse, known as the Town Farm. Finding her bed-ridden and "wasted away to a shadow," Anna sat with Eliza every day for a week to cheer her with "devotional exercises." "I will not send you the painful sketch of gradual decay," she reported to Jemie, who had always been fond of the servant. "[I]t was a mutual comfort to poor Eliza & her 'dearest mistress' as she called me, to listen to each others voices. [P]robably we shall not meet again on earth."[37]

When Anna returned north from her southern visit, it was to neither Stonington nor Scarsdale but to Philadelphia, the nation's second largest city, which she would call home for the next two years. Willie was the reason. Having completed his studies at Trinity in 1857, he had decided to become a doctor

rather than, as Anna had always hoped, a minister. He considered studying in either England or Europe, as Dr. Cammann had done, and the examples of both Cammann and George Palmer were quite possibly his reason for pursuing medicine. Anna had preferred that he go to England, where Haden might serve as mentor, much as he done under very different circumstances in nurturing Jemie's artistic instincts. However, Willie quickly calculated that he could not afford to live in London, not even under Debo's roof.

Instead, he enrolled at what most people regarded as America's premier medical school at the University of Pennsylvania. Fees and books would still cost well above a hundred dollars per year for three years of lectures in anatomy, the theory and practice of medicine, *materia medica* and pharmacy, chemistry, surgery, and obstetrics. He would also receive practical training from a "preceptor," Dr. James Darrach. The son of a physician, Darrach had attained his medical degree aged twenty-four, and now, at thirty-three, was a resident physician at the university hospital. Willie lived in the same boarding house as another of Darrach's students during his first year of studies at 1605 Filbert Street, about a fifteen-minute walk from the Medical Hall, on 9th Avenue. However, when Willie's companion dropped out of school at the end of their first year, Darrach invited Willie to share his lodgings at 1205 Arch Street, a bit closer to the lecture hall.[38]

Willie enjoyed Philadelphia so much that he thought of settling permanently, and it made perfect sense, he told Anna, for her to join him. They already had a circle of friends in the city through the Eastwick and Harrison families, whom Willie visited regularly. They could enjoy a "snug" home in the upper stories of Darrach's house, which Willie judged to be in the "pleasantest part" of Philadelphia. Later, once he earned his degree, they could set up housekeeping on their own. Anna liked the idea. She would be near at least one of her boys, and the many ways she might save money in a single household appealed to her habits of frugality. Anna also thought it an excellent opportunity for Mary Brennan, who was eager to rejoin the family and, as a jubilant Anna put it, be "our fag again! never to leave our home!"[39]

For his part, Willie, who would turn twenty-two in July 1858, had finally found his niche in life. He was composed and focused when first assisting Darrach in surgery. A proud Anna told everyone, "Doct D said few novices could escape fainting at first sight of so much blood." Willie laughingly explained that he had been too busy cleaning and handling instruments during the removal of some cancerous tissue to think of fainting. More to the point, her "sensitive & affectionate" son was finally "shaking off his indifference," Anna observed.

"[H]e is realizing how nearly he is of age and puts off childish whims and assumes responsibility, not self conceit," she emphasized to Jemie, a remark intended to jolt her less responsible son into following the example of his younger brother. Anna was pleased as well to see how quickly Willie had absorbed the spirit of his chosen profession. "[R]eally," she told Jemie, "he talks understandingly & feelingly of a doctors aim." She regretted only his continuing addiction to tobacco, an "indulgence so baneful to his strength."[40]

Anna benefitted further from living with Willie in having Darrach treat her still-weak right eye. The trip south had done little to strengthen it, and while she was astonished by Willie's new knowledge of her ailment, it was to his preceptor that she turned for help. "Dr. Darrach is cautious & mild in his treatment," she assured a concerned James Gamble. "[H]e says as the left eye is affected by sympathy only, he hopes he need only touch the right." Darrach "touched" the eye with "blue stone," or copper sulfate, most likely in a lotion mixed with alum, nitrate of silver, and saltpeter, a common remedy of the day for what he probably diagnosed as granular ophthalmia.[41]

Darrach also recommended that Anna return to Richfield Springs for several weeks of "bathing & drinking the waters." Ann Maxwell again accompanied her, but so, too, did Ida King, the only surviving child of Ralph and Isabella. She had been christened Florida, and had a twin sister, named Georgia, who died quite young. The family had called her Flo until they went to Bremen, where, upon learning that her name resembled the German word for "flea," Florida insisted on being called Ida. Anna became extremely fond of the petite and lovely nineteen year old. She was vivacious and a bit spoiled but also an object of pity. Her mother had recently died after several years of failing health. Consequently, Anna rejoiced to see Ida make friends with some "nice intelligent young people" at their boarding house, and so not feel bound to her elderly and less energetic traveling companions.[42]

The strain on Anna's eyes would come and go for the rest of her life, with the "blue stone" treatments becoming nearly a daily regimen for several years. Reading remained more difficult than writing but to be settled with Willie compensated for any discomfort. He read to her, generally from the Bible, nearly every evening, even following hours in the lecture hall and dissecting room. He assisted with the shopping, too, sometimes, basket in hand, accompanying Anna as she made her round of the shops. Most meaningfully, he became her "chaplain." They said morning prayers together, and he escorted her to services at St. Mark's, the imposing Gothic revival church on Locust Street, only a few blocks from their house.[43]

She lacked only Mary Brennan, whom circumstances had forced to stay with her family in Springfield. As it turned out, Mary would never again serve Anna full-time, although she did help in the occasional emergency. In due course, she became Mrs. Bergen. Even so, the two women corresponded for many years, ever hopeful of an eventual reunion, and with Mary still signing her letters "Servant Mary." Meantime, Anna relied on a trio of servants, the most important one being a "faithful Spinster" named Mary McLaughlin. Anna described her as valuable and trustworthy but "slow." A "nice Protestant Irish" girl named Jane helped Mary twice a week, probably with the laundry. During the winter, Anna had a "good colored" man, John, to maintain the fires and clean boots. When in need of a seamstress, she turned to a "pious Prot[estant] Irish" girl named Elizabeth, recommended by friends of James Gamble who lived very near Anna, on 16th Street.[44]

She traveled very little, and never far, over the next two years. She cultivated several new friends in the city, saw the old ones when opportunity arose, and invited friends and relatives to visit from afar. She did not see as much of the Eastwicks and Harrisons as she might have done. Willie continued to accept invitations to dine with them, but the Harrisons lived on the other side of town, in Rittenhouse Square, too far, Anna said, for her to walk, and the Eastwicks had hired renowned architect Richard Sloan to build their new ornate, Italianate mansion, Bartram Hall, far west of the city, across the Schuylkill River. She also suspected that the Harrisons worried she would not fit into their new "rich, fashionable circle," although she did attend their daughter's wedding and once spent a few days at their summer home on the Delaware River.

Sister Kate came down from Stonington on occasion, most notably to spend three whole weeks when Anna was first settling in and unpacking. Shortly thereafter, fourteen-year-old Donald, Charlie's eldest son, arrived from Florida to live with Anna while he attended school in Philadelphia. Far from being a burden to her, Anna insisted that Donnie, as she called him, provided much "comfort and aid." She took as much pride in his academic achievements and attendance at Sunday school as she would have done with her own sons, and Donald would long remember her "motherly care."[45]

Then there was Jemie. He had been gone for four years by 1859, and it seemed even longer to Anna. As usual, the self-confessed "truant son" was an irregular correspondent. Willie would have written more often, but while the brothers had much in common, they possessed different temperaments. Jemie was more selfish than Willie, more concerned with what amused or attracted him than with the needs or desires of other people. While undisputedly loving his mother,

Jemie had not inherited her devout nature. She valued the Scriptures as guides to "instruction & correction" and sources of "support & comfort thru the suffering of sickness & on the bed of death"; Jemie would later praise the Old Testament as "a source of invective."[46]

Yet, Jemie respected her judgment, more than once saying or thinking since leaving home, "As usual dear Mother you were right!" If not as religious as she, he appreciated, even admired, her mastery of the Bible, a gift that he, perhaps despite himself, had acquired from her. He could even joke with her about it. "[Y]ou seemed amused or impressed by my Pilgrim style of adapting Scripture to your various straits or temptations," Anna observed as he set out for Paris. But none of that could fill a mother's need for her children. As she expressed it a year after his departure, "[H]ow I yearn after my Jemie & Willie, & how lonely I feel often, missing their companionship."[47]

Anna worried chiefly that Jemie would be corrupted by the fleshpots of Paris, not "keep to innocency," as she often phrased it. She lamented that he had not, unlike Willie and George, renewed his confirmation of faith in the church. She pleaded with him, as she had instructed him as a child, to remember the precariousness of life. And in truth, her son's notoriously fragile health gave her cause to worry. He had already been hospitalized once in Paris, and twice he had recuperated from illness under Debo's care. In that respect, she continued to warn him, as she did Willie, against the "evil effects of smoking," although it is hard to tell if she regarded it more as a hazard to health or as a vice leading to "debauch."[48]

Her darkest fears seemed realized in the spring of 1857, when she chanced upon some drawings Jemie had sent Willie. They apparently depicted the rawer side of bohemian life in Paris, most likely, judging from Anna's reaction, being sketches of sordid or lascivious acts. We will never know because she burned them. "[T]hey [may] have been Artistic but they disgusted me," she told him plainly. "[H]uman imagination need not such promptings to familiarity with the snares of the pervading evil of cities, to caricature the fallen is revolting to me." In a word, they were "indecent." On a gentler note, she added, "[I]f you laugh as you generally do at such sketches, let it be en passant, cultivate a *purer* taste dear Jemie & don't send to Willie any again." That would be Willie the nearly twenty-two-year-old medical student.[49]

Yet, she took a genuine interest in Jemie's work and appreciated the depth of his talent. She asked him to describe his course of study and assured him that friends thought his sketches of student life in the Latin Quarter "better than any novel." People who saw his paintings praised his progress. Anna reminded him, as she had done during his years at West Point, that many other people than herself

hoped for his success. Ann Maxwell offered to provide a note of introduction to the Italian artist Giuseppe Fagnani, then residing in Paris, who had, in fact, painted portraits of some Whistler relatives. Anna reminded him, too, of the importance of such potentially valuable contacts as Fagnani. Should he find the artist out when he called at his studio, Jemie must leave his calling card, "& *let me hear* of intercourse between you," she emphasized.[50]

Since part of Jemie's training was to copy masterpieces in the Louvre, Anna encouraged friends in America to commission works from him, which would also allow Jemie to call himself a "professional" artist. Ralph King responded by saying he would like a copy of Anne-Louis Girodet's 1808 *The Entombment of Atala*. It being one of his late wife's favorite paintings, he wished to remember her by it.[51]

It is interesting, then, that Anna asked Jemie *not* to complete one of his earliest commissions. Learning that a one-time resident of Stonington named Williams had paid him a hundred dollars to copy a picture in the Louvre, Anna protested that the man was an "upstart" who had been rude and "ungentle-manly" to her. As an employee of the Stonington Railroad, he had complied with Anna's request for a free pass on the line, only to remark publicly that this courtesy was generally extended only to "mendicants." Anna felt humiliated, and bristled at the thought of such a man claiming to be a patron of her husband's son. She told Jemie that she had silently forgiven his slight, but pointedly declared, "If you would not mortify your Mother have no more dealings with that man, who is beneath our notice." Friends and family would have recognized her response. "[W]ith those persons whom she considered her equals," observed a grand-nephew of Anna, "she was most gracious. [W]ith those whom she did not she was haughty and reserved." No one else ever called Anna "haughty," but a rather privileged life had made her keenly aware of class distinctions and her own social position.[52]

However, Anna's principal hope was that success in Europe would bring Jemie back to America, and she used every possible stratagem to lure him home. She reminded him of all the potential patrons among their wealthy friends, including the Winanses, Eastwicks, Harrisons, and Perines. He may have already missed an opportunity with the Perines. They had sat for their portraits two years earlier, David with the famous Thomas Sully, Mary with the only slightly lesser known John Beale Bordley. However, the Harrisons had a lovely picture gallery in their new home, and Joseph Harrison, keenly interested in promoting American art and artists, also happened to be on the board of directors for the Pennsylvania Academy of Fine Arts.

Thomas Winans had several times shown his willingness to help Jemie's career, and he had recently erected an artist's studio on the grounds of Alexandroffsky. It was currently occupied by another artist, Joseph Alexander Ames, who had painted a portrait of old Ross Winans and had begun one of Thomas and his wife. "Don't you wish you could sit at your easel in the Studio ... in the fairy garden" claimed by this usurper? Anna asked suggestively. And if such appeals to reason failed, she was prepared to play on Jemie's well-known weakness for the opposite sex. "If you could see how pretty your Cousin Ida is," she teased in the summer of 1858, "'her love to Jemie' might be indeed a pleasant message."[53]

A turning point came toward the end of 1858, both in Jemie's career and Anna's role in it. He succeeded that winter, with help from Seymour Haden, in marketing his first portfolio of etchings, to be known as the "French Set." Haden took responsibility for finding buyers in England; Anna became her son's self-styled "agent" in America. More than soliciting commissions from a few wealthy friends, she now asked people of more modest means to invest approximately ten dollars (two guineas per set in England) in Jemie's career. Surely, she thought, someone like John Maxwell, from St. Petersburg days, would want to help, and Ann Maxwell (no relation) had extensive connections in New York City and on Staten Island. "Jemie writes enthusiastically of his expectations too from the exhibition [of his work] in Paris," she told James Gamble by way of enlisting his help, "[b]ut ... to succeed he must obtain 50 subscribers."[54]

In the spring of 1860, Jemie told Anna he would return to America in the fall. At the same time, Dr. Darrach had been suggesting that an ocean voyage might help her shake off the vestiges of a lingering winter cold. With Debo also urging her to visit, Anna decided to spend the summer in London, where Jemie had recently been working, and escort him home. There was nothing at the moment to keep her in Philadelphia. Willie, who had received his medical degree in March after enduring seven grueling days of final examinations and completing his thesis on "The Pathology & Treatment of White Swelling," would be serving his residency at the Howard Hospital and Infirmary of Incurables, where James Darrach's father happened to be on staff. Her friend James Gamble had recovered from a nervous breakdown that had landed him in an asylum the previous summer. So, having found a new place for Mary McLaughlin and arranging for nephew Donald to stay with one of the Hill family, who had moved to Philadelphia from Scarsdale, she booked passage to Liverpool for May 9. Mary Brennan helped her pack; the Eastwicks volunteered to store her furniture.[55]

She did not anticipate knowing anyone aboard the steamer *Africa*, the same ship that had borne her homeward from England seven years earlier, but neither

did that worry her. "[I] have always made friends," she assured Debo. As it happened, the aunt of an old friend was also aboard, and she agreed to share Anna's stateroom. Beyond that, little is known of her activities over the next year. She planned, as usual, to spend a few days with Liverpool friends, but it was no longer possible to stay at the "once hospitable old home" in Preston. She had been estranged for mysterious reasons from John Winstanley since the death of Eliza. John had died two years later, and Alicia, who remained to board in Preston, "dread[ed] taxing her landlady" by having visitors. Astonishingly, the one place Anna is known to have visited outside of London was Russia. She went to see George, who was by then working in St. Petersburg on behalf of the Winanses.[56]

More importantly, she failed to leave England with Jemie in tow. Her artist son had met with sudden and exhilarating fame that summer when he exhibited his first painting, *At the Piano*, at the Royal Academy (fig. 33). Such renowned English artists as John E. Millais and George Frederic Watts praised it. He acquired his first English patron as a result, and new social and artistic circles were opened to him. The painting pleased Anna, too, since it portrayed Debo playing their old Russian piano for the pleasure of Annie. However, the acclaim persuaded Jemie to remain in London.[57]

Anna's disappointment was assuaged upon her returning to America by the marriage of Willie and Ida King in mid November 1860. Everyone was surprised. The cousins had been friends for several years but betrayed no signs of deeper feelings. Willie had even urged Anna to take Ida to England. Anna would have welcomed the girl, whom she described as "a rare combination of brightness & gentleness, so loving so confiding" and so very much like Debo in taste, but Ida's father pleaded that he could not spare her company. Then, that summer, Willie had suddenly presented his "vivacious" and *"extremely pretty"* twenty-one-year-old cousin with a diamond engagement ring, though how he could afford it is a mystery. They were married in the Kings' Brooklyn home less than five months after serving as bridesmaid and groomsman at the wedding of one of Ida's cousins. So, breathed Anna in relief, at least one of her boys was settled.[58]

7
The Manager
1860–67

BUT WHAT PROMISED TO BE a sunny and secure life for the glamorous newlyweds began under a forbidding cloud. The debate over slavery had reached a point of crisis when Abraham Lincoln was elected president of the United States on November 6, eight days before their wedding. Two days before the wedding, New York financial markets plummeted when word spread that South Carolina intended to secede from the Union. By February 1861, the Confederate States of America had been formed; in April, a divided nation went to war.

War also divided the Whistlers. Willie and Ida had gone south in May to visit some of Ida's family; by June, they were in Richmond, Virginia, the Confederate capital, with Ida having turned New England-born Willie into a "thorough secessionist." Anna thought him deluded, but she was herself torn emotionally by the "din of War." Family members from South Carolina, Georgia, and Florida, including six of Ida's cousins, had already enlisted in the Confederate army. In Baltimore, Ross Winans had been arrested for supporting the rebels, and Anna knew that her late brother William, once known for defending their native state of North Carolina "in all table chats and fire side arguments," might well have cast his lot with the South had he lived.[1]

Yet, Anna also knew which side Whistler would have served. As a Whig in politics, he might even have joined the Republican party, as had another Whig, Abraham Lincoln. All the Swifts were staunch Unionists, as were the Hills, Pophams, Cammanns, Gambles, Eastwicks, and Harrisons. Nephew Donald Fairfax was a Union naval officer. Even Jemie, so very proud of his Southern heritage, sent Anna a letter filled with "Patriotic" sentiments. "I am keeping it

to shew Willie," she told him. Nonetheless, as Anna watched her nation drift toward armed conflict from Stonington, she emphasized to all, "Truly, *I* know no North, *I* know no South."[2]

Willie promised to explain his circumstances in the fall, implying that he and Ida would return north by then, but Anna continued to fret. "I know he is acting conscientiously & can have no idea how much he makes me suffer," she confided to Jemie, but his conduct remained "incomprehensible." Her mental agony increased when, on July 21, the first battle of the war was fought at Manassas Junction, or Bull Run. With over 3,500 men killed or wounded in the Confederate victory, the conflict became far more real. Travel between North and South would be more difficult. Willie appeared to be trapped physically in Richmond and caught emotionally, as Anna appreciated, "between his yearning to be with me and his devotion to Ida." Willie suggested that Jemie return to America and care for their mother, but the artist was himself bedridden that summer after another rheumatic attack. His physician, insisting that he recover in a warm climate, sent him to the coast of France.[3]

The next twelve months seemed a time of ceaseless anxiety to Anna, brought on not only by Willie's plight, but also by Jemie's career. She wanted news of each new painting and exhibition. Knowing, as did he, that her son must exploit every possibility for marketing his work, she urged him to send prints of each etching, the better to entice customers. When someone told her that Charles Sumner, a U.S. senator from Massachusetts, and "really a judge of the fine arts," had been "perfectly charmed" by his recent etchings, Anna reminded Jemie that Sumner was just one of several "liberal men of means" eager "to promote the advancement of their countrymen." A list of all his etchings, numbered sequentially, would be helpful, too, she added. "I know you think this is of no importance, but it would make your works more satisfactory to purchasers," Anna explained.[4]

At the same time, Anna's eyesight worsened. It became so bad that one of her teenage nephews, Donnie Palmer, had to write her letters. She tried applications of belladonna to dilate the pupils, a treatment prescribed by Haden when she was in London. Dr. Darrach and Dr. Palmer, in consultation with an eye specialist in Stonington, had then used electrotherapy on her dormant right eye in hopes of stimulating blood flow in the temples. While that seemed to help, Anna decided a return that summer to the "mountain air & Sulphur baths" of Sharon Springs would not be amiss. Two nieces, Julia Catherine Rodewald (William McNeill's second child) and Annie Palmer, accompanied her, but a week of treatment did not materially improve her sight. Finally, on the suggestion of James Gamble's mother, she visited the water cure establishment of Dr. Edward E. Denniston,

in Northampton, Massachusetts. Denniston's preferred treatment required eye drops from "the wine of opium" with a salve of belladonna applied to the closed lids at bedtime. The faithful Mary Brennan, now married and living in New Haven, escorted Anna on an unknown number of trips between Stonington and Northampton in the autumn of 1861, with Anna feeling some improvement by spring.[5]

But she could not escape the war. Whether in Stonington, Sharon Springs, or Northampton, Anna stayed abreast of events through local newspapers and reports from relatives. In turn, she sent Debo and Jemie copies of the Massachusetts papers and had Jackson McNeill do the same from New York. She was deeply moved by the plight of Northern and Southern women who lost husbands, sons, and fathers in the fighting, and wondered at the resolve of those women who contributed to the war effort in whatever way possible, from nursing and charity work to the management of family farms and businesses. Grieved by the growing number of children orphaned by the war, Anna sent a modest financial donation to an "industrious home" devoted to their care in faraway Iowa.[6]

Then, what she feared most: Willie joined the Confederate army, though thankfully not as a soldier. Rather, in October 1862, he received an appointment as an assistant surgeon, something he had failed to do upon first arriving in Richmond. He had also failed in his bid for a clerkship in the War Department, a post that required written testimonials he was unable to provide. He claimed to be a loyal citizen of Maryland with many "warm friends" of the Confederate cause, including Ross and Thomas Winans. He identified himself as a son of Maj. George Washington Whistler and a nephew of Gen. William Gibbs McNeill, but nothing worked for the young man who had always taken pride in his Northern roots. It was a very different story from the one he had told his mother (fig. 34).[7]

Equally alarming, Ida had fallen ill, very likely with scarlet fever, which had infected parts of Richmond that winter. Willie asked his mother to come and nurse her. Feeling it her "sacred duty" to heed the call, Anna applied for a passport through the Confederate lines. Her chances of acquiring one seemed doubtful at first, but, perhaps by employing her husband's name, she was in Richmond by January 1863. She watched over Ida day and night, and felt her labors more than rewarded whenever Ida said, "Mother you cannot pet me too much! I have always been a pet!" Anna spoke of moving her out of the war-wracked capital to a less dangerous environment and warmer climate, possibly to stay with relatives in South Carolina or Georgia, but Ida remained too weak to travel, even by railroad. Instead, everyone did their best for the delicate girl. That

included Willie and Ida's landlady, fifty-year-old Elizabeth Gennet, her husband, and two daughters, who had taken in the young couple "out of pity."[8]

When Ida died in late March, her remains were sent to the Kings' home in Brooklyn, to be buried in Greenwood Cemetery, but Anna stayed on with Willie and the Gennets through the summer. She was herself ill by the spring, and Willie's health had been precarious all winter. His first two medical postings had been to hospitals within the city limits, first at General Hospital No.25, on Main Street between Pear and Peach, then at the infirmary of Libby Prison, which housed captured Union army officers. However, in July, after a month's furlough spent with Anna at Shocco Springs in North Carolina, he was assigned to the newly opened Jackson Hospital, two miles west of town. Even so, a sturdy horse allowed him to spend time with Anna each evening.[9]

Anna filled her days by walking Richmond's shady streets and calling on the many friends she soon made. Several of Jemie's West Point classmates and a few of her husband's former comrades-in-arms were in the city. The latter included Gen. John Henry Winder, the provost marshal of Richmond, and his wife Caroline. Winder, who virtually controlled the capital, including the issuance of passes, had been one class behind Whistler at West Point. Anna also became acquainted with Gen. Samuel Cooper, the highest-ranking officer in the Confederate army and, as adjutant and inspector general, the army's chief administrative officer. A woman named Margaret, or "Maggie," with whom she would correspond long after the war, lived on 7th Street, a few blocks west of the Gennet house. A block closer stood St. Paul's, the most important Episcopal church in Richmond and the place where Anna most likely worshiped. Possibly working through the church, she also did her best "to cheer the distressed." She became especially attached to one crippled woman, to whom she took gifts of fresh fruit.[10]

Most important were the Gennets. With every boarding house and hotel in the city full to bursting by 1863, they, like many residents, discovered that a few dollars could be made by renting out spare rooms. Fortunately, as shown by their concern for Willie and Ida, the Gennets were more benevolent than avaricious. Anna wanted for nothing during her time at their home on Mayo Street, a short thoroughfare between Franklin and Broad, two blocks east of Capitol Square (fig. 35). She found Charles Gennet, a New York-born watchmaker and jeweler, to be a "generous provider," and Elizabeth was "the very nicest house keeper" she had ever met, with "the best cooking & the neatest house!" Anna's biggest joy after an active day of calling and charitable work was to return to their home for a bath before dinner "& then a nap."[11]

Yet, Richmond was far from an oasis of calm. Besides scarlet fever, a smallpox epidemic had struck parts of town that winter, mostly the poorer quarters, and everyone felt the pinch of soaring prices. The week that Ida died, a pound of butter cost three dollars and fifty cents, compared to seventy-five cents in 1860. A bushel of corn meal went for seventeen dollars, compared to a dollar before the war. A pound of candles, necessary to light most homes, leaped from fifteen cents before the war to four dollars. The result, within days of Ida's passing, was rioting in the streets, as hundreds (some said thousands) of men, women, and children sacked nearly two dozen shops before being dispersed by armed troops. After first assembling at Capital Square, the mob had surged southward into the principal thoroughfares of Main and Cary Streets, where most of the violence occurred. Far from limiting their thefts to food, many rioters snatched anything they could carry away, including clothing, shoes, brooms, glassware, and jewelry, although Gennet's shop on Main Street apparently escaped theft or damage. Regardless, the riots were the most serious civil disturbance Richmonders witnessed during the war.[12]

As for external threats, the city, encased in miles of entrenchments and fortifications, remained relatively secure that summer. Gen. Robert E. Lee, Jemie's former superintendent at West Point, had beaten back the most serious threat to Richmond a year earlier by defeating a Union army of over 100,000. The gravest danger during Anna's residence came in early May, when several thousand Union cavalry struck within a few miles of the city. Alarm bells sounded as many wealthy residents packed trunks and hid valuables in anticipation of evacuation. The crisis passed, but some of the war's most momentous battles took place across the country that spring and summer, including Chancellorsville, Gettysburg, and Vicksburg. Richmond itself witnessed one of the war's most poignant scenes with the funeral of Gen. Thomas J. "Stonewall" Jackson, who had been mortally wounded at Chancellorsville. Shops closed and people lined the streets to view the mournful, mile-long procession.[13]

Living amidst such events, hearing constantly of Yankee atrocities, witnessing the resilient spirit of Richmonders, and having her own son in Confederate uniform changed Anna's sympathies. So, too, a shift in the purpose of the war. Having begun as an effort by the United States to quash rebellion and repair the splintered nation, it had also become by January 1863 a war to abolish slavery. As Confederates in Richmond began referring in scornful tones to the Union army as the "Abolition Army," Anna, given her views on that subject and the heavy investment her Southern relations had in slaves, could not help but think the conflict now unwarranted. Jemie changed his opinions for the same reasons, as both he and Willie had inherited Anna's opinions on race.[14]

Anna and Elizabeth Gennet, who had been born in Virginia, talked in August of momentarily escaping the city for the healing waters of White Sulphur Springs, a popular spa. Finally deciding that too many Union soldiers stood between them and their destination, they next considered traveling to see the Natural Bridge, a 215-foot-tall limestone arch that spanned a 90-foot gorge near Lexington, Virginia. A tourist attraction since the eighteenth century, it was accessible by rail some 100 miles to the west. Whether or not they made the journey is unknown, but Anna left Richmond for Stonington sometime that autumn, perhaps as late as mid October. With Ida dead, she doubtless begged Willie to go with her, but either his Hippocratic oath or his loyalty to Ida's memory made him stay. Given her friendship with the Winders, Anna probably found it easier to leave Richmond than to enter the city. If her friendship with Caroline Winder was not enough to gain a passport, the general was notoriously vain and easily flattered by women.[15]

Seeing Willie committed to a seemingly endless war, Anna decided to sit out the conflict in London with Jemie, Debo, and the grandchildren. She could have remained comfortably with Kate's family in Stonington, even now that her sympathies had turned distinctly Southern. As it happened, Dr. Palmer, as shown by his response to Harriet Beecher Stowe, condemned abolitionism and sympathized with the Confederate cause. He was also a Democrat and an Episcopalian, and both identities, as one of his grandsons would recall, were equally "*dreadful sins* in N.E. [New England] in those days."[16]

Some question remains as to exactly how Anna reached England. The story told by previous biographers is that, after returning to Richmond to nurse an ailing Willie, she ran the Union naval blockade to Bermuda, from where she travelled to Liverpool by way of Halifax and Boston. However, the evidence for this bold venture is thin. She did pass through Bermuda, for she mentions, in one of her few references to the journey, sending Willie a "box" from there. However, Anna most likely reached the island from New York, which was trading regularly with Bermuda by the summer of 1863. This scenario is suggested by Kate Palmer, who said of the trip, Anna "*took a very heavy cold on her way across the [Long Island] sound going from Stonington* [Palmer's emphasis] which lasted her over the Atlantic and made her somewhat of an invalid for the first four weeks after her arrival in London."[17]

If not washed ashore in an alien land, like some aged and bedraggled Viola, Anna experienced something similar upon reaching Southampton in December 1863 amidst a raging storm. Jemie rushed to fetch his mother, though with only a week's notice of her coming, and immediately summoned a doctor. It would be

several days before Anna felt strong enough to see Debo and family, who lived nearly two miles east of Jemie, but that was just as well, for she had escaped one war only to land in the middle of another, if less bloody, one.[18]

Jemie had been feuding – very nearly fighting – with his brother-in-law, Seymour Haden (fig. 37). A woman was the immediate cause, but a rupture with his mentor and friend had been brewing for more than a year. Haden had long enjoyed etching as a recreation, but, inspired by Jemie's own success, he had recently pursued it with such energy as to have some of his work exhibited at the Royal Academy. A perplexed Jemie, who had labored long and hard to achieve recognition, silently resented the subsequent praise heaped upon this "amateur."

Then came an absolute insult when Haden refused to honor a dinner invitation from Jemie if the artist's mistress-model, Joanna Hiffernan, were to be present. His "scruples," Haden declared, would not allow it. Jemie was enraged. Knowing that Haden disapproved of his living arrangements with Jo, he had never taken her to Sloane Street, but Haden had dined previously with them, gone about town with the couple, and, from all appearances, had treated the Irish-Catholic girl as an equal. Consequently, Jemie stormed into Haden's house to denounce his brother-in-law's hypocrisy and mock his new-found "virtue." Too stunned to reply, a furious Haden threw him out and forbid Debo to visit her brother's home.[19]

Anna's presence reduced the tension. No one wanted to drag her into the mess, and as Jemie said, "[A] family quarrel is always in bad taste." Something like a truce was observed for her sake. Excuses were made for why Debo could not go to Jemie's home, while Haden grudgingly welcomed Anna to his own. Some awkwardness must have remained, with all the players guarding their language and wearing occasionally false smiles, but if Anna sensed anything amiss, she said naught.

But Jo remained a problem for Jemie. The couple clearly could not continue living together, as they had done for nearly three years. Jemie dared not even allow a bohemian artist friend from Paris who had been staying with him, Alphonse Legros, to remain on the premises. "Well!" he exclaimed to another artist friend who understood his plight, "general upheaval!! I had a week or so to empty my house and purify it from cellar to attic! Find a 'buen retiro' for Jo – A place for Alphonse – go to Portsmouth to meet my Mother! Well you see the goings-on! some goings-on! goings-on up to the neck!"[20]

Nonetheless, mother and son, after eight years apart, settled in comfortably together. Anna adored Jemie's "Artistic abode" and Chelsea neighborhood. The house at 7 Lindsey Row (now 101 Cheyne Walk) overlooked the Thames, much

as their old home in St. Petersburg had fronted the Neva, separated from the river only by a broad road and crumbling sea wall. Once part of the eighteenth-century residence of the Earl of Lindsey, the old mansion had been divided into four-storied townhouses with large, walled back gardens (fig. 38). J. M. W. Turner had briefly lived in a house farther up the road, and a colorful array of poets, writers, and painters had populated the district over the years. As one of its most distinguished residents, Thomas Carlyle, described the place, "Chelsea is a singular heterogeneous kind of spot, very dirty and confused in some places, quite beautiful in others, abounding with antiquities and the traces of great men" (fig. 39).[21]

The decor of Jemie's commodious house, if not what she would have chosen, enchanted Anna. Having become fascinated by Oriental art, Jemie had decorated the place with Japanese prints, screens, fans, dolls, and kakemonos. Persian, Japanese, and Chinese rugs covered the floors of the main rooms. "Are you an admirer of old China?" Anna asked James Gamble in describing Jemie's collection of blue-and-white porcelain. "[H]e considers the paintings upon them the finest specimens of Art . . . some of the pieces more than two centuries old."[22]

She spent most days writing letters or reading while Jemie worked in his studio, a sanctum she hesitated to invade. Weather permitting, she enjoyed his garden, where she fed breadcrumbs to the birds until Jemie's cat, despite being belled, made a "naughty game" of pouncing on them. After dinner, generally taken at 6:30 p.m., Jemie read aloud from *The Times*, to which he subscribed for Anna's sake. Having received reports of how easily Anna had adapted to life with Jemie, Kate Palmer assured Meg Hill, "Altogether my dear sister seems happier and more comfortable than she has been for years."

On Sundays, he escorted her to divine services, initially at Christ Church, in Caversham Street, but finally at the much closer and cozier Chelsea Old Church, in Lindsey Row. Known originally as All Saints and often, by Anna's time, as St. Luke's, a church had stood on the site since at least the thirteenth century. Sir Thomas More had worshiped there when he and other members of the Tudor court made Chelsea their home. Anna was seduced by its "Evangelical spirit" and found much comfort in the sermons of the forty-two-year-old rector, Robert Henry Davies. Inevitably, Davies and his wife began inviting Anna to their home for tea. Jemie eventually stopped attending services, but he continued to meet Anna after church and send her by cab to enjoy the remainder of the day with Debo and the grandchildren.[23]

However, it was not long before Anna, gradually, naturally, almost impercep-tibly, took charge of Jemie's household. "While his genius soars upon the wings

of ambition," Anna explained to James Gamble, she managed "the every day realities" by directing the servants, keeping household accounts, and receiving visitors. Seeking to buffer him from unwanted distractions and interruptions, she either made herself agreeable to callers until her artist could attend them or explained why Jemie was out and when he would return. "God answered my prayers for his welfare," she told Gamble, "by leading me here. [T]he dear fellow studies as far as he can my comfort, as I do all his interests *practically*." She encouraged him to guard his health by spending more evenings "tete à tete" with her, rather than going out so often on the town. "I do not interfere with hospitality in a rational way," she insisted to Gamble, "but do all I can to render his home as his fathers was."[24]

The one discordant note for Anna was to learn that her remaining older sister, Alicia McNeill, had died in September. It happened during Alicia's annual trip to Scotland. Having suddenly fainted on her way to church, she died later the same day, to be buried in Linlithgow. Anna received a legacy of £250 from her, but that scarcely stifled grief. Of more comfort was the fact that Alicia had passed on a Sunday, and on her way to worship God.[25]

A constantly expanding circle of friends compensated for the loss. A "beloved" niece, Mary Isabella Rodewald, William McNeill's eldest daughter, welcomed Anna to her family's "charming house" in Wimbledon. It also happened that another of Mary's aunts, Catherine Julia Cammann, was spending the year there. Anna welcomed the companionship of this old friend most of all. Of similar age and habits, the two women reminisced, visited Greenwich Hospital, and attended concerts of sacred music. Anna found one concert, with an enormous children's choir singing the "Hallelujah Chorus" from Handel's *Messiah* at St. Paul's, "almost overpowering."[26]

She also became attached to several of Jemie's friends, and they to her. Among the first she welcomed as his "mistress of ceremonies" were Dante Gabriel Rossetti, his brother William Michael Rossetti, Algernon Swinburne, and others of the old Pre-Raphaelite circle that shuffled back and forth between Lindsey Row and Gabriel's home in Cheyne Walk. They had been some of the first London artists to welcome her son, and she could tell from their enthusiastic conversations how much they admired his work. She also saw them on their best behavior, with none of the smoking, drinking, and ribald language that marked raucous gatherings at Rossetti's bachelor digs. She became particularly fond of the kinetic little Swinburne, though she had clearly not read his scandalous poetry. William Rossetti, the most mature of the lot, thought Anna "a sweet elegant lady."[27]

She became similarly entwined with Jemie's wealthy merchant friends and patrons. Alexander Constantine Ionides, the first Londoner to invest in Jemie's paintings, and whose youngest son, Luke, had been a student with Jemie in Paris, welcomed Anna to his family's home. Luke laughed at the way Anna would sometimes "scold and reprove" Jemie, but he, like Rossetti and virtually everyone else, thought her "a most delightful old lady." He also observed that while "very pious," Anna could be "very tactful."[28]

Anna also endeared herself to a pair of sisters related to the Ionides, Christine and Marie Spartali, who served as models for Jemie. When Christine, accompanied by Marie, came to pose for one of his new paintings, *La Princesse du pays de la porcelaine*, Anna doted on the girls and served them exotic "American" luncheons of roast pheasant, tomato salads, and canned apricots with cream.[29]

In all this, Anna hoped to further Jemie's career. She now understood what had brought him to London and why he remained. She admired his focus and patience as a painter, his uncompromising pursuit of perfection. Within a few weeks of her arrival, he had worked on at least half a dozen paintings, including several, such as the portrait of Spartali, that borrowed Asian themes and explored Asian traditions of painting. Her favorite was a picture Jemie called *Wapping*. It featured a woman (Jo) and two sailors sitting on the balcony of a riverside inn, but Anna was most captivated by the vitality of river life her son had put on canvas. "The Thames & so much of its life, shipping, buildings, steamers, coal heavers, passengers going ashore, all so true to the peculiar tone of London & its river scenes," she told James Gamble.[30]

And so, just as naturally as she assumed command of his household, Anna resumed her unofficial role in managing Jemie's career. She did not negotiate with galleries, curry favor with critics, or seek contracts the way professional agents would have done, but by soliciting commissions, endearing herself to people, and seeking new patrons among friends in England and America, Anna operated visibly within her son's world. Her combination of piety, daintiness, dignity, quietude, and warmth rarely failed to charm, and it was a role she had filled in one way or another for most of her life as wife and mother.

In the way of sales, she found instant success with James Gamble, who had always taken a friendly interest in Jemie's career. Sensing Anna's excitement when her son won a gold medal for his etchings at an exhibition in Holland, and impressed by the positive response to *Wapping* and one of his Asian paintings, *The Lange Lijzen of the Six Marks*, when exhibited that summer at London's Royal Academy, Gamble offered to buy any one of Jemie's smaller paintings and requested prints of at least two etchings.[31]

Yet, as happy and useful as Anna felt herself to be in London, she could not forget the ongoing distress of her native land. As complete as her sympathy for the Confederacy now seemed to be, Anna would have welcomed an end to the fighting under any circumstances, and she blamed both sides for the carnage. "My daily prayer is that God will bring North & South to repentance," she told James Gamble, "for it is His rod of indignation [that] has taken away the pride of Union."[32]

She had at least learned something of Willie. He had fallen ill shortly after she left Richmond, to be nursed by some of Ida's family. He was well, but Anna, knowing her son to neglect his own comfort and wellbeing while tending to others, resolved to send clothing and articles she thought he might need. The haul included a pair of cavalry boots, three pairs of drawers, six pairs of socks, a dozen pocket handkerchiefs, four towels, writing ink, a pair each of cavalry gauntlets and leather gloves (these last two gifts courtesy of Jemie), and, looking ahead to the end of the war, a "full suit of citizen clothes" and shoes. It was enough to fill two boxes.[33]

Anna did the same for other dear ones besieged in the South, dispatching clothing and such scarce and exorbitantly expensive items in the Confederacy as coffee, tea, and sugar. Everything, as in Willie's case, went first to Wilmington, and from there to her friend Maggie in Richmond, whom Anna trusted to distribute or forward the precious parcels. As usual, she had reliable contacts all along the route, for Anna always seemed to know the right people. Whenever possible, she entrusted her cargo to a ship's captain. She also had a South Carolina cousin, Dr. Peter Porcher, who was connected by marriage to the shipping firm of Fraser, Trenholm and Company, the most successful blockade runners in the South. Although based in Charleston, and running primarily between that city and Nassau, they had branch offices in New York and Liverpool.[34]

Unfortunately, it seems likely that much of her hard work went for naught. The first box to Willie went aboard the *Rattlesnake*, a British steamer, but by the time the ship reached Bermuda, in anticipation of running the blockade to Wilmington, the Confederate garrison in Fort Fisher, which guarded the main entrance to the Cape Fear River, had surrendered to the Federals. Anna entrusted Willie's second package to Captain George M. Horner, a native-born Englishman who had resided in Charleston for many years. Having enjoyed earlier success in eluding the Union blockade, Horner may have gotten through, but Willie never acknowledged the gifts.[35]

Naturally, Anna was also concerned about the fate of Charlie's family in Florida, and in fact, the war had put them in peril. Charlie supported the

Confederacy at the start of the war, but by early 1862, the Federals had captured Jacksonville, eight miles south of Charlie's farm. Charlie took the Union loyalty oath, though it did him little good. Over the course of the next two years, Jacksonville changed hands three more times, until it was virtually in ruins, and the armies of both sides raided the surrounding countryside. "[T]he churches were immediately burnt by the federal troops," Anna related to Gamble, "its shade trees cut down & its homes seized by the soldiery." Charlie's house was simply destroyed, his family reduced to living in abandoned slave quarters for much of the war.

By 1864, the McNeills's second eldest son, Charles, with Donald still in the North, had taken a job with the Federals in Jacksonville, perhaps in hopes of shielding his family from further hardships. According to a family story, his mother had protected him earlier in the war when, with the boy sick in bed with fever, a Union officer attempted to drag him away. Seizing a hand whip, Elizabeth slashed the man across his face with all her might, "bringing blood, and leaving a terrible scar." How that episode may have added to the family's woes is unknown.[36]

At least Willie was soon out of the war. He had continued to work in Richmond's military hospitals until ordered to duty in the field during the spring and summer of 1864 with Orr's Rifle Regiment, from South Carolina. He happened to have cousins in the regiment, but all the men, who called Willie their "plucky little surgeon," praised his skill and courage under fire. Still, his own health suffered so much that he had to be given several medical furloughs, and once the Confederate army, led by Robert E. Lee, was forced back within the defenses of Richmond, Willie was hospitalized with a lichen-related skin disease.[37]

In February 1865, General Lee approved a four-month furlough for Willie to visit his family in England. The one condition was that he carry dispatches to Confederate secret service agents in the country, which, as Willie later put it in his typically laconic way, made "getting through the lines a somewhat more anxious undertaking." Indeed, whatever his mother's trials in traveling to England, Willie's escape from the Confederacy could challenge the most improbable fiction.

With the port of Wilmington effectively closed, he thought to run the blockade from Charleston, but he got no farther than Columbia, South Carolina, before encountering a Union army headed his way. Beating a "very hasty retreat," he stowed away on a train returning to Richmond. He might have frozen to death in the bitter cold and snow had he not encountered a friend with

the authority to put him in one of the passenger cars. Safely back in the capital, Willie decided to risk leaving from a northern port, although that required donning civilian garb and, if identified and captured, being executed as a spy. Using money provided for his mission by the government, he paid $14 for a suit of clothes (clearly not having received *that* parcel from Anna) and another $500 for a wagon ride through enemy lines into Maryland.

So began a string of adventures that found Willie traveling northward on foot, on horseback, by canoe, and by railroad. Aided at crucial moments by friends of the South as he weaved his way through towns and a countryside thick with Union patrols, he passed through Maryland to Delaware, from there to Philadelphia, and finally to New York. It was April before he finally sailed under an assumed name for Liverpool. Little more than a week later, having arrived in England and completed his mission as courier, he and all Europe learned that America's war was over. Willie summed up the whole ordeal by concluding, "I must have been born under a lucky star."[38]

One may imagine the joyous reunion. The brothers, who had not seen each other in nearly a decade, became inseparable; Anna finally had both boys in one place. Her life-long pilgrimage in search of some undefined destination had apparently ended. Even George and his family were in England for a few months, staying in Hastings with Tom and Celeste Winans (fig. 40).

At the same time, Anna's health had begun to suffer from London's smoke-laden air. This and the weather had been her only complaints since arriving in England. "[The cold] is so penetrating," she reported to James Gamble that first winter, "& the fogs are so gloomy." Resorting to the palliative she had adopted in the United States, Anna spent three months during the summer of 1864 at a spa in Germany (fig. 41). The German baths helped, but soon after returning home, she succumbed to influenza, which raged through parts of London that winter. She again fled the city, this time for Torquay, a popular resort town on the southwest coast of England. Praised some years earlier by A. B. Granville in his popular guide to the spas of England for its "fine and handsome buildings," Torquay was considered especially beneficial to people with a "delicate chest."[39]

The summer of 1865 found her in Great Malvern and Malvern Wells, near Worcester, where such luminaries as Charles Darwin, Charles Dickens, Alfred Tennyson, and Thomas Carlyle had sought relief from "nervous" disorders. Anna would have enjoyed not only the famous baths and "pure and invigorating water," but also the benefits of walking among the region's tranquil vales and soaring hills.[40]

She made plans to return to Germany in October, with Willie and George as escort, the mission this time being to restore her fading eyesight as much as to visit the springs. She was to be treated in Koblenz by a noted ophthalmologist named Meurens. Eschewing electroshock and the blue stone, Dr. Meurens, whose reputation was known to Willie, preferred applications of mineral lotions and salves. They seemed to work, for Anna's vision improved markedly in a very brief time. "It shews how necessary to be under the observations of an Occulist to alter prescriptions as my eyes vary in their state, affected by every emotion, or the tones of my general health," she explained to Debo. It also helped to have Willie, with whom she took long walks, as of old. George soon returned to England, it being necessary for him to resume his post in Russia, but he promised to share an expected shipment of "American oysters" before leaving Hastings.[41]

Yet, as good as life now seemed, Anna still fretted over her two youngest sons. Despite his recent professional success, Jemie had been out of sorts. Outwardly as carefree and brash as ever, he was insecure, doubted the quality of his work, and lacked a sense of purpose. Anna encouraged him from afar by insisting that his most recent paintings, two of them commissioned, were quite lovely. He should be more concerned about Willie, she told him, who was struggling to adapt to civilian life. She had taken him to Germany as much to rescue him from idleness as for his companionship. "[I]f I did not know his artistry I'd let him sleep on," she reasoned; "but he is gifted in talent as you are, so you must not entice him to indulge in your luxurious studio, he ought to read & to visit hospitals."[42]

The brothers found a solution to both of their dilemmas, although it was not exactly what Anna had in mind. With his mother still to undergo several more weeks of treatment for her eyes, Willie returned to London in January 1866. However, no sooner had he arrived than he and Jemie were drawn into a dubious money-making scheme with some ex-Confederates in England, their leader being a wartime acquaintance of Willie. The plan was to deliver naval weaponry – torpedoes and torpedo boats – for a handsome commission to the nation of Chile, which was at war with Spain. Jemie and Willie decided that it fitted all their needs: a change of scene, a chance for adventure, and an opportunity for riches.[43]

While not exactly pleased with the project, Anna did think it might do her sons good. She even accepted the fact that Jemie's extended absence meant he would not be renewing the lease on their house, and that all the furnishings would have to be sold, stored, or given away. A veteran packer and mover, she told him exactly what to do. The lovely Turkish and Persian rugs must be beaten and rolled before they could be stored, she instructed from Germany. Perhaps

Rossetti would be so kind as to hold some of the furniture. The rest could stay with Debo.

Anything "too defaced" for Jemie's next home might go to one of their two servants, she suggested, and Jemie *must* find new places for them, not simply discharge them. Anna was especially concerned about young Sarah Harris, the housemaid. Make sure she receives her monthly wage of one pound and ten shillings, Anna reminded her son, and perhaps her mother's home could be made more comfortable by one of Jemie's plain woolen druggets. Anna's old friend Mary Gellibrand, now settled permanently on the family's country estate, Albyns, in Essex, had been seeking a new cook. Jemie should write to her and ask if she might not take their cook and Sarah. And Sarah probably knew some-one willing to purchase Jemie's wine cellar at a "high price." If so, she should be allowed to keep any profit. "I know she has debts," Anna revealed, "besides her child to support & her mother to help."[44]

Then there was Jo. Even after two years in Jemie's household, Anna was apparently unaware of the intimate bond between her son and his favorite "model." That may seem odd, for Anna was generally quite perceptive. It could be argued that her many trips out of London had blinded her to their relationship. Neither Haden nor Debo, out of delicacy, would have raised the issue. Naturally, too, Jemie would have been discreet. He had found a place for Jo to live in Walham Grove, Fulham, more than a mile west of Lindsey Row, so Anna would have encountered her only in his studio. And she did like Jo, even if she shared the common assumption that artists' models were a species of fallen woman, or at least women who had fallen on hard times. She urged Jemie to leave Jo with a hundred pounds, the same handsome sum bequeathed him by his Aunt Alicia. "You promised me to promote a return to virtue in her," Anna reminded him. "I never forget to pray for her." In fact, Jemie did far more. Deeming it prudent to write a will before leaving England, he made Jo his sole beneficiary, assigned his power of attorney to her, and entrusted her with his bank account.[45]

And as things turned out, only Jemie made the journey. U.S. authorities barred Willie from leaving England because he refused to swear allegiance to his newly restored nation. He seethed for another five months before capitulating in order to visit George in Russia. It is unclear where Anna lived when she returned to London in March. She spoke of taking lodgings near Debo, rather than imposing on her daughter. "[Y]ou have all the boys now I know," she explained, "& it is better for old ladies to be quiet & do as they are accustomed to." Instead, she stayed with a series of friends until Jemie returned that autumn. Anna

thought him much improved in health, and even though the arms deal with the Chileans had ended in abject failure, he was flush enough to lease another house in Lindsey Row, this one at No.2 (now 96 Cheyne Walk), where Anna resumed living with him (fig. 43).[46]

She judged the new house a "great improvement" over No.7, but with Jemie safely back, Anna decided it would be a good time for her to visit America. In June 1867, she asked Jemie's solicitor, James Anderson Rose, to make "a sort of temporary Will" for her. Just a few lines, she said, "in case of my not living to make one properly." She left all her possessions to Jemie and Willie, to "share & share alike," a provision that remained unchanged when she made a final will four years later. She had no premonition of disaster. Indeed, Anna felt healthier than in ten years past. She had every intention of traveling alone when boarding the *Java*, a modern, single-screw vessel, in Liverpool, but fortune again blessed her. One of the Prince boys, still employed by Ropes and Company, was also making the voyage. "[T]hus hands are ever extended to help me according to the promises of Scripture," she reasoned.[47]

Anna described the trip as a "holiday," but she had three specific missions upon landing in Boston on July 21: to visit as many people as possible, learn the condition of her Southern family, and conduct necessary legal and financial business in Philadelphia and Baltimore. The business likely involved having dividends from her remaining railroad stocks, her only independent source of income, sent to London. She had hoped to travel as far south as Richmond, but with her business completed, Anna spent the rest of her four months shuttling between Stonington, Scarsdale, Brooklyn, Staten Island, and New York City. Even then, she failed to see everyone. In Baltimore, she had spent only a brief time with her grandson Georgie, who lived there with an aunt after his father remarried, and the Perines. Sadly, the war years had taken a toll on that family, with Mary and two of her sons, including one of Anna's godsons, having died. "[D]istances are so great," Anna reflected, "& my relatives are far between."[48]

In Stonington, she was reunited not only with the Palmers, but also with her nephew Donald McNeill, who was visiting the family. Now twenty-three, he worked as an engineer for the Pacific Steam Navigation Company, based in New York, a post he had first accepted shortly after the start of the war. He returned home to Florida when the fighting ended to help his father repair the damage done to their farm. Together, they planted orange trees and grape vines, and moved the family from the abandoned slave quarters to a new home at Reddy Point. When Donald returned to New York, he took younger brother Charlie with him, and now he, too, being a true McNeill, worked as an engineer.[49]

Anna unexpectedly, and unhappily, learned the fate of other southern relations while visiting an elderly South Carolina cousin, Anna Johnstone, who had fled to New York after the war. Most heart-rending was the plight of Philip and Louise Porcher, whose plantation Anna had visited in 1858. The women of the family, including Anna Johnstone, had lived as refugees for much of the war, although, even then, they had supported the Confederate cause by knitting socks for the soldiers and visiting army hospitals. They tried to return to their Charleston house in the summer of 1864, but a Union naval bombardment of the city made that too dangerous. In November, they returned to their plantation, which had been left in the care of an overseer and slaves. That was shortly before Willie tried to reach Charleston, and just three months before the Union army passed through the plantation gates.

"I will not forget their brutal appearance," one of Louise Porcher's daughters related to a friend. "They came up brandishing their guns with an air of wildness hard to describe, and in a short time were scattered over the plantation, committing every conceivable havoc." The soldiers scattered or slaughtered all the livestock, including cattle, hogs, and sheep, and pillaged the house. "[T]hey ransacked our wardrobe and bureau drawers," reported the girl, a witness to the same scenes as Anna's cousin, "throwing our things out all over the floor, and when they came downstairs took all the cold meats out of the larder." Luckily, when the women retreated once more to Charleston, they encountered a Union officer known to them through a family in New York. It was likely he who arranged passage north for Anna Johnstone.[50]

Family members who remained in South Carolina felt nothing but "humiliation." Surrounded by freed slaves and Union soldiers, the Porchers believed this was "the last phase of man's total degradation, & obliteration of that 'Likeness' in which he was originally made." They relied, as Anna would have done, on religious faith to sustain themselves. Unable to resuscitate their plantation, and with Philip's brokerage business destroyed, Louise turned the Charleston home into a boarding house. Her husband, always a hard drinker, became a drunkard. They detested the social mingling of ex-slaves and Union soldiers, a contempt that only deepened when dire necessity led one of the daughters to accept a pair of shoes and calico dress from a Northern benevolent society.[51]

When Anna left America in late October, she knew she would not be back soon. If nothing else, time and health were against her. She was reminded of this shortly before departing when Ann Maxwell, one of the people she had failed to visit, died in Nyack, aged eighty-three. Almost symbolically, then, Anna's return voyage was made not on the modern *Java* but an old paddle-wheeler. Launched

in 1856, the *Persia* had been the first iron-hulled paddler, and, with accommodations for 200 first-class and 50 second-class passengers, a marvel of speed and luxury. But the once proud ship was to be retired from service the following year, her day having passed (fig. 44). One wonders if Anna, as she braved the Atlantic for the eleventh time in her life, experienced a similar sense of finality, as though leaving behind not just a continent but an era.[52]

8
The Mother
1867–72

WHATEVER HER REVERIE, ANNA WAS rudely awakened in London by a revival of the war between Jemie and Haden. The trouble resumed when Haden maligned his former medical partner James Traer, who had been a good friend to Jemie and Anna. Jemie denounced his brother-in-law publicly as a scoundrel and hypocrite. A chance encounter in Paris then ended in violence, with Jemie shoving his nemesis through a café window. Anna must have been aware of the general circumstances, though no one wished to upset her with the details. "I suppose poor Mother knows every thing but the cowardly attack in the café," Debo told Willie, whom she blamed equally with Jemie for abusing her husband, "and it will certainly not conduce to her happiness any more than to mine."[1]

Still, the tumult might have faded had not Haden, soon after Anna's return, engineered Jemie's expulsion from a gentleman's club to which they belonged. More bitter words were exchanged. Mutual friends were dragged into the row, and family members had to take sides. Haden barred all the Whistlers, including Anna, from entering 62 Sloane Street. Anna, contrary to early comments about Haden's character, now insisted that Major Whistler had never liked their son-in-law, and that she herself had come to distrust him. "I forgive him," she said of Haden's "persecution" of Jemie, "as I do . . . all who have ever injured me or mine." However, she severed contact with all members of Haden's family, save "dear Debo."[2]

The wounds healed relatively quickly among the Whistlers. Anna and Debo began to meet clandestinely at the homes of mutual friends, and Debo eventually reconciled with Jemie and Willie, though mainly through correspondence.

Their physical meetings appear to have been few, perhaps because the "quiet and subdued" Debo feared the wrath of her husband, who was known for his violent temper. It was obvious from the way Debo timidly spoke of her brother to visitors, recalled one person, that Jemie was "not [to] be mentioned in the Haden household." Certainly Jemie and Haden remained enemies, and their quarrel long festered as a source of ill will for the Haden family.[3]

Thankfully, Anna was occasionally distracted during this crisis by a series of American friends who visited London during the summer and fall of 1868. First, Mary Glenn Perine, the third eldest of the Perine children at forty-six, returned Anna's recent visit to her family in Baltimore. Mary had always admired Jemie's etchings, even stopping to visit him in London nine years earlier. This time, she was fascinated by the artistic decor of 2 Lindsey Row, done up, as she thought, like a Chinese pagoda, and the way Jemie wore a silk Chinese shirt while working in the studio. She seemed amused, too, at Anna's response to her son's use of a scantily clad (perhaps even nude) model. "It was a long time before she could reconcile herself to this," Perine reported, "but it seems to be one of the necessities of art."[4]

Anna also welcomed James Gamble and his new wife, Harriet, following their honeymoon in Ireland. Having helped bring the couple together eleven years earlier on a visit to Harriet Cruger's country estate, Anna was also relieved to see them so well matched. Gamble, meantime, had acquired a "monomania" for Jemie's art. Disappointed to find no paintings he could afford, he settled at Anna's urging for a set of etchings, seemingly from what would become the first "Thames Set." Yet, having won a sale, Anna suddenly feared she had unduly pressured her benevolent friend. The value of Jemie's etchings had risen sharply in a very few years, and she knew that Gamble had "many worthy & interesting" causes that merited financial support. For the sake of both her friend and her son, she convinced Jemie to charge only what Gamble would have paid for the earlier "French Set," which reduced the payment by half.[5]

Nonetheless, the sale did serve to boost Jemie's confidence. Besides the disruption to his work caused by the war with Haden, he had been experiencing another of the bouts of self-doubt that periodically marked his career. Nothing he painted satisfied him. Having sold little and exhibited not at all since returning from Chile, he borrowed money from brother George and Tom Winans to stay afloat. "[D]ear Jemie is practicing the greatest self sacrifice," Anna fretted to Meg Hill in December 1868, "if he may but finish such large & more difficult paintings to satisfy his own difficult standard of Art. . . . so his reputation seems hanging on the work of the next three months."[6]

Consequently, she saw little of him that winter. For the sake of better light, he virtually lived at a friend's studio across from the British Museum, several miles to the east. He returned home a couple of evenings each week, but then frequently went out "for air, exercise & to visit friends." He was often ill that winter, too, including a nasty case of neuralgia, through which Anna nursed him. "I do not complain," Anna told James Gamble in explaining the circumstances, "for he is a most tender & dutiful son and we hope he will have more leisure, when his large paintings are advanced further." Jemie continued to marvel at his mother's "kind indulgence and patient forgiveness and loving cheerfulness."[7]

On a more positive note, restless and war-scared Willie had at last settled down to practice medicine. Anna was disappointed that he selected a flat at 14 Old Burlington Street, Piccadilly, some three miles to the east, to serve as both residence and consulting rooms, but that made his visits to Lindsey Row all the more special. She especially enjoyed his Sunday calls, when, now unable to share that day with Debo and her grandchildren, Willie attended church with her.[8]

However, two serious obstacles threatened Willie's future prospects. First, while he soon attracted a goodly number of patients, the poor ones outnumbered the rich, and tenderhearted Willie seldom pressed for payment. Second, and not unrelated, in the chaos of the Civil War and his sudden departure from America, Willie had lost his diploma from the University of Pennsylvania. Until able to verify his credentials, he was unlikely to attract a more solvent clientele, and he could not practice his specialty of laryngology.

Willie sought help from Dr. Darrach and a former medical school professor, but they could only provide personal letters confirming his degree. Seeing the gravity of the situation, Anna took charge. Without consulting Willie, she asked Joseph Harrison to use his influence with the university. "Can you wonder at my begging you to try to prevent his being broken up here," she pleaded, "to be sent adrift on the world, think how affecting to his widowed mother to be again separated from him." Harrison tried, but he, too, failed to secure the diploma. How much Willie's status as an ex-Confederate hindered the quest is anyone's guess, but he would now have to prove his medical skill by passing a pair of examinations for the Royal Colleges of physicians and surgeons. Otherwise, he would be relegated to an overcrowded field of inferior "medical men" who lacked formal training.[9]

Two other events that summer resurrected memories of the war for Anna, one of them also related to Willie. First, Ralph King passed through London on his way to the Continent with a new wife. Anna had met Mildred "Mittie"

Bronaugh, a Virginian nineteen years King's junior, when last in Brooklyn, and liked her. Perhaps as a result of his own good fortune, King told Anna that his son-in-law "ought [now] to have a wife." His words seemed a portent when, a few days later, Willie received an affectionate letter from a Richmond belle he had met after Ida's death. The sudden communication perplexed Anna. She had known the young woman as a good Christian but also as "a coquette," and she was vitally concerned that Willie not only wait until able to support a new wife, but that he also find a woman who would "love him as Ida did." She did not intervene as she had done fifteen years earlier with Jemie's West Point belle, but Willie, in any event, had no intention of pursuing this particular lady.[10]

Even more forcefully, these painful reminders of the war coincided with the news, shortly before the Kings arrived in London, that Anna's brother Charlie, aged fifty-eight, had succumbed to the stress and hardships of the conflict and postwar years. He died hoping that revenue from his farm and money he had invested in stocks would leave his family financially secure, but their house, virtually destroyed during the war, had not been fully rebuilt when he passed away. A generous soul to the end, Charlie stipulated in his will that Elizabeth, even should she remarry, would be entitled to a share of whatever income the farm produced besides $200 in cash to "assist with her new household."

His final wish, carried out by sons Donald and Charles, was that he be buried near his mother at Stonington. Anna felt a particular pang for Donald, who at age twenty-five now bore responsibility for his mother and younger siblings. Upon his father's death, he again returned to Florida from New York, as he had done for a time immediately after the war. Anna tried to help him in his "sacred duty" as family protector with donations of clothes and cash over the following years. She also insisted, as had her brother, that all the children be well educated. If his sons could not enter a "good trade," Charlie had hoped they might devote themselves to farming, which he considered "the best and most independent mode of life."[11]

Other loved ones were also being snatched from Anna's life, some long before their time. Niece Mary Rodewald passed away at age forty-four shortly after Anna returned to England. In South Carolina, Louise Porcher, former mistress of Otranto, succumbed to malaria only weeks after Charlie's death. She had been four years younger than Anna, and her husband Philip, two years Anna's junior, would die in 1871, possibly from alcohol. Anna's brother-in-law, Dr. George Palmer, who had cured and literally saved so many Whistlers over the years, died in 1868. Anna Johnstone, the elderly South Carolina cousin in New York, passed away in 1870. The worst shock, though, came in December 1869, when

dependable and ever-supportive George Whistler died of liver disease in Russia. He was only forty-seven. "George's career resembled his dear Fathers," Anna said stoically in relaying the news to friends, "& [their] opinions were the same."[12]

Anna also grieved the loss of her grandchildren, not through death, but because of continued separation. She and Debo were now meeting regularly, often on Sundays after church, though neither yet dared visit the other's home. Twenty-one-year-old Annie sometimes accompanied her mother, but Anna had not seen Annie's three brothers in over a year by mid 1869. Her first glimpse of them came when Arthur, the eldest boy, was confirmed at the Old Church. She did see more of them thereafter, but everyone feared Haden's wrath if he discovered the subterfuge. "[T]heir father is alas more bitter than ever," Anna lamented to the Gambles. "I can only pray for him, as I forgive him, tho he causes such grief to me, & is so unjust in his libels against Jemie." Of course, she had an explanation for his bitterness: while Debo and the children attended church weekly, Haden never went to "a place of worship," even though he served as family physician to the Archbishop of Canterbury.[13]

Ironically, Anna had another grandson of which she knew nothing. Her amorous Jemie, whom many women found irresistibly charming, had fathered an illegitimate child. One might suspect that the mother was Jo, but in fact, Jemie later confessed that the birth of Charles James Whistler on June 10, 1870, represented his "infidelity" to his longtime lover. The name of a some-times chambermaid, Louisa Fanny Hanson, appeared on the birth certificate as the boy's mother. Indeed, Jemie, unwilling to be drawn into marriage, also gave him Louisa's family name. He may have been named Charles for Jemie's recently deceased uncle, or perhaps for Jo's future brother-in-law, Charles James Singleton, a stockbroker, who had been living with and would later marry Jo's sister. The couple became Charlie's godparents.

Anna was not told of Charlie's birth, and she apparently never learned of it. The baby was sent to live with a wet nurse near London until he was about two years old. Jo then assumed responsibility for rearing Charlie as his "auntie." Jemie, who was genuinely fond of the boy, took financial responsibility for him, had him properly educated, and, in later years, employed him as a secretary until Charlie was able to make his own way as an inventor and electrical engineer. It is not even certain how much the other Whistlers knew of Charlie, the likely exception being Willie, to whom Jemie always turned when "in difficulties with women."[14]

Regardless, as the 1860s gave way to the 1870s, and her sons met with the success she thought they deserved, Anna was content. She had a church and pastor

that suited her, a familiar circle of friends, and a variety of charitable causes to provide spiritual satisfaction. Her health remained dicey, but her eyesight, if not improving, grew no worse. She would never find a pair of spectacles to suit her "queer state of vision," relying, instead, on a magnifying glass to read, but she found the salve prescribed by Dr. Meurens and applied by Willie a great relief.[15]

She certainly had not lost interest in the wider world. From the time she witnessed the celebration of America's victory in the War of 1812, through the technological revolutions led by her husband and brother, to the political revolutions of 1848 and her personal experiences in America's Civil War, Anna's life had been defined by some of the most momentous events of the nineteenth century. The time had passed for her to participate actively in such dramas, but as it turned out, she could at least share in Jemie's occasional brushes with history.

For instance, Jemie's friendship with John O'Leary, four years his senior, gave Anna a nodding acquaintance with what would be known as the Irish Question. O'Leary had been one of her son's earliest friends in Paris, even sharing rooms with him for several weeks. At that time, O'Leary was studying to be a physician, but by the early 1860s, he had become fully committed to Irish independence. Jemie's pride in his own Celtic roots sparked an interest in Fenian activities, but his devotion to art prohibited serious engagement in politics or the fate of nations. He sometimes shared coffee and a cigarette with O'Leary, but when O'Leary was arrested and imprisoned in 1865 for his involvement with the Irish Republican Brotherhood, Jemie lost – or perhaps avoided – contact with him. Whether or not Anna ever met the Irishman is unclear, but it is more than likely that Jemie told her his story.[16]

Anna had more personal knowledge of Italian politics. Her interest grew from Jemie's friendships with the Rossettis and Swinburne, who were devoted to the cause of Italian unification, the Rossettis through heritage, Swinburne through romantic impulse. By the time Jemie met them, they had joined with many other English writers and intellectuals to espouse the revolutionary ideals of Giuseppe Mazzini and Giuseppe Garibaldi. Mazzini, like the Rossettis' own father, had been forced into exile. Coming to London in 1837, Mazzini spent the rest of his life in the city, where he helped to stir the passions of such luminaries as Thomas Carlyle, John Stuart Mill, Leigh Hunt, Walter Savage Landor, George Eliot, and the Brownings. Swinburne became a disciple while a student at Oxford.[17]

As it happened, a new wave of excitement infused Italian nationalism in 1866–67. The country had finally been united as a kingdom in 1861, but Mazzini would settle for nothing less than a republican government. A failed war of independence in 1866 led to irregular warfare against the king and a campaign

in England to raise money and arouse moral support for the rebels. Swinburne wrote poems and a novel that praised the revolution. When he finally met Mazzini in March 1867, he fell to his knees, in his typically dramatic fashion, overcome by the "immense magnetic power" of the living icon.[18]

Jemie's friendship with Emilie Ashurst Venturi drew the Whistlers more personally into Mazzini's circle. Venturi had married yet another Italian refugee, and her father, a solicitor and social reformer, was Mazzini's best friend in London. An amateur painter, Madame Venturi kept a salon after her husband died in 1866 and became a patron and promoter of Jemie's work. Jemie, in turn, made small financial donations to Mazzini, who by 1867 lived in nearby Fulham Road. Mazzini expressed his gratitude to the artist by giving him a copy of his 1860 manifesto, *The Duties of Man*.[19]

Almost predictably, the fortyish Venturi became fond of "dear old Mrs. Whistler," who, in turn, likely admired Venturi's passion for social justice. Besides the Italian cause, Venturi endorsed Irish nationalism, and as a feminist, she was quick to compare the second-class social and economic status of women to the position of the Irish in Britain. She would also become a major figure in the anti-contagious diseases crusade, serving for fifteen years as editor of that movement's weekly circular, *The Shield*.

Most interestingly for her association with Anna, Venturi was ferociously anti-clerical and anti-sectarian in religion, while, at the same time, believing fervently in a "purer" and "higher" Christianity. Consequently, the sophisticated madame and her friends could not but be amused by Anna, whose allegiance to the rituals as well as the spirit of the church made her the "dearest of ancient Christians." "[S]he wrote me the most charming letter so like herself," Venturi confided to Swinburne, "full of quaint old-fashioned Christianism."[20]

Swinburne was similarly amused by Anna. She spoke of him, as she did many young men in whom she took an interest, as a son, much as Jemie called Swinburne a brother, but she had an especially soft spot for Algernon. She was surely delighted to learn that as a boy he had met one of her favorite writers, Elizabeth Sewell. She nursed him following one of his epileptic seizures at Lindsey Row and, being aware of his weakness for drink, gave Swinburne religious tracts in hopes of reforming him. He received them courteously, likely expressing himself in the warmest terms and acknowledging the need for redemption, but Venturi, having heard Anna describe him as "my son Algernon," could imagine the decadent little poet's inner thoughts. "I could not help thinking of your being 'most respectful,'" she told him, "and indulging in ribald laughter at the thought!"

Nonetheless, Swinburne wanted, even needed, Anna's approval. Once, following a disagreement with Jemie that kept him away from Lindsey Row for an unusually long time, he sensed a formality on Anna's part when he next appeared. Eager to make amends, he asked why she had addressed him as "Mr. Swinburne," rather than as Algernon. "You have not been to see us for a long while, you know," came her gently pointed reply. "If you come as you did, it will be Algernon again."[21]

The Franco-Prussian War and subsequent Paris Commune were guaranteed to draw Swinburne's passionate interest, just as they produced Anna's most intimate contact with Continental affairs. The conflict of 1870–71 turned the Parisian art world topsy-turvy. Many French artists and dealers, fleeing the chaos and destruction, landed in London. Among the refugees was a thirty-nine-year-old American painter, Louis Rémy Mignot, who arrived in England with his wife Zairah and son Rémy in the autumn of 1870. Jemie had introduced Anna to Mignot earlier that year, when he exhibited at the Royal Academy. She liked him at once, both as a "Christian gentleman" and as a staunch Confederate who had been born in South Carolina. Tragically, though, upon the family's return to Paris, the artist died of smallpox, leaving his wife and son virtually penniless.

Jemie being out of town, Anna and Willie helped raise funds to relieve the widow's distress and bring her and Rémy back to London. Anna insisted that they stay in Lindsey Row, where Zairah, who happened to be a native of Baltimore, took comfort in speaking of her late husband's "love for God & for their bright boy." Friends of the Whistlers soon joined the cause. Gabriel Rossetti gave the widow five pounds through Willie and called on his friend John Ruskin, who had a charity fund for "Artists in distress," for another twenty pounds. Mary Gellibrand donated ten pounds, and Thomas Winans, who may well have known Zairah's father, Dr. Chaplin Aaron Harris, a pioneer of modern dentistry and a notable art patron in Baltimore, offered to pay ten-year-old Rémy's expenses at a "select boarding school."[22]

Willie's involvement was typical of his instinctive desire to comfort and heal. For a time, Anna feared that, with his knowledge of French and German and experience as an army surgeon, he would volunteer to serve on the Continent. Instead, he continued to work and study for the required British medical examinations. His prospects looked brighter by 1870, too. He had been told it would take at least seven years of labor before he could "cover his expenses" as a private practitioner, but he was prospering enough by that summer to move out of his lodgings in Burlington Street and rent a small house for eighty pounds per annum at 80A Brooke Street, near Grosvenor Square. It was only a half mile

farther west but in a more fashionable part of town. In addition to his private practice, he had also taken a position at a children's charity hospital. He was helped further when James Anderson Rose pressured more solvent patients to pay their bills.[23]

Anna, "busy as a bee," was soon "buzzing" around Willie's new digs, laughed Emilie Venturi. Anna helped him furnish his rooms and took responsibility for acquiring and training a pair of reliable servants, which he could at last afford. She found a seemingly reliable Irish girl named Hannah to cook and clean. At first, everyone praised Hannah's efficiency, honesty, frugality, loyalty, and cheerful disposition, but then she fell into bad company – "giddy acquaintances," Anna called them – and abandoned her post whenever Willie went out. Willie seemed willing to forgive her until, returning home late one evening, he found her entertaining a "very unworthy" young man. That was the end of Hannah. Anna found an Irish charwoman to manage the house until Willie hired a pleasant "sedate couple" to serve his needs.[24]

As it happened, keeping good servants had become an equal nuisance in Lindsey Row. Anna and Jemie had been content with their cook and housemaid, named Harriet and Fanny, since moving to No.2. Anna especially treasured sixty-year-old Harriet, an "Old school of English servant." Harriet appreciated Anna, too. "Well Ma'am," she once told her, "isn't it curious how like are your ways & mine! I tell everyone my Mistress always seems pleased with what I do now!" That was until Harriet betrayed a weakness for ale and became a "brawler." Out went Harriet, and Fanny, too, for unexplained reasons. Anna replaced them with a "capable" and "cheerful" twenty-year-old cook named Lucy and an "obedient" seventeen-year-old housemaid named Lizzie. Anna also felt a sense of relief upon later learning that Hannah had given up drink and married a Chelsea pensioner.[25]

All these comings and goings made Anna realize how lucky she had been to have Mary Brennan for so many years. Then again, experience had taught her to be pragmatic. When Lucy announced her intention to marry a young carpenter named Walter Slater, Anna acted promptly. First, she allowed Walter to pay evening visits to Lucy in the kitchen. A year later, when they finally did marry, Anna expressed her "Motherly interest" in the girl by providing Lucy with all the ingredients needed to bake a "generous large [wedding] Cake, icing and all!" Jemie gave them each a sovereign (twenty shillings), a quite magnanimous gift given their weekly wages of thirty shillings for Walter and ten shillings for Lucy. Anna then allowed Walter to share Lucy's room until the couple could save enough money to rent and furnish their own place. A grateful Lucy remained in service with the Whistlers for several more years.[26]

Of course, servants cost money, which remained a problem for all the Whistlers. It had been so since the major's death, but the pecuniary pinch seemed especially painful at what Anna regarded as a moment of "crisis" in her sons' careers. "[T]hey occupy their time & talents now for future advantage," she insisted to sister Kate in the autumn of 1870, "with their minds intent upon rising in the scale of medical science & Artistic attainment, we must wait patiently for the harvest & I am here to manage expences for each as economically as possible, & uniting our small incomes at present, to try to make them sufficient."[27]

Now comfortably settled at 2 Lindsey Row in a way her frequent journeys away from London had never permitted at No.7, Anna also became better acquainted with her immediate neighbors. Her closest friends, in both age and proximity, were William and Elizabeth Boggett, "a dear old couple" who had lived at No.3 for nearly forty years. She and Elizabeth, who also attended Chelsea Old Church, shared religious readings and comforted each other in times of need. Elizabeth sent Anna freshly baked cakes and contributed two pounds to the fund for Zairah Mignot. William shared grapes from his own garden and freshly caught trout. "I love her as a Sister," Anna told James Gamble of Elizabeth, "so she seems to feel towards me."[28]

The Greaves family, who were among the first residents of Lindsey Row to befriend Jemie, lived at the other end of her block, at No.9. The father, a boat builder and waterman, had rowed Turner on the Thames while the artist sketched. His sons, Henry and Walter, in their early and mid twenties by 1870, did the same for Jemie, whom they idolized. They cleaned his studio, ran errands for him, prepared his canvases and frames, did anything to ingratiate themselves, even helping to paint the drawing room of No.2 when he first moved there. Their sisters, Alice and Eliza, posed for Jemie. In return, Jemie gave Henry and Walter informal lessons in drawing and painting, which, in time, inspired them to become artists in their own right. Given their friendship with her son, Anna naturally smiled on the family.[29]

Anna also paid longer visits to friends outside the neighborhood. She remained close to the Rodewalds, especially the children, even after Mary's death in 1867. She spent at least a week each summer or autumn with the Gellibrands at their lovely sixteenth-century manor house Albyns, where the old friends shared memories that stretched back decades (fig. 45). The grounds at Albyns covered hundreds of acres of woods, meadows, and farmland, and even strolls in the garden provided ample exercise. The orchards supplied a cornucopia of peaches, nectarines, plums, and figs. Daily carriage rides in the fresh country air invigorated Anna, as did, in a quite different way, the family's habit of praying

each afternoon and evening and singing hymns on Sundays. They all visited the Malvern spa one year, where a daily "vapor bath" revived Anna in body and spirit.[30]

Getting about never hindered her, even when Jemie was out of town and she was on her own. She was a veteran walker, which probably explains why she remained relatively fit. Hansom cabs were readily available if she felt poorly or bad weather threatened. An omnibus line ran along Lindsey Row if she was traveling longer distances, as to Wimbledon to visit the Rodewalds, although the family generally sent their carriage to collect her. Anna appears never to have used London's new underground railway, opened in January 1863, eleven months before she arrived in England. Perhaps the lines did not run to her destinations, or she may have shrunk from the thought of being trapped with all that noise and smoke beneath the streets. Although the underground system proved enormously popular, and Anna surely marveled at such an innovative use of her husband's railroads, more than one traveler commented on the "taste of sulphur" on their lips and the "difficulty of breathing."[31]

Jemie's career in London's intensely competitive art market also kept Anna active. By the 1870s, she had become his amanuensis, either taking dictation or writing notes that he neglected or had no time to compose. Some of the correspondence dealt strictly with business, as when negotiating rental terms for a new studio. More often, she dealt with patrons or potential buyers, whom she unaffectedly enchanted. One of them, John Gerald Potter, a Lancashire wallpaper manufacturer who owned three of Jemie's paintings, would do anything to please Anna. She and Debo even used his London home for some of their rendezvous.[32]

Most important was Anna's relationship with the family of Jemie's newest patron, Frederick R. Leyland (fig. 46). Gabriel Rossetti had introduced the thirty-eight-year-old Liverpool shipping magnate and art collector to Jemie in 1869. Leyland immediately commissioned a painting, although the project did not go well. Work on what came to be known as *The Three Girls* became the chief source of Jemie's frustration that winter. He grew so discouraged by his failure to combine classicism and Japonisme in a single design that he returned Leyland's generous advance of £400, even though that meant borrowing money from brother George, just before he died, to stay afloat. Too embarrassed to admit his failure personally to Leyland, he asked Anna to do the dirty work. "All Sons I believe come to their Mother in these difficulties, to ask help & find comfort," she unabashedly explained to the businessman, and so defused a difficult situation.

Anna's letter also confirmed the bond between mother and son. "[H]e always confides in his Mother," she had gone on to explain, "who thus knows intimately all his failings & his virtues." The problem had been Jemie's passion for perfection. "[H]e is poor fellow more to be pitied than blamed," she told Leyland. "[H]e has only tried too hard to make the perfection of Art, preying upon his mind unceasingly it has become more & more impossible to satisfy himself." Going further, she appealed to Leyland to sympathize with Jemie's failure. "You may judge," she proposed, "how painful is this task to me, for tho my experience of blighted hopes in this world has taught me to expect disappointment, I yet tremble as my Sons encounter it, for they have not the faith in God which is my support." She also reaffirmed her own role in Jemie's career. "I am his representative in Chelsea," she assured Leyland, "& shall welcome a call from you, if you have time to spare."[33]

Leyland so appreciated Jemie's honesty and Anna's loyalty that he commissioned portraits of himself, his wife, and three daughters. As a consequence, Anna became a frequent guest over the next several years at Leyland's London house and rented country estate, Speke Hall, outside Liverpool. Although Frederick was not "particularly religious," Anna respected him as a prosperous and "very cultivated gentleman of taste," and she got on famously with his wife Frances (fig. 47). Born in more humble circumstances than her husband, and taught to embrace religious enthusiasm, Frances shared the same bond that cemented most of Anna's closest friendships. The two women went at least twice to hear the famous evangelical preacher Granville A. W. Waldegrave, Lord Radstock, in London. Whenever visiting Lindsey Row, even if there to pose for her portrait, Frances invariably took time, despite social obligations and four children, to sit and chat with Anna.

Frances expressed her appreciation for Anna's friendship by sending "superb bunches" of grapes to London, knowing them to be among Anna's favorite fruits. Other shipments included bottles of the "best Old Port" (a "little" of which Anna had begun to imbibe "for health's sake" on Willie's advice), bottles of Champagne, and braces of pheasant, all accompanied by loving notes. Even in London, upon learning that Anna felt unwell, Frances once sent a large satchel containing a pair of chickens, fresh asparagus, a dozen oysters, another bottle of port, and a bottle of cognac.[34]

It was around this same time that Anna became far more than an agent or publicist for her son. One day in the summer of 1871, probably in July, Jemie's intended model for the day was indisposed. Impatient and anxious as always to be doing something, he asked Anna to pose for him. "[I]t is what I have long intended & desired to do," he explained, "to take your portrait."[35]

He began with some preliminary drawings, including an etching of Anna standing. He had drawn an old Parisian flower seller in similar fashion many years earlier. That etching, *La Mère Gérard*, was a remarkably tender, even poignant work, which, if translated into a painting of Anna, would have been quite brilliant (figs. 48–49). But Anna was incapable of posing "as a statue" for the many hours required. "I stood bravely, two or three days, whenever he was in the mood for studying me," she reported to sister Kate, "but realized it to be too great an effort." Instead, her "dear patient Artist" had his mother sit, "perfectly at my ease," she assured Kate. He then worked rapidly, at least relatively so. Jemie was notorious for the long hours he asked of his sitters. He labored on some portraits for years. It took him only about three months to complete the picture of Anna, who, nonetheless, appreciated how serendipitous had been the entire project. As she told Kate, in reference to the absent model, "I must introduce the lesson experience taught us, that disappointments are often the Lord's means of blessing."[36]

Emilie Venturi, who had a peek at the uncompleted picture, thought it "most promising," but the strain sometimes showed on both sitter and painter. One afternoon, seeing that Anna was unable to pose any longer, Jemie, without complaint, grabbed some pencils and a sketchbook and escorted her down to the river for an outing. Boarding a little steamer, they cruised down the Thames as he sketched and she enjoyed sunny skies and cool breezes. Landing at Westminster Pier, they sauntered through St. James Park before returning by hansom cab to Chelsea.

But the most remarkable part of the day had yet to come. Upon reaching home, Jemie felt a sudden urge to paint the effects of twilight on the river. He rushed upstairs to collect easel and brushes from his studio and position himself at a front window overlooking the Thames. Frantic to finish as much of the scene as possible, he recruited Anna as his studio assistant, the only time she is known to have played that role. "[S]oon I was helping by bringing the several tubes of paint he pointed out that he should use," she revealed to Kate, still excited by the memory of the moment, "& I so fascinated I hung over his magic touches til the bright moon faced us from the window." It was one of Jemie's "moonlights," his personal and unique way of conveying the moods and poetry of a river cloaked in fog, mist, and darkness. When one critic praised the painting, called *Harmony in Blue-Green – Moonlight*, as an "exquisite harmony," Anna proudly sent the review of Jemie's and *her* painting to Kate (fig. 50).[37]

As concerned her portrait, it was the painter who sometimes felt out of sorts. "[N]o!" he ejaculated one morning; "I can't get it right! It is impossible to do it

as it ought to be done perfectly!" There is no telling how many times he wiped all or part of the canvas clean to start again. Jemie did that routinely when painting. Modern X-rays of the picture and ultraviolet light testify to some of his frustration, revealing, as they do, alterations in the positioning of Anna and the placement or shape of some objects, including the chair, footstool, and curtain. Then, one day, it was suddenly all right. Stepping back to admire the finished canvas, Jemie declared, "Oh Mother it is mastered, it is beautiful!" and gently kissed her.[38]

The completed portrait revealed much about both artist and subject (fig. 51). From Jemie's perspective, it demonstrated his new artistic theories concerning the use of color and the purpose of art. At the start of his career, idolizing such colorists as Gustave Courbet, he had depended on bright and varied tones to hold the viewer's eye. More recently, certainly since his return from Chile, he preferred subdued colors and a limited palette, seeking a delicate balance of similar tones and variations of a single color. Indeed, he had become fascinated by the complete absence of color, that is, using black to dominate a canvas. Having first gained notoriety by painting white-on-white with his portrait of Jo as *The White Girl*, he tackled the even more difficult task of painting black-on-black. His first attempt to achieve that effect in portraiture was the still unfinished painting of Frederick Leyland.

If not as dark as his series of so-called "black portraits," in which black was the prevailing – very nearly only – hue employed, the color scheme of Anna's picture was simple enough, and in her case, entirely natural. After all, still as much in mourning as Queen Victoria, Anna always wore black. That fact, plus the colors of Jemie's mostly black and grey studio, nearly demanded the scheme. It followed, then, that he would call the completed painting an *Arrangement in Grey and Black*, which was consistent with his determination to convey no story, moral, or emotion in his paintings. They were "not meant to have any literary twang of poetry about them," he insisted to an American art agent, "but are meant to indicate scientifically the kind of work upon which I am engaged." He had recently begun to emphasize that point by using musical terms, such as "arrangement," "harmony," or "symphony" for the titles of his paintings. Alternatively, in later years, he might use a picture's dominant color, as in *Grey and Silver: Old Battersea Bridge*. In either case, he intended to distance his subject from any particular time, place, or narrative.[39]

Jemie considered the portrait of Anna a perfect example of this broader philosophy. "Art should be independent of all clap-trap – should stand alone, and appeal to the artistic sense of eye or ear, without confounding this with emotions

entirely foreign to it, as devotion, pity, love, patriotism, and the like," he later told a journalist seeking to understand his intentions. "Take the picture of my mother, exhibited at the Royal Academy as an 'Arrangement in Grey and Black.' Now that is what it is. To me it is interesting as a picture of my mother, but what can or ought the public to care about the identity of the portrait?" He went on to say, "The imitator is a poor kind of creator. If the man who paints only the tree, a flower, or other surface he sees before him were an artist, the king of artists would be the photographer."[40]

Paradoxically, despite Jemie's aversion to photographers as "artists" and his determination to avoid sentimentality, his portrait of Anna could well be taken as a perfect photographic likeness of his mother at that moment in her life. It is even possible that he intended, with the dark, chromatic color scheme and formal structure of the painting, to mimic the effects of photography, even as he challenged its supposed objectivity. In any event, it is impossible to miss the affection that infuses the work. Despite Goethe's dictum that "one is never satisfied with a portrait of a person that one knows," people who knew Anna were enchanted by how convincingly Jemie had captured her essence, both in features and spirit. He drew the marks of aging around her eyes and neck tenderly, and her face is luminous, the brightest part of an otherwise somber scene, the point to which eyes are immediately drawn.[41]

James Anderson Rose, who had more or less adopted Anna as his own mother, was so overwhelmed that he returned to Jemie's studio three times within a fortnight to admire the portrait. One of the Leyland daughters said Jemie should write "Peace" upon it, "for that is what it is!" Similarly, an artist friend of Venturi commented on Anna's "holy expression." More than one person would notice the placement of the hands, and the way Anna held her handkerchief. "Oh it is exactly like her!" exclaimed another of the Leyland girls. Rossetti openly admired it. "Such a picture," he told Jemie, "ought to do good to the time we are now living in." Years later, Swinburne continued to be impressed by the "tender depth of expression" in this portrait of Jemie's "venerable mother." As for the artist, he would always refer to the painting simply as "The Mother," as he often called the woman herself.[42]

One wonders if these friends found the composition, with Anna, shoulders slightly bent with age, sitting in severe profile, equally familiar, for scholars have long debated the inspiration for what was a rather unorthodox pose in the nineteenth century. Not that it had always been so. The favored pose for portraits of the highborn and nobility, especially of women, had been the same during much of the Renaissance, although only the head or upper body had been depicted. It

was reminiscent, too, of silhouette portraiture, which had been particularly popular in the eighteenth and early nineteenth centuries. Anna had posed the same way many years earlier in the only other known painting of her. Perhaps Jemie wished to improve on it (fig. 19). Then again, he had drawn and painted people in profile as early as the 1850s, the best-known instance being his positioning of Debo in *At the Piano* (fig. 33).

Other theories say that he borrowed the idea from drawings and paintings by one or another of his artist friends. Rembrandt, who had an early and lasting influence on Whistler's art, is also mentioned, most logically for an etching of his own mother seated and in profile, done in 1631. A strong candidate for at least some elements of the picture is a cartoon drawn by Jemie's friend Linley Sambourne and published just a year earlier in *Punch*. The view of this mother (seen knitting) is frontal, but she wears the same black dress and widow's cap as Anna, and her feet rest on a small stool.[43]

An equally intriguing question concerns Anna's line of vision: What is she looking at? The general issue of what scholars call "the gaze" in works of art has been much discussed in recent decades. It usually involves the way in which we view pictures, especially when a person or people in a painting are looking directly back at us. Alternatively, in considering a picture that includes two or more people, scholars ask what the respective "gazes" of the people within the frame tell us about their relationships with one another.[44]

Neither of these circumstances applies to Anna's portrait, but what of a subject that looks away from the viewer and beyond the frame? This is the intriguing question about Anna, and about her painter son. Jemie betrayed no clear pattern in his use of the gaze; sometimes his subjects look directly at you, at other times they look away. But did his decision not to confront his mother's gaze say something about their relationship? Any number of reasons, with untold psychological theories being top of the list, might explain his choice; but the only reliable evidence points to his well-known concern for the color and composition of a painting. As for what Anna's gaze might mean, generations of enthusiasts, as will be shown, have had their own ideas.

Unnoticed at the time, or at least going without comment, were two other features of the picture that ran as threads through Anna's life. First was her expression. The closed, unsmiling mouth, with her jaw very nearly clenched, conveys a dour, slightly grim look. Yet, besides the fact that few people "smiled" for nineteenth-century portraits, whether painted or photographed, not to mention the futility of smiling in profile, one must remember the sorry state of Anna's teeth, or lack of them. She had lost at least eight of her natural teeth, and though

she probably still wore her "artificial" in 1871, years of dental problems had surely made her self-conscious. That said, most surviving photographs of Anna show the hint of a smile, accompanied by a twinkle in her eyes. That would be the expression most people saw in life, and which endeared her to so many of them.

Even more intriguing is the footstool. Some commentators have speculated wildly on its presence in the portrait while missing its very practical and symbolic importance in Anna's life. She depended on a footstool to keep her feet warm throughout her adult life. She so missed one in Russia that she asked that her favorite be sent from Stonington. More than that, biblical references to the "footstool of God," a demonstration of humility and repentance before the Almighty, appear often in Anna's diaries and correspondence. A woman who could recite Scriptural passages for virtually any situation surely knew Psalms 99:5: "Exalt yea the Lord our God, and worship at his footstool, *for* he *is* holy." Or Matthew 5:34–35, which claims the Earth as God's "footstool." Expressing her joy over one of Kate's newborns, she declared, "Oh that I could always have a heart so full of thankfulness in approaching the footstool of mercy." The one incongruity Anna's family later mentioned concerning this supposed prop was that Jemie had turned his mother's small, "well arched" feet into a "pair of sprawling, flat peasant feet."[45]

9
Onlooker
1872–81

ANNA RARELY SPOKE NOW OF returning to America. She sometimes longed to visit Kate, but the thought of traveling alone, without her boys, and with no certainty that she could survive the journey, ended such fancies. Only if Jemie should return to exhibit in their native land would she consider going. Meantime, both he and Willie were making more headway in life than they had done for several years. Except for his eccentric titles and accusations of not "finishing" his work, more art critics were warming to Jemie's avant-garde ideas about painting. "[H]is years of hard work seem now to be rewarded," Anna assured James Gamble, "& he is more than ever industrious." Willie still needed to take his examinations, but he was improving his "practical knowledge" of throat and lung diseases in a part-time post at the famous hospital of Sir Morell Mackenzie in Golden Square. As he reminded Anna, somewhat defensively, "I'm as proud of my work as Jem is of his." Their mother reminded them both of Proverbs 16:18: "Pride goeth before destruction, and an haughty spirit before a fall."[1]

She herself was extremely proud of her portrait, not for vanity's sake, but as a supreme example of Jemie's talent. She wanted everyone to see it, and she enjoyed hearing visitors to Jemie's studio praise him. "[I]f I were to write all that was said," she blushingly told Gamble, "you'd fear, a proof of the human weakness, had overcome me in my declining years! But my gratitude goes up to the One-source of help on which I rely for the continued success of either of my dear boys." She objected only to the "*fashionable*" custom during the London "Season," from May to September, that found Jemie entertaining visitors to his studio on Sunday afternoons.[2]

The opinions of friends and relatives aside, Anna's portrait received some rough treatment, both physically and verbally, early on. To begin with, it was nearly destroyed by fire before ever going on public display. Jemie had taken the picture to Speke Hall to show the Leylands and add some finishing touches. On the return to London, the railroad car holding the painting caught fire, the result being a scorched frame but no injury to the canvas. Anna hoped the narrow escape was a favorable omen that the painting would be hung properly at the upcoming Royal Academy exhibition, not "skyed," stuck in a dark corner, or otherwise shown to disadvantage. Jemie had not exhibited at London's premier exhibition in seven years; he wanted Anna's portrait to launch his comeback.

As it happened, he was lucky to have the picture hung at all, for the academy's jury initially rejected it. The static nature of the painting, Anna's positioning, Whistler's ideas about form and pictorial space, the seemingly unfinished state of some details, not to mention the curious title, confronted jury members with an exceedingly modern painting that they could not comprehend. That would have ended matters, too, had not William Boxall, who in painting the portrait of a fifteen-year-old Jemie had grown fond of him, threatened to resign from the academy's council over the decision. Other artists applauded his intervention. As Ford Madox Brown told one of his patrons, "I hear that Whistler has had the portrait of his mother turned out. If so, it is a great shame, because I saw the picture, and know it to be good and beautiful." The jury timidly reversed itself.[3]

But public response was mixed. One observer thought the painting "found few admirers among the thousands" who entered Burlington House. The situation was not that bad, but the U.S. consul in London, Benjamin Moran, who had met both Jemie and Anna during their comings and goings from the country, failed to mention it in his careful notes on the exhibition. Mary Gladstone, the artistically inclined daughter of the prime minister, looked only at the paintings of her friends John Millais and George Frederic Watts. Some critics, even if liking the picture, barely mentioned it in their published reviews. Others were frankly puzzled by the unorthodox pose and "monochrome" scheme of this "arrangement," the first time that Jemie had exhibited a portrait with that title. "The treatment of the subject is stiff, and harsh even to painfulness," decided one reviewer, even as he granted the picture's "intellectual power." The *Daily Telegraph*'s critic attacked both the artist, described as "a painter of acknowledged genius, but of incorrigible perversity," and his dull "effigy of an elderly matron." This critic concluded, "[T]he salons of the Royal Academy are not the place for the trial of the experiments of eccentrics."

Other critics were at odds over Jemie's purpose, some of them determined to find the story or message that he had purposefully avoided. The *Pall Mall Gazette* declared, "The picture is in its way consummate, and carries besides a sentiment, a grave poetry of mourning – effacement, depression forlornness, with a strange and sweet dignity in it." On the contrary, said another critic, who considered that the sitter, despite her "mournful garb," projected a "calm, pensive, contemplative mood." Someone else judged the "lines of the face ... beautifully and delicately drawn," while another person thought it "so blurred" that he could "hardly suppose portraiture was his [Jemie's] purpose." Then there was the commentator who declared Anna's face "exquisitely subtle in drawing and modelling" but lacking "the vitality of nature."[4]

If Anna read any of the unappreciative reviews, she made no comment, and sent clippings of more favorable notices to friends and family. She also expected those recipients, as in the past, to share the news. "I do not feel indifferent to sending you the notices which have appeared in many of the London Papers," she had once explained to Kate Palmer. "I'll see if Jemie can select one for your Stonington Weekly." Nor was Stonington the limit of her ambition. In other instances, she asked friends to republish reviews in the New York papers, which, she reasoned, would surely wish to promote such a successful "American Artist."[5]

Jemie was disappointed enough in his treatment by the Royal Academy never to exhibit there again, and he kept Anna's portrait under wraps when the show ended. He considered sending it to the next Paris Salon but thought better of that, too. He would put the painting on public display only once more during Anna's lifetime, and that was at his own one-man exhibition, in 1874. He would not permit an engraving of the picture to be made until 1879, although he did have it photographed almost immediately for the benefit of family and friends. He also used the photograph to promote or advertise his work among dealers and potential buyers, something he had done with other paintings since at least 1865.[6]

Nonetheless, Anna's portrait did draw a pair of positive – and consequential – reactions. The first came from Jemie and Anna's most famous neighbor, Thomas Carlyle, who lived only minutes away in Cheyne Row. It is uncertain whether Jemie and the seventy-seven-year-old historian and philosopher had yet met, but when Emilie Venturi took Carlyle to see Anna's picture, he was impressed enough to have Jemie paint his portrait. He did not commission the work, so Jemie would receive no payment unless able to sell it, but the prestige of painting the great man could only enhance the artist's reputation.

Who suggested that Carlyle sit in virtually the same position as Anna – whether he, the artist, or Venturi – is unclear, but that was the result. Jemie would call the finished painting *Arrangement in Grey and Black, No.2*. Yet, despite similarities of pose and color, the pictures showed two very different people. Anna's portrait, like the person, bespoke tranquility and piety. Carlyle simply looked bored, liable at any moment to stand up and walk away. His countenance came partly from the interminable hours it took to complete the painting, and he later complained that it was more a "portrait" of his clothes than his person (fig. 52). Still, while Whistler escorted him home and they conversed after the initial sessions, the two men grew to like each other. Carlyle thought Jemie's affectations made him "the most absurd creature on the face of the earth," a sort of "pocket Disraeli," with his "mop of black ringlets," but he also called him "a very remarkable person."[7]

The Sage of Chelsea made an equally shrewd comment about Anna. "The Mither-r," as Carlyle called her after their first meeting, "received us – a dainty-sad little auld silvery dame, gentle of speech and shy-authoritative." One wonders what Anna said or did for Carlyle to think of her as "shy-authoritative," but it was a brilliant assessment, perhaps the most insightful observation ever made about her. Anna left no account of Carlyle, even though she was in the house for at least some of his sittings. Perhaps they only exchanged pleasantries. Then again, they might have enjoyed long talks about the healing springs of Malvern.[8]

Perhaps, too, she overheard Carlyle's famous remark to eight-year-old Cicely Alexander. Jemie was painting this little girl's portrait around the same time, and the two sitters occasionally passed each other as one exited and the other entered Jemie's house. Knowing what torturous hours of posing Cicely must be enduring, Carlyle reportedly mumbled, "Puir lassie! Puir lassie!" As it happened, she was also there because of Anna's portrait. Her father, William C. Alexander, a well-heeled Lombard Street banker, had already bought the "moonlight" done by Jemie and Anna when, inspired by sight of the portrait, he asked the artist to paint three of his daughters. Cicely came first.[9]

Anna also played a personal part in the making of Cicely's portrait, which many experts consider one of Jemie's best paintings. First, she conveyed his detailed instructions to the Alexanders regarding the dress Cicely should wear, even down to the shops where the best material could be purchased. When Cicely and her mother came to Lindsey Row for the painting sessions, Anna kept Rachel Alexander company by chatting, crocheting, and reading with her. She provided a nice luncheon, too, as she had done for the Spartali sisters, and if Jemie kept

Cicely posing – and in her case, standing – past lunch time, Anna saved the girl's food in a "plate warmer." Anticipating those long sessions, she often fed Cicely cake and milk before they commenced.

Her considerate acts and their long hours together led to a warm friendship between Anna and Rachel. The Alexanders invited Anna to their home, even sending the family carriage to convey her the eight miles to Hornsey. Anna was pleased to find that William Alexander led daily morning prayers for his children and servants, and their shared religious convictions resulted in Anna occasionally attending church with the family. Gifts of fruit and flowers flowed to Chelsea from the Alexanders' garden, a bounty that Anna shared with "a few invalid neighbours."[10]

Fittingly, Anna, Carlyle, and Cicely shared the spotlight when, in January 1874, Jemie included their portraits in his first one-man exhibition. The Leyland portraits were also on display, and critical response to the entire show was generally upbeat. Anna's painting, already "widely known," received less press coverage than the newer pictures, but more critics responded favorably to it than two years earlier. Sidney Colvin, who saw much potential in Jemie's work, called it "the best" of all the portraits. One of the few critics not familiar with the painting thought this "apparently invalid lady" possessed "much beauty of countenance." Even the most scathing review, which found Anna's likeness "as flat as a board," detected "considerable character in the head" of this "venerable-looking lady."[11]

It is unclear whether Anna, whom Jemie had taken to the Royal Academy exhibition, saw this show at all. She may well have done if Debo attended, and Jemie did send his sister an invitation to the private view. Mother and daughter now saw each other fairly regularly. They had tea at least once a week, and Anna had even dared to visit 62 Sloane Street on a day when Haden was out of town. They took afternoon drives, sometimes in Haden's own brougham, and called on mutual friends. The grandchildren were nearly grown by this time. Annie, aged twenty-four, was still at home, but Seymour (aged twenty-two) was in his last year at Oxford, with Arthur (aged twenty) preparing to be a doctor, and Harry (aged seventeen) working for the mercantile firm of Brown, Shipley, and Company in Liverpool.[12]

Anna had also found something of a second daughter in Kate Livermore (née Prince). Kate's husband had prospered as a lawyer since their early wedded days in New Hampshire, when Anna had sent Topsy to help the novice housekeeper. In 1870, he received a diplomatic appointment as U.S. consul in Ireland, which allowed Kate to visit Anna. Both Arthur and Kate thought Jemie "somewhat

vain & selfish," but they shared the often wayward son's "true & deep affection for one of the best & sweetest Mothers man ever had." Kate also shared Anna's interest in Christian charities, and on an early visit to London revealed her own campaign to prepare "poor ignorant Irish women" for domestic service with a training school in Dublin. Given Anna's own trials with servants over the years, she judged Kate's school a "benefit to society" and asked friends as far away as America to subscribe to the worthy cause.[13]

Her only disquietude in the mid 1870s grew from her sons' financial woes. Anna's largely successful efforts to manage household accounts aside, Jemie had incurred debts from a pair of lawsuits against him by a former patron and the owner of the gallery where he had held his exhibition. Anna was named as a plaintiff in one of the cases. Jemie, working and enjoying himself at Speke Hall, shrugged it off and asked Anna and Willie, working through James Rose, to handle the matter.[14]

Willie's more consequential debts still resulted from having too many of "God's Patients," that is, people too poor to pay him. Even with Rose having wrung some money out of the genuine deadbeats, Willie, who was far from a spendthrift, could not afford much needed medical equipment, and his back rent was mounting. For a time, a bailiff – the dreaded "man in possession" – took up residence in his house. Anna's portrait, which had been hanging there, was nearly confiscated before Jemie swore to the sheriff that the painting belonged to him. Rose again came to the rescue, but not before Willie suffered "great mental depression."[15]

But Anna's own physical distress was about to overshadow all else. She no longer felt the "excruciating pain" in her left hand and arm that had deprived her of sleep a few years earlier, but the dampness and polluted air of London wreaked havoc on her eyes and general health. The same conditions affected her sons and Debo, but Anna, now in her seventies, was especially susceptible. She felt robust enough to visit the Livermores in Ireland and cousin Ann Clunie in Scotland in the summer and fall of 1873, escorted by grandson Georgie Whistler, then twenty-two, who had come over from Baltimore, but her constitution deteriorated upon returning to London. Indeed, she was fortunate not to have been one of the thousands of people who died that December from the dense black fog, the worst anyone could remember, that engulfed the city.[16]

Anna called it the "season of illness," her own recovery slowed by the need to nurse Jemie, who succumbed to a combined attack of rheumatic fever and bronchitis at the same time as her own sickness. Willie, who found nothing wrong with her heart or lungs, diagnosed a "general disability" and prescribed "strong

bark & Quinine, Old Port wine & frequent nourishment." Anna responded by saying, as she did on more than one occasion, "I am so thankful to have a doctor Son!" Still, she remained weak, often confined to bed, through the summer of 1874, although a three-week stay with the Gellibrands at Albyns helped mightily.[17]

London enjoyed a glorious Indian summer that year, which quite agreed with Anna's "Southern blood." She escaped serious illness that winter, despite "cold fogs & East winds," by wearing warm gloves indoors and bathing her feet in hot water. However, a severe case of bronchitis, a nearly annual affliction since moving to England, landed her in bed for nearly two months in early spring 1875. Willie abandoned his practice to attend to his mother for eighty-five consecutive, largely sleepless, hours as she fell in and out of consciousness.

Anna felt herself slipping away on April 7, the same date that death had taken her husband and mother. Willie summoned Debo in anticipation of the worst. Kate Livermore arrived from Dublin at Debo's request to help a full-time nurse hired by Willie. "Such a bright Christian she is!" Anna later exclaimed of the family's longtime friend. "No wonder my Pastor remarked to me once, that Mrs. L made religion charming!" That pastor was still Robert Davies, who always enquired if Anna missed more than one Sunday service at Chelsea Old Church. He, too, visited, while the Gellibrands, Leylands, and other concerned friends sent hampers full of jellies, fruit, eggs, and spirits. Finally able to rise for a while each afternoon, Anna mused as she brushed her grey hair, "I see verified . . . the chastening which is the lot of all the human race, beauty to consume away & to become ashes."[18]

July brought a second, less deadly but severely painful illness when Anna suffered an attack of erysipelas, a highly contagious febrile disease that causes acute inflammation of the skin. Blisters the size of hen eggs formed on her eyebrows and ears. Though the summer was damp and cool, she required a constant fire. Her breathing became labored; a heavy cough settled in her chest; at times, she lost her voice. In August, Willie, in consultation with other physicians, decided she must leave London for a warmer climate and purer air. Jemie carried her down the stairs to a waiting carriage, bound for the Charing Cross railway station and a train to Hastings, in Sussex. Anna rested comfortably in the plush car, pulled by a locomotive more powerful than her husband could have imagined. She could not have known it, but this would be her final journey by rail.[19]

William the Conqueror had found the beaches of Hastings largely deserted when he arrived in 1066. By 1875, it was one of several fashionable resort towns, including neighboring St. Leonards, on England's southeastern coast. A. B.

Granville's 1841 guide to the spas of England had not thought highly of it as a place for sea bathing, but thirty years on and Hastings had become a mecca. The town's recent popularity could be judged by the numerous complaints made about aggressive "photographers and photographic touts" who pestered tourists to take their pictures for a shilling.[20]

It was a thriving town, too. A recent building boom had produced two new churches and a public bath. Its growing population of some 35,000 residents supported an Athenaeum that held fortnightly debates, a Philosophical and Historical Society, a Mechanics Institution, and two political clubs, the Liberal Club having been established a year earlier to complement the five-year-old Conservative Club. A school of art had opened in response to the increased interest in art across the nation, with drawing and painting lessons given in rooms above the town music hall. Hastings also had an active temperance society and a Christian association. Local newspapers regularly carried items about religious activities and concerts of sacred music. Should Anna's health require it, she could visit the private Pelham Baths, which boasted "hot and cold sea water and medicated vapours." The vapors cost four shillings, twice the price of a warm bath. Or she might try the chalybeate spring at St. Andrews Spa, "highly recommended by the most eminent medical authorities."[21]

Willie had been fortunate enough to find rooms for Anna in a private home rather than a boarding house, and on bluffs high above the ocean and bustling town. Oddly, Hastings' largest newspaper, which announced newcomers under the heading of "Fashionable Intelligence," informed readers that a "Mr. & Mrs. G. W. Whistler" had arrived to reside at 43 St. Mary's Terrace, though the editor could not say for how long (fig. 53). Neither could Anna. She assumed at first that the move would be temporary, like all of her visits to spas and bathing places, perhaps lasting through the winter. As it happened, she would spend the rest of her life in Hastings.[22]

She was comfortably situated, with a suite of three second-floor rooms, and cared for by a trustworthy, Christian landlady, fifty-four-year-old Janet Mudie, and her younger maiden sister, Elizabeth Price. A local physician, Dr. C. B. Garrett, a friend of Willie, checked on Anna's condition weekly. She had gained sufficient strength after a few weeks to release the professional nurse brought from London and take recuperative walks along the terrace. Boasting fifty numbered structures, besides some "small houses," the terrace sloped steeply downhill, south to north, with an inn, the Angel, sitting at the topmost end. Anna's chief goal, and a significant incentive to full recovery, was to worship at the Emmanuel Church, just one street over, but at the top of a steep incline.

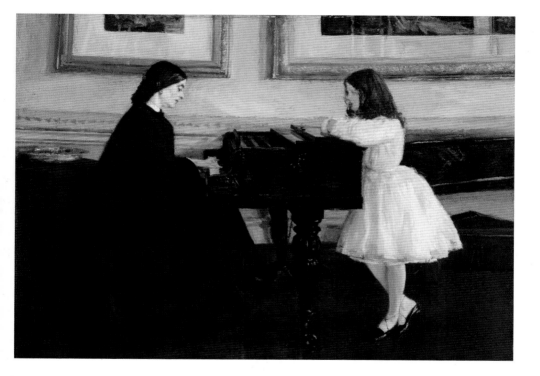

33
At the Piano, 1859, Jemie's painting of
sister Deborah Haden, aged thirty-four,
and niece Annie, aged eleven, at the
family's "Russian" piano.

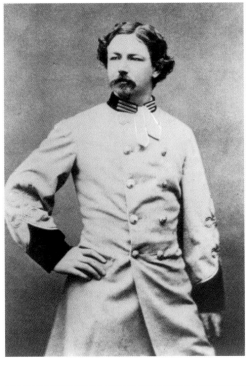

34
William McNeill Whistler in
Confederate uniform, c. 1863.

35
Capitol Square, Richmond, Virginia, 1865.
The Genet house was just east of the square.

36
James Whistler in a careless bohemian posture that always perplexed his mother, date unknown.

37
Francis Seymour Haden, Deborah's husband and Jemie's former friend turned foe, date unknown.

38
7 Lindsey Row
(now 101 Cheyne Walk),
Anna's first home with Jemie
in Chelsea.

39
The "Adam and Eve," Old Chelsea.
This 1878 etching and drypoint by
Jemie of the Lindsey Row waterfront
shows the tower of Chelsea Old
Church on the far left. 7 Lindsey Row
stood slightly beyond.

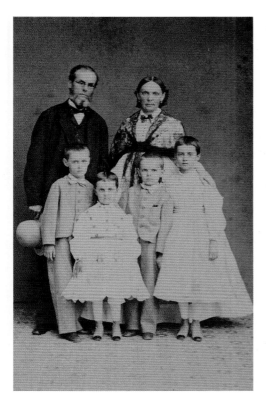

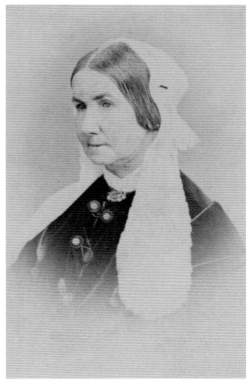

40
George William Whistler and family,
1864.

41
Anna McNeill Whistler when
in Germany, 1864–65.

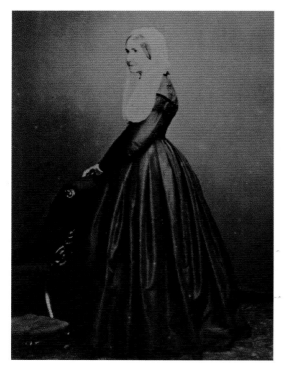

42
Anna McNeill Whistler in a
photograph dating possibly
from the mid to late 1860s.

43
2 Lindsay Row (now 96 Cheyne
Walk), Anna's second home in
Chelsea, and where Jemie would
paint her portrait.

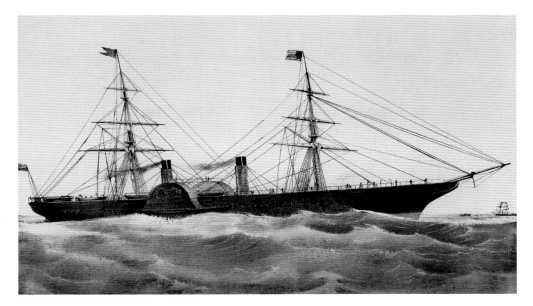

44
The *Persia,* the last ship to carry
Anna across the Atlantic.

45
Albyns, the country house of William
Gellibrand in Essex, England, and a place
of repose for Anna.

46
Frederick R. Leyland,
etching by Jemie, c. 1875.

47
Frances D. Leyland,
etching by Jemie, c. 1874.

48
La Mère Gérard,
etching by Jemie, 1858.

49
Anna McNeill Whistler,
etching by Jemie, 1871.

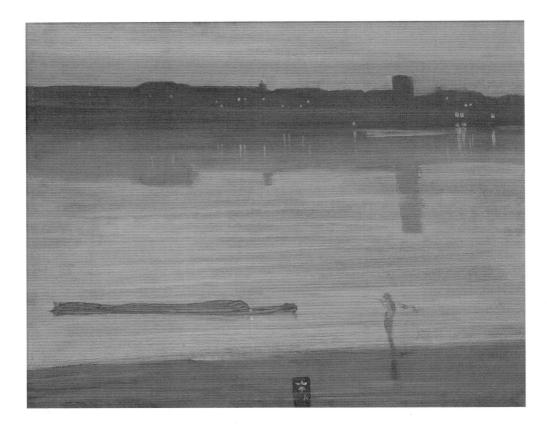

50
Harmony in Blue-Green – Moonlight (later
retitled *Nocturne: Blue and Silver–Chelsea*),
the painting done by Jemie with Anna's
assistance in 1871.

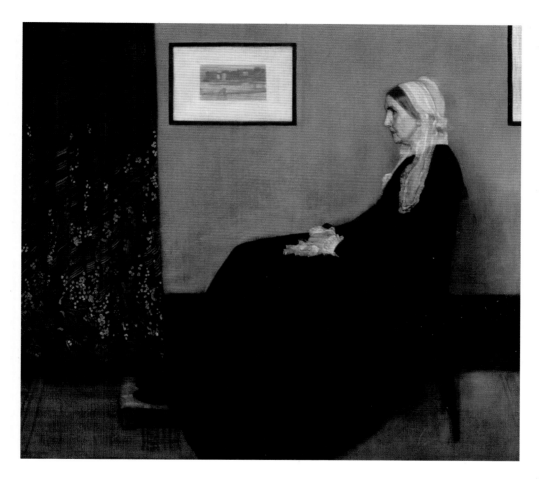

51
Arrangement in Grey and Black No.1:
Portrait of the Artist's Mother, 1871,
by James Whistler.

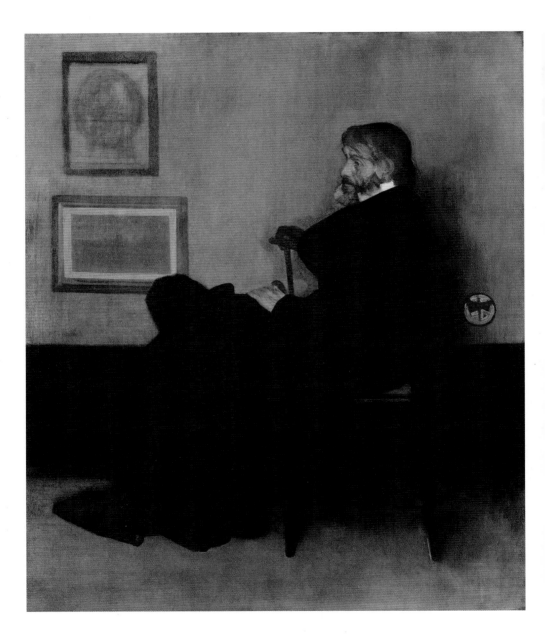

52
Arrangement in Grey and Black, No. 2:
Portrait of Thomas Carlyle, 1873,
by James Whistler.

53
43 St. Mary's Terrace, Hastings, England,
Anna's last home, from 1875 to 1881. No.43
is the middle house, with the bay windows.

54
William McNeill Whistler, the prominent
physician, date unknown.

55
Deborah Haden, c.1870s.

56
Annie Haden, after 1903.

57
Charles W. McNeill, the second
eldest son of Anna's brother Charlie,
date unknown.

58
James Whistler, 1885.

59
Eleanor Roosevelt as a
slumbering Anna, 1944.

60
One of many modern
caricatures of Anna, *The New Yorker*,
May 1996.

"[T]he walk around to it is not greatly beyond my daily stroll," she reported to the Gambles, "tho rather more up hill than I can yet attempt." In the meantime, Mrs. Mudie asked the vicar, August F. Benwell, who would soon be a neighbor at 37–38 St. Mary's Terrace, to visit Anna and for some ladies of her acquaintance to pay calls.[23]

Unexpectedly, Anna discovered two other Whistler women in the vicinity. She apparently never met the Mrs. Whistler who lived nearer St. Leonards, but a Miss Whistler became a "much valued friend." The latter lived in Hastings with two other women at St. Clements House, very near St. Clements Church. Anna thought she and Miss Whistler must somehow be related, and they certainly were kindred spirits. Her residence suggests that Anna's new friend was associated with the ministry of St. Clements, and she did serve on the committee of the town's "Convalescent Home," on the same street as the church. The home offered board, lodging, and medical advice for ten shillings weekly to a "class" of women that included dressmakers, schoolmistresses, mission women, and servants.[24]

Family and friends in Great Britain and America assured Anna through letters and visits that they had neither abandoned nor forgotten her. People from whom she had not heard in years, including nephew Donald Fairfax, now an admiral in the U.S. Navy, wrote affectionate letters of encouragement. Willie made the three-hour roundtrip train ride from London as often as twice a week in the early months of her stay, later to write to her weekly. Debo became Anna's surest source of news from London, while Jemie wrote rarely and went to Hastings hardly at all. Instead, he sent greetings through other people. "[M]y dearest Mama," he excused himself when writing to acknowledge her birthday, "I always wish to write – but you know how my not writing is only the result of my utter abhorrence of the pen – and then I do work so hard!" It was not a good excuse, or even an honest one, but Anna understood.[25]

By the spring of 1876, friends and relations from afar were visiting. The Alexanders paid their respects while spending Easter in Hastings. The Gellibrands twice interrupted a holiday in Eastbourne, another of the region's coastal resorts, to see her. Summer brought grandson Georgie, this time accompanied by his new wife, Hetty. They spent a month with Anna, even sharing her rooms. That autumn, the Gambles came from New York.[26]

Anna knew by then that Hastings would remain her home. Providence, she decided, had led Willie to the Mudie home, and she was content it should remain so. She told Jemie, "My enjoyment of the loveliness of nature surrounding me is so concentrating" that a return to London held less and less appeal. "Tell

Willie I feel better for the serenity of nature," she continued. "I breathe the soft air with ease & . . . the deep blue sea beyond the green slopes [is] so refreshing. I never weary of such sameness, or feel lonely." In as much as London's deadly atmosphere would become ever more "dark and hopeless" as the city's population grew, Anna was well out of it.[27]

Her biggest regret was that she could not play a more active role in the lives of her children. She began to feel like a mere onlooker. She missed, for instance, Debo's piano recital, accompanied by Polish violin virtuoso Henryk Wieniawski, at a benefit musical soirée in London. It was also more difficult to correct and guide her children from this distant outpost. Hearing that Jemie, heedless and careless as ever, had neglected two South Carolina cousins who were visiting London, she scolded him for his lack of "politeness & hospitality."[28]

As she soon learned, though, Jemie was immersed that summer in his most spectacular and promising commission to date. Frederick Leyland had asked him to decorate the dining room of his new London house, and the artist was enormously proud of the results. Everyone who saw what would be known as the Peacock Room, he assured her, including Debo and the Alexanders, were "amazed and delighted" with his progress. He did find time to spend one day in Hastings, and when he wrote, he confessed his neglect and promised, as he had done when seeking forgiveness as a boy, to do better. "I think of you constantly and wish always to go down to you and tell you how I love you," he insisted. "I am always your fond son."[29]

They both knew, too, that the £2,000 promised by Leyland for the completed work would help wipe out the son's mounting debts. Anna had done her best, and with admirable results, to keep Jemie's finances in check while living with him. However, a year without her restraining hand and watchful eye had produced a crisis. Free of his mother's presence, he had returned to the unbridled artist's life he had enjoyed before Anna's arrival in London. Emilie Venturi, who had always thought the "propinquity" of mother and son a bit odd, almost rejoiced to see Jemie return to "his evil ways," but his frequent and costly entertainments spelled financial disaster.[30]

Whatever Anna may have heard of his renewed habits, she could not feel too harshly toward a son who sounded so enthusiastic about his work and future prospects. "It is a long story, my dear mother, and one of these days you will know how courageous I have been in these past years of tribulation and heartbreaking discouragement," he told her both in atonement and hope. "The reward I believe, though, I now feel dawning upon me, – and . . . I believe . . . you will rejoice with me, not because of the worldly glory alone, but because of the joy

that you will see in me, as I produce lovely works." He begged for just a "little more" of her "long forbearance and patience," for when successful, he would at last "owe no one."[31]

Still acting the agent, Anna again made sure that news of his triumph reached America. Sending James Gamble an article from a London paper that lavished praise on the Peacock Room, she instructed him, "I think we must have an extract sent to N. York to appear in some journal for the gratification of our kind sympathizers." Perhaps the New England papers, especially in Boston and Lowell, she suggested encouragingly, would also promote Jemie's work. She made sure, as well, to tell Mary Eastwick, in Philadelphia, of this latest demonstration of the "Whistler genius."[32]

Anna knew, though, that very few people would ever enter Leyland's private dining room, and that the best proof of Jemie's artistry remained his paintings and etchings. She was personally taken with the "moonlights," even though they still bewildered many supposedly astute critics. She wished he would exhibit her own portrait more often, for it continued to find favor, even without being on public display. When the Duchess of Argyle, herself a sculptor, saw the painting in Lindsey Row, she asked Jemie to make a copy for her. He gave her, instead, one of the photographs he had been distributing to friends, agents, and potential patrons. And his etchings continued to rise in value, some of them to four times their original price. In sending Gamble the review of the Peacock Room, Anna enclosed a circular for a proposed set of new etchings. "[N]ot for you to apply to yourself," she emphasized, "but in case any one you have shewn your Collection to, may desire to avail of the opening."[33]

As for Willie, having finally passed the examinations required of him by the College of Physicians and College of Surgeons, he was now a "full pledged" medical doctor, on the permanent staff of Mackenzie's hospital in addition to conducting a prosperous private practice (fig. 54). Best of all, his financial stability allowed Willie, now forty years old, to remarry. Indeed, marriage was considered "a necessary part of a physician's professional equipment" in mid-Victorian London, a sign of his social standing as a gentlemen and an assurance that female patients could comfortably consult him. Jemie had *nearly* married three years earlier, having been engaged to Frances Leyland's younger sister, Elizabeth; but after a tumultuous courtship of nearly two years, the flirtatious Lizzie broke with him.[34]

Everyone was delighted, though, when Willie and twenty-seven-year-old Helen Ionides, a niece of one of Jemie's earliest patrons, announced their engagement in January 1877. The Ionides family also knew Willie and the Whistlers

well enough to endorse the couple's desire to marry as soon as practicable, which turned out to be April. Anna felt too weak to attend the ceremony – two of them, in fact, one each in Anglican and Greek Orthodox churches – but the thoughtful newlyweds spent a week of their "wedding holiday" with her in Hastings. Luke Ionides recalled that Anna "lectured" Helen, or Nellie, on the importance of attending church regularly, although, if true, that did not diminish the new Mrs. Whistler's fondness for her mother-in-law. She and Willie urged Anna to share their commodious new house in London, at 28 Wimpole Street, but she demurred, preferring, she explained, the "mild sea breezes" of the coast to "bleak & foggy" London.[35]

Meantime, Debo's life's was in tatters (fig. 55). She had never been physically robust, and now, in her early fifties, she spent many weeks each year seeking relief in Germany, Switzerland, or some temperate part of England. Nor was Haden the easiest man with whom to live. Though never physically abusive, Haden could be thoughtless, tyrannical and short-tempered. A year earlier, after nearly thirty years at 62 Sloane Street, he moved the family to Hertford Street, in Mayfair. Situated in a small maze of streets, the new locale was not nearly "so airy a place" as Sloane Street, but the neighborhood was more fashionable, where the "Grand MDs [medical doctors] cluster," said Anna with uncharacteristic sarcasm. Hinting at larger problems, Anna told James Gamble, "God loves whom he chastens & so my dear daughter experiences trial after trial, to render her more & more a lovely Christian." Just as cryptically, she noticed that Willie's loving and affectionate sister had been "sorry to decline attendance" at his wedding.[36]

Then came Debo's most severe trial. Two of her sons, Seymour, the eldest at twenty-six years, and Harry, the youngest at twenty-one, had recently emigrated to South Africa and Australia, respectively, to seek their fortunes. Anna cherished both boys as "very talented & free from evil habits," but they were adventurous. Harry, in particular, had chafed in his job in the mercantile world. He decided to try sheep farming, and seemed to be making a go of it when seized by an attack of dysentery on his twenty-second birthday. He died a few days later. Fortunately for Anna, his sister Annie was staying with her when the news came. What had been a thoughtful effort on Annie's part to relieve the "monotony" of Anna's life in Hastings became a time of mutual consolation (fig. 56).

Were that tragedy not enough to bruise the entire family, Anna then learned of the death of her sister Kate, aged sixty-five, in Stonington. The timing was doubly cruel because the eighth and final of Kate's grandchildren, Donald P. Stanton, had been born just a few months earlier. "The pain that centered around

my heart, the chill thro my poor feeble frame," Anna confessed to James Gamble, "I thought must be fatal. I could not weep, did nothing, said nothing." Luckily, this time, Willie and Nellie were with her when the news came. Kate Livermore arrived to comfort all three of them, and friends in America, most notably Meg Hill, sent condolences. As the visitors slowly drifted away, an invalid neighbor insisted that Anna join her in recuperative carriage rides.[37]

Anna also found solace in her charities, which, given the circumstances, offered a type of redemption or atonement for having again cheated death while so many younger people preceded her to Paradise. She supported several worthy causes in Hastings. "[W]e must have our local charities," she told Kate Palmer, "for the suffering poor around us as conscientiously cared for as our natural branches." Though financially strained, Anna donated her mite to help children "whose parents need[ed] all their pennies for daily food & clothing." This enduring concern for the welfare of the young also brought Anna in contact with Charlotte Murray, a "blooming young Lady" well known for writing hymns and spiritual poetry. Charlotte's father had opened a "Gentlemen's School" at 64 St. Mary's Terrace, on the far northern end of Anna's street. Flattered by Murray's own "fondness for the elderly American stranger," Anna made a habit of visiting the school. When she discovered a nephew and godson of the Alexanders enrolled there, she immediately invited him to dine with her.[38]

Among more distant causes, Anna became fascinated by the reform efforts of an Episcopal diocese in the American West. Centered in Utah, its missionary efforts extended into Idaho and Montana, where Anna hoped it might help rescue people from Mormonism. Similarly, she saw the death of Pope Pius IX in early 1878 as a sign that his type of religious liberalism, which disapproved even of Bible societies, might be swept aside. She shuddered, as she had done in Russia when confronted by the orthodoxy of the Greek Church, to see people "ignorantly worshipping the Virgin & Saints, in place of the only Intercessor." Warming to the possibilities of this "most eventful era," her enthusiasm led Anna to exclaim, "The power of Mahomet too is nearly ended!"[39]

In England, the work of Thomas J. Barnardo sparked her enthusiasm. The Irish-born reformer, who wrote frequently for *The Christian*, one of several religious periodicals to which Anna subscribed, had been working to educate, clothe, and feed destitute children and orphans in London's East End since the mid 1860s. Focusing at first on the welfare of young boys in the region of Limehouse, parts of which Jemie had so brilliantly etched early in his career, Barnardo soon brought girls into the fold. By the mid 1870s, he and his wife had created a girls "village" in Barkingside, complete with cottages, a school, hospital, and church.

Barnardo extended God's grace to adults by converting an East End pub into a People's Mission Church, where the working classes could enjoy nutritious meals, games, newspapers, and temperance beverages. On Sundays, he preached to thousands in the church's Great Hall. Anna supported this multifaceted ministry by purchasing several copies of Barnardo's weekly halfpenny newspaper and distributing them to family and friends. When he solicited funds to provide a thousand children with Christmas dinner, she persuaded Mrs. Mudie and Miss Price to join her in donating to the worthy cause.[40]

The future of some other children was even closer to Anna's heart. Stunned to have learned in 1876 of the accidental death of her nephew Donald McNeill, she asked the next eldest boy, Charles, who, aged thirty, was now titular head of his family, what she could do to help him (fig. 57). She sent his mother, Elizabeth, a copy of *The Christian*, which, when read aloud, Anna suggested, provided "a profitable way to spend an hour of a winters fireside circle." Not wishing to impose, she promised to send more issues only if Elizabeth welcomed it but assured everyone that the death of her brother Charlie, now eight years past, had not lessened her interest in the family's welfare. Anna only regretted that her impaired health and dependence on others for a home prevented her from doing more for the three youngest children, now in their middle to late teens. She had even thought of bringing one or both of the girls to England. "I am the last left of my generation!" she reminded Charles, "& my only ambition for my two sons, my grandchildren & nephews & nieces [is] that they may be true christians."[41]

Still perplexed by the plight of her brother's family, Anna's heart was touched in early 1878 by a childhood note from Jemie (fig. 58). She found it while reading a packet of old letters, something she did periodically, and which always induced a flood of memories, both sad and glad. The note from Jemie featured the words of Irish poet and songwriter Thomas Moore written out for her on the eve of his tenth birthday. The closing lines declared:

> *This heart, my own dear mother, bends,*
> *With love's true instinct, back to thee.*

"So may it be my own precious Jamie!" Anna wrote in reminding him of the occasion, "although during the 34 years since you copied the verses, you have as often let flatterers & the love of Fame usurp my place in your affections, this is a favorable time now for the connecting link to be cemented & let it never again be severed! for my term is short & yours uncertain."[42]

The timing of such a pointed reminder of filial duty was likely purposeful. Perhaps Anna hoped to spur a visit, and the note most certainly resembled others intended to emphasize the brevity of life. Equally, though, she wrote at another moment of looming crisis in Jemie's life, with his artistic and financial fortunes about to take a calamitous turn.

First, he had broken with the Leylands. Frederick Leyland, not nearly as impressed as Jemie's artistic friends with the glorious Peacock Room, had refused to pay more than half of the promised £2,000. An acrimonious correspondence ensued. A defiant Jemie, in Leyland's absence, opened the room to a "private view," added a bitingly satirical mural to one of the room's walls, and carried on a romantic affair with Leyland's wife. In the end, Frances, calculating her social and financial position, retreated from the possibility of scandal, but the breach between artist and patron was complete, with Jemie a further £1,000 in debt.[43]

Then came a public uproar over his new artistic direction. Both Jemie and his "moonlights," which, in keeping with the musical titles of many of his paintings, he now called "nocturnes," had been ridiculed in print by John Ruskin, generally recognized as England's foremost authority on art. Ruskin denounced him as an impudent Cockney coxcomb for daring to ask two hundred guineas for a recent painting (and easily his most revolutionary one), *Nocturne in Black and Gold: The Falling Rocket*. Anna would have endorsed many of Ruskin's theories. She could easily agree with his conception of the home as a "sacred place, a vestal temple," guarded and inspired by the ideals of "true womanhood." She would have understood, given her unsettled life, his belief that "home" was more a state of mind than a physical place. But this was not the first time Ruskin had derided her son's work, and Jemie now sued him for libel.[44]

Both events – the break with Leyland and the clash with Ruskin – were inextricably tied to Jemie's debts. He had desperately needed the full payment for the Peacock Room, not only to pay his poulterer, wine merchant, and tailor, but also to meet the costs of a new house he had commissioned. Not by chance, he sued Ruskin for the same amount, £1,000, owed him by Leyland. Anna's first definite hint of the financial implications of all this came in the summer of 1878, a few months before the trial, when she received a demand for nearly twenty pounds in back rent from the now abandoned home in Lindsey Row.[45]

If she did not know all the details of this complex drama, Anna became intimately affected by its results. Even the Hastings newspapers reported the Ruskin trial. Jemie won his case but received a mere farthing in damages, a reflection of the judge's estimate of his reputation as an artist. Most of the nation had a

good laugh at the expense of both Ruskin and Jemie. The caption for a *Punch* cartoon opined, "Naughty Critic, To Use Bad Language! Silly Painter, To Go To Law About It!" The leading Hastings newspaper reached a similar conclusion, although it tended to agree with Ruskin's criticism of Jemie's art. "He may often be one-sided," the paper said of Ruskin, "always peculiar, verging on eccentricity, . . . but he is ever earnest, seeking after high ideals." Anna might well have protested that the same could be said of her son.[46]

Far from a laughing matter, the consequence for Jemie was bankruptcy. He lost his house, his collection of "blue and white," his works of art, everything. Though not irrevocably sacrificed, even Anna's portrait had to be used as security for a paltry loan of a hundred pounds through print dealers Henry Graves & Company. His only hope was a fresh start, which came by chance when the recently established Fine Art Society agreed to finance a trip to Venice in return for a set of etchings from the city. Before leaving London, in September 1879, Jemie spent two days in Hastings. Anna did not know when she might see him again.[47]

Anna relied on neighbors and her immediate world for diversion. "I form no plans, for my term of days seem to me to be drawing to an end," she confessed to nephew Charlie McNeill. She could still manage the walk to Emmanuel on Sundays, and however fragile her health, she knew she was immeasurably better off than in London. "[T]he country is hilly & beautifully green with the sea all around the town," she assured her nephew. "This West hill is sheltered from east winds, which are so injurious on all other coasts of England." Winter, too, touched this southern coast more lightly. Looking out her front bay window, she could see, year round, green pastures sweeping down from the terrace toward the streets of town.[48]

And the town continued to grow, even becoming a bit pretentious. Between 1875 and 1880, St. Mary's Terrace added seven new numbered properties, and several residents adopted distinctive names for their homes. Janet Mudie christened No.43 as Talbot House; next door, No.42 was now St. Mary's Villa. Further along the street, one found Farncombe Villa, Nevill House, Castle View, and others. The city directory, besides listing the names of individuals, had a separate "House and Villa Directory." In 1878, Thomas Brassey, son of one of England's railroad pioneers, and himself the member of Parliament for Hastings, commissioned an ornate Venetian Gothic-style institute building that would bear the family's name. It was due to open in 1881.[49]

Anna most appreciated an unexpected addition to her enclave of friends. The references are inexact, but a Mrs. Hooper, an "old cronie" that Anna had first

known in Philadelphia, took a house at 46 St. Mary's Terrace. The women had earlier been reunited in London, when Mrs. Hooper rented apartments near Lindsey Row during the winter of 1874–75. Hooper, perhaps also suffering in health, moved to Hastings around 1879 so that she and Anna might enjoy the same "cheery companionship" they had shared in London.[50]

Equally unexpected was a visit from an even older friend. James B. Francis had been hired as a young man by Whistler to work at the locomotive works in Lowell. When the Whistlers moved on, he remained in Lowell to become one of the world's foremost hydraulic engineers. He also remained grateful to Anna's husband for launching his career, and kept a portrait of his "old master" hanging on an office wall ever after. Chancing to be in London at the time of Major Whistler's death, Francis had helped Anna and the children work through their grief. He had already purchased the family's old house in Lowell, where he raised his own family and tried to replicate Anna's garden.

When Anna learned that Francis was visiting London in the summer of 1879, she asked him to call on her. More surprising was her reason for summoning him. According to Francis, Anna's letter said she wanted to discuss her funeral arrangements with him. She wished to be buried beside her husband in Stonington, and while she had already mentioned the matter to the Livermores, Anna thought Francis could "do what was needful in America." Yet, once seated comfortably at St. Mary's Terrace, Francis found Anna eager to talk about anything other than the main issue. She treated him to a very nice lunch, and they chatted pleasantly, but despite his efforts to steer the conversation toward "the particular matter," nothing was said of it by the time he left. There being no reason to doubt Francis's account of the meeting, or Anna's reason for asking him to call, the question arises as to her state of mind. Had she forgotten the reason for inviting him to Hastings? Or had she changed her mind about being buried in Stonington?[51]

For much of the rest of that and the following year, Anna awaited word of Jemie's progress in Venice. He wrote to her directly only a few times, more often enquiring after her health and sending his love through Debo and Nellie Whistler, Anna's most usual correspondents. Conceding yet again his negligence, he instructed Debo on one occasion, "[Y]ou must pass on to dear Mother ... this greeting from the generally-misunderstood-though-well-meaning-yet-difficult-to-explain brother Jim!" Responding to a setback for her health in March 1880, he told Nellie, "I do hope and trust that the Mother will not be ill again – and dear me I have so meant every day to write – but I am worked to death."[52]

Of course, all was forgiven when Anna received a letter of her own, filled with gossip about the important people he had met and descriptions of the beautiful things he was creating. He wrote of their family and friends and about days past, in one instance comparing a Venetian rainstorm to one they had experienced together on the Isle of Wight, when torrents of water ran down clefts in the chines. And again, the dutiful plea for absolution: "I received your nice Christmas card Mama dear – and meant to have written at once to tell you how gratified I was – but it is the same old story dear Mother I am at my work the first thing at dawn and the last at night, and loving you all the while though not writing to tell you."[53]

Yet, other than a brief visit soon after his return to London in mid November, Anna saw and heard little of Jemie, who immersed himself almost immediately in preparing two exhibitions for the Fine Art Society. First came an etchings show, in December, to be followed by one for his pastels, which was slated to open in late January 1881. He used part of his slender profits from the etchings exhibition to pay down the remaining debt on Anna's portrait.[54]

The far more successful pastels show opened to the public on January 31, the same day that Anna died, aged seventy-six. Her sons and Nellie had rushed to Hastings when told the end was near, but they arrived too late to say goodbye. Willie had to return to London almost at once, but Nellie remained to help a badly shaken Jemie arrange for a funeral at the borough cemetery, not Stonington. Anna's passing stirred little public notice. The principal Hastings newspapers verified her death several days later in their standard obituary listings, where she was identified only as "the widow of Major George Washington Whistler." The same description appeared in New York and London papers. Nothing was said about a funeral service or her place of internment. The death on the same day of Elizabeth Cloak, a ninety-three-year-old Hastings resident who kept a small sweet shop in town, received more attention. The papers devoted extensive coverage to the passing of Anna's old Chelsea neighbor Thomas Carlyle when he died a few days later.[55]

The borough cemetery sat two miles north of town. No account of the funeral conducted by Rev. Benwell has survived. We may assume that all the family in London attended. Doubtless, Mrs. Hooper, Janet Mudie, and Elizabeth Price joined them. Quite possibly, Kate Livermore, the Gellibrands, members of the Ionides family, and other friends within a day's journey of Hastings also assembled at the graveside. In their turn, Willie, Nellie, and Nellie's aunt and uncle, who moved to Hastings around the same time as Anna, would be buried in the same cemetery. Jemie chose to be buried with his wife Beatrice, whom he married

in 1888, in Chiswick. He does not appear ever again to have visited Anna's grave, not for lack of affection, but because he dreaded death. He excused himself from Willie's funeral in 1900 for the same reason, although he said it was because he had only just recovered from a severe case of influenza, the illness that killed Willie. But while Anna had gained the eternal life she believed in so fervently, Jemie, as things turned out, had immortalized her.

10
Icon
1881–2018

ANNA'S PORTRAIT WAS "PRETTY WELL KNOWN" by the time of her death, even though few people had seen it outside of the two public exhibitions of 1872 and 1874. Whistler (as we shall now call Jemie) allowed a mezzotint engraving to be made in 1879, but sales had hardly begun when his bankruptcy threw the issue of copyright into confusion. With Henry Graves still in possession of the painting, Whistler could not even be said to own it. The public, then, knew the picture mainly through reproductions in newspapers and magazines.[1]

Yet, people who had not known Anna personally remained largely indifferent to the portrait. Shortly after the Ruskin trial, Frederick Wedmore, a critic who thought more of Whistler's etchings than his paintings, judged that neither the Carlyle nor *The Mother*, which were almost invariably mentioned together, would stand the test of time. "Paintings like some of the 'Nocturnes' and 'Arrangements,'" Wedmore predicted, "are defended only by a generous self-deception when it is urged for them that they will be famous to-morrow because they are not famous to-day. Alas! How much of the Art around us has that credential to immortality!"[2]

Nonetheless, Anna's portrait, hidden from view for so long, began its bid for immortality barely a year after her death, and in her "native land." While Whistler's etchings were widely admired in the United States, only one of his paintings, *The White Girl*, had been exhibited there. Consequently, curiosity was building, thanks as well to a laudatory article by William C. Brownell, one of Whistler's earliest American admirers and soon to be one of the nation's foremost literary and art critics. The article appeared in *Scribner's Magazine*, one of the

country's most popular periodicals in 1879, the same year as Wedmore's article. Brownell did not single out Anna's portrait for praise, but he did describe both it and the Carlyle as genuinely complete "pictures," with their "pictorial quality . . . as prominent as the portraiture."[3]

Two years later, the Pennsylvania Academy of Arts decided it was time to show a Whistler. They asked Anna Lea Merritt, a thirty-seven-year-old, Philadelphia-born artist who had worked in Europe and England since 1865, to "persuade" Whistler to give them something for a planned exhibition of American painters. Merritt, who had lived in Chelsea and knew Whistler, did not ask him specifically for *The Mother*, and Whistler never explained why he offered it. Perhaps Henry Graves urged him in hopes of a sale, but Whistler, despite later rumors, never intended to give up the picture.[4]

As had happened in England, critical appraisals of the painting were colored by personal reactions to the artist. Most people conceded that it was an "important" work, and some of them saw in it the human qualities that would eventually define the painting, namely, the gentleness of motherhood, the "grace of old age," and a vague spirituality. But the timing of the show was unfortunate. Coming as it did in the aftermath of the Peacock Room, Ruskin trial, and Whistler's noticeably more combative public posture after his return from Venice, some critics found it hard to judge him or his work fairly.[5]

That did not prevent the picture from being exhibited regularly through the 1880s, with stops in Paris (1883), Dublin (1884), Munich (1888), Amsterdam (1889), Glasgow (1889), and London (1889). By 1888, the picture actually belonged to Whistler, as he had finally paid off his debt to Graves. It won second-class honors at the Paris Salon and a third-class medal in Munich. An irritated Whistler protested both awards as beneath the picture's (and his own) dignity. He had hoped for nothing less than the Légion d'honneur in Paris, and he urged friends in Germany to lobby for something similar in that country. Learning that he had been "deeply wounded" by the "second-class compliment," influential German politicians and artists secured the Cross of St. Michael of Bavaria and honorary membership in the Royal Academy of Munich for him.[6]

This apparent lack of respect began to change in 1891, when a group of young Scots artists, soon to be known as the Glasgow Boys, persuaded their city to purchase the Carlyle portrait for 1,000 guineas. The sale inspired other of Whistler's admirers and friends to launch a quiet campaign to put Anna's portrait in Paris's Musée du Luxembourg. Given that French reaction to the painting and Whistler's work generally had been relatively more positive than in either England or America, the scheme made sense, and it worked. A combination of

dealers, politicians, artists, and writers, mostly French, collaborated, intrigued, and negotiated until the French government offered Whistler 4,000 francs for *The Mother*.

The sum equaled less than £200, but Whistler ignored the insult this time. As he later said, "[O]ne cannot sell one's Mother." He knew, too, that the painting would be transferred to the Louvre after his death, which, he insisted, was the highest honor an artist could receive. It was the perfect retort to Ruskin, the critics, and anyone else who had ever doubted the genius of Anna's son. Some Americans were embarrassed that the painting had gone to France, and an English critic regretted that his nation, by showing Whistler less respect than he deserved, had driven him into the arms of the French. "[It] is to France's honour and to England's shame," he said, "[that] perhaps the greatest portrait of the century has found a permanent home in Paris."[7]

Equally flattering, if more subtle, tributes came from Whistler's fellow artists, who appropriated the composition of the painting, especially Anna's pose, for their own pictures. Twenty-six-year-old Cecilia Beaux, two years after having seen *The Mother* at the 1881 Philadelphia exhibition, based a painting of a mother and child on Anna's portrait. More seasoned painters, including Thomas Eakins, Whistler's erstwhile friend William Merritt Chase, and John Millais, who had earlier borrowed from *The White Girl*, also copied the composition. In later years, Thomas Dewing, Stacy Tolman, and Xavier Martinez did little to disguise their adaptations of Anna's portrait. Henry Ossawa Tanner, another young artist who, like Beaux, had attended the 1881 Philadelphia show, painted his own *Portrait of the Artist's Mother* in 1897. Intriguingly, Tanner, an African-American, probably knew nothing of Anna's Southern roots or slave-selling ancestors when he immortalized his mother, the daughter of a slave.[8]

Yet, by the time of Whistler's death, in 1903, Anna's portrait had to compete for attention with another thirty years of his dazzling oils, watercolors, pastels, etchings, and lithographs. It seemed less unique, if not simply taken for granted. Everyone conceded the picture's greatness but almost in passing, as though willing to concede the point in order to discuss more interesting examples of Whistler's art. Few critics reflected on *why* the painting had become "renowned." Instead, they fell back on such patently vague descriptions as "its purity of color, its flawless execution, and its noble style." Many of them continued to couple it with the Carlyle, or used the two paintings to contrast competing tensions in Whistler's work. Carlyle represented a "revelation of intellect," as opposed to the "intense pathos" and "tender depth of expression" in Anna's portrait. Carlyle

revealed the "masculine side" of Whistler's art, while *The Mother* was "more sensitive," the "most poetic and lovable of filial tributes."[9]

Most people missed the secret to the picture's popularity: it appealed to both artists and the public, even if for very different reasons. Théodore Duret, the French critic and collector, understood the connection. He had been one of the leaders in convincing his government to purchase Anna's portrait, besides having stood for his own portrait with Whistler. Reflecting on the *The Mother*'s impact at the Salon of 1883, the first time it was shown in Paris, he observed that Whistler "had the good fortune to please both the people who knew and the crowd." Continuing, Duret explained, "The old lady, seated in so simple a pose, arrested the common herd by its expression of pathos, while as for the artists and connoisseurs, they loudly praised the harmony and transparence of the greys and blacks, in which was revealed the mastery of a man who obtained the most powerful effects by the most sober means."[10]

After having been confined to the Luxembourg since 1891, the painting made brief but important encores in 1905 at retrospectives of Whistler's work in London and Paris. Unfortunately, Anna tended to be swallowed up by the daunting scale of the shows. The few critics who commented specifically on her picture tended to be longtime Whistler advocates. For instance D. Croal Thomson, who had promoted the artist's work in the *Art Journal* (which Thomson edited), declared, "Nothing more delicately wonderful in quiet dignity has ever been set on canvas." Artist and art critic D. S. MacColl, who had been known to enjoy a glass of absinthe with Whistler, emphasized the picture's painterly, rather than its human, qualities. In that context, he compared it favorably to *At the Piano*, a long overdue observation that had eluded critics until able to see the two paintings in the same exhibition.[11]

However, even as the significance of the painting as art seemed to wane, the importance of Anna as subject became more fixed. Rather than being narrowly viewed as an elderly lady or Whistler's mum, she embodied by now two universal qualities. First, she symbolized the poignant dignity of old age. A leading American art critic, English-born Charles H. Caffin, declared, "She gazes with tranquil intensity beyond the limit of our comprehension along the vista of memories, leading back through maternity to a beautiful youth." Other observers credited the picture's status as a masterpiece to its "beautiful and complete study of old age, tender and pathetic"; they marveled at how "[t]he benignity, fortitude and resignation of old age transpire from every detail."[12]

More often, Anna symbolized the universal mother. The earliest statement of this elevated status came from a retrospective of Whistler's work in Boston, held

in 1904, a year before the London and Paris shows. Intriguingly, Anna's portrait was not included in the exhibition. Yet, so closely had it become tied to her son's reputation that, despite its absence, some reviewers felt compelled to comment on *The Mother*. Most notably, Kenyon Cox, an artist, teacher, and critic who had not seen the picture in ten years, believed that the humanity of the portrait made it "a type of *the* mother ... for all of us, or as we should wish her to be." This *idealized* image of motherhood, Cox concluded, was "far more important than any 'arrangement in gray and black,' however exquisite," in explaining the painting's power and popularity.[13]

The pigeonholing of people, and particularly women, as recognizable "types" had become a popular way to make sense of a rapidly changing world. In America alone, the "New Woman," "American Girl," "Beautiful Charmer," "Woman Militant," and "Normal American Woman" were all visually defined in popular magazines and illustrated newspapers, and on sheet music and advertising posters. Interestingly, Anna did not initially fit the image of the "American Mother," who, while a source of "purifying and ennobling influence," was generally pictured as a younger woman. That began to change in 1910, when her ties to old age were gradually overshadowed by an alternative ideal of motherhood. A popular English periodical of that year went so far as to proclaim Anna a symbol of "mother-worship," and "typical of how the mother is viewed ideally to-day – the mother as the Giver of Life, the Bringer of Peace." She was certainly a welcome antidote to disquieting images of the New Woman.[14]

Yet, as recognizable as Anna had become as both painted image and "type," people still knew little about her as a person. Typical of her treatment was an 1895 article tracing Whistler's ancestry. Titled "The Genesis of Jim Whistler," it focused almost exclusively on the blood lines and life of his father. Anna was not mentioned until the final page, and only then as George Whistler's second wife and sister of William Gibbs McNeill. Even old friends, followers, and students of Whistler who published their recollections of him said little about Anna, although this was partly because so few of them had ever met her. Albert Ludovici, a close friend in the 1890s, could "well imagine" Whistler's devotion to Anna, but he based his judgment on stories he had heard about mother and son and on Whistler's unfailingly courteous behavior toward women, especially "elderly women."[15]

The situation showed promise of changing in 1908 with publication of Elizabeth and Joseph Pennell's *Life of James McNeill Whistler*. Based largely on Whistler's musings, the reminiscences of friends, and the Pennells's personal acquaintanceship with him during the last decade of his life, the book was more chronicle than biography, a manifesto rather than a balanced or entirely accurate

account of the artist's life. The Pennells even altered the wording of some sources, including Anna's Russian diary, to accomplish their goal of turning Whistler into an untutored genius. Still, they discussed Anna's lineage, gave her a prominent role in Whistler's childhood, and reproduced a photograph of her.[16]

However, two other trends were more troubling. First, if Anna represented a "type," she had become a negative one for some critics. While most of the world had been persuaded that she must have been a perfect mother, and that her portrait documented the loving bond between Anna and her son, some contrarians looked for holes in those assumptions. While praising the painting as art, they turned Anna's pious demeanor on its ear by making her "the incarnation of Puritanism," a word which by the early twentieth century carried unflattering connotations in the United States. Anna became an old scold.[17]

Sadakichi Hartmann, a German-Japanese poet and critic, seemed most intent on cutting Anna down to size. In a book devoted to Whistler's life and work, he ranked her portrait as the artist's "most finished and perfect work" because it embodied the "reverence and calm we feel in the presence of our own aging mother," a "symbol of the mother of all ages and all lands." Yet, in speculating about the relationship between mother and son, Hartmann described Anna as "a stern Presbyterian" whose religious views "must have been trying to her son." That Whistler could see beyond "the old lady's strict Sabbatarian notions" and "rigid Quaker-like" fanaticism to create an ultimately "sympathetic pose" Hartmann found remarkable.[18]

The second, and in some ways more damaging, trend found *The Mother* becoming even more ubiquitous than it had been at the turn of the century. Photographs and cheap reproductions of Anna's portrait were so pervasive as to be ornamental, a tasteful, decorative touch to hang on the walls of middle-class homes. Much like a sampler that reads "Home, Sweet Home," her reassuring image rescued a room from "an unhomely and unfriendly look." The same English magazine that had acknowledged Anna as a symbol of "mother-worship" included a "presentation plate" of her portrait, complete with instructions for framing and mounting, in one of its Christmas issues. In this way, the editor boasted, a picture that had "cost next to nothing" to reproduce could be turned into a "charming" addition to any household.[19]

Still, something of the old deferential tone had been restored by the 1920s. When, in 1922, Anna's portrait was transferred from the Luxembourg to the Jeu de Paume, a small museum in the Tuileries Gardens, American visitors to Paris were aghast. Although the move was only temporary, and preliminary to the painting's scheduled transfer to the Louvre in 1926, they dismissed the Jeu de

Paume as a mere "annex," decried the lack of respect shown in moving the picture there, and charged that the portrait had been poorly hung. By contrast, back home, Anna's portrait graced the cover of an American magazine, the *Literary Digest*, for the first time in 1928.[20]

The picture was highly regarded in England, too, as shown by a 1927 debate over the value of hanging reproductions of famous paintings in the nation's schools. The goal was to bring children "in contact with beautiful things," and after scrutinizing scores of pictures to determine which ones best suited the various stages of child development, a national review board judged Anna's portrait most appropriate for older children. Its "subject-matter" was less important than Whistler's "method of treatment," said the experts, and it was a picture students would hear mentioned all their lives.[21]

More importantly for Anna, the decade increased public knowledge of her life. In 1925, the *Atlantic Monthly* published selections from nineteen of her letters to members of the Gamble family. Offered without commentary or context but aptly titled "The Lady in the Portrait," it was the first time Anna had been presented to the public free of her son's biography. Around the same time, Whistler's birthplace in Lowell made national news. The landmark had been purchased in 1907 by the Lowell Art Association for use, after restoration, as an "art centre" and gallery. In 1926, a grandniece of Whistler, herself an artist, donated an exact copy of *The Mother* to the centre. In an oddly phrased message of gratitude, the association said it was thrilled to have this "poignant reminder of the woman who did most to make the house famous."[22]

Given this build-up, it is strange that a sudden spurt of stage plays about her son, produced in the United States and England beginning in 1920, did not include Anna as a character. With such titles as *The Wasp, The Baronet and the Butterfly*, and simply *Whistler*, they opted, instead, for portrayals of Ruskin, Swinburne, and Oscar Wilde in plots that revolved around such episodes as the Ruskin trial and the painting of *The White Girl*. The most serious bid for success came in 1931, with a script by Pauline Hopkins and Sarah Curry. Described as a "romance with a comedy turn," *Mr. Whistler* featured opera baritone and actor Richard Hale as Whistler. It played well in Baltimore, but when a Chicago engagement was cancelled, the play disappeared, at least for the moment.[23]

Still, the stage was set, so to speak, for what can best be described as the Anna Craze of 1932–34. It began when France allowed her portrait to be exhibited in the United States, its first trip across the Atlantic in a half century. Americans went wild. "Whistler's 'Mother' Comes Home Again," announced the *New York Times*. A. Conger Goodyear, president of New York's Museum of Modern

Art, where the painting would form part of a retrospective of American art, praised the loan as "an act of international goodwill on the part of the French Government and a reaffirmation of the artistic solidarity of France and the United States." The Louvre rarely allowed its paintings to leave the country, but in the midst of a world economic depression, and with many countries, including the United States and Germany, blaming France for worsening financial conditions, French politicians saw the loan as a way to improve their world image. Anna had become a tool in international politics.[24]

The average American, though, saw Anna's portrait as a reassuring symbol of stability and reaffirmation of American values. The nation needed a nurturing mother-figure in such trying times, someone who expressed the "dignity and patience of motherhood." Whistler's painting, according to the *New York Times*, had already been adopted as "the symbol of mother of all ages and all lands," but as an American mother, Anna also fueled a sense of national pride.[25]

Some people, refusing to be swept up in the sentimentality, were drawn to more contemporary works in the exhibition, such as Grant Wood's recently completed *American Gothic*, but by the time the show closed, over 100,000 people in three months had flocked to see Whistler's "American holy icon." So many other cities clamored to display the picture that the Louvre extended its loan to mid May 1934. From New York, the painting toured the country, with stops (in order) in San Francisco, Los Angeles, St. Louis, Columbus (Ohio), Chicago, Cleveland, Kansas City, Baltimore, Toledo (Ohio), and Boston before a final viewing in New York. By the time Anna's portrait was returned to France, more than two million people had seen it.[26]

The frenzy surrounding the tour could be seen not only in the long gallery queues, but also in the elaborate security precautions used to protect a painting that had been insured for one million dollars. In Chicago, state militiamen transferred the painting in an armored car from the railroad depot to the Art Institute of Chicago, where the men posed in front of its still sealed packing crate for photographers. Iron railings and electronic alarms protected the painting once hung in Chicago, while armed guards were used by another gallery. In Boston, the painting was removed each night to a vault and protected by a pair of Belgian shepherds.[27]

The tour was capped, if not positively crowned, in May 1934 with the issuance of a U.S. postage stamp bearing Anna's image. President Franklin D. Roosevelt, who was elected during the painting's first week in New York, had personally endorsed the design to commemorate Mothers' Day, which fell on May 13. As it happened, 1934 was also the centenary of Whistler's birth, a perfect occasion for

his face to have adorned a stamp, but that would not happen until 1940. For the moment, Mother had eclipsed him.

The United States had established Mother's Day as a national holiday in 1914. Anna Jarvis, the southern-born woman who led the campaign, had conceived of it as a semi-religious occasion, to be commemorated on a Sunday with "special services" held in churches across the land. Although, like most holidays, the event swiftly fell victim to commercialization – most notably by florists and the greeting-card industry – Jarvis's work had been inspired by the memory of her own mother, whose life was said to have been "a beautiful emblem of Christianity." Something similar happened in Great Britain, where Constance Penswick-Smith, inspired by Jarvis's example, resurrected the centuries-old tradition of Mothering Day, with which a British Mothers' Day soon coincided.[28]

Although neither Jarvis nor Penswick-Smith associated Anna's image with Mother's Day, one might have predicted rejoicing over her postage stamp. Instead, the American art community went apoplectic. The stamp's cropped design eliminated every detail of Whistler's painting, save for Anna. Worse yet, a vase of flowers, sitting at her feet, had been gratuitously added. Whistler would have been struck dumb by the "mutilation." As one wag put it, "The old gray *mère* ain't what she used to be."[29]

Perhaps to mute the outcry, Roosevelt dispatched his mother to view the picture during its final stop in New York. She agreed reluctantly to pose beside the picture for photographers and newsreel teams from both France and the United States. Consenting, as well, to comment on the painting for a national radio broadcast on May 15, Mrs. Roosevelt said, "I know it would give his mother great happiness to see her son appreciated and honored by his native land." Four days later, the picture was returned to France. Cole Porter summed up the American response to Anna's portrait later that year with his hit song "You're the Top," which jauntily decreed:

> *You're the nimble tread*
> *Of the feet of Fred Astaire,*
> *You're an O'Neill drama,*
> *You're Whistler's mama.*[30]

The tour, coming as it did during the centenary of his birth, revived the son's reputation, too, which had stagnated amidst Post-Impressionism, Abstraction, Cubism, Dadism, and all the other "modern" artistic movements of the post-World War I era. The defunct Hopkins-Curry play of 1931 was rewritten and

staged again in 1934, though with no better results, and still without Anna. Talk of a Hollywood film about Whistler then surfaced, and while nothing came of it, the very possibility grew as much from Anna's recent celebrity as from that of her son. "As the painter of the famous ... 'Whistler's Mother,'" declared an announcement for the intended film, "he has become an international figure." Whistler made it to radio in 1937 as part of a Federal Radio Theater series about famous painters, "Portraits in Oil." The half-hour dramatization centered on Leyland, the Peacock Room, and Ruskin, with no mention of Anna until the narrator's closing remarks, when he ventured that her portrait was copied "more than any other one painting."[31]

Inevitably, the extensive press coverage that accompanied the nineteen-month long tour encouraged new speculation about Anna's personal life, character, and her relationship with her son. More of her personal correspondence also surfaced, including perhaps the single most important of her letters to have survived. Written to Kate Palmer in November 1871, and discovered in an old desk in the Scarsdale cottage, it described the origins and creation of her portrait.[32]

Some of the most perceptive commentary on Anna came from journalist and novelist Anne Miller Downes, writing for the *New York Times* in the aftermath of the tour. In a story meant to offer a brief sketch of Whistler's life, Downes dismissed the oft-mentioned assumption that he had a "mother fixation." Nonsense, Downes said. Whistler simply admired his mother's moral strength and courage. They disagreed about many things, but "they respected each other's differences and found a common ground in her appreciation and understanding of his art." Equally, Downes suggested that Anna shared her son's artistic instincts, and that her own "poetic" nature had helped shape his own. Reading the newly discovered letters and Anna's well-known Russian diary, by then housed in the New York Public Library, Downes was struck by "phrases, sentences and even here and there single words" that showed Anna, as much as her son, had been "endowed with the 'seeing eye' – the artist's power of visualization."[33]

Less visibly, a descendant of Anna, Kate R. McDiarmid was busily adding to the world's knowledge of her. McDiarmid had begun collecting information for a biography of Anna in 1928. Her method mirrored the Pennells in that she contacted anyone who may have known something of Anna's life. The mixed results also mirrored the Pennells. Her book, which would not be published until 1981, well after her death, was a mishmash of rumor, family legends, and popular theories about Anna and her family, more chronicle or compilation than genuine biography. Originally titled "Mrs. Anna Whistler – Gentlewoman," the

manuscript was politely rejected by two commercial publishers, despite, as one of them said, the "distant charm" of Anna's story.[34]

Yet, McDiarmid deserves credit for her labors. She confirmed or discovered some intriguing facts about Anna, garnered especially from descendants of Anna's siblings, Kate Palmer and Charles McNeill. She might have learned more had not Elizabeth Pennell falsely told her that she knew nothing of Anna's surviving correspondence. Whistler's sister-in-law and the executrix of his estate, Rosalind Birnie Philip, was also less than forthcoming. And even if not publishing her work, McDiarmid gave public lectures about Anna's life and became an important resource for what would become the first published biography.[35]

That biography came in 1939, a year, coincidentally, when Anna also loomed large in a book about her husband. George Washington Whistler's biography might almost have been written as a reaction *against* the Anna craze. Its author, Albert Parry, a thirty-seven-year-old Russian émigré who had recently completed his PhD in history at the University of Chicago, despised Anna. He thought her manipulative and joyless, an altogether "power-grasping," "simple minded," "obnoxious," "spiteful," and "stifling woman." Reviewers of the book could scarcely credit Parry's "self-indulgent virulence." That he was a sloppy writer did not further his case. "His prejudices are extravagant," pointed out one critic, "his words and sentences are crude and grandiose, his indignation is ungoverned, his metaphors are mixed." Why Parry should have pounded Anna so mercilessly is unclear, although he was apparently repelled by the "puritanic faith" that guided her life.[36]

Anna's biography, as one might expect, better fitted the image held by her adoring public. The author, "Elizabeth Mumford," was actually two people, Bessie Judith Jones and Elizabeth Herzog, with Jones being the wife of acclaimed literary scholar and Harvard professor Howard Mumford Jones. The women, having become fascinated by Anna, wished to "call back from the shadow of obscurity and the fog of legend the woman behind the portrait." They made a good effort. By contacting some of the same people as Kate McDiarmid, as well as McDiarmid herself, they assembled a reasonable chronicle that, in the words of one reviewer, helped bring Anna "to life." In that respect, Mumford succeeded in having Anna recognized as a "vitally interesting woman" and "a personality in her own right." However, reviewers also thought the book lacked depth. It was uncritical, overly sentimental, written in a "fulsome" style, and lacked documentation of any kind.[37]

Mumford, along with McDiarmid and other of Anna's admirers, had also set her up for the inevitable fall. No one would again attack her in the manner of

Parry, but as a symbol, type, and now icon, Anna was in an even more precarious position than when her image was simply taken for granted. A forewarning came in 1919, when Marcel Duchamp adorned Leonardo da Vinci's *Mona Lisa*, the closest comparison to Anna as an icon in portraiture, with a mustache and goatee. Anna, too, was now ripe for caricature, parody, and exploitation.[38]

It was a defining moment, this almost imperceptible transformation from famous painting to icon. The word itself is fraught with difficulty. Having long been associated with the sacred, its meaning since the early twentieth century has shunned religious subjects entirely. Instead, a complex amalgam of factors, often imperfectly applied, decides which work of art shall be iconic. Some factors have little to do with the work itself. The composition, spatial properties, color, tone, size, or style of a painting carry far less weight than one might expect. Pictorial conventions, how a canvas is treated, the material space on which the painting rests may all set it apart as a masterpiece, but an icon requires more. Where a picture is kept and exhibited, for instance, can be crucial, imparting as it does a degree of prestige, a validation of the painting's merits. *Who* painted it also counts for much. The artist is usually someone of note, even notoriety, recognized as a master with a catalogue of other great works. The whims of the market may even tip the scales.

Most important, though, is what the picture tells us, or rather, suggests. It must be symbolic, emblematic in ways that hint at universal truths or values. It imitates elements of the human condition recognized by all. At the same time, it must be enigmatic, equivocal, containing enough ambiguity to nurture doubt about its meaning and leave something to the imagination, a truth to be interpreted in light of personal experience. It is the tension between these two factors – universality and ambiguity – that separates the icon from the masterpiece. It may or may not evoke an emotional response, but it must stimulate thought, force the viewer to confront its meaning. That meaning also may differ from the artist's purpose, which, concerning Anna's portrait, is certainly the case with Whistler.

Ironically, this delicate balance between universal truths and inexactness is also what makes an icon suited to parody. The possibility of widely varying interpretations allows us to tamper with that balance in extreme ways, to turn the sacred into the profane, and so, strangely enough, confirm the immutable nature of the original. Once Anna's portrait, like the *Mona Lisa*, was viewed in that light, as a part of popular as well as high culture, her immortality was assured. And it happened quickly, barely a half century after being created, making *The Mother* one of the first "modern" paintings, and easily the first modern portrait,

to be both treated as an icon and abused by the iconoclasts. Fittingly, the son who had placed her in that situation was, during his lifetime, perhaps the most caricatured artist in history.

A few cartoonists had made fun of Anna's portrait nearly from the start, but their target had been Whistler's painting style and philosophy of art, not the subject. The first attempts to exploit Anna as a symbol came during World War I, and, not unexpectedly, they played on the twin themes of motherhood and old age. A recruiting poster for the Irish Canadian Rangers used her portrait to represent the universal mother, needing only to add the legend, "Fight for Her" above her image. The other instance, nearly identical in format, was used to sell British war bonds. That caption read, "Old Age Must Come." Toward the end of the war, British poet Harry Tobias used Anna's portrait as the illustration for his sentimental ballad, "The Bravest of Them All," which concluded:

> *Though she did not fight a battle or use a sword and gun,*
> *Her sacrifice was mighty, for she lost her only son.*
> *When the time comes to reckon and Honor those who Fall,*
> *Will we think of the Mother, the Bravest of Them All.*[39]

Such patriotic borrowing was well enough, but by the mid 1920s, even as her portrait regained something of its earlier luster, Anna was used by commercial advertisers to sell their wares. Her picture was not alone in suffering this fate. As one U.S. advertising executive put it, famous paintings, instantly recognizable to millions, had become "the poor man's picture gallery" in consumer marketing. The earliest examples again came in Great Britain. It was done respectfully, with Anna's image invariably used to suggest a connection to motherhood, but old friends of Whistler objected. "I cannot refrain from expressing the great resentment I felt," declared Albert Ludovici, "on seeing his very fine portrait of her being used as a poster, and plastered over Tube stations advertising some commodity."[40]

Americans, at least, appropriated her image in more tasteful ways. The most monumental tribute – quite literally – came from a small Pennsylvania town in 1937. The Ashland Boys Association was an interesting organization, formed not of "boys," but of men who served as a support group for other Ashland men, most of them coal miners, who had been forced to leave the region in search of work during the Depression. Nothing better represented the welcoming embrace and nostalgic ties to home they wished to convey than a statute representing motherhood, and no one better fit that image than Anna. Designed and sculpted

by a pair of New York artists, her seven-foot-tall bronze likeness was placed high above the town center on a stonework terrace constructed by the Works Progress Administration, a New Deal agency for the unemployed. An inscription on the statue's marble base, taken from Samuel Coleridge, read: "A Mother is the Holiest Thing Alive." It stands there still.[41]

No one was inclined to mock Anna in the 1930s, but some potential gadflies, with a collective wink and nod, were clearly in her debt. For instance, a cartoon in the 1932 Mother's Day issue of the *New Yorker* showed a parade of elderly women dressed in floor-length black dresses as they contorted themselves to spell out the word "Mother." Two years later, the same magazine ran a cartoon of a cranky old woman, earphone in hand, leaning forward and frowning as she listened to the latest "scat song" ("Skee dooten doo") on her radio. Her feet rested on a footstool.[42]

However, the 1940s, and particularly the years after World War II, began a steady erosion of the reverence that Anna had lately enjoyed. As advertising agencies and cartoonists saw the rich possibilities of her image in an increasingly cynical and sarcastic world, they used Anna to spoof or ridicule accepted social values as often as they did to reinforce them. Hers would not be the only work of art to suffer these indignities, and it was far from the first time in history that Pop Art molested recognized masterpieces. It has been argued that Whistler's own generation was the first to create this "transgressive" art by parodying older genres of painting, a clear example being Edouard Manet's *Le Déjeuner sur l'herbe*. The difference in twentieth-century transformations of masterpieces was the tendency to destroy, rather than replicate, the spirit of the original work, as with Duchamp's treatment of the *Mona Lisa*. By the 1960s, what one scholar has described as "an Intractable Avant-Garde" proposed nothing less than the "dethronement of beauty," which had been the defining quality of art for at least two centuries past.[43]

One of the earliest and most outrageous examples involving her portrait was an advertisement for lingerie in which an alarmed Anna all but leaps through the picture frame to stop her son from painting a picture of a "Whistler white" negligee. In a more dignified, though no less exploitive, instance, the Wilmington Chamber of Commerce offered souvenir picture postcards of her portrait. Even Eleanor Roosevelt, the president's wife, posed playfully as a slumbering Anna in a 1944 photograph that circulated privately among family friends. Quite a contrast to her mother-in-law's encounter with Anna's portrait exactly a decade earlier (fig. 59).[44]

The past half-century has seen Anna's likeness manipulated in a variety of

ways, not only in advertisements and cartoons, but also superimposed on coffee mugs, T-shirts, tote bags, men's ties, women's sportswear, and whiskey bottles. Most of this commercialization has been completely frivolous, done with a sense of fun. Advertising since the 1960s has shown that derisive uses of a masterpiece may even reinforce its symbolic power. However, Anna has also found herself in the hands of social, artistic, and political commentators who seek to manipulate her image for more serious ends. At least one observer has denounced this "desacralization" as "crude, witless, and ugly," though also acknowledging that the mocking is only possible because Anna remains "such a powerful nexus of symbols."[45]

Exploitation of her image has generally taken one of five directions. For instance, a cartoon of the early 1960s shows an artist hurling a handful of paint at a canvas, the suggestion being that the finished piece of "art" would be a consequence of whatever pattern the paint happened to produce. To his horror, he makes a perfect likeness of *The Mother*. The cartoonist was poking fun at abstract art, but his statement would have been twice as amusing to those who recalled that John Ruskin had accused Whistler in 1877 of flinging a pot of paint in the public's face. A decade later, the Metropolitan Museum of Art used Anna's portrait to promote a series of mail-order "Art Seminars in the Home," her picture being the first in a twelve-part subscription intended to stimulate a wider appreciation of great art. Well aware of the many ways in which she had been abused, the advertisement began by saying, "If people understood this famous painting, they might not put it through such indignities."[46]

Secondly, Anna appears as Whistler painted her but not as a static figure. This format is used most often to provide playful reasons for Anna's intense gaze. Art critics had been speculating about that for years, usually to suggest something of Anna's mood or character. In modern times, the purpose is more often to produce laughter. Anna has been shown watching television, sitting at a computer, stroking a cat, holding a light saber, or in conversation. A 1957 *New Yorker* cartoon shows her speaking to Whistler as he gazes out the window on a rainy day. "Surely, Son," runs the caption, "you can find something to paint indoors." A recent health warning, seen in many physicians' offices, has Anna holding a tissue to her mouth as a reminder to "Cover your Cough."[47]

A third possibility has been to remove Anna completely from her usual surroundings but to maintain her identity, if not always her familiar pose. For instance, another *New Yorker* cartoon shows her sitting in a large, ornately decorated room watching the U.S. television program "Masterpiece Theater" in company with the Mona Lisa, Henry VIII, the Duke of Urbino, and Rodin's *The*

Thinker. A similar situation finds her at a gathering of other familiar – and sometimes caricatured – subjects of famous paintings, including the Mona Lisa (her nearest rival in this and other assimilations into pop culture), the farm couple in Grant Wood's *American Gothic* (a close second), Goya's *Naked Maja*, the apparition from Edvard Munch's *The Scream*, and the little princess in Velásquez's *Las Meninas*.[48]

Mother's Day inspires some of the richest examples of this format. A *Six Chix* cartoon from 2002 shows Anna talking on the telephone to Jemie while her portrait sits on the floor, leaning against a wall. "Let's see," she tells her son, "I got roses from your brother with a very large check. And your sister sent candy with a lovely card. Oh, and I got your nice little picture too, dear."[49]

Fourthly, Anna remains identifiable even though altered in appearance or character. In this guise, she has ridden a ski lift and been knocked out of a boxing ring (having been melded into a parody of George Bellow's 1909 painting, *Stag at Sharkey's*). Again, the possibilities for Mother's Day are numerous, and in this instance, convenient for poking fun at the ideal of motherhood that Anna had previously represented in such a positive way. As early as 1963, an unamused Anna became a foil for the antics of Alfred E. Newman on the cover of *Mad Magazine*. A generation later, and nearly as irreverently, a Mother's Day cover of the *New Yorker* featured Anna glaring at the telephone on a table beside her. Her facial features sharpened to a frightening degree, she waits impatiently for Whistler to ring her up (fig. 60).[50]

Fifthly, in perhaps the most frequently used format, another person or character sits in Anna's chair. She has been replaced by cartoon characters from Daffy Duck to Bugs Bunny, from Minnie Mouse to Bullwinkle. Cats, dogs, and *Star Wars*'s Darth Vader have occupied her seat. In another reversal of roles, she has been replaced by a pipe-smoking man, sitting beneath the legend, "Remember Father's Day." Here, too, politics has most often intruded. Ronald Reagan, even wearing Anna's cap, appeared in caricature during his second presidential campaign to raise the question, "Is 74 too old to be the president?" A more recent political cartoon, cleverly titled "Whistleblower's Mother Russia," shows Vladimir Putin as Anna with a young Edward Snowden sitting on his lap.[51]

Then, too, artists and advertisers have found ways since Anna's own time to reference the portrait without using either her or her surroundings. As early as 1876, a *Punch* cartoon showed a young artist painting a quite pedestrian portrait of his mother as she sat across from him. As much a tribute to Whistler as to Anna, the unstated comparison was clear to all. A more obvious reference using that same motif appeared in a 1959 *New Yorker* cartoon as a modern artist

admires a portrait of his own mother he has painted *a la* Anna. In 1916, a clever advertisement for Kodak cameras utilized an elderly, motherly looking woman to suggest an easier way than painting to create images of loved ones.[52]

So universally have Anna and the values she represented become known since the 1930s that visual images may be dispensed with completely when exploiting "Whistler's mother." Following Cole Porter's lead, numerous composers and lyricists have found clever ways to use her. Richard Rodgers and Lorenz Hart had a character in their 1940 musical *Pal Joey* sing:

> *Zip! I am just a mystic.*
> *I don't care for Whistler's mother,*
> *Charlie's aunt and Schubert's brother.*
> *Zip! I'm misogynistic.*

She even appeared in the title of some 1940s songs, such as "Whistler's Mother," by Herb Silver. Nor need she or her son have anything to do with the storyline, as in "Whistler's Mother-in-Law," by Bert Stevens and Larry Wagner:

> *If you're whistlin' cause you're happy*
> *Be very careful Pappy,*
> *No tellin' what a whistler's mother-in-law will do.*

"Singing a Song to My Mother," by Vivian Ellis, did not feature Anna in either lyrics or title, but her portrait adorned the cover of the sheet music.[53]

Anna finally made it on stage, too. Robert A. Bachmann's play *Whistler's Mother*, written in the mid 1940s, does not appear to have been staged in an American theater, but it had a brief run in London in 1952. Veteran stage and film actress Louise Hampton, then seventy-one years old, played Anna. Unfortunately, and oddly, given the play's title, her role was rather minor, her principal assignment being to steer Whistler into marrying his eventual wife, Beatrice, even though that marriage did not occur until several years after Anna's death. Anna did sit for her portrait midway through the play, but the rest of the "flat and uninspired" action consisted mostly of conversations among Whistler (played by Robert Beaumont), Wilde, and Swinburne.[54]

Far darker was English playwright Edward Bond's use of a wheelchair-bound Anna to represent the devil in his 1976 satire *Grandma Faust*. The plot revolves around the efforts of the devil's grandson to steal the soul of a black man for her. As a commentary on American racism, one critic found the use of Anna "an

inventive aid" to Bond's "reassessment of evil," but one wonders if Bond was also aware of Anna's slaveholding lineage.[55]

Anna has never appeared as a character in the movies, but her name has been mentioned and her image shown frequently. Not surprisingly, the first instance came in 1934, with a passing reference to her in the lyrics of "Your Mother," the signature tune of *Sing and Like It*, starring Zasu Pitts. More substantial uses of the portrait are found in all types of films, from the black comedy *The Fortune Cookie* (1966) to the animated feature *Cloudy with a Chance of Meatballs 2* (2013). The portrait, though never seen, is used as a plot device in *The Naked Gun 2½: The Smell of Fear* (1991), and it looms briefly in the background of several action sequences of the post-apocalyptic *I Am Legend* (2007). Anna is neither mentioned nor featured in Roger Corman's 1970 film about Depression-era outlaw Ma Barker, *Bloody Mama*, but her 1934 Mother's Day stamp is shown on screen during the closing credits to draw a darkly humorous distinction between two very different mothers. If some of these instances seem incompatible with her gentle, nurturing image, it is because directors like to exploit Anna as a counterpoint to violence or cultural ignorance.[56]

In other instances, Anna's portrait has provided convenient artistic references for filmmakers. In the creepy thriller *Kind Lady* (1951), the villain, played by Maurice Evans, decides that a portrait he has painted of his elderly victim (Ethel Barrymore) is "Not as elegant as the Whistler, perhaps." In a quite different context, Rupert Everett, playing the lead in the 2004 clunker *Sherlock Holmes and the Case of the Silk Stocking*, tells Dr. Watson in the final scene, "I shall sit and stare at the wall, like Whistler's mother, a study in grey." In Guy Ritchie's 2008 *RocknRolla*, neither Anna nor her portrait is mentioned, but we are reminded of her presence when crime boss Tom Wilkinson declares, "You know a man's cultured when he's got a Whistler on the wall."

The most reverent, not to say philosophical, film use of Anna's portrait is the Oscar-winning *Babette's Feast* (1987), based on an Isak Dinesen short story but with the screenplay written by the film's director, Gabriel Axel. At the story's turning point, Babette, a former Parisian gourmet chef turned housekeeper for a religiously devout Danish family, strikes an Anna-like pose as she makes a momentous decision of self-sacrifice. Still a young woman (played by Stéphane Audran), there is no suggestion of motherhood or old age in her attitude. Rather she is a symbol of quiet Christian virtue.

However, the more fascinating link to Anna in this film – of which Axel was likely unaware – is the way her life is reflected in the tension between the sacred and the profane, between the religious and secular worlds, that forms the

heart of the drama. On the one hand, Anna would have felt quite comfortable in the religious community that Babette awakens to its moral hypocrisy. On the other hand, Anna was never as bigoted or distrustful of the material world as the people of that community, and she had much in common with Babette. Anna learned to maneuver between the material and spiritual worlds, to integrate religious faith and secular duties, so that while unquestionably devout, she was never petty, intolerant, or small-minded. Equally intriguing for this association with Anna, Babette, the master chef, redeems the community as an "artist," an identity not lost on her grateful employers, who assure Babette, "In Paradise you will be the great artist God meant you to be."[57]

No such uplifting message is conveyed in the outrageous 1997 comedy *Mr. Bean*, staring Rowan Atkinson, in which his ludicrously inept signature character accidently destroys Anna's portrait. In the end, no one is the wiser, as Bean successfully replaces the original painting with a photographic reproduction, a stunt that has led a leading scholar of these many uses and misuses of Anna's image to ask provocatively, "Is it Whistler's painting itself that we prize so highly, or is it really Whistler's *Mother* the icon, a set of collective meanings formed over the last century by cultural appropriations of the image?"[58]

As seen in this remark, Anna's portrait is still very much a topic for discussion and analysis by art historians and critics. Most general histories of art must mention it in their obligatory section on Whistler, and while none consider the painting his greatest work, they all recognize the power of its imagery. It is always a touchstone in books about the subject of mothers in painting, of which there have been several. Some scholars have tried to plum the relationship between Whistler and his mother through a psychological "reading" of the portrait. Not surprisingly, they divide in their opinion as to whether Whistler loved or hated Anna.[59]

It is assumed, too, that artists since Whistler, and because of Whistler, have found it impossible to paint their mothers without treating them in some symbolic fashion. An early example was Arshile Gorky, whose fascination with Anna's portrait in the mid 1920s began, as one of his biographers puts it, a "life-long quest to repossess his mother" in portraiture. The contrast between the quiet domestic setting of Anna's tranquil portrait and more unsettled, tension-filled twentieth- and twenty-first-century mother portraits is also notable. Most modern artists, battling against the "feminine mystique" and their own Oedipal complex, have depicted, in the words of one scholar, far more "powerful and somewhat daunting figures."[60]

Inevitably, Anna and her portrait have also made their way into fiction. A pair

of novels about Whistler, both published in 1972, employ Anna, though not to her benefit. She is little more than a bit player in one cast as Whistler's autobiography. She plays a more extensive part in the second book, with an entire chapter devoted to the making of her portrait. Yet, its author, the playwright and novelist Ted Berkman, appears to have been unduly influenced by Albert Parry, in that his oppressively "autocratic" Anna is made responsible for turning Whistler into a psychological mess. A similarly dour, not to say petulant, Anna also appears in a 2013 novel about Jo Hiffernan, although this time, her principal purpose is to antagonize Jo and strain her relationship with the son.[61]

More imaginatively, Don DeLillo, the American novelist, playwright, and essayist, uses one of the characters in his multilayered 1997 novel *Underworld* to explore the portrait's meaning. A small print of the painting hangs in a spare room of Klara Sax, a young visionary artist who is fascinated by it. She thinks the picture "clashingly modern," and can imagine Anna being "lifted out of her time into the abstract arrangements of the twentieth century." Yet Klara remains haunted by the thought that has fueled interpretations and speculation about the painting since it was first exhibited at the Royal Academy. What is Anna looking at, what does she see, what is she thinking? As Klara gazes "into the depths of the picture, at the mother, the woman, the mother herself, the anecdotal aspect of a woman in a chair," she falters, and can only conclude that Anna is "lost . . . in memory, caught in the midst of a memory trance, a strong elegiac presence."[62]

Ultimately, though, for most lovers of art, Anna's portrait is to be used, interpreted, and enjoyed according to individual needs and whims. Given the opportunity, people still flock to see *The Mother* in large enough numbers that the French must regularly share her with the rest of the world. Since the end of World War II, the picture has been exhibited in Scotland (twice), England (twice), Australia, Canada, Japan, Spain, Denmark, Germany, and, of course, the United States, where Anna has been seen more frequently than anywhere except France.

The U.S. tours occurred in 1953–54, 1964–65, 1983–84, 1995, 2004, 2006, 2010, 2015, and 2017, not always as the only picture in the exhibition but nearly always as the biggest draw. The painting has looked particularly striking since 1986, when the Louvre had it thoroughly cleaned prior to moving it to a new home in the Musée d'Orsay. Curators are now keener than ever to have Anna's portrait, even if negotiations with Paris and fellow curators routinely take years and involve, as did its exhibition in the 1930s, "some shrewd museum politics." People around the world want to be photographed with Anna, sometimes striking an identical pose in front of the painting. Others take sillier postures, or excitedly "tweet" friends to say they are standing beside her, or give thanks that

Mr. Bean did not *really* destroy the painting. Children, either inspired by the moment or encouraged by teachers, draw pictures of their own mothers. Artists and critics may ponder the painting more seriously, but most people simply enjoy Anna. They like her. And if they have fun with her, it is in a warm, familiar way, much like the English wag who decided, "I have noticed that Whistler's mother is getting younger, like policemen."[63]

Even most art critics like her, although their commentaries are sometimes strained. They read all manner of ideas and symbols into the portrait that never would have occurred to Whistler or Anna, but then that is the point. *The Mother* endures as the ultimate symbol of motherhood; she may be read in in a variety of ways, yet she is infused with a spiritual element completely lacking in other mother portraits. Anna reigns not only as an American icon, but also as a "global celebrity." She still "grips the imagination," as an Australian commentator observed during her 2016 tour of that country, "both statuesque and nervous, formidable and frail, as proper and as light as the lace that drapes over her shoulders." Her artist son would probably still insist that she is an arrangement in grey and black, but he would surely also be pleased to find The Mother understood and beloved as Anna Whistler.[64]

NOTES

Abbreviations of People

ME: Mary E. H. Eastwick
JG: James H. Gamble
HG: Harriet Gamble
DH: Deborah Delano (Whistler) Haden
JH: Joseph Harrison
MH: Margaret G. Hill
FRL: Frederick R. Leyland
FL: Frances (Dawson) Leyland
KM: Kate McDiarmid
CJM: Charles Johnson McNeill
CM: Charles W. McNeill
WM: William Gibbs McNeill
JM: John Stevenson Maxwell
CP: Catherine Jane (McNeill) Palmer
JR: James Anderson Rose
JS: Joseph Gardner Swift
WS: William Henry Swift
AW: Anna Matilda (McNeill) Whistler
GWW: George Washington Whistler
GW: George William Whistler
JW: James Abbott McNeill Whistler
WW: William McNeill Whistler

1 A Child of Two Worlds, 1804–31

1. Daniel L. Schafer, *Zephaniah Kingsley Jr. and the Atlantic World: Slave Trader, Plantation Owner, Emancipator* (Gainesville, Fla., 2013), 18–25.

2. Ibid., 30, 32–34.

3. Georgia Toutziari, "Anna Matilda Whistler Correspondence—An Annotated Edition" (PhD diss., Univ. of Glasgow, 2002), 24–26; William L. Saunders and Walter Clark, eds., *The Colonial and State Records of North Carolina*, 26 vols. (Goldsboro, N.C., 1886–1907), XVIII:vii, 213–17, 422–23, 477–83, 591. Kate R. McDiarmid, *Whistler's Mother: Her Life, Letters and Journal* (North Wilkesboro, N.C., 1981), 5, states that McNeill received his medical education in Scotland and served with the British army, but much else she says about his early life is incorrect. For the confusion attached to Anna's Scottish roots, see F. W. Coburn, *Whistler and His Birthplace*, ed. Edith Williams Burger and Liana De Girolami Cheney (Tewksbury, Mass., 1988), 15–16, and F. W. Coburn to Walter S. Brewster, September 26, 1934, Walter S. Brewster Collection of Whistleriana, 1871–1947, AIC.

4. Notes by Ida B. Kellam, in Anna Matilda McNeill Whistler Papers, N.C.; Saunders and Clark, *Records of North Carolina*, XXVI: 825.

5. Notes by Kellam; Jane Censer, *North Carolina Planters and their Children, 1800–1860* (Baton Rouge, La., 1984), 8–9; Bradford J. Wood, *This Remote Part of the World: Regional Formation in Lower Cape Fear, North Carolina, 1725–1775* (Columbia, S.C., 2004), 178–81.

6. Schafer, *Zephaniah Kingsley Jr.*, 12, 13–14; Censer, *North Carolina Planters*, 42–47, 54–56; Catherine Kerrison, *Claiming the Pen: Women and Intellectual Life in the Early American South* (Ithaca, N.Y., 2006), 13–14; Anya Jabour, "'Grown Girls, Highly Cultivated': Female Education in an Antebellum Family," *Journal of Southern History*, 64 (February 1998), 24–25; Mary Kelley, *Learning to Stand and Speak: Women, Education, and Public Life in America's Republic* (Chapel Hill, N.C., 2006), 39, 66–67, 76–77.

7. Censer, *North Carolina Planters*, 46–52; Cynthia A. Kierner, *Beyond the Household: Women's Place in the Early South, 1700–1835* (Ithaca, N.Y., 1998), 108–11, 150–51; Kelley, *Learning to Stand and Speak*, 69–71, 76–77; Jane H. Pease and William H. Pease, *Ladies, Women, and Wenches: Choice and Constraint in Antebellum Charleston and Boston* (Chapel Hill, N.C., 1990), 7–8, 10.

8. Kerrison, *Claiming the Pen*, 82, 101–02; Carl N. Degler, *At Odds: Women and the Family in American from the Revolution to the Present* (New York, N.Y., 1980), 26–29, 73–77.

9. Schafer, *Zephaniah Kingsley Jr.*, 259–60 ns.3, 7; Censer, *North Carolina Planters*, 6; Wood, *Remote Part of the World*, 124–29; Kerrison, *Claiming the Pen*, 83, 98; Kierner, *Beyond the Household*, 182–84.

10. Diana Hochstedt Butler, *Standing Against the Whirlwind: Evangelical Episcopalians in Nineteenth-Century America* (New York, N.Y., 1995), 35–36, 46.

11. Kerrison, *Claiming the Pen*, 17–19, 28, 30, 40, 102–03; Johann David Schoepf, *Travels in the Confederation*, trans. and ed. Alfred J. Morrison, 2 vols. (1911; New York, N.Y., 1968), II:147–49.

12. Saunders and Clark, *North Carolina Records*, XXVI:304, 825; Christine L. Ingram et al., eds., *New Hanover County Slave Deeds*, 3 vols. (Wilmington, N.C., 2013), III:37; Anna P. Stanton to KM, April 22, 1928, Don P. Stanton to KM, October 19 [1930], S180, S208, WC.

13. Alan Grub, "House and Home in the Victorian South: The Cookbook as Guide," in Carol Bleser, ed., *In Joy and Sorrow: Women, Family, and Marriage in the Victorian South, 1830–1900* (New York, N.Y., 1991), 167.

14. Kelley, *Learning to Stand*, 76–77; Kerrison, *Claiming the Pen*, 80, 84–85, 87–90.

15. Carroll Smith-Rosenberg, *Disorderly Conduct: Visions of Gender in Victorian America* (New York, N.Y., 1985), 28, 53–76; Jean E. Friedman, *The Enclosed Garden: Women and Community in the Evangelical South, 1830–1900* (Chapel Hill, N.C., 1985), xii–xv; Glenna Matthews, *The Rise of Public Women: Women's Power and Woman's Place in the United States, 1630–1970* (New York, N.Y., 1992), 72–84; Kierner, *Beyond the Household*, 153–55.

16. Joseph G. Swift, *Memoirs of Joseph Gardner Swift* (Worcester, Mass., 1890), 72; Caroline Elizabeth Burgwin Clitherall Diaries, August [1813], v.6, p.24, SHC; Anna M. Whistler Diary, January 1844, March 14, 1846, NYPL (microfilm copy in AAA).

17. James Sprunt, *Chronicles of the Cape Fear River, 1660–1916* (2nd ed.; Raleigh, N.C., 1916), 139; Ira Rosenwaike, *Population History of New York City* (Syracuse, N.Y., 1972), 18, 31; Henry R. Stiles, *A History of the City of Brooklyn*, 3 vols. (Brooklyn, 1867–70), II:194, 197–99; Swift, *Memoirs*, 112.

18. Anna P. Stanton to KM, April 22, 1928; Delmas D. Haskett, "New Hanover County, North Carolina,

1815 and 1845 Tax Lists," p.7, typescript, North Carolina Room, New Hanover County Public Library, Wilmington; Ingram et al., *New Hanover County Slave Deeds*, II:22, 28, 32.

19. Margaret Steele to John Steele, February 19, 1807, Margaret to Mrs. John Steele [January 1807], Mary Brown to Margaret, December 6, 1809, John Steele Papers, SHC; unknown to Samuel Mordecai, December 24, 1810, [Myer Myers] to Samuel Mordecai [November 1814], Mordecai Family Papers, SHC.

20. Schafer, *Zephaniah Kingsley Jr.*, 59, 71, 135–36, 259–60 n.7, 264 n.29; Swift, *Memoirs*, 113–14.

21. Stiles, *History of the Brooklyn*, II:34; Edwin C. Burrows and Mike Wallace, *Gotham: A History of New York City* (New York, N.Y., 1999), 449; Axel L. Klinkowström, *Baron Klinkowström's America, 1818–1820*, ed. and trans. Franklin D. Scott (Evanston, Ill., 1952), 87.

22. Stiles, *History of Brooklyn*, II:15, 198–99, 200, 210, 216.

23. Ibid., II:196, 199, 208, 217, 220, 225; Klinkowström, *Baron Klinkowström's America*, 63.

24. Stiles, *History of Brooklyn*, II:37, 54, 134–36, 208; Burrows and Wallace, *Gotham*, 449–50; Robert Furman, *Brooklyn Heights: The Rise, Fall and Rebirth of America's First Suburb* (Charleston, S.C., 2015), 53, 77; Klinkowström, *Baron Klinkowström's America*, 120–21; *Hunt's Merchant's Magazine and Commercial Review*, 38 (March 1858), 374.

25. AW to JW, April 11, 1853, *GUW* 6427.

26. AW to JW, July 11, 1876, *GUW* 6559. For the Petigrus, see Jane H. Pease and William H. Pease, *A Family of Women: The Carolina Petigrus in Peace and War* (Chapel Hill, N.C., 1999).

27. Klinkowström, *Baron Klinkowström's America*, 120–21, 126–29; Stiles, *History of Brooklyn*, II:13–14, 18–22, 27–29, 194–95, 202, 211, 226–27; Swift, *Memoirs*, 183–84, 191–92; Nine-Penny Whist Club Papers, in DeRosset Family Papers, Box 9, f.161, SHC.

28. Stiles, *History of Brooklyn*, II:108–09, 218; Florence Wilcox to KM, January 10, 1929, August 15, 1931, W1037, W1041, WC; Butler, *Standing Against the Whirlwind*, 42–156.

29. AW to CWM, October 10–12, 1877, *GUW* 6561; Anna P. Stanton to KM, April 22, 1928; Stiles, *History of Brooklyn*, II:198.

30. Kelley, *Learning to Stand*, 39, 66–73; Stiles, *History of Brooklyn*, I:392, II:234.

31. Samuel Mordecai to Rachel Mordecai, August 17, 1811, Mordecai Family Papers, SHC; Stiles, *History of Brooklyn*, II:109; Swift, *Memoirs*, 135–36.

32. George W. Cullum, *Register of Officers and Cadets of the United States Military Academy for 1819* (New York, N.Y., 1819), 215.

33. Ibid., 162–63.

34. Ibid., 215, 237–38.

35. Swift, *Memoirs*, 187–88; WS to JS, February 25,

1821, Joseph Gardner Swift Letters, NYPL (microfilm copy in AAA).

36. Elizabeth Mumford, *Whistler's Mother: The Life of Anna Whistler* (Boston, Mass., 1939), 29.

37. Grace S. Fleming to KM [1929], July 2, 1920, W354, W358, WC.

38. Martha McNeill to Louisa Swift, February 20, May 30, and August 13, 1827, Swift Letters.

39. Ibid., February 20, May 30, 1827.

40. Cullum, *Register for 1819*, 161–63.

41. James D. Dilts, *The Great Road: The Building of the Baltimore and Ohio, the Nation's First Railroad, 1828–1853* (Stanford, Calif., 1993), 52–64; Forest G. Hill, *Roads, Rails, and Waterways: The Army Engineers and Early Transportation* (Norman, Okla., 1957), 96–113; Anton Chaitkin, "How the Government and Army Built America's Railroads," *Executive Intelligence Review*, 25 (July 17, 1998), 44–54.

42. Frances Ann Kemble, *Records of a Girlhood* (2nd ed.; New York, N.Y., 1883), 560–61; Martha McNeill to Louisa Swift, August 13, 1827, Swift Letters.

43. Cullum, *Register for 1819*, 214–16; W. Edwin Hemphill et al., eds., *Papers of John C. Calhoun*, 28 vols. (Columbia, S.C., 1959–), VIII:54; GWW to JS, February 20, May 21, and October 31, 1828, October 24 and November 3, 1829, and February 8, 1831, Swift Letters.

44. Dilts, *The Great Road*, 84–85.

45. Ibid., 70–71, 85–88; GWW to JS, February 16, 1829, Swift Letters.

46. GWW to JS, February 16, 1829, GWW to WM, July 15, 1842, Swift Letters.

47. Don P. Stanton to KM, April 28, 1930, S200, WC; Swift, *Memoirs*, 205.

48. Martha McNeill to Louisa Swift, February 1, 1830, Swift Letters; AW to CP, November 22, 1829, GUW 344.

49. Mumford, *Whistler's Mother*, 22–23; AW to CP, November 22, 1829.

50. 50. AW to CP, November 22, 1829, *GUW* 6347; Anna P. Stanton, to KM, March 29 [1928], Don P. Stanton to KM, July 18, 1930, S176, S204, WC.

51. AW to MH, January 14, 1830, *GUW* 7625.

52. AW to MH, January 14, 1830, and for next few paragraphs.

53. AW to JG, June 12, 1864, GUW 6525; Martha McNeill to Louisa Swift, February 28, 1830, and January 28 and April 25, 1831, Swift Letters.

54. Charles F. O'Connell Jr., "The Corps of Engineers and the Rise of Modern Management, 1827–1856," in Merritt Roe Smith, ed., *Military Enterprise and Technological Change* (Cambridge, Mass., 1985).

55. Dilts, *The Great Road*, 76–79, 111, 152–55; Hill, *Roads, Rails and Waterways*, 105–06, 110–11; WS to JS, June 5, 1831, Swift Letters.

56. GWW to JS, February 8, 1831, July 12, 1831, Swift Letters.

57. Grace S. Fleming to KM [1929], Don P. Stanton to KM, April 28, 1930, Florence Wilcox to KM, February 6, 1929, S200, W1038, WC.

2 Wife and Mother, 1832–43

1. AW biographical sketch of GWW [July 1849], PWC; "The McNeills and the Whistlers," *Bulletin of the Passaic County Historical Society*, 5 (November 1962), 100; Martha McNeill to Louisa Swift, February 1 and 28, 1830, and June 19, 1832, Joseph Gardner Swift Letters, NYPL (microfilm copy in AAA).
2. Jane H. Pease and William H. Pease. *Ladies, Women, and Wenches: Choice and Constraint in Antebellum Charleston and Boston* (Chapel Hill, N.C., 1990), 21–22; William A. Alcott, *The Young Wife, or Duties of a Woman in the Marriage Relation* (Boston, Mass., 1837), 21–22; AW sketch of GWW.
3. Glenna Matthews, *"Just a Housewife": The Rise and Fall of Domesticity in America* (New York, N.Y., 1987), 9–14; Anya Jabour, *Marriage in the Early Republic: Elizabeth and William Wirt and the Companionate Ideal* (Baltimore, 1998), 2–3; Cynthia A. Kierner, *Beyond the Household: Woman's Place in the Early South, 1700–1835* (Ithaca, N.Y., 1998), 184–89, 194–95.
4. Margaret F. MacDonald, *Whistler's Mother's Cook Book* (2nd ed.; San Francisco, 1993), 7–8.
5. WS to JS, August 26, 1832, Swift Letters; Joseph G. Swift, *Memoirs of General Joseph Gardner Swift* (Worcester, Mass., 1890), 213; J. G. De Roulhac Hamilton, ed., *The Papers of William Alexander Graham*, 6 vols. (Raleigh, N.C., 1957–76), I:268–69; Forest G. Hill, *Roads, Rails and Waterways: The Army Engineers and Early Transportation* (Norman, Okl., 1957), 117–18.
6. Hill, *Roads, Rails, and Waterways,* 113–15; GWW to JS, February 12, 1834, WS to JS, January 6, 1834, Swift Letters.
7. GWW to JS, March 3, 1834, Swift Letters; Swift, *Memoirs,* 218.
8. Thomas Dublin, *Women at Work: The Transformation of Work and Community in Lowell, Massachusetts, 1826–1860* (New York, N.Y., 1979), 25–26, 32–35, 58–61, 66–67; Harriet H. Robinson, *Loom and Spindle, or Life Among the Early Mill Girls* (1898; Kailua, Hawaii, 1976), 4–5; Henry A, Miles, *Lowell, As It Was, and As It Is* (Lowell, 1845), 35–41.
9. John O. Green Diaries, February 14, 1834, Green Family Diaries, LNHP; Dublin, *Women at Work,* 86–97.
10. Robinson, *Loom and Spindle,* 5–6; "Lowell Notes: Kirk Boott," LNHP; GWW to JS, March 3, 1834, Swift Letters.
11. Elizabeth Mumford, *Whistler's Mother: The Life of Anna McNeill Whistler* (Boston, Mass., 1939), 36–37.
12. Frederick Prince to Katherine Prince, January 8, 1835, Frederick and Leslie Prince to Katherine, August 26, 1835, Katherine Prince Collection, AAA.
13. Martha McNeill to Sarah Swift, September 29, 1836, Swift Letters; Swift, *Memoirs*, 225; Mumford, *Whistler's Mother*, 38–39.
14. Mumford, *Whistler's Mother*, 39–40.
15. Matthews, *Just a Housewife*, 13–14; MacDonald, *Whistler's Mother's Cook Book*, 71–130.
16. Matthews, *Just a Housewife*, 31–34; AW sketch of GWW.
17. AW sketch of GWW; Daniel E. Sutherland, *Americans and Their Servants: Domestic Service in the United States, 1800–1920* (Baton Rouge, La., 1981), 3–6, 47–48, 87–89, 92–95; Martha McNeill to Sarah Swift, September 29, 1836, Swift Letters.
18. Dublin, *Women at Work*, 98–103.
19. Green Diary, May 26, June 23, 26, 1835; *Lowell Journal and Mercury*, December 11, 1835, 1; *Lowell Journal,* May 25, 1836, 3; Robinson, *Loom and Spindle,* 3–4.
20. WS to JS, January 27, 1835, and May 24, 1836, Swift Letters.
21. Stephen Salsbury, *The State, the Investor, and the Railroad: The Boston & Albany, 1825–1867* (Cambridge, Mass., 1967), 161, 370 n.14; WS to JS [August 4, 1836], Swift Letters.
22. Gregg M. Turner and Melancthon W. Jacobus, *Connecticut Railroads: An Illustrated History* (Hartford, Conn., 1986), 2–8; GWW to JS, June 27, and September 4, 1837, Swift Letters.
23. Kate R. McDiarmid, *Whistler's Mother: Her Life, Letters and Journal* (North Wilkesboro, N.C., 1981), 29–31; GWW to JS, October 7, 1839, Swift Letters.
24. GWW to JS, October 16, 1838, Swift Letters.
25. McDiarmid, *Whistler's Mother*, 28.
26. GWW to JS, December 25, 1838, Swift Letters.
27. AW sketch of GWW; GWW to C. Palmer, March 2, 4, and 6, 1839, GWW to William D. Lewis, June 27, 1839, Box 1, f.30, Thomas F. Madigan Collection, NYPL; WS to JS, November 24, 1839, GWW to JS, October 16, 1838, May 22, October 7 and 23, November 24, 1839, and May 8, 1840, Swift Letters.
28. McDiarmid, *Whistler's Mother*, 32; *Springfield Republican*, April 24, 1910, 25. The house was torn down in 1939.
29. *Springfield Republican*, September 3, 1898, 2, and April 24, 1910, 25.
30. Swift, *Memoirs*, 244–45; WS to JS, April 24 and 29, 1842, GWW to JS, May 29, 1842, Swift Letters.
31. GWW to JS, May 29, 1842, GWW to WM, July 15, 1842, Swift Letters.
32. WS to JS, July 10, 1842, Swift Letters.
33. WS to JS, December 12, 1841, and November 4, 1842, Swift Letters.

34. Lucy A. Rodman to Mary A. Rodman [1842/43], Rodman–Harvey Family Papers, NYPL; WS to JS, October 4, 1842, Swift Letters; GWW to JW, February 15, 1843, *GUW* 6659; WW to GWW, February 25, 1843, W968, WC.

35. Basil Greenhill and Ann Gifford, *Travelling by Sea in the Nineteenth Century: Interior Design in Victorian Passenger Ships* (New York, N.Y., 1974), 33–40; Douglas R. Burgess Jr., *Engines of Empire: Steamships and the Victorian Imagination* (Stanford, Calif., 2016), 37–41; Eugene W. Smith, *Trans-Atlantic Passenger Ships Past and Present* (Boston, Mass., 1947), 2–5, 35, 54; Allan Nevins, ed., *The Diary of Philip Hone, 1828–1851* (New York, N.Y., 1936), 317–18, 324–25, 400–402, 409–10.

36. Greenhill and Gifford, *Travelling by Sea,* 41–44; Nevins, *Diary of Hone,* 239–40, 297, 317–19, 324, 388, 397; Charles Dickens, *American Notes* (1859; New York, N.Y., 1996), 3–32.

37. Anna M. Whistler Diary, November 28, 1843, NYPL (microfilm copy in AAA).

38. Ibid.; DH to JS, October 6, 1843, Swift Letters.

39. Whistler Diary, November 28, 1843, March 29, June 17, August 27, and September 26, 1844.

40. John S. Maxwell, *The Czar, His Court and People* (London, 1848), 90–94; Colin Macrae Ingersoll, "My First Year in Russia, 1847–48," Pt.1, May 19, 1847, Box 7, f.3, Ralph Ingersoll Papers, BU; DH to JS, October 6, 1843; Whistler Diary, November 28, 1843.

41. JM to Mother, September 30, May 2, 1843, John Stevenson Maxwell Papers, NYHS.

42. Whistler Diary, November 28, 1843; DH to JS, October 6, 1843.

3 Russia, 1843–44

1. JM to Mother, January 24, September 9–10, and 30, 1843, John Stevenson Maxwell Papers, NYHS; Katherine Prince Diary, December 12, 1845, f.3, in Katherine Prince Collection, AAA.

2. James H. Baxter, *St. Petersburg: Industrialization and Change* (Montreal, Que., 1976), 77–78; Anthony Cross, *By the Banks of Neva: Chapters from the Lives and Careers of the British in Eighteenth Century Russia* (Cambridge, Eng., 1997), 10–11, 17–18; Rodney S. Hatch III, ed., *Dr. Edward Maynard: "Letters from the Land of the Tsar, 1845–1846" America's Pioneering Dental Surgeon Turned Civil War Gun Inventor* (North Salem, N.Y., 2010), 49.

3. Cross, *By the Banks of the Neva,* 90–93, 117; J. G. Kohl, *Russia and the Russians in 1842,* 2 vols. (London, 1842), I:208–09; G. H. Prince to Cousin, November 23/December 5, 1843, Box 2, Ropes Family Papers, MHS.

4. Baxter, *St. Petersburg,* 50–51, 54–62; Marie-Louise Karttunen, "The British Factory at St.

Petersburg: A Case Study of a Nineteenth-Century NGO". Accessed July 26, 2017, www.helsinki.fi/project/eva/pop/pop_Karttunen.pdf; Anthony Cross, "The English Embankment," in Cross, ed., *St. Petersburg, 1703–1825* (Basingstoke, Eng., 2003), 50–68; GWW to JS, November 3, 1843, Joseph Gardner Swift Letters, NYPL (microfilm copy in AAA).

5. Cross, *By the Banks of the Neva,* 244–47; James D. Dilts, *The Great Road: The Building of the Baltimore and Ohio, the Nation's First Railroad, 1828–1853* (Stanford, Calif., 1993), 303, 439 n.12; John S. Maxwell, *The Czar His Court and People* (London, 1848), 124–27.

6. Harriet Tyler Cabot, "The Early Years of William Ropes & Company in St. Petersburg," *American Neptune,* 13 (April 1963), 131–39; Evrydiki Sifneos, "Navigating the Hostile Maze: Americans and Greeks Exploring the 19th Century Russian Market Opportunities". Accessed July 7, 2017, www.ebha.org/ebha2011/files/Papers/Navigating%20the%20hostile%20maze.pdf; Anna M. Whistler Diary, November 28, 1843, NYPL (microfilm copy in AAA).

7. JM to Mother, September 30, 1843, JM to Uncle, February 25, 1843, Maxwell Papers.

8. Walther Kirchner, *Studies in Russian-American Commerce, 1820–1860* (Leiden, 1975), 196–97, 214–15; Cabot, "Early Years of Ropes & Company," 135–37; Karttunen, "The British Factory," 17–21; Joseph L. Ropes to William L. Ropes, May 2, 1845; William H. Ropes to William L. Ropes, December 7/19, 1845, Box 2, Ropes Family Papers; Whistler Diary, February 14, July 1, and August 26, 1844.

9. Whistler Diary, November 28, 1843 and January 1844.

10. 10. JM to Mother, January 24, March 1, May 2, and October 20, 1843, Maxwell Papers.

11. Whistler Diary, November 28, 1843 and January 1844.

12. Julie A. Buckler, *Mapping St. Petersburg: Imperial Text and Cityscape* (Princeton, N.J., 2005), 80–85; W. Bruce Lincoln, *Sunlight at Midnight: St. Petersburg and the Rise of Modern Russia* (New York, N.Y., 2000), 124–30; Nikolai Gogol, *Arabesques,* trans. Alexander Tulloch (1835; Ann Arbor, Mich., 1982), 151–55.

13. Lincoln, *Sunlight at Midnight,* 121–24, 135–36; Astolphe, Marquis de Custine, *Journey for Our Time: The Journals of the Marquis de Custine,* ed. and trans. Phyllis Penn Kohler (1843; New York, N.Y., 1951), 132; Baxter, *St. Petersburg,* 74; Kohl, *Russia and Russians,* 26–36.

14. J. N. Westwood, *Endurance and Endeavour: Russian History, 1812–1986* (Oxford, Eng., 1987), 32–38; Patrick L. Alston, *Education and the State in Tsarist Russia* (Stanford, Calif., 1969), 30–37.

15. Westwood, *Endurance and Endeavour,* 42–47; W. Bruce Lincoln, *Nicholas I: Emperor and Autocrat of*

All the Russias (Bloomington, Ind., 1978), 239–52.

16. Westwood, *Endurance and Endeavour*, 38–40, 47–53, 62–67; Lincoln, *Nicholas I*, 253–55; Alexander Herzen, *My Past and Thoughts: The Memoirs of Alexander Herzen*, trans. Constance Garnett, revised, Humphrey Higgins, 4 vols. (New York, N.Y., 1968), II:431.

17. Westwood, *Endurance and Endeavour*, 57–61, 103–04; Lincoln, *Nicholas I*, 155, 180–95, 235–68.

18. GWW to JS, April 26, 1845; Whistler Diary, November 28, 1843 and February 26, 1844.

19. Whistler Diary, November 28, 1843; JM to Mother, January 1, 1844, Maxwell Papers.

20. Whistler Diary, November 28, 1843.

21. Ibid.; JM to Mother, September 9–10, 1843 and January 1, 1844, Maxwell Papers.

22. Maxwell, *The Czar*, 318–19; Whistler Diary, November 28, 1843.

23. Hatch, *Dr. Edward Maynard*, 47, 66; Whistler Diary, November 28, 1843 and February 14, 1844.

24. Whistler Diary, November 28, 1843, January, February 14, April 22, 23, and 25, June 2, 1844, April 10, 1845, and February 6, May 2, 1847.

25. Ibid., November 28, 1843, March 22, April 22 and 28, June 5 and 17, and July 1, 1844.

26. Ibid., November 28, 1843, January, March 22, 1844; AW to JW, January 8–9, 1849, *GUW* 6381.

27. Whistler Diary, February 14 and 26, and March 22 and 29, 1844; JM to Mother, October 20 and November 1, 1843, January 1, March 6-7, and May 1, 1844, Maxwell Papers.

28. Whistler Diary, February 14 and 26, and March 22 and 29, 1844.

29. Nevins, *Diary of Hone*, 473–74; ibid., January 1844.

30. Whistler Diary, February 14, 1844.

31. Ibid., February 14 and April 24, 1844; JM to Mother, January 4, 1844, Maxwell Papers.

32. Whistler Diary, February 26, 1844.

33. Ibid., April 10, 22, and 25, May 30, and July 1, 1844.

34. Ibid., February 14, March 22, April 22 and 25, 1844.

35. Ibid., January, February 14, April 22, 23, 25, and 28, 1844; JM to Mother, October 20, 1843, March 6-7 and 26, April 1, and May 1, 1844, Maxwell Papers.

36. Whistler Diary, April 22 and June 2 and 25, 1844.

37. Maxwell, *The Czar*, 157–59; Kohl, *Russia and the Russians*, 149–53, 160–70; Susan Dallas, ed., *Diary of George Mifflin Dallas* (Philadelphia, Pa., 1892), 72, 85.

38. Whistler Diary, March 9–10 and 29, 1844.

39. Ibid., April 10, 1844.

40. Ibid., May 3, 1844; Alexandre Dumas, *Adventures in Czarist Russia*, ed. A. E. Murch (London, 1960), 56.

41. Stephen Lovell, *Summerfolk: A History of the Dacha, 1710–2000* (Ithaca, N.Y., 2003), 2–4, 9–10, 30–31, 36–39; Whistler Diary, March 22,

May 4, 1844; GWW to JS, April 4–May 18, 1844, Swift Letters.

42. Mary Gellibrand to William, September 7/19, 1844, Box 2, Ropes Family Papers; Whistler Diary, May 29 and 31, June 5 and 10, July 1, 6, and 12, August 13 and 22, and September 13, 1844. For a drawing of Alicia done by Jemie, see M.6.

43. Whistler Diary, July 18, and September 13, 1844.

44. Ibid., July 1, 8, 11, 13, and 22, 1844.

45. Ibid., June 10, July 1, and August 16, 1844.

46. Ibid., June 10, July 22, and August 11 and 18, 1844.

47. Ibid., May 13, 1845 and August 12 and 24, 1846; Kirchner, *Studies in Russian-American Commerce*, 197.

48. Whistler Diary, July 1, 1844 and October 10, 1847.

49. Ibid. August 11, 1844.

50. Ibid., June 25, July 13, and August 1–2, 5, 15, and 17, 1844.

51. Hatch, *Dr. Edward Maynard*, 47; GWW to JS, April 4 and May 4 and 18, 1844, Swift Letters.

52. William Patten to KM, July 10, 1931, January 2, 1936, P169, P174, WC; Whistler Diary, April 23, June 25, July 1, and August 13 and 15, 1844.

53. Cross, *By the Banks of the Neva*, 286–93; Whistler Diary, May 29 and August 28, 1844.

54. Whistler Diary, September 23, 1844.

55. Ibid., July 24 and September 23 and 26, 1844; Hatch, *Dr. Edward Maynard*, 56.

4 Impatient Reformer, 1845–49

1. Anna M. Whistler Diary, April 10 and June 6, 1845, NYPL (microfilm copy in AAA).

2. Ibid., June 6, 1845.

3. Ibid., March 22, April 10, and July 1, 1844; Galina Andreeva, "The Cradle of 'Uncommon Genius,'" and Georgia Toutziari, "The Whistlers in Russia," both in Andreeva and Margaret F. MacDonald, eds., *Whistler and Russia* (Moscow, 2006), 58–61, 83–84.

4. Whistler Diary, August 29, 1844 and April 10, 1845; AW to JW, September 30 and October 12, 1848, *GUW* 6368.

5. Whistler Diary, January 9, July 7, November 14, and December 29, 1846; GWW to JS, April 4/May 4, 1844, December 19, 1845, and July 26, 1846, Joseph Gardner Swift Letters, NYPL (microfilm copy in AAA).

6. Whistler Diary, April 10, May 1, June 6, and August 28, 1845, May 22 and 30, and November 2, 1846; AW to JW, January 8–9, 1849, *GUW* 6381.

7. Whistler Diary, April 10, 1845; AW to GWW, June 8/10, 1847, *GUW* 6357.

8. Whistler Diary, December 25, 1846; JM to Mother, May 1, 1844, John Stevenson Maxwell Papers, NYHS.

9. Whistler Diary, August 12 and 24 and September 12, 1846.

10. Ibid., March 25, 1845 and February 8, 1846.

11. Ibid., April 7, 1846, January 1, and April 25, 1848.

12. Ibid., July 5–6 and 14, 1844, and July 7, 1846.

13. Ibid., July 5–6, 1844, April 10, May 13, 1845, and March 10, 1846.

14. Ibid., March 9, 1846; Hatch, *Dr. Edward Maynard*, 69.

15. Whistler Diary, May 30, 1846; Colin Macrae Ingersoll, "My First Year in Russia, 1847–48," Pt.2, September 1 and November 12, 1847, Box 7, f.5, Ralph Ingersoll Papers, BU.

16. AW to JW [December 25, 1848], *GUW* 6379.

17. Joseph G. Swift, *The Memoirs of Gen. Joseph Gardner Swift* (Worcester, Mass., 1890), 250; Whistler Diary, September 28, 1846; Hatch, *Dr. Edward Maynard,* 45, 52, 62, 71–72.

18. Ingersoll, "My First Year in Russia," Pt.1, June 3, 1847, Box 7, f.3, Ingersoll Papers; Whistler Diary, June 6, 1845.

19. Whistler Diary, April 19, 1845 and January 9, 1846.

20. The sketchbook is preserved at the Hunterian Gallery of Art, University of Glasgow, although several of the drawings are also reproduced and discussed in M.7.

21. Whistler Diary, April 10, May 2–3, and August 28, 1845.

22. Ibid., May 2 and 5 and December 27, 1845.

23. Albert Parry, *Whistler's Father* (Indianapolis, 1939), 241–42; Whistler Diary, January 1 and 5, 1846.

24. GWW to JS, December 19, 1845 and July 26, 1846, Swift letters; Diary of Ralph I. Ingersoll, May 30, 1847, Box 5, f.5, Ingersoll Papers; Hatch, *Dr. Edward Maynard*, 38, 74; Whistler Diary, December 1846, March 1,13,and 23, and May 19, 1847.

25. Whistler Diary, January 5, 1846; AW to JS, September 24, 1846, Swift Letters; AW to JW, November 1–2 and December 13, 1848, *GUW* 6370, 6377; Hatch, *Dr. Edward Maynard*, 42, 109.

26. Hatch, *Dr. Edward Maynard*, 43, 52, 57, 59, 85, 96; Whistler Diary, April 10, 1845; AW to Edward Maynard, February 7, 1846, *GUW* 6356.

27. AW to JW, October 20, 1848, *GUW* 6369; Hatch, *Dr. Edward Maynard*, 97, 103, 123.

28. AW to JS, September 24, 1846, Swift letters; Whistler Diary, September 28, 1846.

29. Whistler Diary, September 28 and October 29, 1846.

30. Ibid., October 6, 15–16, and 29, 1846; JM to GWW, December 13, 1846, January 22, 1847, Maxwell Papers.

31. Whistler Diary, December 5, 25, and 29, 1846, January 23 and 30, February 6 and 27, and March 23, 1847.

32. Ibid., January 30, 1847.

33. Ibid., July 27, August 12 and 24, 1846, April 15, and September 12, 1847.

34. Ibid., June 26, 1847; AW to GWW, June 8/10,

35. Whistler Diary, July 28 and September 10, 1847.

36. Ibid., September 10, 1847.

37. Ibid.

38. GWW to AW, September 17, 1847, Swift Letters.

39. Whistler Diary, September 10, 1847.

40. JM to GWW, November 18, 1845, January 14, April 6, November 4, December 13, 1846, and February 11, 1848, Maxwell Papers.

41. Whistler Diary, September 10, 1847.

42. Ibid.

43. Ibid., September 10, 1847 and April 25, 1848; GWW to JS, March 11/25, 1848, Whistler House Museum, Lowell, Massachusetts.

44. Whistler Diary, June 1848; AW to GWW, June 20–21, 1848, *GUW* 6358.

45. Whistler Diary, June, July 6 and 22, 1848.

46. Ibid., July 22, 1848.

47. Ibid., August 1–2 and 8, 1848.

48. Ibid., July 22, August 1–2 and 8–9, 1848.

49. Ibid., September 9, 1848; GWW to JW, August 9, 1848, AW to GWW, September 12 [1848], *GUW* 6662, 6361.

50. WW to JW, September 13 [1848], W971, WC; AW to JW, September 14 and 15–16/18 [1848], *GUW* 6362–63.

51. AW to JW, September 22–23, and 26–27, 1848, *GUW* 6364–65; W. Bruce Lincoln, *Nicholas I: Emperor and Autocrat of All the Russias* (Bloomington, Ind., 1978), 271–90.

52. AW to JW, September 12 and 14 [1848], September 26–27, October 3 and 20, November 1–2, and December 4–5, 1848, *GUW* 6361, 6367, 6369–70, 6374.

53. AW to JW, September 30, October 12, November 1–2 and 27, December 4–5 and 13, 1848, and January 20, 1849, *GUW* 6368, 6373, 6377, 6382.

54. AW to JW, December 4–5 and 11, 1848, *GUW* 6375.

55. Arthur P. Bagby to wife, January 15 and April 1, 1849, Arthur P. Bagby Letters, AL; Ingersoll, "My First Year in Russia," Pt.1, May 28 and June 28, 1847, Pt.2, January 21, 1848, Pt.3, February 22, 1843, Box 7, f.6, Ingersoll Papers; AW to JW [January 7/February 28, 1849], *GUW* 6385.

56. AW to JW, December [25]–26 [1848], January 20, February 15, 19–24, and March 9–10, 1849, GWW and AW to JW, February 28–March 22, 1849, *GUW* 6380, 6386–88, 6383.

57. Eliza J. Winstanley to CP, W1081, WC; AW to JW, March 9–10 and 16, and April 16, 1849, *GUW* 6389, 6391.

5 A Widowed Mother, 1849–54

1. AW to JW, May 10, 1849, AW to JH, June 11 and 25, July 15, and August 8, 1849, *GUW* 6392, 7627, 7633, 7635–36; Mary Ann Whistler to

Grandmother, May 11, 1849, W960, WC; JH to AW, June 25, 1849, Joseph Harrison Letterpress Books, v.1, HSP.

2. AW to Sarah Harrison, June 29 [1849], *GUW* 7632, AW to JW, May 10, 1849.

3. AW to JW, May 10, 1849; DH to JW, July 28, 1849, H10, WC.

4. AW to JH, June 11, and August 8, 1849, AW to JW, May 10, 1849.

5. AW to JH, June 19 and 25, 1849, and July 7 and 15, 1849, *GUW* 7629, 7634.

6. Eugene W. Smith, *Trans-Atlantic Passenger Ships Past and Present* (Boston, Mass., 1947), 35, 39; AW to JH, July 7 and August 8, 1849; Arthur Bagby to wife, May 16, 1849, Arthur P. Bagby Letters, AL.

7. JH to AW, June 4, 22, and 25, 1849, JH to GW, July 10, 1849, v.1, Harrison Letterpress Books.

8. JH to WS, June 27, 1849, v.1, Harrison Letterpress Books; AW to JH, August 13 [1849], AW to JW, August 23, 1849, *GUW* 7637, 6393; Elmer F. Farnham, *The Quickest Route: The History of the Norwich and Worcester Railroad* (Chester, Conn., 1973), 7–8; Greg M. Turner and Melancthon W. Jacobus, *Connecticut Railroads: An Illustrated History* (Hartford, Conn., 1986), 36–40.

9. JM to Mother, April 1, 1843, JM to GWW, November 4, 1846, John Stevenson Maxwell Papers, NYHS; AW to JW, May 10, 1849.

10. Anna M. Whistler Diary, July 12 and August 2 and 15, 1850, Box 33, PWC. Hereafter cited as Whistler Diary (PWC).

11. JM to Mother, March 26, 1844, Maxwell Papers; Whistler Diary (PWC), January 29, May 22 and 29, and June 1, 1850.

12. Whistler Diary (PWC), February 6, April 22–23, May 30, and July 1–5, 1850.

13. Ibid., March 25, April 24–25, and June 11, 1850; Margaret M. MacDonald, *Whistler's Mother's Cook Book* (2nd ed.; San Francisco, 1995), 19–22; AW to JW, August 9, 1850, *GUW* 6394.

14. Whistler Diary (PWC), September 16–17, 1850, January 14, March 16–17, April 24 and 26, May 1 and 21, June 7, July 13 and 24, 1851.

15. GWW to JS, May 20 and July 26, 1846, Joseph G. Swift Letters, NYPL (microfilm copy in AAA); JH to WS, April 3, 1849, JH to AW, June 22, 1849, v.1, Harrison Letterpress Books; Ross Winans to Thomas Winans, April 23, 1846, October 13, 1846, Box 1, f.5, Box 2, f.32, Winans Papers, MdHS; AW to JH, June 19, 1849.

16. Whistler Diary (PWC), April 2, 5, and 16, and May 21, 1850; AW to Nicholas I, November 1849, *GUW* 955.

17. Whistler Diary (PWC), January 9, April 8, May 1, and July 23, 1850.

18. Ibid., March 25, April 20, May 14–15, 17, 21, 24, and 27, 1850; JH to AW, December 6, 1849, and January 2, February 1, April 18, May 27, [July], and October 3, 1850 (all v.1), November

4, 1851 (v.2), Harrison Letterpress Books. The Russian negotiations are summarized in Richard Mowbray Haywood, *Russia Enters the Railway Age, 1842–1855* (New York, N.Y., 1998), 368.

19. Daniel L. Schafer, *Anna Madgigine Jai Kingsley* (Gainesville, Fla., 2003), 45–47, 56–57, 96.

20. Anna M. Whistler Diary, March 29, 1844, NYPL (microfilm copy in AAA); Daniel L. Schafer, *Zephaniah Kingsley Jr. and the Atlantic World: Slave Trader, Plantation Owner, Emancipator* (Gainesville, Fla., 2013), 230–45, and *Anna Kingsley*, 68–75. The will and other information may be found in Daniel W. Stowell, ed., *Balancing Evils: The Proslavery Writings of Zephaniah Kingsley* (Gainesville, Fla., 2000), 116–21.

21. U.S. Bureau of the Census, *Population Schedule of the Seventh Census, 1850, Duval County, Florida*, RG 29, NA (M432, roll 58, p.103b); Schafer, *Zephaniah Kingsley*, 253, 255; Schafer, *Anna Kingsley*, 96; Whistler Diary (PWC), May 9, 1850.

22. Whistler Diary, May 30, 1844, July 7, 1846, and January 30, 1847.

23. Stowell, *Balancing Evils*, 1–22; Schafer, *Anna Kingsley*, 56. For a different but flawed interpretation of these events, see Paul C. Marks, "James McNeill Whistler's Family Secret: An Arrangement in White and Black," *Southern Quarterly*, 26 (Spring 1988), 67–75.

24. Joseph G. Swift, *Memoirs of Gen. Joseph Gardner Swift* (Worcester, Mass., 1890), 267–68; Daniel E. Sutherland, *Whistler: A Life for Art's Sake* (London, 2014), 12–16, 18–21.

25. AW to JW, June 10, July 10–11, August 6, September 16 [1851], and October 6, 1851, *GUW* 6396–98, 6400, 6403; WW to JW, June 19 [1851], and July 10–15, 1851, W979, W981, WC.

26. AW to JW, June 10, August 6 and 27, 1851, September 16 [1851], and January 15–16, 1852, *GUW* 6399, 6409.

27. AW to MH, October 8, 1861, AW to JW, June 10, July 10–11, August 6, October 6, and November 25, 1851, *GUW* 7638, 6407.

28. Grace S. Fleming to KM, October 26, 1928, WW to JW, December 8, 1851, F351, W980, WC; AW to MH, October 8, 1851, AW to JW, August 6 and 27, and September 23–24, 1851, *GUW* 6399, 6401.

29. AW to MH, October 8, 1851, AW to JW, November 13 and 25, 1851, *GUW* 6406.

30. AW to JW, July 10–11, August 27, September 23–24, 1851, AW to MH, August 3 [1851] and October 8, 1851, *GUW* 9557.

31. Anna P. Stanton to KM [April 22, 1928], Don P. Stanton to KM [April 28, 1930], S180, S200, WC.

32. AW to MH, October 8, 1851, AW to JW, November 13 and 25, 1851, May 3–4, 1852, July 7 [1852], and September 3, 1852, *GUW* 6414, 6417–18.

33. Don P. Stanton to KM, August 31, 1930, S205, WC; AW to MH, April 15, 1852, AW to JW, December 17 and 19, 1851, March 3, 1852, and April 22 [1852], *GUW* 9559, 6408, 6412–13.

34. AW to MH, October 8, 1851, AW to JW, September 23–24, 1851, July 7, 29 and 31 [1852], *GUW* 6416.

35. AW to JW, October 6 and November 25, 1851, February 10–11, March 3, July 7 [1852], September 3 and 12, 1852, *GUW* 6410, 6419.

36. AW to JW, April 15, 1852, April 22 [1852], September 12, 1852, and [September] 20 [1852], *GUW* 6409, 6420; Elias Glenn Perine to The Century Company, May 28, 1920 (Box 22), Clippings File (Box 20), David M. Perine Papers, MdHS.

37. AW to Robert E. Lee, September 24 [1852], *GUW* 7549.

38. AW to JW, October 6 [1852] and August 1, 1858, *GUW* 6421, 6498; Sutherland, *Whistler*, 28–29.

39. AW to JW, September 12, 1852; WW to JW, October 14 [1852], W982, WC.

40. 40. AW to GW, WW, and JW, November 18–19, 1852, AW to JW, November 24, 1852, *GUW* 6422–23; WM to JW, December 14, 1852, M80, WC.

41. AW to GW, WW, and JW, November 18–19, 1852, AW to Catherine Julia Cammann, April 27–28, 1853, *GUW* 6422; Jack Rohan, *Yankee Arms Maker: The Incredible Career of Samuel Colt* (New York, N.Y., 1935), 197–203; WM correspondence with Samuel Colt, 1841–44, and Colt to Ned, November 17, 1852, Samuel Colt Papers, CHS.

42. AW to MH and Alethea B. Hill, February 21–22, 1853, AW to WW, February 27 and March 3, 1853, AW to GW, WW, and JW, November 18–19, 1852, AW to JW, November 24, 1852, *GUW* 7640, 6425.

43. AW to JW, November 24, 1852, December 31, 1852 and January 4, 7, 1853, AW to MH and Alethea B. Hill, February 21–22, 1853, AW to JW, December 31, 1852 and January 4 and 7, 1853, *GUW* 6424; Barbara Denny, *Chelsea Past* (London, 1996), 55. Remarkably, John Betjeman includes Anna (as "Whistler's mother") in his poem "Holy Trinity, Sloane Street," written in the 1930s.

44. AW to JW, December 31, 1852 and January 4 and 7, 1853.

45. AW to GW, WW, and JW, November 18–19, 1852, AW to JW, November 24, 1852, AW to MH, December 24, 1852, *GUW* 7639.

46. AW to MH and Alethea B. Hill, February 21–22, 1853.

47. AW to WW, February 27 and March 3, 1853, AW to MH, December 24, 1862, AW to MH and Alethea B. Hill, February 21–22, 1853, AW to JW, April 7, 11, 13, 1853, *GUW* 6426–27.

48. AW to JW, April 7, 1853, AW to Catherine J. Cammann, April 27–28, 1853, *GUW* 7641; Don P. Stanton to KM [May 27, 1930], S201, WC.

49. AW to JG, September 28 and October 1 [1853], AW to JW, September 29 [1853] and November 16, 1853, *GUW* 6428–30. For Cammann's impressive career, see James R. Learning, *Memoir of George P. Cammann, M.D.* (Boston, Mass., 1864).

50. AW to Jane Wann, November 18 [1853], AW to JW, November 16, 1853 and December 1 [1853], *GUW* 6431–32; *Doggett's New York City Directory, 1849–50* (New York, N.Y., 1849), 80, 327.

51. AW to JW [December 26, 1853/January 1854], *GUW* 6434.

52. AW to JW, February 10 and March 17, 1854, AW to JG, April 3, 1854, *GUW* 6435, 6442, 6438.

53. Ibid.; AW to JW, April 3, 1854, *GUW* 6437.

54. AW to JW, April 3, [April] 27, and May 29–30, 1854, AW to JG, April 3, 1854, *GUW* 6641, 6439. The portrait was by Emile-Francois Dessain, *GUW* 221.

55. AW to A Fair Stranger, September 2 [1854], *GUW* 6443.

6 Sojourner, 1854–60

1. AW to JW, October 30 [1854], *GUW* 6444.

2. Ibid., [November 1854], November 26–27, December 7, 1854, and January 15, 1855, *GUW* 6445–47, 6450.

3. AW to Thomas H. Seymour, February 1855, AW to JW, January 1–2, 1855, *GUW* 6448, 9560; Thomas Winans Diaries [Account Books], 1853–54, Box 22, Winans Papers, MHS.

4. AW to JW, December 7, 1854, January 1, 2, 8, 1855, and [January 15/February 1855], *GUW* 6449, 6462.

5. Daniel E. Sutherland, *Whistler: A Life for Art's Sake* (London, 2014), 34–38; AW to JW, February 13, March 15, [March 21, 1855], and April 17, 1855, *GUW* 6452, 6454–56.

6. AW to JW, March 17, [March 21, 1855], [March] 28 [1855], and April 19, 1855, *GUW* 6453, 6458; Winans Diaries, May 17, 1855.

7. AW to JW, July 11 and 25, 1855, *GUW* 6463–64; Winans Diaries, July 30, 1855.

8. AW to JW, July 11 and November 2–5, 1855 and January 29, 1857, *GUW* 6469, 6480.

9. AW to JW, February 13, 1855, August 17/ September 16, 1857, AW to JG, April 3, 1854, *GUW* 6438, 6487.

10. AW to JW, October 10–15 and November 2–5, 1855 and January 29, 1857, *GUW* 6468.

11. AW to JG, April 3, 1854 and May 27, 1856, AW to JW, January 29, August 17/September 16, 1857, *GUW* 6438, 6473, 6480, 6487.

12. Harry B. Weiss and Howard R. Kemble, *The Great American Water-Cure Craze: A History of Hydropathy in the United States* (Trenton, N.J., 1967), 22, 24–26, 31, 41–42, 127, 134, 155–81; Susan E. Cayleff, *Wash and Be Healed: The Water-Cure Movement and Women's Health* (Philadelphia, 1987), 17–74; "Sulphur Springs of New York," *Harper's New Monthly Magazine*, 13 (June 1856), 1–17.

13. AW to JW, July 11, 1856, *GUW* 6474; "Sulphur Springs of New York," 16.

14. Walter Barrett, *The Old Merchants of New York*

City. Second Series (New York, N.Y., 1870), 333–34; AW to JG, February 4, 1856 and June 10, 1857, AW to Jane Wann, July 15–16, 1857, AW to JW, July 13–15 [1857], *GUW* 6471, 6484–86.

15. Buddy Sullivan, ed., *"All Under the Bank": Roswell King, Jr., and Plantation Management in Tidewater Georgia, 1819–1854* (Darien, Ga., 2003), 18–35; Malcolm Bell, Jr., *Major Butler's Legacy: Five Generations of a Slaveholding Family* (Athens, Ga., 1987), 159–69, 530–32.

16. AW to JG, February 4, 1856.

17. Allan Nevins and Milton Halsey Thomas, eds., *The Diary of George Templeton Strong*, 4 vols. (New York, N.Y., 1952), IV:131; Hendrik Hartog, *Man and Wife in America: A History* (Cambridge, Mass., 2000), 176–87. The details of Harriet's life may be found in Angus Davidson, *Miss Douglas of New York: A Biography* (New York, N.Y., 1953).

18. Nevins and Halsey, *Diary of Strong*, IV:131–32; *New York Times*, November 14, 1874.

19. AW to JG, September 28/October 1 [1853], September 20, 1855, and May 27, 1856, *GUW* 6428, 6465, 6473.

20. AW to JW, August 17/September 16, 1857, AW to JG, September 17, 1857, *GUW* 6488.

21. Ibid. and AW to JG, October 8, 1857, *GUW* 6489.

22. AW to JG, January 13, 1857, November 9 [1857], AW to JW, January 29, 1857, *GUW* 6479, 6492, 6480.

23. AW to JG, December 2 [1857] and January 23 [1858], *GUW* 6492–93; Thomas Scharf, *Chronicle of Baltimore* (Baltimore, Ma., 1874), 563; Soup House Expense Account, June–December 1861, Box 23, Winans Papers.

24. AW to JG, January 23 [1858].

25. U.S. Bureau of the Census, *Population Schedule of the Eighth Census, 1860, Duval County, Florida*, RG 29, NA (M653, roll 106, p.34); *Agricultural Schedule of the Eighth Census, 1860*, RG 29, NA (T1168, roll 3); AW to JW, March 23, 1858.

26. Daniel L. Schafer, *Zephaniah Kingsley Jr. and the Atlantic World: Slave Trader, Plantation Owner, Emancipator* (Gainesville, Fla., 2013), 180–81, 236–37, 242–45; AW to JW, March 23, 1858.

27. Horace Hart to KM, June 5, 1933, H152, WC; AW to JW, May 7, 1858, AW to CM, October 10–12, 1877, *GUW* 6561.

28. Daniel L. Schafer, *Anna Madgigine Jai Kingsley* (Gainesville, Fla., 2003), 96–98, and *Zephaniah Kingsley Jr.*, 242, 296; Horace Hart to KM, June 5, 1933, Don P. Stanton to KM, February 20 [1929] and January 29 [1930], S193, S195, WC; U.S. Bureau of the Census, *Population Schedule of the Seventh Census, 1850, Duval County, Florida*, RG 29, NA (M432, roll 58, p.103b), *Population Schedule of the Ninth Census, 1870, Duval County, Florida*, RG 29, NA (M593, roll 129, p.291).

29. Barbara Jeanne Fields, *Slavery and Freedom on the Middle Ground: Maryland during the Nineteenth Century* (New Haven, Conn., 1985), 7–9, 47–48, 62; U.S. Bureau of the Census, *Population Schedule of the Eighth Census, 1860, Baltimore County, Maryland [Slave Schedule]*, RG 29, NA (M653, roll 484, p.194); Frank Towers, *The Urban South and the Coming of the Civil War* (Charlottesville, Va., 2004), 45–46; Winans Diaries, July 6, 1855.

30. AW to JW, May 7, 1858; Bernard E. Powers Jr., *Black Charlestonians: A Social History, 1822–1885* (Fayetteville, Ark., 1994), 9–11, 36–38, 41–42, 45–47, 268. Named for Horace Walpole's Gothic novel, Otranto still stands.

31. AW to JG, February 4, 1858; Jane H. Pease and William H. Pease, *A Family of Women: The Carolina Petigrus in Peace and War* (Chapel Hill, N.C., 1999), 88–94; Larry E. Tise, *Proslavery: A History of the Defense of Slavery in America, 1701–1840* (Athens, Ga., 1987), 12–40, 75–96.

32. Michael Fellman et al., *This Terrible War: The Civil War and Its Aftermath* (3rd ed.; New York, N.Y., 2015), 50–51.

33. Ibid., 56–69; Don P. Stanton to KM, [May 27, 1930], S201, WC.

34. AW to Catherine Julia Cammann, April 27–28, 1853, *GUW* 7641.

35. Tise, *Proslavery*, 348; AW to JW, December 15, 1856, *GUW* 6477.

36. AW's many references to Eliza between 1851 and 1854 may be found in *GUW* 6398–6400, 6428, 6430–31, 6441, 7639.

37. AW to JW, September 23, 1856, *GUW* 6476.

38. AW to JW, July 25, 1855 and January 29, 1857, AW to JG, June 10, 1857, *GUW* 6464, 6480, 6484; William Frederick Norwood, *Medical Education in the United States before the Civil War* (Philadelphia, 1944), 392–94; *Catalogue of the Trustees, Officers, and Students of the University of Pennsylvania: Session 1859–60* (Philadelphia, 1860), 22, 34–36; School of Medicine Matriculation Book, 1859–61, Sessions of 1857–58, 1858–59, 1859–60 for William McNeill Whistler (Item 15), Inscription Book, 1852–61, October 2, 1857 (Item 16), Register of Students (Medical), 1857–66, for William McNeill Whistler and William R. Blount (Item 46), all in School of Medicine: Student Records (UPC 2.7), UP.

39. AW to JW, July 13–15 [1857], March 23 and May 7, 1858, *GUW* 6485, 6495–96.

40. AW to JW, July 13–15 [1857] and April 27, 1857, AW to JW, June 29, 1858, *GUW* 6483, 6497. At some point, Willie gave Darrach at least one of Jemie's drawings, perhaps in gratitude for his role as preceptor. See M.218.

41. AW to JG, June 29, 1858; Charles Bader, *The Natural and Morbid Changes of the Human Eye, and Their Treatment* (London, 1868), 112.

42. L. M. W. Gibbs to Charlotte Porcher, October 8, 1853, Charlotte Porcher Letters, and Katherine Meares to Mother, September 10, 1857, DeRosset Family Papers, Box 2, both in SHC; Julia King to KM, August 30, 1929, K13, WC; AW to JG, June 29, 1858, AW to JW, December 15, 1856, August 1, and August 17/September 16, 1857, *GUW* 6477, 6498.

43. AW to JG, October 17 [1858] and November 11 [1858], AW to JW, November 18, 1858, *GUW* 6499–6501.

44. AW to JG, November 22, 1859, AW to ME, September 8–9, 23, and 29, 1874, *GUW* 6507, 11843.

45. Ibid. and AW to JG, October 16/30 and December 30, 1858, AW to JG and Jane and Samuel Wann, [June] 24 and 28 [1859], AW to CM, October 10–12, 1877, *GUW* 6478, 6505–06.

46. Anna M. Whistler Diary, January 23, 1847, NYPL (microfilm copy in AAA); AW to JW, October 10, 1855 and April 27, 1857, *GUW* 6466, 6483.

47. AW to JW, July 25 and October 10, 1855, AW to JG, May 27, 1856, *GUW* 6473.

48. AW to JG, May 27, 1856, AW to JW, July 11, September 23, and December 25, 1856, January 29, 1857, and August 1, 1858.

49. AW to JW, April 30 and May 4 [1857], *GUW* 6472.

50. AW to JW, September 23, 1856, January 29, April 27, August 17/September 16, 1857, and August 1, 1858.

51. AW to JW, August 17/September 16, 1857. If JW made a copy of the painting for King, its whereabouts are unknown.

52. AW to JW September 23, 1856, January 29, 1857, and July 13–15 [1857]; Don P. Stanton to KM [May 27, 1930], S201, WC. JW may have accepted as many as five commissions from Williams, but none are known to have survived. See YMSM 10, 13, 15–17.

53. AW to JW, April 27, 1857, April 30 and May 4 [1857], and May 7, August 1, and November 18, 1858; Thomas Sully to Elias Glenn Perine, May 15 and 25, 1856 and April 25, 1858, John Beale Bordley to Perine, February 3 and June 16, 1856, David Maulden Perine Papers, MdHS; Nicholas Biddle Wainwright, "Joseph Harrison, Jr., A Forgotten Art Collector," *Antiques*, 102 (October 1972), 660–68.

54. Sutherland, *Whistler*, 50–51; AW to JG, December 5 [1858], *GUW* 6502.

55. AW to JG and Jane and Samuel Wann, [June] 24 and 28 [1859], AW to JG, March 27 and May 7, 1860, AMW to DH, May 4, 1860, *GUW* 6508–10; Classes of Candidates, 1859–60, inside cover and Class XIII (Item 38), School of Medicine: Student Records.

56. AW to DH, May 4, 1860, AW to JW, December 15, 1856, March 23, 1858, and August 19, 1861, *GUW* 6477, 6495, 6517.

57. Sutherland, *Whistler*, 59–62; YMSM 24.

58. AW to DH, May 4, 1860 and August 4, 1863, *GUW* 6521; Kate R. McDiarmid, *Whistler's Mother: Her Life, Letters and Journal* (North Wilkesboro, N.C., 1981), 140; Julia King to KM, August 30, 1929, K13, WC.

7 The Manager, 1860–67

1. AW to JG, June 20, 1861, AW to JW, July 11, 1861, *GUW* 6514, 6511; Helen Whistler to J. Solis Cohen, June 22, 1900, William McNeill Whistler file, Box 2944, Office of Alumni Records: Biographical Records, 1750–2002 (UPF 1.9 AR), UP; John W. Lamb, *A Strange Engine of War: The 'Winans' Steam Gun and the Civil War in Maryland* (Baltimore, 2011), 28–30, 37–41; T. H. Galloway, ed., *Dear Old Roswell: Civil War Letters of the King Family of Roswell, Georgia* (Macon, Ga., 2003), 5; J. G. De Roulhac Hamilton, ed., *The Papers of William Alexander Graham*, 6 vols. (Raleigh, N.C., 1957–76), I:269.

2. JH to GW, January 23, 1861, v.5, Joseph Harrison Letterpress Books, HSP; AW to JG, June 20, 1861, AW to JW, July 11, 1861.

3. AW to JW and DH [July 15/31, 1861], AW to JW, August 3, 1861, *GUW* 6512, 6516.

4. AW to JW, May 12, 1862, *GUW* 6519. Sumner may have purchased some of Jemie's etchings when visiting London and Paris in 1859. He later published *Best Portraits in Engraving* (New York, N.Y., 1871), although he did not address modern engravings and etchings, and worked in Congress to eliminate the tariff on works of art. See Edward L. Pierce, ed., *Memoir and Letters of Charles Sumner*, 4 vols. (Boston, Mass., 1877–93), III:594, IV:23.

5. AW to JG, June 20, 1861 and February 19, 1862, AW to JW, July 11, August 3 and 19, 1861, and May 12, 1862 *GUW* 6517–18.

6. AW to JW, May 12, 1862.

7. WW to Walter H. Taylor, November 6, 1861, William M. Whistler file in U.S. War Department, *Compiled Service Records of Confederate Generals and Staff Officers*, War Department Collection of Confederate Records, RG 109, NA (M331, roll 264).

8. William K. Scarborough, ed., *The Diary of Edmund Ruffin*, 3 vols. (Baton Rouge, La., 1972–89), II:520; AW to JG, November 15, 1862, AW to DH, August 4, 1863, *GUW* 6520–21; U.S. Bureau of the Census, *Population Schedule of the Eighth Census, 1860, Henrico County, Virginia*, RG 29, NA (M653, roll 1353, p.523).

9. Harry C. Vail to KM, December 12, 1930, B188, WC; AW to DH, August 4, 1863; Whistler, *Compiled Service Records*; Robert W. Waitt Jr., *Confederate Military Hospitals in Richmond* (Richmond, Va., 1964), 17, 20.

10. AW to DH, August 4, 1863, AW to JG, June 12, 1864, AW to Margaret, December 23–24, 1864, *GUW* 6526, 11479.

11. J. B. Jones, *A Rebel War Clerk's Diary at the Confederate States Capital,* 2 vols. (Philadelphia, Pa., 1866), I:237; Judith W. McGuire, *Diary of a Southern Refugee During the War* (New York, N.Y., 1867), 88; *Butters' Richmond Directory, 1855* (Richmond, 1855), 85; AW to DH August 4, 1863.

12. Jones, *Rebel War Clerk,* I:250, 282–83, 284–86; Ernest B. Furguson, *Ashes of Glory: Richmond at War* (New York, N.Y., 1996), 193–96; *Richmond Directory and Business Advertiser for 1856* (Richmond, Va., 1856), 81, 118.

13. Jones, *Rebel War Clerk,* II:5; Sallie B. Putnam, *Richmond during the War: Four Years of Personal Observation* (New York, N.Y., 1867), 214–15; 219–25.

14. Jones, *Rebel War Clerk,* I:241, 245; Daniel E. Sutherland, *Whistler: A Life for Art's Sake* (London, 2014), 87; William Michael Rossetti, *Some Reminiscences of William Michael Rossetti,* 2 vols. (New York, N.Y., 1906), II:320; AW to DH, August 4, 1863.

15. AW to DH, August 4, 1863, AW to JG, February 10–11, 1864, AW to Margaret, December 23–24, 1864, *GUW* 6522; Whistler, *Compiled Service Records;* Arch Frederic Blakey, *General John H. Winder, C.S.A.* (Gainesville, Fla., 1990), 53–54.

16. Don P. Stanton to KM, June 29, 1930, S203, WC.

17. AW to Margaret, December 23–24, 1864, [June 19, 1869], *GUW* 11479, 8179; CP to MH, January 28, 1864, *GUW* 4406. The blockade story first appeared in an obscure newspaper article by William Laurie Hill, who claimed that he and his wife had accompanied Anna on the voyage. Unfortunately, it is impossible to verify his account, which, in any event, contains several contradictions, improbable events, and demonstrable errors of fact. Besides, Hill, a novelist and poet by profession, was known for spinning a good yarn.

18. CP to MH, January 28, 1864, *GUW* 6522.

19. Sutherland, *Whistler,* 77, 86–87.

20. JW to Henri Fantin-Latour, January 3–February 4, 1864, *GUW* 8036.

21. Carlyle quoted in Arthur Jerome Eddy, *Recollections and Impressions of James A. McNeill Whistler* (Philadelphia, 1903), 110.

22. CP to MH, January 28, 1864, AW to JG, February 10–11, 1864.

23. Ibid.; Barbara Denny, *Chelsea Past* (London, 1996), 8–13, 21–24, 55; AW to JG, June 2 and 7, 1864 and October 30 [1868], AW to MH, December 14–15/19, 1868, *GUW* 6524–25, 6537, 11473.

24. AW to JG, February 10–11, 1864, September 7–10, 1870, AW to CP, May 21–June 3 [1872], *GUW* 6545, 9938.

25. AW to JG, February 10–11, 1864; William Charnley to CP, October 23, 1863, *GUW* 575.

26. AW to JG, February 10–11 and June 7, 1864.

27. AW to JG, February 10–11, 1864; Rossetti, *Some Reminiscences,* II:320.

28. Luke Ionides, *Memories* (1925; Ludlow, Eng., 1996), 14.

29. AW to JG, February 10–11, 1864.

30. Ibid.; Sutherland, *Whistler,* 88–89.

31. AW to JG, February 10–11, 1864.

32. AW to JG, June 7, 1864.

33. Ibid., AW to JG, February 10–11, 1864, AW to Margaret, December 23, 1864, *GUW* 11479.

34. AW to DH, August 4, 1863, AW to JG, June 7 and 12, 1864, AW to Margaret, December 23–24, 1864; Stephen R. Wise, *Lifeline of the Confederacy: Blockade Running during the Civil War* (Columbia, S.C., 1988), 46–47, 63–65, 95–96.

35. Wise, *Lifeline of the Confederacy,* 208–09; Frank E. Vandiver, ed., *Confederate Blockade Running through Bermuda, 1861–1865: Letters and Cargo Manifests* (Austin, Texas 1947), 130–31; Glen N. Wiche, ed., *Dispatches from Bermuda: The Civil War Letters of Charles Maxwell Allen, United States Consul at Bermuda, 1861–1888* (Kent, Ohio, 2008), 130.

36. Daniel L. Schafer, *Anna Madgigine Jai Kingsley* (Gainesville, Fla., 2003), 109, 113–14; AW to DH, August 4, 1863, AMW to JHG, June 7, 1864, *GUW* 6521; Horace Hart to KM, June 5, 1933, H152, WC. For the war along the St. Johns River, see Daniel L. Schafer, *Thunder on the River: The Civil War in Northeast Florida* (Gainesville, Fla., 2010).

37. "Obituary: William MacNeill Whistler, M.D.," *British Medical Journal,* March 10, 1900, 613; Whistler, *Compiled Service Records;* Robert R. Hemphill to JW, October 12, 1898, *GUW* 2119.

38. WW to Robert R. Hemphill [November 29, 1898], *GUW* 7028.

39. AW to JG, February 10–11, 1864, AW to Margaret, December 23–24, 1864, *GUW* 11479; A. B. Granville, *Spas of England and Principal Sea-Bathing Places: The Midlands and South* (1841; Bath, Eng., 1971), 475, 478.

40. AW to MH, October 22, 1865, *GUW* 11965; Harry B. Weiss and Howard R. Kemble, *The Great American Water-Cure Craze: A History of Hydropathy in the United States* (Trenton, N.J., 1967), 1–17; Janet Brown, "Spas and Sensibilities: Darwin at Malvern," in Roy Porter, ed., *The Medical History of Spas* (London, 1990), 102–13; Granville, *Spas of England,* 266–67.

41. AW to JW, November 25 [1865], AW to DH, January 24, 1866, *GUW* 6526, 6528.

42. Sutherland, *Whistler,* 91–94; AW to JW, November 25 [1865].

43. Sutherland, *Whistler,* 94–96.

44. AW to JW, November 25 [1865], AW to DH, January 24, 1866, AW to JW and WW, January 22, 1866, *GUW* 6527.

45. AW to JW and WW, January 22, 1866.
46. AW to DH, January 24, 1866; Sutherland, *Whistler*, 96–100.
47. AW to JR, June 13, 1867, June 14, 1867, Last Will and Testament, June 17, 1867, and 1871, AW to Jane Wann, July 27, 1867, AW to JG, August 3/27, 1867, and [August 27, 1867], *GUW* 1221, 12216, 11979, 12217, 6531–32, 6535; Eugene W. Smith, *Trans-Atlantic Passenger Ships Past and Present* (Boston, Mass., 1947), 105.
48. AW to Jane Wann, July 24, 1867, July 27, 1867, August 23 [1867], AW to JG, August 3/27, 1867, [August 27, 1867], September 16/October 29, 1867, *GUW* 6530, 6534, 6536.
49. AW to JG, August 3/27, 1867, and September 16/October 29, 1867.
50. Arthur P. Ford and Marion J. Ford, *Life in the Confederate Army* (New York, N.Y., 1905), 99–127; Jane H. and William H. Pease, *A Family of Women: The Carolina Petigrus in Peace and War* (Chapel Hill, N.C., 1999), 192–97, 201–03.
51. Pease and Pease, *A Family of Women*, 202–03, 235–37.
52. AW to JG, September 16/October 29, 1867; Smith, *Trans-Atlantic Passenger Ships*, 50, 147; Basil Greenhill and Ann Gifford, *Travelling by Sea in the Nineteenth Century: Interior Design in Victorian Passenger Ships* (New York, N.Y., 1974), 47, 49, 130–31.

8 The Mother, 1867–72

1. Daniel E. Sutherland, *Whistler: A Life for Art's Sake* (London, 2014), 104–06; DH to WW [May 4/6, 1867], *GUW* 1914.
2. Sutherland, *Whistler*, 107; AW to DH, December 14 [1867], *GUW* 6541.
3. William Rothenstein, *Men and Memories: A History of the Arts, 1872–1922*, 2 vols. (New York, N.Y., 1931–32), I:306–07; Daria E. Seymour-Haden to Scott Stevenson, December 5, 1940, Scott Stevenson Letters, TMA; Daria E. Seymour-Haden to W. S. Brewster, April 18, 1947, Walter E. Brewster Collection, AIC.
4. Mary Glenn Perine Diary, July 20, 1868, Box 25, David Maulden Perine Papers, MdHS.
5. AW to MH, December 14–15/19, 1868, AW to JG, November 17 and 22 [1868], *GUW* 6539–40.
6. Sutherland, *Whistler*, 110–14; AW to MH, December 14–15/19, 1868, *GUW* 11473.
7. Ibid.; AW to JG and HG, May 6, 1869, AW to JG, October 30 [1868], JW to AW, [April 27/May 1867], *GUW* 6542, 6537, 6529.
8. AW to JG, October 30 [1868] and November 11 [1868].
9. AW to JH, May 14, 1868 and February 5, 1870, *GUW* 11470, 11968; Roy Porter, *Bodies Politic: Disease, Death and Doctors in Britain, 1650–1900* (Ithaca, N.Y., 2001), 17–18, 233–34, 255; M.

10. AW to Jane Wann, August 23 [1867], AW to Margaret [June 19, 1869], *GUW* 8179.
11. Ibid.; AW to JG and HG, May 6, 1869, AW to CP, October 29–November 5, 1870, *GUW* 11841; Donald Schafer, *Anna Madgigine Jai Kingsley* (Gainesville, Fla., 2003), 114–16; Horace Hart to KM, June 5, 1933, H152, WC.
12. AW to JH, February 5, 1870, AW to JG, September 7–10, 1870, *GUW* 11968, 6545; Jane H. Pease and William H. Pease, *A Family of Women: The Carolina Petigrus in Peace and War* (Chapel Hill, N.C., 1999), 236–37.
13. AW to MH, September [8–10, 1870], AW to CP, November 3–4, 1871, AW to HG and JG, May 6, 1869, *GUW* 7642, 10071.
14. Sutherland, *Whistler*, 116–17.
15. AW to MH, December 14–15/19, 1868.
16. Ronald Anderson, "Whistler: An Irish Rebel and Ireland: Implications of an Undocumented Friendship," *Apollo*, 123 (April 1986), 254–58, tries to make a case for Jemie's deeper involvement in the Fenian movement.
17. Harry W. Rudman, *Italian Nationalism and English Letters: Figures of the Risorgimento and Victorian Men of Letters* (London, 1940), 97–103, 119–22, 287–96; Christopher Duggan, *A Concise History of Italy* (Cambridge, Eng., 1994), 108–11; Harry Hearder, *Italy: A Short History* (Cambridge, Eng., 1990), 166–70.
18. Rudman, *Italian Nationalism*, 142–52; Philip Henderson, *Swinburne: The Portrait of a Poet* (London, 1974), 36, 133–34, 137–39; Cecil Y. Lang, ed., *The Swinburne Letters*, 6 vols. (New Haven, Conn., 1959–62), I:314.
19. E. F. Richards, ed., *Mazzini's Letters to an English Family, 1844–72*, 3 vols. (London, 1920–22), I:22–25, III:197, 200, 203, 223, 227, 228, 240; Denis Mack Smith, *Mazzini* (New Haven, Conn., 1994), 186–89; AW to CP, October 29–November 5, 1870, JW to Giuseppe Mazzini [January 1870/72], *GUW* 11841, 4031.
20. Venturi expresses her views quite forcefully in Emilie Venturi Letters to John Dillon, James Marshall and Marie-Louise Osborn Collection, YU. Quotations from Terry L. Myers, ed., *Uncollected Letters of Algernon Swinburne*, 3 vols. (London, 2004–05), I:136, 138, 199.
21. Myers, *Uncollected Letters of Swinburne*, I:138; E. R. and J. Pennell, *The Life of James McNeill Whistler*, 2 vols. (London, 1908), I:112.
22. AW to CP, October 29–November 5, 1870, AW to JG, September, 7–10, 1870, *GUW* 11841.
23. Peterson, *Medical Profession*, 74, 90–92, 212–15, 221–23; AW to Margaret [June 19, 1869], AW to JH, February 5, 1870, AW to MH, September [8–10, 1870]; Memorandum of Agreement, August 20, 1870, WW to JR, November 28, 1871,

Jeanne Peterson, *Medical Profession in Mid-Victorian London* (Berkeley, Calif., 1978), 81, 85–86; Sutherland, *Whistler*, 141–42.

December 1, 1871, WW to Mr. Brelez, May 18, 1872, Box K, f.10, PWC.

24. Myers, *Uncollected Letters of Swinburne*, I:199; AW to Jane Wann, May 7, 1872, AW to JG, April 10–20, 1872, November 5 and 22, 1872, *GUW* 6551, 6549, 6553.

25. AW to HG and JG, May 6, 1869, AW to Margaret [June 19, 1869], AW to JG, September 7–10, 1870, November 29, 1871; AW to CP, May 21–June 3 [1872], *GUW* 6547.

26. AW to JG, November 5/22, 1872, *GUW* 6553.

27. AW to CP, October 29–November 5, 1870.

28. Ibid.; AW to JG, April 10–20, 1872, November 5/22, 1872, *GUW* 11841, 6549, 6553.

29. Sutherland, *Whistler*, 100–101; AW to Walter Greaves, November 14 [1868], AW to Walter and Henry Greaves, January 18, 1871, AW to My Young Friends, December 24, 1871, *GUW* 11492, 12323, 9601.

30. AW to CP, October 29–November 5, 1870, AW to JG, September 7–10, 1870, November 29, 1871, March 13, 1872, November 5/22, 1872, AW to ME, September 8–9/23/29, 1874, *GUW* 6547–48, 11843; Biographical Sketch of William C. Gellibrand Papers, UL; Joanna Livingston, *Gellibrands* (n.p., 2005), 60.

31. Alan A. Jackson, *London's Metropolitan Railway* (London, 1986), 16–17; Christian Wolmar, *The Subterranean Railway: How the London Underground was Built and How It Changed the City Forever* (revised ed.; London, 2012), 39–46, 79–83; Judith Flanders, *Victorian City: Everyday Life in Dickens' London* (New York, N.Y., 2012), 77–79.

32. AW to JG, May 6, 1869, AW to JR, July 28 [1870], AW to FRL, August 23 [1871], *GUW* 12215, 11867.

33. Sutherland, *Whistler*, 110–12; AW to FRL, March 11 [1869], *GUW* 8182.

34. AW to CP, October 29–November 5, 1870, May 21–June 3 [1872], AW to JG, September 7–10, 1870, November 29, 1871, April 10–20, 1872, November 5/22, 1872.

35. AW to CP, November 3–4, 1871, *GUW* 10071; Margaret F. MacDonald, "Whistler: The Painting of the 'Mother,'" *Gazette des Beaux-Arts*, 85 (February 1975), 73–74.

36. G.24; AW to CP, November 3–4, 1871.

37. AW to CP, November 3–4, 1871, AW to JG and HG, September 9–20, 1875, *GUW* 6555; YMSM 103; Catherine C. Goebel, "Arrangement in Black and White: The Making of a Whistler Legend" (PhD diss., Northwestern Univ., 1988), 237–42, 756–62.

38. AW to CP, November 3–4, 1871; Margaret F. MacDonald, "The Painting of Whistler's *Mother*," in MacDonald, ed., *Whistler's Mother: An American Icon* (Aldershot, Eng., 2003), 54–55.

39. Sutherland, *Whistler*, 101–03, 108–09, 118–20; Ruth Bernard Yeazell, *Picture Titles: How and*

Why Western Paintings Acquired Their Names (Princeton, N.J., 2015), 204–24.

40. *The World*, May 22, 1878; James McNeill Whistler, *The Gentle Art of Making Enemies* (London, 1892), 127–28.

41. Heather McPherson, *The Modern Portrait in Nineteenth-Century France* (Cambridge, Eng., 2001), 4–10, 33–34, 146–47; Alexander Sturgis and Hollis Clayson, eds., *Understanding Paintings: Themes in Art Explored and Explained* (New York, N.Y., 2000), 160; Shearer West, *Portraiture* (Oxford, Eng., 2004), 191–99.

42. AW to CP, November 3–4, 1871, AW to JG, April 10–20, 1872, *GUW* 6549; Algernon Swinburne, "Mr. Whistler's Lecture on Art," *Fortnightly Review*, 49 n.s. (June 1888), 746–47; Don P. Stanton to KM, April 28, 1930, Grace S. Fleming to KM, August 28 [1928], S200, F356, WC.

43. Frank Gibson, "Whistler's Portrait of His Mother," *Burlington Magazine*, 28 (December 1915); Patricia Simon, "Women in Frames: The Gaze, the Eye, the Profile in Renaissance Portraiture," *History Workshop Journal*, 25 (Spring 1988), 4–30; MacDonald, "Whistler," 81–83; MacDonald, "The Painting of Whistler's *Mother*," 42–52; Jonathan Weinberg, *Ambition and Love in Modern American Art* (New Haven, Conn., 2001), 6–7; "A Serious Matter," *Punch*, 58 (January 22, 1870), 22.

44. Margaret Olin, "Gaze," in Robert S. Nelson and Richard Shiff, eds., *Critical Terms for Art History* (Chicago, Ill., 1996), 208–19; Stephen Kern, *Eyes of Love: The Gaze in English and French Culture, 1840–1900* (New York, N.Y., 1996), 7, 10–14, 28–30, 102–04.

45. Anna M. Whistler Diary, July 1, 1844, November 2, 1846 and May 22, 1848, NYPL (microfilm copy in AAA); AW to GWW, June 8/10, 1847, AW to JW, September 3, 1852, AW to JW and DH July 15/31, 1861, AW to JG, September 30/ October 2, 1874, *GUW* 6357, 6418, 6512, 6554; Don P. Stanton to KM, April 28, 1928. Examples of speculation about the stool may be found in Weinberg, *Ambition and Love,* 23, and Sarah Walden, *Whistler and His Mother: An Unexpected Relationship* (London, 2003), 59–60.

9 Onlooker, 1872–81

1. AW to ME, September 8–9/23/29, 1874, AW to JG, November 5/22, 1872, *GUW* 11843, 6553; M. Jeanne Peterson, *The Medical Profession in Mid-Victorian London* (Berkeley, Calif., 1978), 248, 266.

2. AW to Jane Wann, May 7, 1872, AW to JG, March 13, 1872, April 10–20, 1872, November 5/22, 1872, *GUW* 6551, 6548–49.

3. AW to JG, April 10–20, 1872; Marion H. Spielmann, "James A. McNeill Whistler,"

Magazine of Art, n.s., 2 (November 1903), 13 note; Daniel E. Sutherland, *Whistler: A Life for Art's Sake* (London, 2014), 123.

4. Sutherland, *Whistler*, 123; Catherine C. Goebel, "Arrangement in Black and White: The Making of a Whistler Legend" (PhD thesis, Northwestern Univ., 1988), 242–48, 763–68.

5. AW to JG, November 5/22, 1872, AW to CP, November 3–4, 1871, and May 21–June 3 [1872], *GUW* 10071, 9938.

6. JW to Henri Fantin-Latour [August 1872], *GUW* 8041; Sutherland, *Whistler*, 129; Grace S. Fleming to KM, October 26, 1928, F351, WC; Margaret F. MacDonald, "Whistler: The Painting of the 'Mother,'" *Gazette des Beaux-Arts*, 85 (February 1975), 84–85.

7. Max Beerbohm, "Hethway Speaking," *Atlantic Monthly*, 200 (November 1957), 70; Sutherland, *Whistler*, 125. One scholar believes (erroneously, we believe) that Jemie saw Carlyle as a substitute for his father, and so positioned him in a way that "restores the lost parental couple." See Jonathan Weinberg, *Ambition and Love in Modern American Life* (New Haven, Conn., 2001), 15–16, 23.

8. Beerbohm, "Hethway Speaking," 70.

9. E. R. and J. Pennell, *The Life of James McNeill Whistler*, 2 vols. (London, 1908), I:171; YMSM 103.

10. Sutherland, *Whistler*, 123–25; AW to JG, November 5/22, 1872.

11. Sutherland, *Whistler*, 131–32; Goebel, "Arrangement in Black and White," 269–81, 792–816; AW to ME, September 8–9/23/29, 1874. Quoted reviews are *Manchester Examiner* and *The Times*, June 8, 1874; *The Academy*, 5 (June 13, 1874), 672; *The Builder*, 32 (July 25, 1874), 622; *The Queen*, June 13, 1874; and *The Art Journal*, n.s., 13 (August 1874), 230.

12. JW to DH [June 1/6, 1874], AW to JG, April 10–20, September 30/October 2, and November 5/22, 1874, *GUW* 11232, 6554.

13. Kate Livermore to Louisa Graves, September 22, 1893, Arthur Livermore Papers, MHS; AW to JG, September 30/October 2, 1874.

14. AW to JG, September 30/October 2, 1874.

15. Ibid., JW to [Sheriff] [February 28, 1874], *GUW* 12261; WW correspondence with JR, 1873–76, in Box K, ff.11–13, PWC.

16. AW to CP, October 29–November 5, 1870, AW to JG, April 10–20 and November 5/22, 1872, AW to JG and HG, September 9–20, 1875, Thomas Layland to JW, December 9, 1873, *GUW* 11841, 6555, 2609; Christine L. Corton, *London Fog: The Biography* (Cambridge, Mass., 2015), 77–80.

17. AW to ME, September 8–9, 23, and 29, 1874, JW to Cyril Flower [July/August 1874] *GUW* 9093.

18. AW to JG, September 30/October 2, 1874, AW to FL, May 12 [1875], AW to JG and HG, September

9–20, 1875, AW to ME, July 19, 1876, *GUW* 8181, 12635. See also for Kate Livermore, Leonard Allison Morrison, *Rambles in Europe* (Boston, Mass., 1887), 66.

19. Kate Livermore to AW, July 27, 1875, AW to JG and HG, September 9–20, 1875, AW to ME, July 19, 1876, *GUW*, 2623.

20. A. B. Granville, *Spas of England and Principal Sea-Bathing Places: The Midlands and South* (1841; Bath, Eng., 1971), 583–93; *Hastings and St. Leonards Observer*, September 18, 1875.

21. Anthony Belt, Jr., ed., *Hastings: A Survey of Times Past and Present* (Hastings, 1937), 54; Rex Marchant, *Hastings Past* (Chichester, Eng., 1997), 53; *Hastings and St. Leonards Observer*, August 21 and October 23, 1875; *Pike & Ivimy's Annual Hastings and St. Leonards Directory* (Hastings, Eng., 1876), "General Information."

22. *Hastings and St. Leonards Observer*, September 4, 1875. Helena Wojtezak, *Notable Women of Victorian Hastings: A Collection of Mini-Biographies* (Hastings, Eng., 2002), 69, briefly mentions Anna in a chapter titled "A Compendium of Visitors," although she resided at Hastings for over five years.

23. AW to JG and HG, September 9–20, 1875, AW to CM, February 11–12/14, 1878, *GUW* 6563; *Pike & Ivimy's Directory*, 71; *W. T. Pike's Hastings & St. Leonards Directory and Local Blue Book for 1878* (Hastings, 1878), 15, 144, 174, 361.

24. WW to Rose Fuller Whistler, September 9, 1887, *GUW* 12616; *Pike's Directory for 1878*, 21, 297.

25. AW to JG, September 8–9, 1876, JW to AW [September 26/27, 1876], *GUW* 6560, 6564.

26. AW to ME, July 19, 1876, AW to JG, September 8–9, 1876.

27. AW to JG, September 8–9, 1876, AW to JW, June !2 [1876], *GUW* 6556; Corton, *London Fog*, 81–85, 173.

28. AW to JW, June 12 [1876] and July 11, 1876, *GUW* 6559.

29. Ibid.; AW to JG, September 8–9, 1876, JW to FL [August 20/31, 1876], JW to AW [July 1876], *GUW* 8058, 9563.

30. Sutherland, *Whistler*, 133.

31. JW to AW [July 1876], [September 27/28, 1876], *GUW* 6564.

32. AW to JG, September 8–9, 1876, AW to ME, July 19, 1876.

33. Ibid.

34. JW to FL [September 1873], AW to ME, July 19, 1876, AW to JG, September 8–9, 1876, *GUW* 8055, Sutherland, *Whistler*, 116–17, 129, *The Times*, June 14, 1876, 10; Peterson, *Medical Profession*, 50–51, 90–92, 107–08, 162, 215, 222.

35. AW to JG, June 8–12, 1877, *GUW* 6565; Luke Ionides, *Memories* (1925; Ludlow, Eng., 1996), 14.

36. AW to JG, September 8–9, 1876 and June 8–12, 1877.

37. AW to JG, June 8–12, 1877.

38. AW to CP, October 29–November 5, 1870, AW to JG September 8–9, 1876, AW to JW, June 29 [1878], *GUW* 11841, 6557; *W. T. Pike's Hastings & St. Leonards Directory and Local Blue Book 1880–81* (Hastings, 1880), 58, 163.

39. AW to JG, September 30/November 2, 1874, September 8–9, 1876, and June 8–12, 1877, AW to CM, February 11–12/14, 1878; Robert Joseph Dwyer, *The Gentile Comes to Utah: A Study in Religious and Social Conflict* (Salt Lake City, 1971), 38–41.

40. Gillian Wagner, *Barnardo* (London, 1979), 26–30, 34–37, 57–66, 79–87; Martin Levy, *Doctor Barnardo: Champion of Victorian Children* (Stroud, Eng., 2013), 39, 64–68, 92–95, 105–09; AW to CM, February 11–12/14, 1878.

41. AW to CM [January 25, 1878], October 10–12, 1877, and February 11–12/14, 1878, *GUW* 6561–62.

42. AW to JW, February 10, 1878, *GUW* 6354.

43. Sutherland, *Whistler*, 140–41, 142–43. For the complete story of JW, the Leylands, and the Peacock Room, see Linda Merrill, *The Peacock Room: A Cultural Biography* (New Haven, Conn., 1998).

44. Sutherland, *Whistler*, 145–47; Georgia Toutziari, "Ambition, Hopes, and Disappointments: The Relationship of Whistler and His Mother as Seen in Their Correspondence," in Lee Glazer et al., eds., *James McNeill Whistler in Context* (Washington, D.C., 2008), 208–09. The most complete account of the Whistler-Ruskin quarrel is Linda Merrill, *A Pot of Paint: Aesthetics on Trial in Whistler vs. Ruskin* (Washington, D.C., 1992).

45. Fred Payne to AW, August 28, 1878, *GUW* 8853.

46. Sutherland, *Whistler,* 159–60; *Hastings and St. Leonards Times,* November 30, December 7, 1878.

47. Sutherland, *Whistler,* 163–67; MacDonald, "Whistler," 84; Algernon Graves to JW, September 9, 1878, JW to Ada Maud Jarvis [September 6, 1879], *GUW* 1797, 9170.

48. AW to CM, February 11–12/14, 1878.

49. *Pike's Directory for 1878,* 144–45, 307–21; *Pike's Directory for 1880–81,* 163, 333–48.

50. Elizabeth Mumford, *Whistler's Mother: A Biography* (Boston, Mass., 1939), 242–43; *Pike's Directory for 1880–81,* 163; AW to ME, September 8–9/23/29, 1874, AW to JW, June 29 [1878].

51. James B. Francis Cash Account Books, LHS; James B. Francis to Sarah Francis, May 9, 1849, James B. Francis to George E. Francis, June 19, 1879, Elizabeth Brown to James Laver, November 4, 1965, X4, James Laver Papers, GUL; F. W. Coburn, *Whistler and His Birthplace,* ed. Edith Williams Burger and Liana De Girolami Cheney (Tewksbury, Mass., 1988), 51–52, 55–56. Thanks to Richard Marion of Lowell for information about Francis's garden.

52. JW to DH [January 1, 1880], JW to HW [February 20/March 1880], [March 1880], [March 22, 1880], *GUW* 11563, 6689–90, 6688.

53. JW to AW [March/May 1880], *GUW* 13502.

54. Sutherland, *Whistler,* 175–76; Henry Graves to JW, January 10, 1881, *GUW* 1800.

55. Sutherland, *Whistler,* 178–80; *Hastings and St. Leonards Independent,* February 3, 1881; *Hastings and St. Leonards News,* February 4, 1881; *Hastings and St. Leonards Times,* February 5, 1881; *Hastings and St. Leonards Chronicle,* February 5, 1881; *Hastings and St. Leonards Observer,* February 5, 1881; *New York Daily Tribune,* February 15, 1881.

10 Icon, 1881–2018

1 *New York Times,* April 6, 1882, 5; Algernon Graves, "James Abbott McNeill Whistler," *Printseller,* 1 (August 1903), 341–42; Margaret F. MacDonald, "Whistler: The Painting of the 'Mother,'" *Gazette des Beaux-Arts,* 85 (February 1975), 84–85.

2. Frederick Wedmore, "Mr. Whistler's Theories and Mr. Whistler's Art," *Nineteenth Century,* 30 (August 1979), 339.

3. YMSM 38; William C. Brownell, "Whistler in Painting and Etching," *Scribner's Magazine,* 18 (August 1879), 483, 492. See also Brownell, "American Pictures at the Salon," *Magazine of Art,* 6 (October 1883), 498–99.

4. E. R. and J. Pennell, *The Life of James McNeill Whistler,* 2 vols. (London, 1908), I:297–98; Henry Graves & Company to JW, January 10, 1881, Algernon Graves to JW, March 17, 1881, *GUW* 1800, 1802; Sylvia Yount, "Whistler and Philadelphia: A Question of Character," in Linda Merrill, ed., *After Whistler: The Artist and His Influence on American Painting* (London, 2003), 50–52.

5. Nicolai Cikovsky Jr., "Whistler and America," in Richard Dorment and Margaret F. MacDonald, eds., *James McNeill Whistler* (New York, N.Y., 1995), 34; Philadelphia *North American,* November 7, 1881; *Independent,* November 24, 1881, *New York Times,* April 6, 1882; *New York Sun,* April 9, 1882.

6. YMSM 101; Daniel E. Sutherland, *Whistler: A Life for Art's Sake* (London, 2014), 195–96, 203, 234.

7. Sutherland, *Whistler,* 249–54; Joy Newton and Margaret F. MacDonald "Whistler: Search for a European Reputation," *Zeitschrift für Kunstgeschichte,* 41 (1978), 148–59; MacDonald and Newton, "Selling the Mother," in MacDonald, ed., *Whistler's Mother: An American Icon* (Aldershot, Eng., 2003), 74–79; *National Observer,* December 5, 1891, 59.

8. Merrill, *After Whistler,* 27, 51, 138–41, 150–53, 176–77, 226–27; Peter Funnell et al., *Millais: Portraits* (Princeton, N.J., 1999), 113–17, 204–07; Cikovsky, "Whistler and America," 34.

9. "Some Newspaper Estimates of Whistler," *Literary Digest,* 27 (August 1, 1903), 132–33; Pascal Forthuny, "Notes sur James Whistler," *Gazette des Beaux-Arts,*

30 (November 1903), 390; Wilfrid Meynell, "James Abbott McNeill Whistler," *Pall Mall Magazine*, 31 (November 1903), 411; William Losee, "James McNeill Whistler, The Painter," *Brush and Pencil*, 12 (August 1903), 332–33; Christian Brinton, "Whistler," *Critic*, 41 (August 1903), 150.

10. Théodore Duret, *Whistler*, trans. Frank Rutter (Philadelphia, Pa, 1917), 101.

11. D. Croal Thomson, "Whistler and His London Exhibitions," *Art Journal*, 67 (April 1905), 109; D. S. MacColl, "The Whistler Exhibition – II," *Saturday Review*, 99 (March 4, 1905), 268; "The Whistler Exhibition," *Athenaeum*, No. 4036 (March 4, 1905), 280.

12. Charles H. Caffin, "James McNeill Whistler," *International Studio*, 20 (September 1903), clv, and *American Masters of Painting* (New York, N.Y., 1902), 43; Marion H. Spielmann, "James A. McNeill Whistler: 1834–1903," *Magazine of Art*, n.s., 2 (November 1903), 13; Frank Jewett Mather Jr., "The Art of Mr. Whistler," *World's Work*, 6 (September 1903), 3923.

13. Lee Glazer, "Whistler, America, and the Memorial Exhibition of 1904," in Merrill, *After Whistler*, 86–96; William Howe Downes, "Whistler and His Work," *National Magazine*, 20 (April 1904), 15–16; Kenyon Cox, "The Art of Whistler," *Architectural Record*, 15 (May 1904), 474–75.

14. Martha Banta, *Imaging American Women: Idea and Ideals in Cultural History* (New York, N.Y., 1987), 58–65, 564–69, 678–81; Holbrook Jackson, "A Note on Whistler's Masterpiece," and Ethel Robert Wheeler, "The Mother in Literature," *T. P.'s Christmas Weekly*, 16 (1910), 29–30, 33–34.

15. Joseph Smith, "The Genesis of Jim Whistler," *Illustrated American*, 17 (May 25, 1895), 61–64; Albert Ludovici, *An Artist's Life in London and Paris, 1870–1925* (London, 1926), 91–92.

16. Daniel E. Sutherland, "Getting Right with Whistler: An Artist and His Biographers," in Glazier, *James McNeill Whistler in Context*, 170–72; Phoebe Lloyd, "Anna Whistler the Venerable," *Art in America*, 72 (November 1984), 150, 8n.

17. Christian Brinton, "Whistler from Within," *Munsey's Magazine*, 36 (October 1906), 16–20.

18. Sadakichi Hartmann, *The Whistler Book* (Boston, Mass., 1910), 21, 137, 143–46. In his later *History of American Art*, 2 vols. (1901; Boston, Mass., 1932), I:172–73, Hartmann dropped the religious connotations of the painting.

19. "Pictures and Small Incomes," *T. P.'s Weekly*, 8 (November 16, 1906), 626, (December 21, 1906), 810; "How to Frame the Whistler Picture," *T. P.'s Christmas Weekly*, 16 (1910), 50.

20. *New York Times*, July 5, 1925, Sec.7, p.3; May 2, 1926, Sec.8, p.15; *Literary Digest*, 97 (May 5, 1928), cover and p.27.

21. "Pictures in Schools, *The Times*, December 27, 1927, 15.

22. "The Lady in the Portrait," *Atlantic Monthly*, 136 (September 1925), 319–28; F. W. Coburn, *Whistler and His Birthplace*, ed. Edith Williams Burger and Liana De Girolami Cheney (Tewksbury, Mass., 1988), 85–86, 89–91, 97–100, 107–10.

23. *New York Times*, March 7, 1920, Sec.5, p.6, June 6, 1920, Sec.6, p.1, January 14, 1923, Sec.7, p.1, June 8, 1924, Sec.7, p.1, July 25, 1925, Sec.7, p.6, October 4, 1931, Sec.8, p.1, July 19, 1931, Sec.8, p.1, July 20, 1931, 21, November 29, 1931, Sec.8, p.1, December 6, 1931, Sec.8, p.2, December 13, 1931, Sec.8, p.1. Production records for *Mr. Whistler* may be found in Rowland Stebbins Papers, Box 10, NYPL.

24. *New York Times*, October 13, 1932, p.32, October 23, 1932, Sec.6, p.9. Kevin Sharp, "Pleasant Dreams: Whistler's *Mother* on Tour in America, 1932–34," in MacDonald, *Whistler's Mother*, 81–99.

25. *New York Times*, October 14, 1932, 18, October 23, 1932, Sec.6, p.9.

26. *New York Times*, November 1, 1932, p.26, November 6, 1932, p.10; Steven Biel, *American Gothic: A Life of America's Most Famous Painting* (New York, N.Y., 2005), 83–87; Sharp, "Pleasant Dreams," 88, 98.

27. *Art Digest*, 7 (April 1, 1933), 14; Sharp, "Pleasant Dreams," 90–92, 94–95.

28. Leigh Eric Schmidt, *Consumer Rites: The Buying and Selling of American Holidays* (Princeton, N.J., 1995), 244–75; Ronald Hutton, *The Stations of the Sun: A History of the Ritual Year in Britain* (Oxford, Eng., 1996), 150, 174–77.

29. Sharp, "Pleasant Dreams," 80, 94–97; *New York Times*, May 5, 1934, 1, 11, May 10, 1934, 19, May 16, 1934, 21; quote in Aline B. Saarinen, "Profile of Whistler's Mother," *New York Times Sunday Magazine*, February 14, 1954, 13.

30. Martha Tedeschi, "The Face that Launched a Thousand Images: Whistler's *Mother* and Popular Culture," in MacDonald, *Whistler's Mother*, 130.

31. *New York Times*, April 15, 1934, Sec.10, p.1, July 8, 1934, Sec.6, p.4, August 5, 1934, Sec.4, p.1, April 5, 1936, Sec.9, p.1; *Art Digest*, 8 (July 1, 1934), 13; *Chicago Defender*, June 16, 1934, p.12; "James McNeill Whistler, by Georgia Haswell Fawcett, in WPA Radio Scripts, Series LXXVII, Box 50, f.11, NYPLR.

32. *Art Digest*, 7 (January 1, 1933), 6, 30; Anne Miller Downes, "A Portrait of Whistler by His Mother," *New York Times*, July 8, 1934, Sec.6, p.4; Grace S. Fleming to KM, November 2, 1928, F352, WC. The letter, dated November 3–4, 1871, is *GUW* 10071.

33. Downes, "Portrait of Whistler," SM4.

34. Kate R. McDiarmid, *Whistler's Mother: Her Life, Letters and Journal* (North Wilksboro, N.C., 1981); Kathleen Morehouse to KM, February 12, 1928, M454, Little, Brown and Co. to KM,

February 24, 1931, L154, Beecher Stowe to KM, June 25, 1928, D62, WC.

35. Elizabeth R. Pennell to KM, January 4 and 9, 1929, P210, Rosalind B. Philip to KM, February 11, 1929, P578, A. R. Newsome to KM, October 3 and 23, 1934 and June 1, 1935, N63–65, WC. McDiarmid's surviving correspondence, which is more valuable than her book for understanding Anna, is part of WC. Other of her surviving papers are in the Anna Matilda McNeill Papers, NC.

36. Albert Parry, *Whistler's Father* (Indianapolis, 1939), ix–x; Katherine Woods, "Whistler's Famous Mother – and His Father, Too," *New York Times*, November 5, 1939, Sec.6, p.4. See also the exchange of letters between Parry and Woods in "Letters to the Editor," *New York Times*, November 19, 1939, Sec.6, p.18.

37. Elizabeth Mumford, *Whistler's Mother: The Life of Anna McNeill Whistler* (Boston, Mass., 1939), v; Woods, "Whistler's Famous Mother," 97. The first "biography" of George Whistler was George Leonard Vose, *A Sketch of the Life and Works of George W. Whistler* (Boston, Mass., 1887).

38. Gina Strumwasser and Monroe Friedman, "Mona Lisa Meets Madison Avenue: Advertising Spoofs of a Cultural Icon," in Sammy R. Danna, ed., *Advertising and Popular Culture: Studies in Variety and Versatility* (Bowling Green, Ohio, 1992), 85–86; Donald Capps, *At Home in the World: A Study in Psychoanalysis, Religion, and Art* (Eugene, Ore., 2013), 30–49.

39. Francesca Bonazzoli and Michele Robecchi, *Mona Lisa to Marge: How the World's Greatest Artworks Entered Popular Culture* (Munich, 2014), 15–16; Tedeschi, "The Face that Launched a Thousand Images," 131–32; accessed July 27, 2017, www.wdl.org/en/item/283/; "The Bravest of Them All," Harris Broadsides, Brown University Library.

40. Ludovici, *An Artist's Life in London and Paris,* 92.

41. Tedeschi, "The Face that Launched a Thousand Images," 130–31.

42. *New Yorker*, 8 (May 7, 1932), 10 (May 5, 1934).

43. Anthony Julius, *Transgressions: The Offences of Art* (Chicago, 2002), 18–20, 53–58, 88–92; Arthur C. Danto, *The Abuse of Beauty: Aesthetics and the Concept of Art* (Chicago, 2003), x–xix, 25–29, 45–46. Another author sees this transformation in all the arts, including music, dance, and literature, as well as painting, beginning in what she calls the Revolution of 1910. Mary Settegast, *Mona Lisa's Moustache: Making Sense of a Dissolving World* (Grand Rapids, Mich., 2001), 66, 91–99.

44. Martha Banta, *Barbaric Intercourse: Caricature and the Culture of Conduct, 1841–1936* (Chicago, 2003), 4–5, 25; *New York Herald Tribune*, September 5, 1948, pictured in MacDonald, *Whistler's Mother*, 11; KM to Louis T. Moore, May 9, 1945, M40, WC; *Life Magazine*, 72 (May 12, 1972), 9.

45. Bonazzoli and Robecchi, *Mona Lisa to Marge*, 16–18; Sarah Walden, *Whistler and His Mother: An Unexpected Relationship* (London, 2003), 124–28.

46. *New Yorker*, 37 (September 16, 1961), 45; *New York Times Book Review*, June 14, 1970, 32.

47. *New Yorker*, 33 (December 14, 1957), 48; Intelligent Healthcare Displays, LLC (Antioch, Ill., 2008). Tedeschi, "The Face that Launched a Thousand Images," 133–41, provides several other examples.

48. *New Yorker*, 60 (December 10, 1984), 45; 55 (August 20, 1979), 27. For the *Mona Lisa*, see Donald Sassoon, *Becoming Mona Lisa: Making of a Global Icon* (New York, N.Y., 2001), 220–75; Biel, *American Gothic*, 112–72.

49. *Northwest Arkansas Times*, May 7, 2002, 11.

50. *Mad Magazine*, No.79 (June 1963); *New Yorker*, 72 (May 13, 1996).

51. *New Yorker*, 46 (June 20, 1970), 29; *New York Herald Tribune*, June 26, 1984, 4; *Northwest Arkansas Times*, August 5, 2013, 7.

52. *Punch*, 71 (November 11, 1876), 201; *New Yorker*, 35 (September 26, 1959), 169; Jim Heimann, ed., *1900–1919: All-American Ads* (Köln, Ger., 2005), 315.

53. Tedeschi, "The Face that Launched a Thousand Images," 132–33.

54. *The Times*, June 21, 1952, 8.

55. "Grandma Faust. Almost Free," *The Times*, October 28, 1976, 11.

56. Richard Armstrong, *Billy Wilder, American Film Realist* (Jefferson, N.C., 2000), 121.

57. For a sampling of the multiple religious interpretations of the film, see Wendy M. Wright, "Babette's Feast: A Religious Film," *Journal of Religion and Film*, 1 (October 1997), 1–28; Thomas J. Curry, "Babette's Feast and the Goodness of God," *Journal of Religion and Film*, 16 (October 2012), 1–44.

58. Tedeschi, "The Face that Launched a Thousand Images," 138.

59. Robert Hughes, *American Visions: The Epic History of Art in America* (New York, N.Y., 1997), 237–42, and *Nothing If Not Critical: Selected Essays on Art and Artists* (New York, N.Y., 1991), 110–13; Paul Johnson, *Art: A New History* (New York, N.Y., 2003), 561–64; Judith Thurman, *The Artist's Mother: The Greatest Painters Pay Tribute to the Women Who Rocked Their Cradles* (New York, N.Y., 2009); Juliet Heslewood, *Mother: Portraits by 40 Great Artists* (London, 2009); Barbara Coller, "The Artist's Mother: Portraits and Homages," 9–12, and Donald Kuspit, "Representing the Mother: Representing the Unrepresentable?," 23–29, in Coller, *The Artist's Mother: Portraits and Homages* (Huntington, N.Y., 1987); Lloyd, "Anna Whistler the Venerable," 138–51; Emily

A. Beeny and Stéphane Guégan, *Pas de Deux: An Exchange of Masterpieces* (Seattle, 2015), 42–47; Jonathan Weinberg, *Ambition and Love in Modern American Art* (New Haven, Conn., 2001), 3–28; Capps, *At Home in the World*, xxii, 50–68.

60. Nouritza Matossian, *Black Angel: The Life of Arshile Gorky* (Woodstock, N.Y., 2000), 150, 155; William Vaughn, "A Chance Meeting of Whistler and Freud? Artists and Their Mothers in Modern Times," in MacDonald, *Whistler's Mother*, 100–19.

61. Lawrence Williams, *I, James McNeill Whistler: An "Autobiography"* (New York, N.Y., 1972); Ted Berkman, *To Seize the Passing Dream: A Novel of Whistler, His Women and His World* (Garden City,

N.Y., 1972); Cherry Smyth, *Hold Still* (London, 2013).

62. Tedeschi, "The Face that Launched a Thousand Images," 138–39; Don DeLillo, *Underworld* (New York, N.Y., 1997).

63. Walden, *Whistler and His Mother*, 192–222; *Detroit Free Press*, March 7, 2004, Sec.K, pp.1, 5; *Detroit News*, May 6, 2004, Sec.D, pp.1, 6; *The Times*, October 24, 1994, 19. Thanks to Carol Togneri and Christine Goo of the Simon Norton Museum, Pasadena, for sharing the photographs and reactions of visitors to their 2015 exhibition of *The Mother*.

64. Quoted in *Sydney Morning Herald*, March 29, 2016.

ARCHIVES AND SELECTED SOURCES

AAA: Archives of American Art, Washington, D.C.

AIC: Ryerson and Burnham Libraries, Art Institute of Chicago

AL: Alabama Department of Archives and History, Montgomery

BU: Howard Gotlieb Archival Research Center, Boston University

CHS: Connecticut Historical Society, Hartford

FGA: Freer Galley of Art, Arthur M. Sackler Gallery Archives, Washington, D.C.

G: *James McNeill Whistler: The Etchings. A Catalogue Raisonné*, ed. Margaret F. MacDonald. Online edition, University of Glasgow, 2008. http://etchings.arts.gla.ac.uk. G followed by catalogue number.

GUL: University of Glasgow Library

GUW: *The Correspondence of James McNeill Whistler, 1855-1903*, ed. Margaret F. MacDonald, Patricia de Montfort, and Nigel Thorp, including *The Correspondence of Anna McNeill Whistler, 1855-1880*, ed. Georgia Toutziari. Online edition, University of Glasgow, 2003. http://whistler.arts.gla.ac.uk/correspondence. *GUW* followed by document number.

HL: Hastings Reference Library

HSP: Historical Society of Pennsylvania, Philadelphia

LC: Library of Congress. Washington, D.C.

LHS: Lowell Historical Society, Lowell, Massachusetts

LNHP: Lowell National Historical Park, Lowell, Massachusetts

M: *James McNeill Whistler: Drawings, Pastels and Watercolours: A Catalogue Raisonné* (New Haven and London, 1995). M followed by catalogue number.

MdHS: Maryland Historical Society, Baltimore

MHS: Massachusetts Historical Society, Boston

MO: Musée d'Orsay, Paris

NA: National Archives and Records Center, Washington, D.C.

NAL: National Art Library, Victoria and Albert Museum, London

NC: North Carolina Department of Archives and History, Raleigh

NYHS: New-York Historical Society

NYPL: New York Public Library

NYPLR: New York Public Library for the Performing Arts, Billy Rose Theatre Division

PWC: Pennell-Whistler Collection, Library of Congress, Washington, D.C.

SH: Lyman & Merrie Wood Museum of Springfield History, Springfield, Massachusetts

SHC: Southern Historical Collection, University of North Carolina, Chapel Hill

TMA: Taft Museum of Art, Cincinnati, Ohio

UL: Special Collections, Brotherton Library, University of Leeds

UO: Department of Special Collections and Western Manuscripts, Bodleian Library, University of Oxford

UP: University of Pennsylvania Archives and Record Center, Philadelphia

WC: Whistler Collection, University of Glasgow Library

YMSM: *The Paintings of James McNeill Whistler*, ed. Andrew McLaren Young, Margaret F. MacDonald, Robin Spencer, and Hamish Miles (New Haven and London, 1980). YMSM followed by catalogue number.

YU: Beinecke Rare Book Room and Manuscript Library, Yale University, New Haven, Conn.

SELECTED BIBLIOGRAPHY

MANUSCRIPTS

American Play Company Records, NYPLR

Arnold and Appleton Family Papers, SHC

Arthur P. Bagby Letters, ADAH

Emma Haden Bergeron Correspondence, UO

Walter S. Brewster Collection of Whistleriana, AIC

Caroline Elizabeth Burgwin Clitherall Diaries, SHC

Henry Cole Collection, NAL

Henry Cole Diaries, NAL

Samuel Colt Papers, CHS

DeRossett Family Papers, SHC

James B. Francis Cash Account Book, LHS

Charles Lang Freer Papers, FGA

Gellibrand Family Papers, UL

Giles Family Papers, SHC

Green Family Diaries, LNHP

Haden Family Correspondence, UO

Francis Seymour Haden Correspondence, NYPL

Joseph Harrison Letterpress Books, 1844–1865, HSP

Horsley Family Paper, UO

Ralph Ingersoll Papers, BU

James Laver Papers, GUL

Arthur Livermore Papers, MHS

Thomas David Smith McDowell Papers, SHC

Ben Dixon MacNeill Papers, SHC

Thomas F. Madigan Collection, NYPL

John Stevenson Maxwell Papers, NYHS

Benjamin Moran Diaries, LC

Mordecai Family Papers, SHC

John Owen Papers, SHC

Pennell–Whistler Collection, LC

University of Pennsylvania Office of Alumni Records: Biographical Records, 1750–2002, UP

University of Pennsylvania School of Medicine: Student Records, 1828–1952, UP

David Maulden Perine Papers, MdHS

Pettigrew Family Papers, SHC

Charlotte Porcher Letters, SHC

Porcher and Haskell Family Papers, SHC

Katherine Prince Collection, AAA

Rodman–Harvey Family Papers, NYPL

Ropes Family Papers, MHS

Isidore Spielmann Correspondence, NAL

Rowland Stebbins Papers, NYPL

John Steele Papers, SHC

Scott Stevenson Letters, TMA

Denys Sutton Papers, GUL

Joseph Gardner Swift Letters, NYPL/AAA

Emilie Venturi Letters to John Dillon, James Marshall, and Marie-Louise Osborn Collection, YU

Whistler Collection, GUL

Anna M. Whistler Diary, 1843–1848, NYPL/AAA

Anna Matilda McNeill Whistler Papers, NC

John and William A. Williams Papers, SHC

Wilmington (North Carolina) Papers, SHC

Winans Papers, MdHS

WPA Radio Scripts, NYPLR

PUBLISHED PRIMARY SOURCES

Alcott, William A. *The Young Wife, or Duties of a Woman in the Marriage Relation*. Boston, Mass., 1837.

Bader, Charles. *The Natural and Morbid Changes of the Human Eye, and Their Treatment*. London, 1868.

Barrett, Walter. *The Old Merchants of New York City*. New York, N.Y., 1870.

Beerbohm, Max. "Hethway Speaking," *Atlantic Monthly*, 200 (November, 1957), 69–72.

Brownwell, William C. "Whistler in Painting and Etching," *Scribner's Magazine*, 18 (August, 1879), 481–95.

Caffin, Charles H. *American Masters of Painting*. New York, N.Y., 1902.

_____. "James McNeill Whistler," *International Studio*, 20 (September, 1903), cliii–clvi.

Cox, Kenyon. "The Art of Whistler," *Architectural Record*, 15 (May, 1904), 467–81.

Ford, Arthur Personneau, and Marion Johnstone. *Life in the Confederate Army*. New York, N.Y., 1905.

Gibson, Frank. "Whistler's Portrait of his Mother," *Burlington Magazine*, 28 (December 1915), 117.

Granville, A.B. *Spas of England and Principle Sea-Bathing Places: The Midlands and South*. [1841] Bath, Eng., 1971.

Hamilton, J. G. De Roulhac, ed. *Papers of William Alexander Graham*, 6 vols. Raleigh, N.C., 1957–76.

Hartmann, Sadakichi. *A History of American Art*, 2 vols. Boston, Mass., 1932.

_____. *The Whistler Book*. Boston, Mass., 1910.

Hatch III, Rodney S. III, ed. *Dr. Edward Maynard: "Letters from the Land of the Tsar, 1845–1846." America's Pioneering Dental Surgeon Turned Civil War Gun Inventor*. North Salem, N.Y., 2010.

Ingram, Christine L. et al., eds. *New Hanover County Slave Deeds*, 3 vols. Wilmington, N.C., 2013.

Ionides, Luke. *Memories*. [1925] Ludlow, Eng., 1996.

Jones, J. B. *A Rebel War Clerk's Diary at the Confederate States Capital*, 2 vols. Philadelphia, Pa., 1866.

Klinkowström, Axel L. *Baron Klinkowström's America, 1818–1820*. Edited and translated by Franklin D. Scott. Evanston, Ill., 1952.

Kohl, J.G. *Russia and the Russians in 1842*, 2 vols. London, 1842.

Ludovici, Albert. *An Artist's Life in London and Paris, 1870–1925*. London, 1926.

MacColl, D. S. "The Whistler Collection—II," *Saturday Review*, 99 (March 4, 1905), 267–68.

McGuire, Judith W. *Diary of a Southern Refugee during the War by a Lady of Virginia*. New York, N.Y., 1867.

Maxwell, John S. *The Czar, His Court and People*. London, 1848.

Miles, Henry A. *Lowell, As It Was, and As It Is*. Lowell, Mass., 1845.

Myers, Terry L. ed. *Uncollected Letters of Algernon Charles Swinburne*, 3 vols. London, 2004.

Nevins, Allan. *The Diary of Philip Hone, 1828–1851*. New York, N.Y., 1936.

Nevins, Allan and Milton Halsey Thomas, eds. *Diary of George Templeton Strong*, 4 vols. New York, N.Y., 1952.

Pennell, E. R. & J. *The Life of James McNeill Whistler*, 2 vols. London, 1908.

Putnam, Sallie B. *Richmond During the War: Four Years of Personal Observation*. New York, N.Y., 1867.

Randall, Lillian M. C., ed. *The Diary of George A. Lucas: An American Art Agent in Paris, 1857–1909*, 2 vols. Princeton, N.J., 1979.

Robinson, Harriet H. *Loom and Spindle, or Life Among the Early Mill Girls*. [1898] Kailua, Hawaii, 1976.

Rossetti, William Michael. *Some Reminiscences of William Michael Rossetti*, 2 vols. New York, N.Y., 1906.

Rothenstein, William. *Men and Memories: A History of the Arts, 1872–1922*, 2 vols. New York, N.Y., 1940.

Saunders, William L. and Walter Clark, eds. *The Colonial and State Records of North Carolina*, 26 vols. Goldsboro, N.C., 1886–1907.

Smith, Joseph. "The Genesis of Jim Whistler," *Illustrated American*, 17 (May 25, 1895), 651–54.

Stiles, Henry Reed. *A History of the City of Brooklyn*, 3 vols. Brooklyn, 1867–70.

Stowell, Daniel W., ed. *Balancing Evils: The Proslavery Writings of Zephaniah Kingsley*. Gainesville, Fla., 2000.

"Sulphur Springs of New York," *Harper's Monthly Magazine*, 13 (June, 1856), 1–17.

Swift, Joseph Gardner. *The Memoirs of Gen. Joseph Gardner Swift*. Worcester, Mass., 1890.

Thomson, D. Croal. "Whistler and His London Exhibition," *Art Journal*, n.s., 57 (April, 1905), 107–111.

Toutziari, Georgia. "Anna Matilda Whistler: Correspondence – An Annotated Edition." PhD diss., University of Glasgow, 2002.

Wedmore, Frederick. "Mr. Whistler's Theories and Mr. Whistler's Art," *Nineteenth Century*, 30 (August 1879), 334–43.

Whistler, James McNeill. *The Gentle Art of Making Enemies*. London, 1892.

PUBLISHED SECONDARY SOURCES

Andreeva, Galina and Margaret F. MacDonald, eds. *Whistler and Russia*. Moscow, 2006.

Banta, Martha. *Barbaric Intercourse: Caricature and the Culture of Conduct, 1841–1936*. Chicago, Ill., 2003.

_____. *Imagining American Women: Idea and Ideals in Cultural History*. New York, N.Y., 1987.

Baxter, James H. *St. Petersburg: Industrialization and Change*. Montreal, Que., 1976.

Beeny, Emily A. and Stephane Guégan. *Pas de Deux: An Exchange of Masterpieces*. Seattle, Wash., 2015.

Belt, Anthony, ed. *Hastings: A Survey of Times Past and Present*. Hastings, Eng., 1937.

Bleser, Carol, ed. *In Joy and in Sorrow: Women, Family, and Marriage in the Victorian South, 1830–1900*. New York, N.Y., 1991.

Bonazzoli, Francesca and Michele Robecchi. *Mona Lisa to Marge: How the World's Greatest Artworks Entered Popular Culture*. Munich, 2014.

Butler, Diana Hochstedt. *Standing Against the Whirlwind: Evangelical Episcopalians in Nineteenth-Century America*. New York, 1995.

Cabot, Harriet Ropes. "The Early Years of William Ropes & Company in St. Petersburg," *American Neptune*, 13 (April, 1963), 131–39.

Capps, Donald. *At Home in the World: A Study in Psychoanalysis, Religion, and Art*. Eugene, Ore., 2013.

Cayleff, Susan E. *Wash and Be Healed: The Water-Cure Movement and Women's Health*. Philadelphia, Pa., 1987.

Censer, Jane Turner. *North Carolina Planters and Their Children, 1800–1860*. Baton Rouge, La., 1984.

Coburn, F. W. *Whistler and His Birthplaces*. Edited by Edith Williams Burger and Liana De Girolami. Tewksbury, Mass. 1988.

Coller, Barbara et al. *The Artist's Mother: Portraits and Homages*. Huntington, Calif., 1987.

Cross, Anthony. *By the Banks of the Neva: Chapters from the Lives and Career of the British in Eighteenth-Century Russia*. Cambridge, Eng., 1997.

_____. "The English Embankment," in Cross, *St. Petersburg*, 50–70.

_____, ed. *St. Petersburg, 1703–1825*. Basingstoke, Eng., 2003.

Danna, Sammy R., ed. *Advertising and Popular Culture: Studies in Variety and Versatility*. Bowling Green, Ohio, 1992.

Danto, Arthur C. *The Abuse of Beauty: Aesthetics and the Concept of Art*. Chicago, Pa., 2003.

Davidson, Angus. *Miss Douglas of New York: A Biography*. New York, N.Y., 1953.

Degler, Carl N. *At Odds: Women and the Family in America from the Revolution to the Present*. New York, N.Y., 1980.

Denny, Barbara. *Chelsea Past*. London, 2001.

Dilts, James D. *The Great Road: The Building of the Baltimore & Ohio, the Nation's First Railroad, 1828–1853*. Stanford, Calif.,1993.

Dorment, Richard, and Margaret F. MacDonald, eds. *James McNeill Whistler*. New York, N.Y., 1995.

Dublin, Thomas. *Women at Work: The Transformation of Work and Community in Lowell, Massachusetts, 1826–1860*. New York, N.Y., 1979.

Friedman, Jean E. *The Enclosed Garden: Women and Community in the Evangelical South, 1830–1900*. Chapel Hill, N.C., 1985.

Furman, Robert. *Brooklyn Heights: The Rise, Fall, and Rebirth of America's First Suburb*. Charleston, S.C., 2015.

Glazer, Lee et al., eds. *James McNeill Whistler in Context*. Washington, D.C., 2008.

Goebel, Catherine Carter. "Arrangement in Black and White: The Making of a Whistler Legend." PhD diss., Northwestern University, Ill., 1988.

Greenhill, Basil and Ann Giffard. *Travelling by Sea in the Nineteenth Century: Interior Design in Victorian Passenger Ships*. New York, N.Y., 1974.

Guroff, Gregory, and Fred V. Carstensen, eds. *Entrepreneurship in Imperial Russia and the Soviet Union*. Princeton, N.J., 1983.

Hartoq, Hendrick. *Man and Wife in America: A History*. Cambridge, Mass., 2000.

Haywood, Richard Mowbray. *Russia Enters the Railway Age, 1842–1855*. Boulder, Colo., 1998.

Heslewood, Juliet. *Mother: Portraits by 40 Great Artists*. London, 2009.

Hutton, Ronald. *The Stations of the Sun: A History of the Ritual Years in Britain*. Oxford, 1996.

Jabour, Anya, "'Grown Girls, Highly Cultivated': Female Education in an Antebellum Southern Family," *Journal of Southern History*, 64 (February, 1998), 23–64.

_____. *Marriage in the Early Republic: Elizabeth and William Wirt and the Companionate Ideal*. Baltimore, Md., 1998.

Jackson, Alan A. *London's Metropolitan Railway*. London, 1986.

Julius, Anthony. *Transgressions: The Offences of Art*. Chicago, Ill., 2002.

Karttunen, Marie-Louise. "The British Factory at St. Petersburg: A Case of Nineteenth-Century NGO." www.helsinki.fi/project/era/pop/pop-karttunen.pdf.

Kelley, Mary. *Learning to Stand and Speak: Women, Education, and Public Life in America's Republic*. Chapel Hill, N.C., 2006.

Kern, Stephen. *Eyes of Love: The Gaze in English and French Culture, 1840–1900*. New York, N.Y., 1996.

Kerrison, Catherine. *Claiming the Pen: Women and Intellectual Life in the Early American South*. Ithaca, N.Y., 2006.

Kierner, Cynthia A. *Beyond the Household: Women's Place in the Early South, 1700–1835*. Ithaca, N. Y., 1998.

Kirchner, Walther. *Studies in Russian-American Commerce, 1820–1860*. Leiden, 1975.

Lincoln, W. Bruce. *Nicholas I: Emperor and Autocrat of All the Russias*. Bloomington, Ind., 1978.

_____. *Sunlight at Midnight: St Petersburg and the Rise of Modern Russia*. New York, N.Y., 2000.

Lloyd, Phoebe. "Anna Whistler The Venerable," *Art in America*, 72 (November, 1984), 138–51.

Lovell, Stephen. *Summerfolk: A History of the Dacha, 1710–2000*. Ithaca, N.Y., 2003.

McDiarmid, Kate R. *Whistler's Mother: Her Life, Letters and Journal*. North Wilkesboro, N.C., 1981.

MacDonald, Margaret F. *James McNeill Whistler: Drawings, Pastels and Watercolours: A Catalogue Raisonné*. New Haven, Conn., 1995.

_____. ed. *Whistler's Mother: An American Icon*. Aldershot, Eng., 2003.

_____. "Whistler: The Painting of the 'Mother,'" *Gazette des Beaux-Arts*, 85 (February, 1975), 73–88.

_____. *Whistler's Mother's Cook Book*, 2nd ed. San Francisco, Calif., 1995.

McPherson, Heather. *The Modern Portrait in Nineteenth-Century France*. Cambridge, Eng., 2001.

Marks, Paul C. "James McNeill Whistler's Family Secret: An Arrangement in White and Black," *Southern Quarterly*, 26 (Spring, 1988), 67–75.

Matthews, Glenna. *"Just a Housewife": The Rise and Fall of Domesticity in America*. New York, N.Y., 1987.

_____. *The Rise of Public Women: Woman's Power and Woman's Place in the United States, 1630–1970*. New York, N.Y., 1992.

Merrill, Linda et al. *After Whistler: The Artist and His Influence on American Painting*. New Haven, Conn., 2003.

_____. *The Peacock Room: A Cultural Biography*. New Haven, Conn., 1998.

_____. *A Pot of Paint: Aesthetics on Trial in Whistler & Ruskin*. Washington, D.C., 1992.

Mullen, Robert Bruce. *Episcopal Visions of American Reality: High Church Theology and Social Thought in Evangelical America*. New Haven, Conn., 1986.

Mumford, Elizabeth. *Whistler's Mother: The Life of Anna McNeill Whistler*. Boston, Mass., 1939.

Nelson, Robert S., and Richard Shiff, eds. *Critical Terms for Art History*. Chicago, Ill., 1996.

Newton, Joy, and Margaret F. MacDonald. "Whistler: Search for a European Reputation," *Zeitschrift für Kunstgeschichte*, 41 (1978), 148–59.

Parry, Albert. *Whistler's Father*. Indianapolis, 1939.

Pease, Jane H. and William H. Pease. *A Family of Women: The Carolina Petigrus in Peace and War*. Chapel Hill, N.C., 1999.

_____. *Ladies, Women, and Wenches: Choices and Constraint in Antebellum Charleston and Boston*. Chapel Hill, N.C., 1990.

Peterson, M. Jeanne. *The Medical Profession in Mid-Victorian London*. Berkeley, Calif., 1978.

Porter, Roy. *Bodies Politic: Disease, Death and Doctors in Britain, 1650–1900*. Ithaca, N.Y., 2001.

_____, ed. *The Medical History of Waters and Spas*. London, 1990.

Rosenwaike, Ira. *Population History of New York City*. Syracuse, N.Y., 1972.

Sassoon, Donald. *Becoming Mona Lisa: The Making of a Global Icon*. New York, N.Y., 2001.

Schafer, Daniel L. *Anna Madgigine Jai Kingsley*. Gainesville, Fla., 2003.

_____. *Zephaniah Kingsley Jr. and the Atlantic World: Slave Trader, Plantation Owner, Emancipator*. Gainesville, Fla., 2013.

Schmidt, Leigh Eric. *Consumer Rites: The Buying and Selling of American Holidays*. Princeton, N.J., 1995.

Sifneos, Evrydiki. "Navigating the Hostile Maze: Americans and Greeks Exploring the 19th Century Russian Market Opportunities." www.ebha.org/ebha2011/files/papers/Navigating%20the%20hostile%20maze.pdf.

Simon, Patricia. "Women in Frames: The Gaze, the Eye, the Profile in Renaissance Portraiture," *History Workshop Journal*, 25 (Spring 1988), 4–30.

Smith, Eugene W. *Trans-Atlantic Passenger Ships Past and Present*. Boston, Mass., 1947.

Smith, Merritt Roe, ed. *Enterprises and Technological Change*. Cambridge, Mass., 1985.

Smith-Rosenberg, Carroll. *Disorderly Conduct: Visions of Gender in Victorian America*. New York, N.Y., 1985.

Strong, Rowan. *Episcopalianism in Nineteenth-Century Scotland: Religious Responses to a Modernizing Society*. Oxford, 2002.

Sturgis, Alexander and Hollis Clayson, eds. *Understanding Paintings: Themes in Art Explored and Explained*. New York, N.Y., 2000.

Sutherland, Daniel E. *Whistler: A Life for Art's Sake*. London, 2014.

Thurman, Judith. *The Artist's Mother: The Greatest Painters Pay Tribute to the Women Who Rocked Their Cradles*. New York, N.Y., 2009.

Tise, Larry E. *Proslavery: A History of the Defense of Slavery in America, 1701–1840*. Athens, Ga., 1987.

Toutziari, Georgia. "Ambition, Hopes, and Disappointments: The Relationship of Whistler and His Mother as Seen in Their Correspondence," in Glazer, 205–14.

_____. "Anna Matilda Whistler: A Life," in MacDonald, *American Icon*, 13–28.

_____. "The Whistlers in Russia," in Andreeva and MacDonald, 78–87.

Walden, Sarah. *Whistler and His Mother: An Unexpected Relationship*. London, 2003.

Weinberg, Jonathan. *Ambition and Love in Modern American Art*. New Haven, Conn., 2001.

Weiss, Harry B., and Howard R. Kemble. *The Great American Water-Cure Craze: A History of Hydropathy in the United States*. Trenton, N.J., 1967.

Westwood, J. N. *Endurance and Endeavour: Russian History, 1812–1986*, 3rd ed. Oxford, 1987.

Wolmar, Christian. *The Subterranean Railway: How the London Underground was Built and How It Changed the City Forever*. London, 2004.

Wood, Bradford J. *This Remote Part of the World: Regional Formation in Lower Cape Fear, North Carolina, 1725–1775*. Columbia, S.C., 2004.

Yeazell, Ruth Bernard. *Picture Titles: How and Why Western Paintings Acquired Their Names*. Princeton, N.J., 2015.

Young, Andrew McLaren et al. *The Paintings of James McNeill Whistler*, 2 vols. New Haven, Conn., 1980.

INDEX

PICTURE CREDITS

Plate 1: Mrs Charles Donald McNeill (Martha Kingsley, 1800/03, watercolour on ivory, 2½ × 1½ in (6.4 × 3.8 cm). Art Institute of Chicago. Gift of Mr. Walter S. Brewster, 1933.780. © 2018 The Art Institute of Chicago / Art Resource, NY / Scala, Florence

Plate 2: St. James Episcopal Church and Burgwin-Wright House, Wilmington, North Carolina; c. 1847, daguerreotype. Amon Carter Museum of American Art, Fort Worth, Texas. P1981.65.28

Plate 3: Crystal Bridges Museum of American Art, Bentonville, Arkansas, 2006.98. Photography by Dwight Primiano

Plate 4: University of Glasgow Library, Special Collections

Plate 5: Courtesy of the West Point Museum Collection, United States Military Academy

Plate 6: University of Glasgow Library, Special Collections

Plate 7: University of Glasgow Library, Special Collections

Plate 8: Courtesy of the Maryland Historical Society, Item ID MC711.5

Plate 9: Image Source: Daniel Sutherland

Plate 10: University of Glasgow Library, Special Collections

Plate 11: Smithsonian Institution Archives. Image MAH-14293

Plate 12: Courtesy of the Library of Congress

Plate 13: Wood Museum of Springfield History

Plate 14: University of Glasgow Library, Special Collections

Plate 15: *Illustrated London News*, 24 March 1849

Plate 16: The State Hermitage Museum, St. Petersburg. Photograph © The State Hermitage Museum / photo: Vladimir Terebenin, Svetlana Suetova

Plate 17: The State Hermitage Museum, St. Petersburg. Photograph © The State Hermitage Museum / photo: Vladimir Terebenin, Svetlana Suetova

Plate 18: The State Hermitage Museum, St. Petersburg. Copyright line: Photograph © The State Hermitage Museum / photo: Vladimir Terebenin, Svetlana Suetova

Plate 19: University of Glasgow Library, Special Collections

Plate 20: Courtesy of the Library of Congress

Plate 21: Longridge and District Local History Society

Plate 22: University of Glasgow Library, Special Collections

Plate 23: Samuel Lovett Waldo and William Jewett, *Mrs Charles (Martha Kingsley) McNeill*, 1834, oil on wood, 24⅛ × 19½ in (61.3 × 49.6 cm) Wadsworth Atheneum Museum of Art, Hartford, CT. Bequest of Clara Hinton Gould, 1948.182. Photo: Allen Phillips\Wadsworth Atheneum

Plate 24: Scarsdale Public Library

Plate 25: University of Glasgow Library, Special Collections

Plate 26: Courtesy of the Maryland Historical Society, Item ID PP127.4

Plate 27: Courtesy of the Maryland Historical Society, Item ID PP192.24

Plate 28: University of Glasgow Library, Special Collections

Plate 29: University of Glasgow Library, Special Collections

Plate 30: University of Glasgow Library, Special Collections

Plate 31: Sharon Historical Society, New York. Courtesy Sandra R. Manko

Plate 32: Courtesy of The Charleston Museum, Charleston, South Carolina

Plate 33: James Abbott McNeill Whistler, *At the Piano*, 1858–59, oil on canvas, 26⅝ × 36¾ × 1⅜ in Bequest of Louise Taft Semple, Taft Museum of Art, Cincinnati. Image courtesy of the Taft Museum of Art, Cincinnati, Ohio. Photo: Tony Walsh

Plate 34: Courtesy of the Library of Congress

Plate 35: Courtesy of the Library of Congress

Plate 36: Charles Lang Freer Papers, Freer Gallery of Art and Arthur M. Sackler Gallery Archives, Smithsonian Institution, Washington D.C., Gift of the Estate of Charles Lang Freer, FSA A.01 12.02.1.06

Plate 37: University of Glasgow Library, Special Collections

Plate 38: Courtesy of the Library of Congress

Plate 39: © Trustees of the British Museum

Plate 40: University of Glasgow Library, Special Collections

Back cover and plate 41: University of Glasgow Library, Special Collections

Plate 42: University of Glasgow Library, Special Collections

Plate 43: Courtesy of the Library of Congress

Plate 44: © National Maritime Museum, Greenwich, London

Plate 45: © Trustees of the British Museum

Plate 46: Freer Gallery of Art and Arthur M. Sackler Gallery, Smithsonian Institution, Washington D.C., Gift of Charles Lang Freer, F1907.150

Plate 47: Freer Gallery of Art and Arthur M. Sackler Gallery, Smithsonian Institution, Washington D.C., Gift of Charles Lang Freer, F1898.336

Plate 48: Freer Gallery of Art and Arthur M. Sackler Gallery, Smithsonian Institution, Washington D.C., Gift of Charles Lang Freer, F1890.10

Plate 49: Freer Gallery of Art and Arthur M. Sackler Gallery, Smithsonian Institution, Washington D.C., Gift of Charles Lang Freer, F1903.252

Plate 50: *Nocturne: Blue and Silver —Chelsea*, James Abbott McNeill Whistler, 1871, pastel, 19.8 in × 23.9 in (50.2 cm × 60.8 cm) © 2018 Tate, London. Bequeathed by Miss Rachel and Miss Jean Alexander, 1972

Front cover and plate 51: Photo © RMN-Grand Palais (Musée d'Orsay) / Jean Schormans

Plate 52: © CSG CIC Glasgow Museums and Libraries Collections

Plate 53: Courtesy of Daniel Sutherland

Plate 54: University of Glasgow Library, Special Collections

Plate 55: Courtesy of the Library of Congress

Plate 56: University of Glasgow Library, Special Collections

Plate 57: University of Glasgow Library, Special Collections

Plate 58: Courtesy of the Library of Congress

Plate 59: Franklin D. Roosevelt Presidential Library and Museum

Plate 60: © Edward Sorel

First published by Yale University Press 2018
302 Temple Street, P.O. Box 209040
New Haven CT 06520-9040
47 Bedford Square, London WC1B 3DP

yalebooks.com / yalebooks.co.uk

Copyright © 2018 Daniel E. Sutherland and Georgia Toutziari

ISBN 978-0-300-22968-4
Library of Congress Control Number: 2017954570

10 9 8 7 6 5 4 3 2 1
2022 2021 2020 2019 2018

Designer: Will Webb
Typeset by M Rules
Printed in China

Front cover: J.M. Whistler, *Arrangement in Grey and Black
No. 1: Portrait of the Artist's Mother*, 1871
Back cover: Anna McNeill Whistler when in Germany, 1864–65